The Horses
of San Marco

Venice

The Horses of San Marco

Venice

Translated by John and Valerie Wilton-Ely

with 279 illustrations, 24 in colour

Thames and Hudson

First English-language edition published in Great Britain in 1979 by Thames and
Hudson, London

© 1977 and 1979 Procuratoria di S. Marco, and Olivetti

Printed and bound in Italy

Contents

John Wilton - Ely *Preface*

The Horses of San Marco

Preface

In the course of history certain great works of art, removed from their original location and transported to a new country or civilisation, have had a profound influence on artists, becoming an integral part of that culture in the process. In particular, many works of classical antiquity have fulfilled this seminal role in European art, such as the Laocoorn or the Apollo Belvedere. There are, however, two exceptional groups of antique sculpture which have possessed symbolic associations in addition to their formal properties - the Elgin Marbles and the Horses of San Marco. While the former were associated with the myth of Periclean democracy in the cause of Greek independence during the era of Byron, the Venetian quadriga possesses an even more complex and fascinating history closely bound up with the foundation of Constantinople and the fortunes of the Serenissima.

Even before the Horses were seized from the hippodrome in Constantinople in 1204 by the Venetians on the Fourth Crusade, they may already have travelled from the Old to the New Rome when Constantine established his capital on the Bosphorous nearly a thousand years earlier. These magnificent gilded bronzes, incorporated into the façade of the Basilica of San Marco along with many other trophies and spoils, swiftly became a symbol of Venetian power in the Mediterranean and formed an essential part of the scenic character of the great Piazza. They were to witness Marco Polo's departure for the East in 1260 and a century later were described by Petrarch when witnessing a tournament from the loggia of the Basilica. Through the centuries they were recorded by a succession of painters including Gentile Bellini, Carpaccio, Canaletto, Francesco Guardi, Turner, Bonington, Whistler and Sickert. Meanwhile they continued to inspire the many artists who interpreted the horse in painting and sculpture such as Pisanello, Donatello, Verrocchio, Leonardo and Canova.

The public prominence of the Horses, however, also involved serious threats to their very existence. Even after they reached Venice in the early 13th century, they remained in the Arsenal for over fifty years in constant danger of being melted down for cannons before they were accorded the place of honour on the Basilica. In 1378 the Genoese threatened "to curb the Horses of San Marco" during the Battle of Chioggia, and some four centuries later they were carried off by Napoleon to Paris when the Republic fell in 1797. Returning to Venice in 1815, they were again removed on two occasions during the present century when taken to safety during the First and Second World Wars. But perhaps the greatest threat of all to the Horses has

been provided in our own time by the insidious corrosion from industrial pollution menacing Venice and its rich heritage.

As a consequence of extensive metallographic examinations in 1965 by the Central Institute for Restoration in Rome, an international commission was set up to study the history of the Horses and their conservation. The results of these exhaustive enquiries, involving archaeologists, art historians and scientists from many specialised fields, were presented in an exhibition at the former convent of Santa Apollonia, Venice, in 1977, organised by Professor Guido Perocco. The publication accompanying this exhibition (which was subsequently transferred to Turin) took the form of a collection of specialised essays on every aspect of the Horses. This material, with certain revisions and additions, now forms the basis of the present book issued to coincide with a major exhibition at the Royal Academy, presented and organized by Olivetti, entitled ''The Horses of San Marco'', which had one of the horses as its focal point.

Following a series of introductory articles, the three main sections of this book represent the principal aims of the commission and the exhibition. The first of these sets the Horses of San Marco in the context of ancient Greek and Roman art as a contribution to the historic debate over the origins of these celebrated works. It is hoped that the resulting discussions will serve to clarify the controversy over the dating of these sculptures, at present varying between the 4th century B.C. and the 4th century A.D., and their authorship by either a Greek or Roman artist. Secondly, a group of contributions underlines the importance of these striking works of art as a constant source of ideas to those many painters and sculptors who have attempted to express the horse in monumental terms. Finally, it is hoped that the important technical section dealing with the conservation of these masterpieces of bronze casting will awaken further public concern and support for the urgent cause of saving Venice and its unrivalled wealth of art treasures.

These researches may open up new vistas in the entire field of future conservation through international co-operation and the fruitful collaboration between archaeology, art history and the many disciplines of science.

JOHN WILTON-ELY

The Horses of San Marco

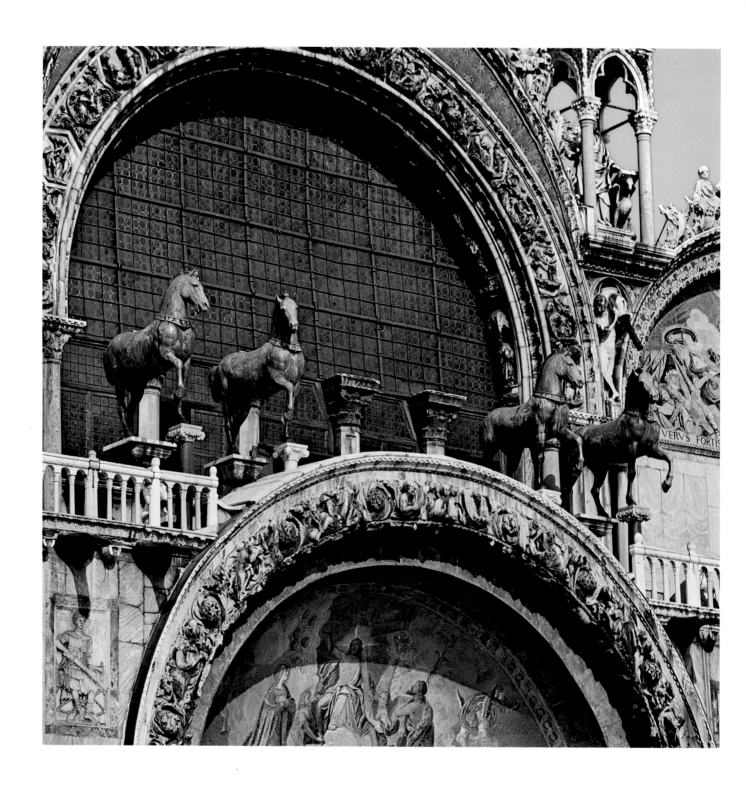

1. The bronze Horses of San Marco on the façade of the Basilica

The fortune of the Horses of San Marco in History

Massimo Pallottino

The whole question of the Horses of San Marco has been examined with fresh concern in recent years, particularly the urgent need for their conservation in the light of an ever increasing quantity of destructive agents attacking them. This exhibition is intended to promote a well-balanced discussion and to emphasize these problems which are inevitably governed in the first place by considerable technical factors. However, such a discussion obviously cannot be attempted without bearing in mind the whole range of artistic, historical and cultural values which combined to produce the unique and universal appeal of these outstanding works of art. Indeed, it is almost impossible to think of any other work of art which has suffered a fate comparable to that of the Horses. Together they have survived so many vicissitudes through different ages and civilisations, accumulating so many new and diverse meanings during the process.

These splendid survivors from a lost age, which are also living symbols of our own history, provide an ideal opportunity for us to reflect on the nature of the period separating us from antiquity. By their means we are able to consider if, how, where and when the break, or series of breaks, occurred; we are thus enabled to distinguish between an ''archaeological'' past, as reconstructed from surviving fragments, and a past which extends in unbroken continuity to our own present times. Unlike most remains of antiquity revealed by excavation or chance recovery, or certain isolated relics from the ravages of the Dark Ages, these precious works, at the beginning of the thirteenth century, still belonged to an unbroken ancient tradition, which only the historical paradox of Byzantium could hand on intact at the dawn of our modern western world. The crusade which conquered Constantinople in 1204 and carried off the Horses to Venice marked the moment of transition from their ancient to their modern history, through a simple military event devoid of any epoch-making significance. All that preceded this event lies within the province of archaeological study involving certain open, if not unresolvable, questions about the identity of the Horses as determined by classical and byzantine sources, their date and the circumstances of their casting as well as their iconographic origins and stylistic character.

Technical researches now being carried out are also making extremely valuable contributions to these studies. The fascination aroused by these Horses through the combined effects of their structural and sculptural character as seen in the exquisite detailing of their heads - almost as if they were the enlarged works of a goldsmith - reveals certain intrinsic qualities. These indeed are absolute values unrelated to the debate concerning their historical origins (now tending towards the Late Empire, after the second century A.D.) and their original location, or to the fact that they represent only one example or indication of the excellence of Greek-Roman bronzes.

With their first existence past and forgotten, the Horses' second life began with Enrico Dandolo offering his war booty to San Marco; they undoubtedly constituted the most extraordinary part of it, as shown by their privileged setting on the Basilica's façade. As trophies both of power and of religion, characteristic of that indivisible relationship linking Venetian politics to the name and glory of the Republic's patron saint, they were to become passionate and jealously-guarded symbols of Venetian civic pride, hallowed by their antiquity and as part of an incomparable ceremonial backcloth. But this symbolic meaning was subsequently to assume various nuances as when, for example, the memory of the Horses being the spoils of war was used to justify their appropriation by Napoleon. In the rhetorical phrase of the time, they were described as ''always harnessed to the bloodstained chariot of Victory'' as distinct from an opposing political ideology when they were seen to represent Liberty. The striking contrast between the immobility of the emblem and the restless stance of the Horses, which appear as if striving to free themselves from their gilded prison, has more recently been revived by Aldo Palazzeschi in his short story *The Doge*.

Another fresh perspective of values and interests in the history of the Horses of San Marco can be traced from the Renaissance. They were to attract attention and admiration for their intrinsic and formal qualities in the excitement of rediscovering and developing classical forms.

For the first time they became a direct influence on European culture as artistic creations and models. At the same time scholars began to show a parallel interest through their curiosity about the Horses' origin, when they were attributed to Lysippus from the sixteenth century onwards and were also associated with the images on Imperial Roman coins. A fresh and vital approach towards art-historical analysis and evaluation was to occur during the period of Neo-classicism, especially as a result of their

3

transfer to Paris and subsequent return to Venice. The contemporary praise of classical ideals began to find more precise expression through the Parthenon sculptures acquired by Lord Elgin. This widening of intellectual horizons encouraged direct comparisons with outstanding Greek originals, fostering among other things a controversy over whether the Horses belonged to Greek classical art or to that of the Roman ''decadence''. Indeed, nineteenth and twentieth-century scholarship has continued to debate the iconographic and stylistic problems of the Horses substantially in these terms, oscillating between an attribution to Greek work of the fourth-century B.C. and to Roman or even Late Roman design (as most recent opinions tend to suggest) without being able to carry out an organic and definitive study of the question which now is urgently called for.

Recently a wide concern for their material safety has joined the traditional interest in the Horses in terms of their historical and symbolical significance as well as their character as works of art. This clearly stems from the inescapable fact the condition of the bronze is rapidly deteriorating. It is also due to a developing sensitivity in our times towards monuments and objects such as these as part of our irreplaceable and universal cultural heritage, which must be cherished and conserved above all for the enjoyment of future generations. The problems of protection and restoration have thus become the highest priority.

The Procurators of San Marco have undertaken to promote an enquiry and research at the highest level within the organisations responsible, notably the Istituto Centrale del Restauro. This initiative can only be based on criteria established by means of the most rigorous scientific methods, which are also a product of our present era. For the first time, some of the most advanced scientific techniques are to be applied to the Horses of San Marco, throwing light on their study and helping to widen knowledge and unravel secrets about them - secrets, for instance, such as that of the scored lines intentionally made on the original gilding - besides determining the norm for their treatment.

The considerable public concern and, one might even say, the impatience shown over the fate of the Horses, has recently often led to hastily formed judgements and suggestions which are not always sufficiently thought out in the light of all available information on the nature and extent of dangers threatening them, the urgent need for remedies, and the most suitable way to preserve them.

A delicate problem which has been discussed in increasingly impassioned tones is whether to leave them in the open or to place them under cover. It is clear, however, that such discussions should not depend on emotional factors, superficial impressions, subjective and unilateral considerations or on purely theoretical points of view. They should, in fact, be a logical outcome from the evaluation of technical and scientific data, as well as from the rational and painstaking examination of every other appropriate channel to find the best ways to preserve, value and display such precious relics for public enjoyment, while still preserving their varied meanings and the sense of their rich architectural setting for many centuries on the façade of San Marco.

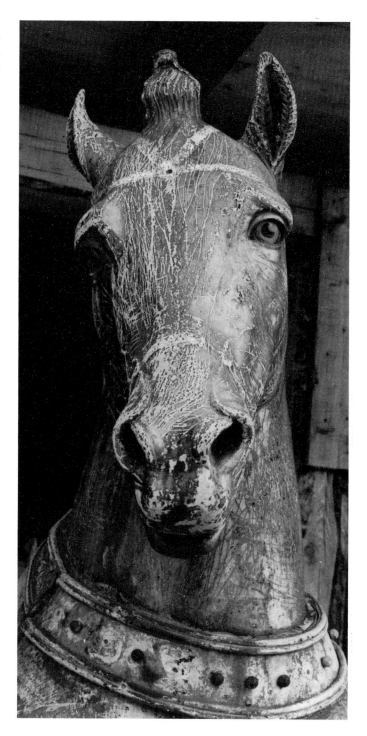

2. Head of a San Marco Horse

4

It now seems beyond doubt that any form of protection *in situ* would be unable to prevent the progressive deterioration of the bronze, and would in any case involve altering the appearance of the Basilica's façade. The most generally favoured solution, now officially adopted, is to substitute copies for the originals which would be housed in a suitable museum where they would be protected from any harm, studied, restored and, as works of art, could be more closely admired by the public.

As well as the scientists, historians and art critics, all those who care about civilization are asked to reflect further on this problem. To enable this to be done, therefore, we have gathered together a documentary review of all the current ideas on the nature, the vicissitudes and the condition of the bronze Horses of San Marco, which is as complete and as open-minded to all the issues involved as possible. We believe that for the first time, therefore, all the factors that contribute to their fame will emerge through systematic study and direct observation. Above all, it will be seen that no distinction can be made between historical and artistic knowledge and the technical action required to restore and preserve the Horses.

To understand and to conserve. One might even suggest that to understand *is* to conserve. In Venice and from Venice comes the firm resolution which is also an invitation, for these extraordinary witnesses of a civilization rich in so many levels of meaning are not the heritage of Venice alone. Although the city is their custodian, they belong to the entire civilised world. Therefore, the wider the interest shown, the more onerous is the responsibility for their understanding and their protection.

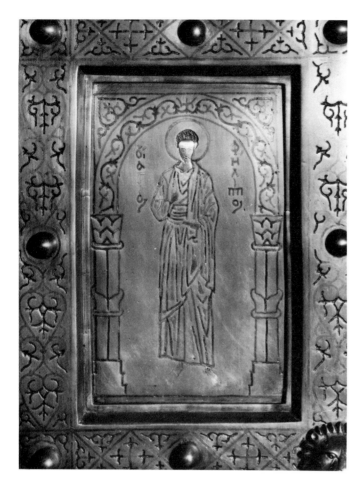

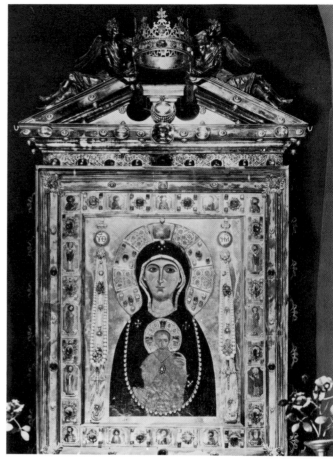

3. Detail of the leaf of the door, named after San Clemente and donated by the Emperor Alexius Comnenus in the 12th century, after its recent restoration.

4. Image of the Madonna Nicopeja after its recent restoration.

The Surveyor of the Basilica

Angelo Scattolin

According to tradition the Procurators invested the Surveyor of San Marco with full responsibility for everything concerning the church. This included all activities relating to the maintenance and conservation of the historic fabric as well as of its marble decorations, mosaics, sculptures and the priceless Treasury of the Basilica. In order to understand the innumerable problems concerned in the restoration and conservation of the building which involves the remains of earlier structures, it will be necessary to outline certain key points in the history of its origins.

The foundation of the Basilica dates from 828 when the tribunes Rustico da Torcello and Buono da Malamocco, who had probably been sent to Alexandria by the Doge Giustiniano Partecipazio, were able to secure the remains of St. Mark the Evangelist through a skilful subterfuge. They brought the Saint's body back from Alexandria, then under control of the Muslims, to the new seat of the Venetian government at the Rialto. The young Republic, through its possession of this precious relic, not only performed an act of devotion by saving it from the Infidel but also derived considerable political advantages from it at the same time. There can be no doubt that this fact was decisive in the dispute between Aquileia and Grado over the seat of the Patriarchate which arose from decisions taken at the Synod of Bishops at Mantua in 827.

The possession of the relic thus became the exclusive property and coveted privilege of the Republic, which lost no time in laying the foundations of a religious building to serve both as the ducal chapel and to house the remains of St. Mark, now designated the new patron saint of the Republic. This building was finished in the surprisingly brief period of three years through the support of the Partecipazio family. Considering the urgency of the enterprise, it had been Doge Partecipazio who authorised the masons to help themselves freely from the materials already assembled to finish the church which was being constructed at his own expense for the Benedictine Order in the convent of S. Ilario. In fact, bearing in mind the immediate need to build the first Basilica of San Marco, it is probable that the design and responsibility were given to the same architect who was undertaking the church of S. Ilario with a basilican plan of three naves, thus simplifying the choice of materials already to hand. The first Basilica of San Marco was inaugurated in 832.

Documentary sources for the architectural history of the Basilica refer to its rebuilding, reconstruction or restoration during the rule of the Doge Saint Orseolo I as necessitated by the fire and damage caused during the popular uprising against Doge Candiano IV. This reconstruction or restoration appears to have been carried out, according to this evidence, between 976 and 978. Virtually no reference at all is made to the modifications and embellishments which almost certainly must have been carried out during the 140 years or so between the inauguration of the Partecipazio Basilica and the restored building of Orseolo. In this respect no traces, let alone proof, survive to support the various hypotheses advanced concerning the first building on the site. Only by painstaking study using modern techniques to investigate its particular structural character is there a chance of obtaining evidence of sufficient importance to throw light on the historical background of the early building. According to most of the original sources, construction of the present Basilica began in 1063. Doge Domenico Contarini was entrusted by the Republic with the building of a basilica unequalled in size and splendour, to be worthy of sheltering the precious relic and, indeed, of the power of the Republic of San Marco. The nationality of the designer, together with the oriental influences on the form of the building, has been much discussed without reaching any substantial agreement.

However, it is a striking fact that the new Basilica, roofed with masonry vaults and domes, was the first example of a monumental structure to be built in the upper Adriatic; more specifically in the vast area of the lagoon where there was no past experience at all of how the terrain might react to heavy loads concentrated on a very few points of support. It has been discovered that the inclusion of various parts of the earlier buildings in the new structure soon began to produce considerable problems of settlement, which are still today requiring constant attention and control.

With the consecration of the Basilica in 1094 when Vitale Falier was Doge, the basic structure of the fabric was virtually complete. It was only the beginning, however, of a continuous sequence of partial modifications and additions, the programme of valuable embellishments being carried on well into the 19th century. These splendid and rare decorations are unequalled in their richness and importance. Covering the entire surface of the building, they comprise more than 5,000 square metres of monu-

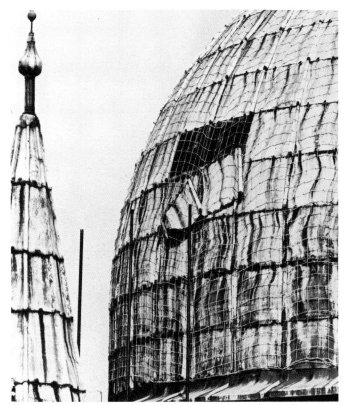
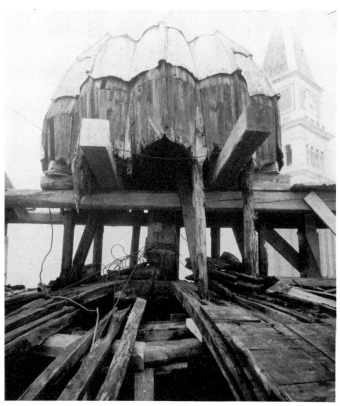
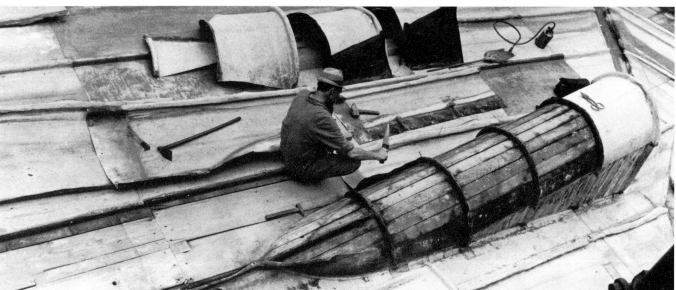

6. Exterior of the dome of the Ascension showing the restoration of the wooden framework in progress.

5. Exterior of the dome of San Giovanni showing the effective temporary method used to secure the structure while the woodwork was being restored.

7. Restoration of the wooden structure forming the pitched roof above the pier named after the Madonna del Bacio.

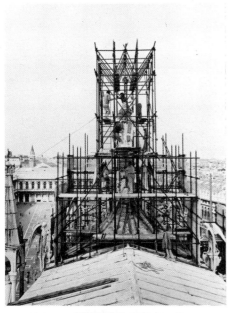
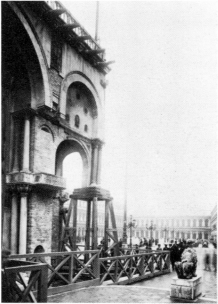
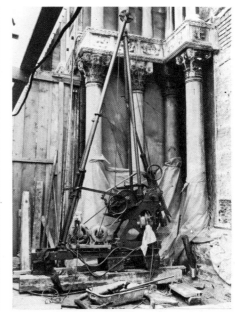

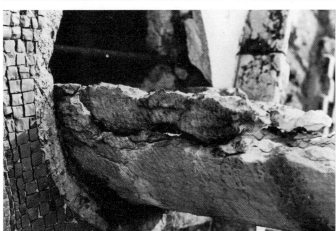

8. Work in progress on the central pinnacle to secure the structure and preserve the marble and stonework of the sculpture.

9. Restoration work being carried out on the porch of S. Alipio.

10. External corner of the Basilica related to the Capella dei Mascoli showing holes being drilled for pointed piles to reinforce the foundations.

11. Detail of the Basilica façade facing the Molo showing the disintegration of a marble drainpipe.

12. Baptistry - an archaeological discovery of great historical interest: the remains of the ancient 12th-century baptismal font.

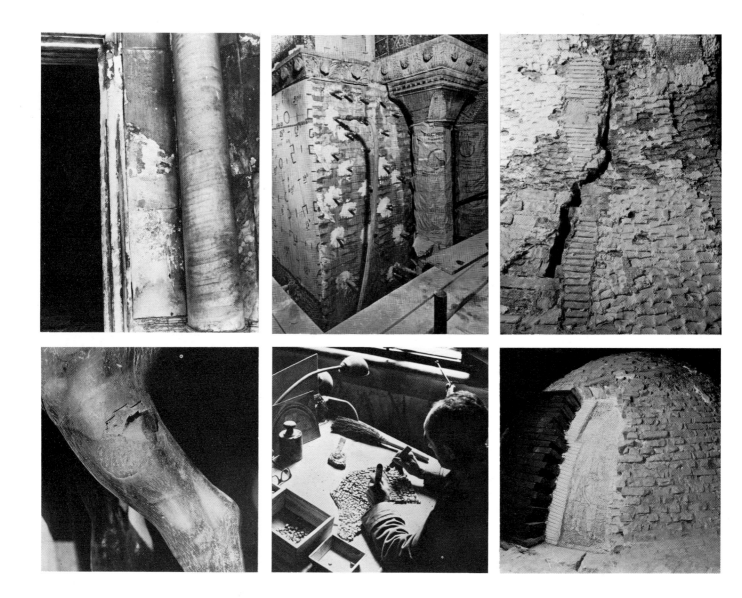

13. Detail of the Porch of S. Alipio showing one of the many instances of marble disintegrating through the combined action of rising damp, wind and atmospheric pollution.

14. Interior of the Basilica showing the technique for strengthening the masonry core by injecting liquid cement under pressure.

15. Detail of the interior of the Basilica showing cracks in the wall of a small vault.

16. The state of a horse's leg before the restoration carried out in 1903.

17. The restoration of a piece of detached mosaic in the workshop.

18. Restoration of the small cupola nearest to the corner of S. Alipio. This photograph shows how the mosaic surface on the inner face of the cupola remains undisturbed while the masonry support is reconstructed.

mental mosaics, about 1,500 square metres of Cosmatesque pavement, 800 square metres of marble facing, and more than 500 columns with shafts of rare marble. There is also an immense variety of antique capitals, not to mention the innumerable pieces of sculpture found all over the building, the damascened or bronze doors, and above all, the fabulous Horses together with various works in gold and enamel as well as sacred vessels, all of them originally obtained through the conquest of Constantinople. Even more than the Doge's Palace, the Basilica of San Marco was jealously looked after by the Venetian Republic which at the end of the 9th century founded a special magistrature, the Procuratoria to be responsible for the upkeep and administration of the building. Until the 13th century the Procurators of San Marco were appointed directly by the Doge, and subsequently by the Great Council, making a Procurator the highest dignitary in the Republic after the Doge himself. Thus the procurators enjoyed the privilege of wearing the toga for life and of residing, like the Procurators of Citra, in the buildings overlooking Piazza San Marco which were appropriately called the Procuratie.

From earliest times the technical committee of the Procurators chose the Surveyor of San Marco from among the most celebrated architects of the time. In this capacity he planned and directed the necessary works connected with further alterations or general maintenance. A line of famous architects, such as Jacopo Sansovino and Baldassarre Longhena, extended right up to the end of the last century when Pietro Saccardo was followed by Luigi Marangoni, Ferdinando Forlati and Antonio Rusconi who has recently died.

The restoration undertaken by Jacopo Sansovino consisted mainly of an impressive system of forged metal tie-bars and masonry supports strengthening the apsidal area of the basilica. This succeeded in controlling the statics of the entire building, previously threatened by the settlement of the ground produced by a lack of adequate buttressing for the thrusts originating from the principal vaults. In more recent times Luigi Marangoni renovated various parts of the structure, his work on the great vault of the Paradise and the adjacent arch of the Apocalypse being particularly masterly. This was carried out by concentrating work on the outer surface of each arch in order to leave the mosaic facing undisturbed. Moreover, the procedure and result of his restoration undertaken in the area of the arch of S. Alipio is still considered exemplary. Ferdinando Forlati, who succeeded Marangoni, conducted delicate works of reconstruction in various parts of the basilica and for the first time in its history reinforced the foundations of the Mascoli Chapel, where he employed methods derived from experiments in conservation relying on recent technology. Forlani also carried out the restoration of the wooden structure and lead cladding which covered the two secondary cupolas, and he must take the credit for drawing attention to the urgent need to protect the Horses. The last Surveyor, Antonio Rusconi, had to face numerous restoration problems and by initiating work on the central pediment which dominates the whole Basilica, he outlined the difficulties involving the conservation of the gilded Horses after an extensive study.

19. - 21. Details showing the deterioration of a capital on the main façade.

Previously, between 1962 and 1964, the International Congress of ferrous and non-ferrous metal specialists had already considered this question in a conference at the Fondazione Cini, concluding that it was imperative to act urgently in the matter. The Surveyor of the Basilica, Ing. Rusconi, proposed to the Procurators that a commission of specialists should be set up to carry out an exhaustive study of the physico-chemical effects of copper casting, together with the nature and extent of the restoration required. Meanwhile, in conjunction with the Ministero di Pubblica Istruzione, it was decided to invite certain distinguished experts in the fields of science and history to draw up, if possible, a course of action which would simultaneously consider techniques of conservation and decide through methods of attribution whether the Horses were cast by Greek or Roman artists. On the initiative of its President, now the Surveyor of the Basilica, the Accademia di Belle Arti di Venezia offered in 1976 to assist the Commission by providing it with a plaster cast of one of the Horses, formerly in the cast collection belonging to the gallery of the Accademia.

The present exhibition, originally held in S. Apollonia, aims to bring the results of the current restoration into focus so that undisputed conclusions may be formed enabling those in charge of the enterprise to reach reliable decisions on the best line of action to adopt.

Part One The Horses of San Marco in History

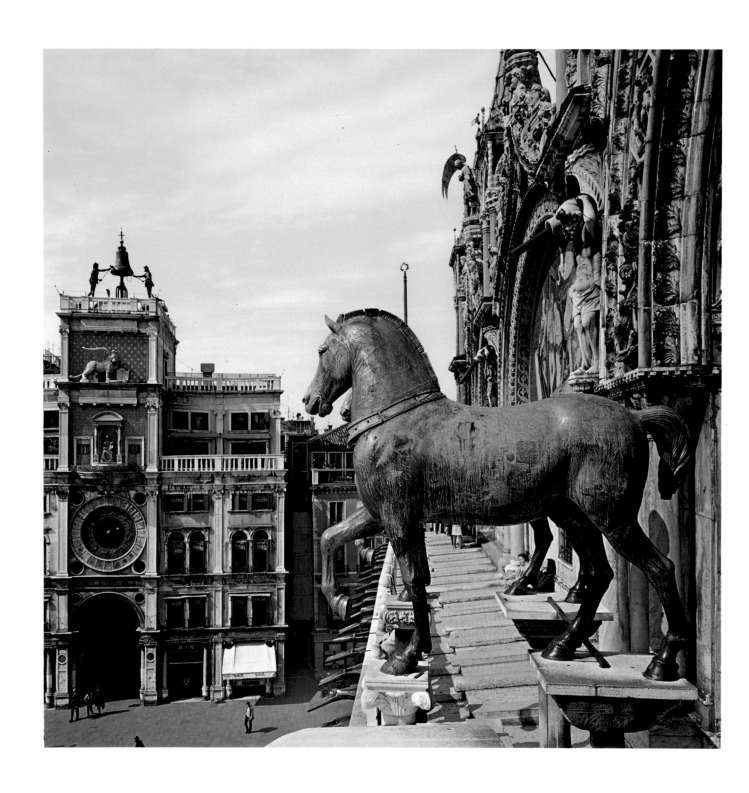

22. The Horses of San Marco overlooking the clock tower

14

The stylistic problem of the Horses of San Marco

Licia Borrelli Vlad, Giulia Fogolari and Anna Guidi Toniato

The following pages will attempt to gather together most of the relevant material for a critical analysis of the horses. However, as is the case in any logical analysis, a conclusion does not emerge automatically from even the most complete data. Similarly, with this enquiry, even the most exhaustive analysis cannot by itself provide an answer to the question of origins and authorship posed at the outset. Indeed, it is still a legitimate question to pose even though a solution seems less necessary today than when scientific enquiry was more concerned with causes and effects rather than with actual appearances. Ontology and teleology belong to the philosophy of the past and even recent archaeological enquiry concentrates on an accurate study of the artistic and material evidence of past centuries rather than attempting to classify them immediately on a stylistic and anagraphic basis.

This approach might seem inconclusive but it conforms to tendencies in contemporary thought and rejects the idealism which had for a long time provided justification for critical aesthetic judgements.

This, of course, does not mean that historical enquiry can be dispensed with for it still clearly remains the starting point for archaeological research. However, it does emphasise the fact that even if a final conclusion is not reached but only a stage for subsequent enquiries to start out from, the results should be equally valid in the context of a ceaseless "work in progress".

The Horses of San Marco have not escaped the romantic assumption that their artistic excellence is explained by their Hellenistic origins. The following pages will trace the immense efforts made to give them illustrious origins and how, during the controversy over their provenance, the more ancient the origins claimed the more noble the Venetians felt themselves to be as guardians of such time-honoured works. Although research has only gradually been able to clear away such prejudices, no unanimous conclusion has yet been reached concerning the Horses. The theories of the last twenty years, though supported by apparently well-founded arguments, have in fact proposed dates widely spaced between the era of Lysippus (4th century B.C.) and that of Constantine (4th century A.D.). The truth of the matter is that no other horses with comparable anatomical and stylistic characteristics have been found to provide a decisive comparison with the Venetian works in the field of Greek and Roman art. Just to illustrate this quandary, a series of examples which have so far been used as a basis for comparison with the Venetian Horses will be discussed.

The first sculptor acclaimed by Humanism as the creator of the Horses of San Marco was Phidias [1] - the artist whose conceptions lay behind the monumental reconstruction of the Athenian Acropolis, inaugurated by Pericles half-way through the 5th century B.C. The solemn Panathenaic procession on the Parthenon frieze contains the purest expression of Phidias's art (fig. 24). Here the horses are most dynamically expressed; they gallop, paw the ground with lean, nervous hooves, their slender muzzles animated by a network of veins appearing on the surface as well as by the projecting parts of the bone structure beneath. Their mouths are pulled open by the bit, the lower jaws drawn further back than the upper ones. The energetic and quivering heads show a series of folds below the cheek bone, echoed at the roots of the manes which themselves are never loose, though long enough to emphasise the impetus of the animal. The veins which wind along the abdomen, the flattened ears and arched tails are all imbued with a vigorous and vibrating sense of form.

Other horses appear on the pediments of the Parthenon. The one on the west illustrates the contest between Poseidon and Athena for the possession of Attica, while the eastern pediment depicts the birth of the goddess from Zeus's head before a divine assembly. This scene is framed on one side by the rising of the Sun god with his pair of rearing horses, and on the other by the descent of Selene's chariot into the depths of the night (fig. 23). The mane of Selene's horse has been carefully cut with the middle part emerging between the two lower-cut outer edges - a particular treatment which is not repeated in the frieze and therefore cannot be used to establish chronological order.

The relief with the horse and bearded horseman belongs to the school of Phidias (fig. 25). The rider's calm and dignified bearing and the horse's vitality recall the solemnity of the Panathenaic procession. The fairly short but flowing mane, the folds in the skin lying parallel to the base of the neck, the flattened ear set backwards, the lean head and marked cheekbones are clearly similar to the Parthenon frieze. This relief draws particular attention to the roundness and protruding nature of the eyeball; the upper lid forms a circular rim which is almost upright where it joins the lower one at the inside corner of the eye.

Horses from the fifth century B.C. are all very different from the

15

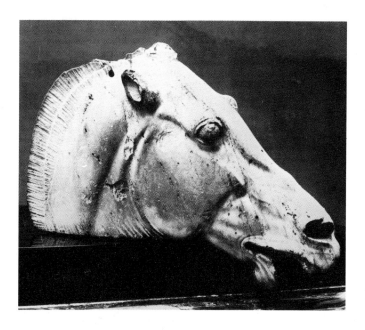

23. Horse of Selene from the east pediment of the Parthenon.

Venetian ones, both in terms of style and of the somatic type represented.

Between the end of the fifth and the beginning of the fourth century B.C., artistic circles regarded Phidias's noble models as their own unattainable ideal. One of the finest examples of this taste is the funerary stele of Dexileos (fig. 16) who died aged twenty, in 394 B.C., during the Corinthian war. Its composition and design are still influenced by the Parthenon, but the technique of the high relief, the slight outward twist of the horse's head and almost foreshortened position of the rider already indicate different solutions in the rendering of movement.

A fruitful comparison concerning the horse's movement could also be made with the relief representing a victorious horseman approaching a tripod by Briassides, active towards the middle of the fourth century B.C. The animal advances with restrained energy, resolutely lifting its left foreleg and right hindleg as in a trot. Although it is not exactly the same movement as found in the Horses of San Marco which walk forward, there is a certain similarity in the position of the forelegs.

The frieze from the Mausoleum of Halicarnassus has been referred to by the American archaeologist Markham in his study of the horse in Greek art [2]. He contends that the Horses of San Marco are Hellenistic and places them stylistically between those in the Mausoleum frieze and the Pergamum one. Without entering here into the problem concerning the artists of the former monument, it seems that, for instance, a comparison with the horse in Scopas's frieze depicting the Amazonomachia only serves to underline the striking differences. The nervous, tense body of the horse with the Amazon mounted backwards hurls itself forward in the Scythian manner (fig. 28). Nor, indeed, is there any resemblance to the huge muscular horses of the quadriga of Mausoleum and of the Sun on the Pergamum altar with their boldly modelled anatomy (fig. 16).

It would be better instead to look closely at Lysippus and his followers since both early and recent criticism has frequently mentioned them when discussing the Horses of San Marco. According to Pliny (*Naturalis Historia,* 34, 63) numerous animals such as dogs, lions, and above all, horses in quadrigas figured among the 1500, or so, works attributed to Lysippus. In particular a quadriga of the Sun, which was executed for the people of Rhodes, was placed by Pliny among Lysippus's sculptures. His style is certainly echoed in the figures on the magnificent sarcophagus discovered in the necropolis at Sidon and now in the Istanbul Museum, which is named after Alexander but was more probably destined for Abdalonimus, the Macedonian's ally and King of Sidon who died in 304 B.C. This is particularly noticeable in the horseman with the flowing cape who is impetuously borne forward by his charger (fig. 29).

The bronze statuette of a horse supposedly with Alexander riding it, which was discovered at Herculaneum in 1761, is attributed to the School of Lysippus (fig. 30). It was undoubtedly inspired by an original of the late fourth-century B.C. It is well known that Lysippus was so fascinated by Alexander's fiery personality that

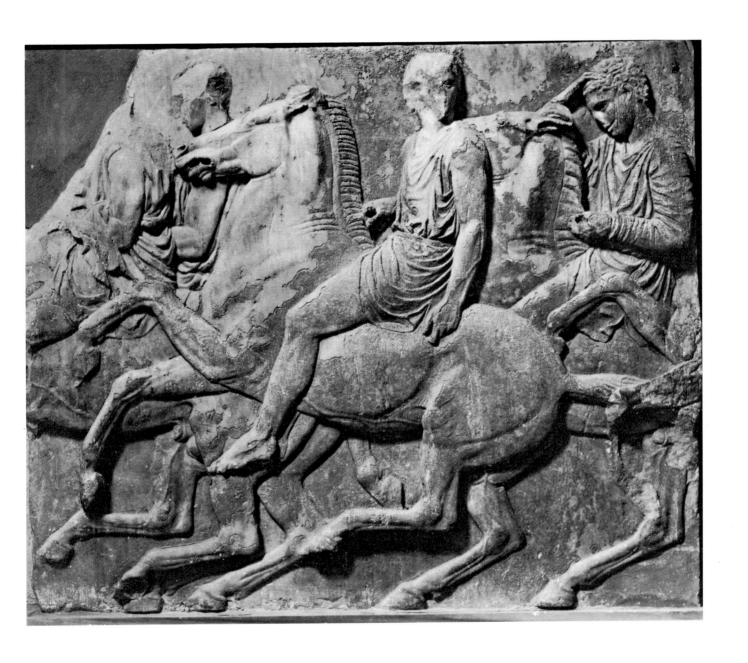

24. Detail of the Parthenon frieze, Athens.

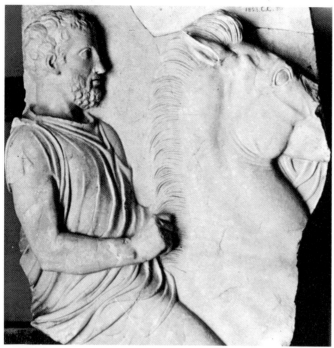

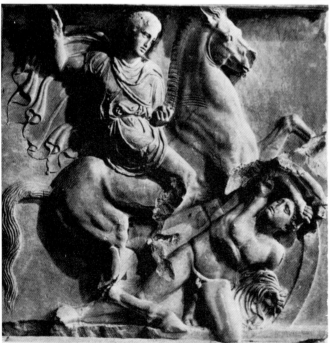

25. Fragment of a relief with a horseman, Vatican Museum.

26. The Stele of Dexileos. Museum of Ceramics, Athens.

he depicted the emperor in individual statues as well as in battle or hunting scenes. A generic similarity with a head of Alexander caused the horseman to be identified as the great Macedonian, but it is more likely to have been one of the emperor's bodyguards. Also in the same style is a bronze statuette of a galloping horse from Herculaneum (fig. 31), dating from Roman times as well, but inspired by an original closely resembling the one just mentioned.

While still considering these works relating to the time of Alexander, mention should be made of the famous Pompeian mosaic from the House of the Faun. This tumultuous scene which may represent the Battle of Issus between the Persians and the Macedonians in 333 B.C., contains a detail of a huge horse falling heavily in the midst of a host of lances together with entangled bodies and animals (fig. 32). Still relating to the influence of Lysippus, reference should also be made to the bronze horse in the Palazzo dei Conservatori, Rome, which was discovered in Trastevere in 1894. The large gap in the back of this life-size horse was probably caused by the removal of the rider. In fact, it has been suggested that this particular horse belonged to the equestrian monument of a Hellenistic king. A curious inscription on the upper part of the left-hand hindleg L.I. XXIIX (*loco primo* 28) might refer to directions for its siting.

Today the rather vague attribution to Lysippus favoured by the humanists and later enthusiastically approved by Neo-classicism is largely discounted. However, Crome made far more convincing comparisons of Lysippus's works with the Horses of San Marco in 1961 and 1963; also significant was Forlati's hypothesis (1964-5) in favour of one of Lysippus's followers, active at the beginning of the 3rd century B.C. as the creator of the Venetian Horses.

The above-mentioned works used as comparisons and the bronze statuette from Herculaneum (fig. 31), despite their inevitable inferiority as copies, certainly reflect Greek prototypes of great beauty in their agile freedom of movement, the total three-dimensional nature of their volume and their nervous and tense structure. Some details correspond to those of the Horses of San Marco; the short-cut mane, the forelock bound upright, the ears pointed outwards with stiff hairs inside (fig. 33). But the differences are equally striking. While the former aspects reveal the dynamic conception of Lysippus's art prefiguring Hellenistic naturalism, the latter are characterised by a balance and composure appearing to come from a profound and original rethinking of the most ancient classical models.

It was originally intended to include a bronze horse's head with slight traces of gilding from the Florence Archaeological Museum in the Venice exhibition. This was chosen not only for its beauty but above all because, together with certain other examples dating from about the same epoch, it epitomises the artistic expression of the late Hellenistic period where many critics place the Horses of San Marco. This head (fig. 35) is recorded as one of the objects confiscated from the Medici in 1495 and had been used as a fountain in the Palazzo Medici-Riccardi where one imagines it might logically have been seen by

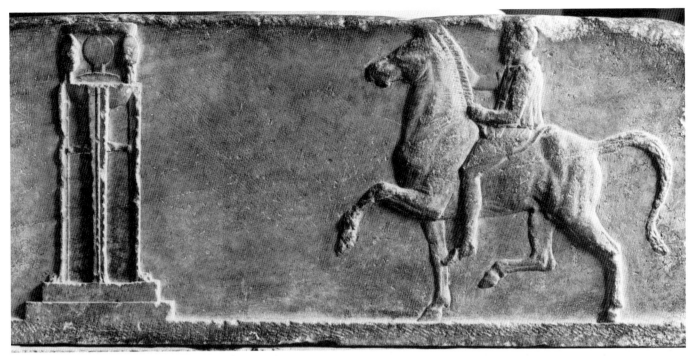

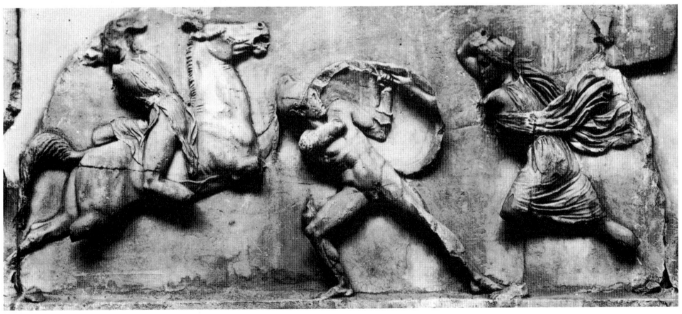

27. Relief of Briasside. National Museum, Athens.

28. Detail of the frieze from the Mausoleum of Halicarnassus. British Museum, London.

19

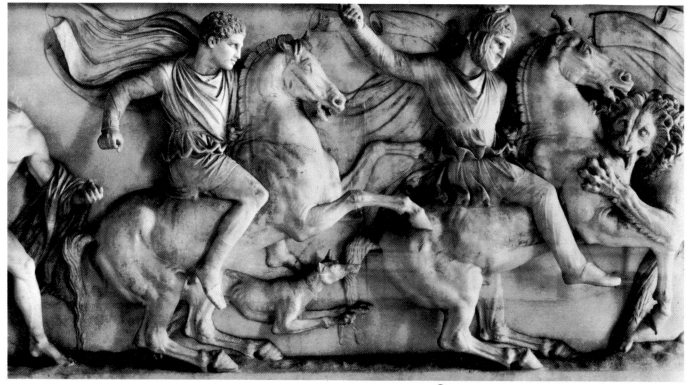

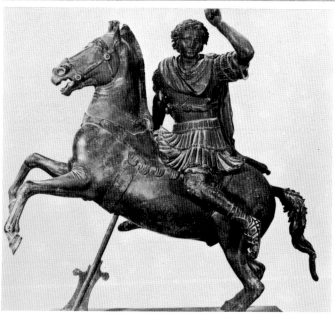

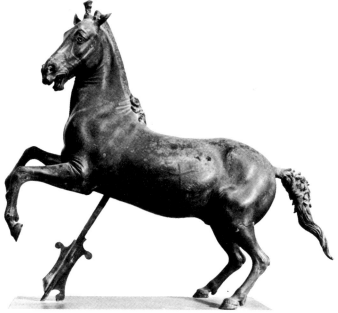

29. Detail of the Alexander Sarcophagus. Archaeological Museum, Istambul.

30. Figure presumed to depict Alexander the Great on horseback. National Museum, Naples.

31. Galloping horse from Herculaneum. National Museum, Naples.

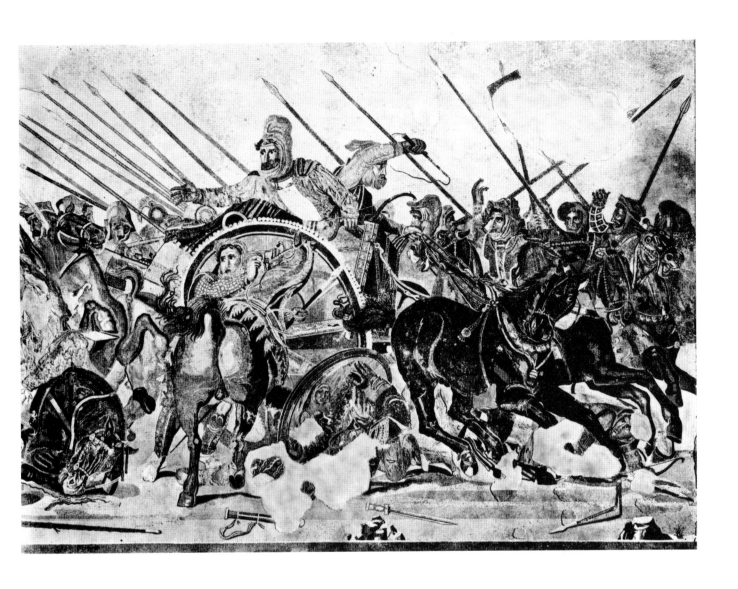

32. Detail of the Battle of Issus mosaic. National Museum, Naples.

Donatello and Verrocchio. Its mouth pulled open by the bit, its lips revealing teeth with the tongue just glimpsed between them, its dilated nostrils, its ears with hair round the edges and the shape of its eyes are all indications of a sculptor's anxiety to create a likeness with the greatest artistic skill. The same tendency, although perhaps here even more pronounced, is found in a huge late Hellenistic head from Palazzo Carafa in Naples (fig. 34) - another magnificent bronze which is now in the Museo Nazionale in Naples. Early Neapolitan chroniclers identified this colossal head as being the same as that described in a letter written in 1194 by Corrado di Querfurt, Henry VI's Chancellor and envoy in Naples. Certain miraculous powers were attributed to this head which was connected with Virgil, as often happened in medieval Neapolitan folklore, even assuming it to be in some way an emblem of the city. It was in fact a gift from Lorenzo de' Medici to Diomede Carafa, as revealed through the discovery of a letter written by the Neapolitan aristocrat on 12th July 1471 to thank the Medicean ruler. The work was actually attributed to Donatello and this was repeated, though with reservations, by Vasari[3].

Despite their being so celebrated, these two bronze heads are not specifically referred to in documents and even their dates are hypothetical. Magi[4], in fact, argues that if it were possible to date them more accurately, it would be invaluable in establishing the dates of the Horses of San Marco and vice-versa. The Florentine and Neapolitan bronzes have certain characteristics in common: hairy ears, forelocks bound upright and their short mane springing up between two short ridges. However, in their mature formal elegance the Venetian Horses yet again provide a contrast with the bold, quivering impetuosity of these two heads.

Two types of horses are found in the field of Roman art between the second and first centuries B.C.: the above-mentioned Hellenistic example caught in a moment of impetuous action, and a new domestic kind of horse, found in the context of specific everyday activities which features in a frieze depicting the highest official sacrifices, the *suovetaurilia* (fig. 37). Here the modelling is smooth and rounded and the horse motionless. With a certain degree of exaggeration the horse's tail is shown arched in a harmonious manner which, when studied closely, recalls the treatment of the Venetian Horses' tails.

The official art at the beginning of the Empire, originating from the ruling class, showed a return to classical models. This is evident on the cuirass of the Augustus from Prima Porta, particularly as found in details such as the chariot of the Sun which is shown drawn by four horses stampeding towards the heavens.

Another important comparison with the Horses of San Marco can be found in the two heads discovered at Cartoceto in 1946, which belong to one of the few gilded bronze monuments extant. This work, from the first half of the first century A.D. (fig. 60)[5], is comprised of a male and a female figure together with fragments of others.

Both the alloy, which has been analysed[6], and the moulding of the eyeballs, ears and trappings of these horses are very different from those of the Horses of San Marco. However, there is some similarity in the forelocks and in the arch above the eyes which

projects and is defined with rather stiff folds in the skin. The style of the two heads is completely different, as seen by comparing them. The sharply tufted manes represent a clear departure from the Greek tradition and recall another head (fig. 38), also in gilded bronze, which is the first in a series of horses recovered from the excavations at Pompeii and Herculaneum. These objects, thanks to this very circumstance, cannot be dated later than 79 A.D., the year of the catastrophic eruption of Vesuvius which destroyed the two cities. The head from Herculaneum is similar to those from Cartoceto in having the harness cast together with the remainder of the sculpture and decorated with different motifs - the *phalerae*. The nostrils also dilate in almost the same way as found in the Venetian Horses.

Another head, also from Herculaneum (fig. 39), is notable for its lack of harness, its short mane, its forelock bound upright both at the top and base, as well as the fine hair in the ears and the way its pupil is indicated by two concentric circles.

The following bronze which belongs to an equestrian monument assembled from many fragments has also not been studied sufficiently (fig. 40). It seems certain that the rider and mount do not belong to one another and that even the body and the head were not originally part of the same statue.

Owing to the extremely fine modelling of the horse's head, the cut of the mane and the way in which ears are turned backwards, it has been described as being ''close to the creations of Greek bronze modelling''[7]. It also has the familiar harness with *phalerae,* a sensitive rendering of the nostrils and a powerful expressiveness. Its forelock was tied at the base with a ribbon, evidence of which can still be seen where the ends fell onto the forehead. The legs of this horse advance diagonally while the Horses of San Marco move their hooves forward in lateral rather than diagonal pairs, as also found in the equestrian monument of Marcus Nonius Balbus the Elder (fig. 41). According to some authorities[8] this gait, together with the form of the head and body, the low protruding stomach, and tail recall those of the Horses of San Marco. Despite these aspects in common, however, there are others in marked contrast. For instance in the Balbus horse the ears are completely smooth and slender, the eyes are totally unlike those of the Venetian Horses while the flowing mane can be seen as the first example of a typically Roman style.

Kluge's and Lehmann Hartleben's hypothesis that the Venetian works come from the same era is based on certain similarities found between horses belonging to this period and the horses of San Marco. While being unable to agree with these scholars, it certainly would not be correct to place the Venetian Horses in the Flavian era. However, in support of this view it is interesting to consider the quadriga on the Arch of Titus in Rome which depicts the emperor in his chariot in the triumphal procession celebrating his conquest of Jerusalem (fig. 42). The allegorical representation of the emperor crowned by Victory and the position of the four horses raising their right forelegs in perfect symmetry had become by then a conventional expression of triumphal iconography. The chest muscles are clearly defined as are the folds in the animals' skin resulting from the low view of the raised

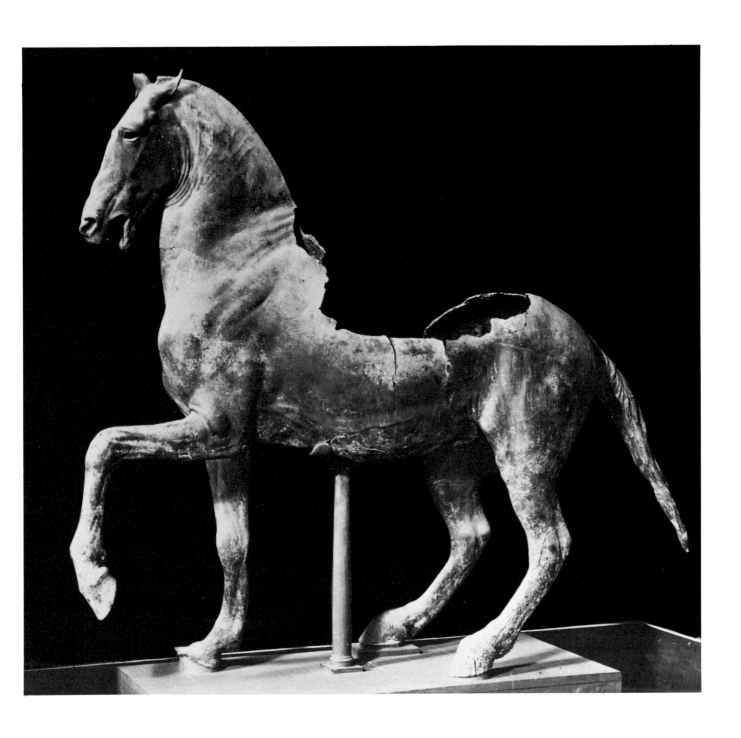

33. Bronze horse. Palazzo dei Conservatori, Rome.

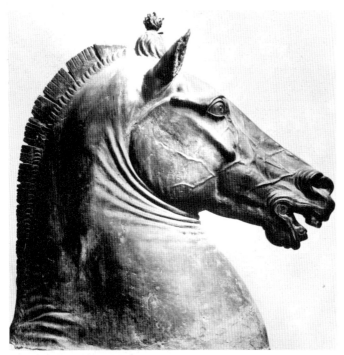

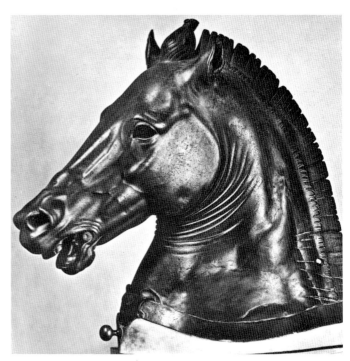

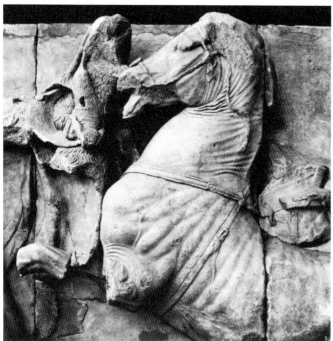

34. Horse's head. National Museum, Naples.

35. Horse's head. Archaeological Museum, Florence.

36. Detail from the Pergamum Altar frieze. State Museum, Berlin.

24

hooves, all of which recall the Venetian Horses. The manes, on the other hand, are different, falling in long, thick, flowing locks which convey effects of chiaroscuro in the volume created. The harness, moreover, is complex, consisting of many traces with studs stretched along the necks of the horses, the nearest having an ornament in the form of a delicate half-moon suspended at the centre of its chest.

The great master who recorded Trajan's achievements should be mentioned for he has left behind a rich quantity of source material concerning the Roman warhorse from the second decade of the second century A.D. In the huge low relief, probably derived from Trajan's Forum but incorporated into the Arch of Constantine, the emperor is shown urging his steed into the enemy hosts (fig. 43). The classically restrained mount of this august figure contrasts with the more naturalistically free ones of the barbarians and their horses. The light falls on the powerful neck of the imperial charger, arched to an almost unrealistic degree and bearing an elegant, classically-styled mane with the middle part springing from a lower ridge somewhat similar Selene's mane on the Parthenon pediment. This is the only short mane in the composition, all the others having an unruly mass of curls. Could this, therefore, be an antique cut of the mane to distinguish the emperor's horse from the others?

The horses of ordinary Roman soldiers, on the other hand, are depicted in a relief on Trajan's Column (fig. 44). The animal is held in a somewhat static pose though possessing a most beautiful naturally flowing tail.

On account of the undisputed likeness of these Trajanic horses to the Venetian ones, the hypothesis has recently been advanced that the Horses of San Marco originally provided the crowning glory of the Basilica Ulpia in Trajan's Forum. According to this theory, Constantine would later have decorated his Roman arch with the slabs bearing the frieze while the quadriga would have been transferred to his new capital to embellish the hippodrome there [9].

Precise documentary evidence of hunting customs in the imperial era appears in eight circular reliefs from Hadrian's reign incorporated into the Arch of Constantine and depicting the emperor's departure on a hunting expedition, his sacrifices to the gods and his attacks on a lion, bear and then a wild boar (fig. 45). The horses are three in number with as many types of manes which suggest that the cut of the Venetian animals' manes cannot be regarded of prime importance in determining their date. The eyes, eyebrows and ears should be studied carefully at close range - not an easy task since they are situated high up on the arch. It could, however, be held that as the wild boar's ear is hairy, the horses' ears will also be the same.

The horses from the Antonine era must be considered differently. A marble equestrian statue from the Villa Barberini at Castel Gandolfo (fig. 46) comes from the middle of the second century A.D. Magi had already observed the "way the hair in the ears was quite considerably more stylised and baroque than in other statues" and proposed that "this stylisation should be considered as an indication that they came from the same workshop and,

37. Detail of the Altar of Domitius Aenobarbus. Louvre, Paris.

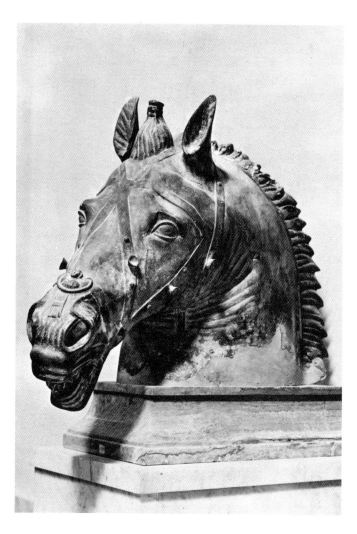

38. Horse's head of gilded bronze from Herculaneum. National Museum, Naples.

therefore, provides a strong argument for their dating at least from the beginning of the Antonine age'' [10].

The decoration of the quadrangular base of the triumphal column dedicated to Antoninus Pius does no more than repeat on two sides the circular procession of a military parade or tournament with Roman soldiers (fig. 47) ''in conventional perspective on a neutral background'' [11]. These horses, like those on the Arch of Titus and on the Trajanic and Hadrianic reliefs, wear harness decorated with the characteristic half-moon feature as well as heart-shaped or three-lobed leaves. These horses' bodies seem to be more robust than in the past, without, however, becoming very heavy in form [12]. A new triumphal composition is found in a relief depicting Marcus Aurelius in the Palazzo dei Conservatori in Rome (fig. 48). The Emperor's chariot is drawn by four horses each of which, following the dictates of triumphal iconography, raises a forefoot in an impressive but unnatural position. The manes are discreetly enlivened through undercutting, the inside of their ears have smooth but rather thick edges, neither manes nor ears differing appreciably from those found in the sculpture from the era of Antoninus Pius. However, the way in which the collar is represented is interesting as it has almost the same shape as those on the Horses of San Marco, a fact further confirmed by the rounded edge which runs along each collar. Their eyes have a line under the cornea as well as the pupil, but in comparing the quadriga of Marcus Aurelius with the Venetian Horses, once again the latter stand out as being more impressive, indeed unique.

There are numerous horses along the frieze of the column dedicated to Marcus Aurelius after his death (fig. 50). In spite of the extensive damage suffered over the years, the new understanding of figurative space is still striking. Here also the imperial iconography has changed under the influence of the oriental conception of the monarch's ''divine majesty''.

The most famous Roman equestrian statue of Marcus Aurelius which dominates the Piazza del Campidoglio in Rome is also imbued with this new spirit (fig. 49). In the tenth century this work stood in the Piazza del Laterano are where it was carefully preserved on the assumption it was an equestrian statue of Constantine. In 1538 it was transferred to the Capitol following Michelangelo's design both for the square and for the pedestal where it now stands. It seems that originally there had been the figure of a conquered barbarian under the raised hoof. According to popular legend, when this statue turns golden again, the time for the Last Judgement will have come. It is, in fact, a gilded bronze equestrian statue. The alloy, however, appears to have a lower proportion of copper than found in the Horses of San Marco; that is 85.3% against about 98% [13]. The horse's head has many features of great interest - the flowing mane, forelock tied upright, ears with a rough indication of stiff hair inside, striking *phalerae* where the harness is joined together, the pupils of the eyes hollowed in a circular shape, lines one above the other in the arch surrounding the eyeball, dilated nostrils, and its mouth pulled open by the bit. One of these elements has been considered by Magi who thought it significant when estimating the date of

the Venetian Horses. In his words: "..... let us pause to examine the most celebrated horse of Marcus Aurelius. The hairs in its ears are rendered with almost exactly the same degree of stylisation as found in the Venetian Horses This new and important argument confirming the Roman origin of the Horses of San Marco could, however, alter their date from Constantine's reign, as proposed elsewhere, to that of Antoninus ..."[14].

The theme of the victorious emperor on a chariot drawn by four horses can be found again on the triumphal arch built at Leptis Magna, the birthplace of Septimus Severus (fig. 51). In this "presentation image" the horses raise, two by two in stiff symmetry, either their left or right foreleg. Their collars differ in proportion to the weight which each had to pull in the four-horse chariot. Their smooth bodies contrast with the drapery of the august personages and noble figures taking part in the procession. The use of the bow-drill emphasises the colourful pomp of the Severan style.

Besides these monuments illustrating the triumphal expression of Roman achievement, there are others exalting mythological figures. Notable among these are the two colossal copies of the Dioscuri with their horses standing impressively in the Piazza del Quirinale and Piazza del Campidoglio in Rome. The Quirinal Dioscuri (fig. 53), originally in the Baths of Constantine, now almost form a heraldic composition with the obelisk from the Mausoleum of Augustus brought here by Pope Pius VI. As if to testify to the group's presumed nobility, it bears a post-Constantinian inscription, *Opus Phidiae e opus Praxitelis* - a totally unfounded claim except for the undoubted classical inspiration of these sculptures approximately dating from the second century B.C. The rearing horses bear some similarity to those of San Marco. It is worth pointing out that Cicognara, who supported the Roman origin of the Horses of San Marco, thought the Quirinal Dioscuri to be superior, considering them to be "among the most handsome productions of Greek sculptors"[15].

The Dioscuri placed at the top of the stairs leading to the Piazza del Campidoglio belong to the same classical taste but are interpreted less elegantly with baroque rhetoric. They were found in the nearby Ghetto (fig. 52). These massive animals belong by now to that heavy breed that starts to appear in the Roman world from the second century A.D. onwards[16], and in some respects, such as the similar ambling gait, they recall the Horses of San Marco. It is worth remembering here the splendid mosaic from Constantina (fig. 157, p. 135) with the Triumph of Neptune and Amphitrite on a quadriga drawn by rearing seahorses (4th century A.D.).

The artistic trends of the third century A.D. are also reflected in a large number of sarcophagi. The mythological battle between the Acheans and the Amazons under the walls of Troy is the theme of a sarcophagus in the Vatican Museum (fig. 54). The naked figure of Achilles supporting the wounded Penthesilea stands out in the midst of the crowded composition. The iris and the pupils in the eyes are clearly marked both in the horses and the human beings. The more typically Roman sarcophagi represent intricate battle scenes with the deceased in the centre of the fray, as seen on the

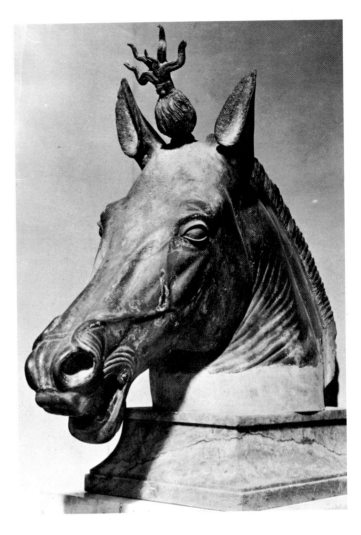

39. Horse's head of bronze from Herculaneum. National Museum, Naples.

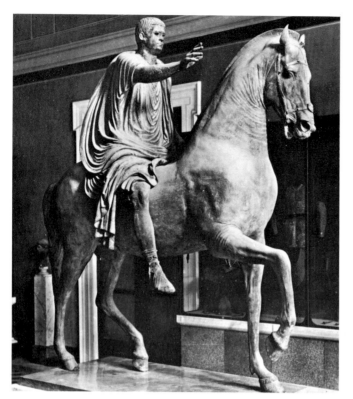 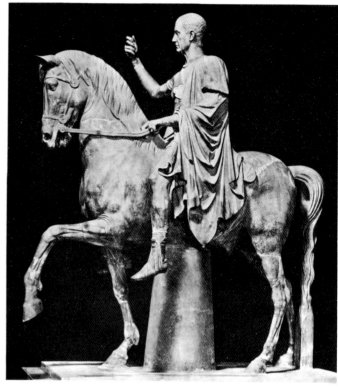

40. Equestrian statue from Pompei. National Museum, Naples.

41. Equestrian statue of M. Nonius Balbus the Elder. National Museum, Naples.

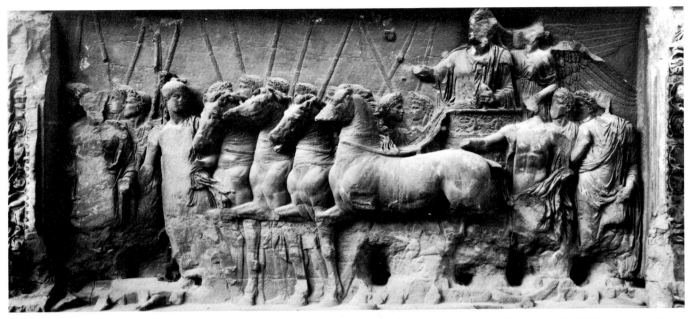

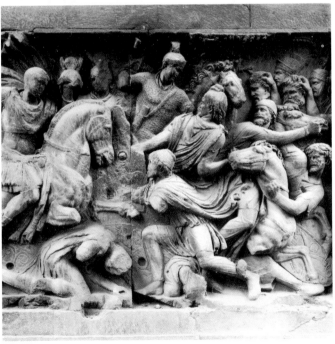

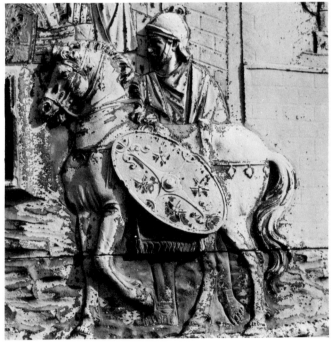

42. Detail of a relief on the Arch of Titus, Rome.

43. Detail of a relief on the Arch of Constantine. Rome.

44. Detail of a relief on Trajan's Column, Rome.

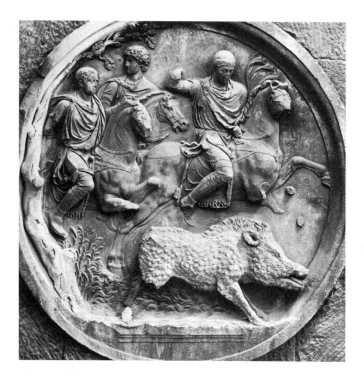

great sarcophagus in the Ludovisi collection (fig. 56). The commander on horseback occupying the central position has been identified as Hostilian, the second son of the emperor Decius, who was nominated Augustus in 251 but died of the plague in November of the same year. Besides the bold examples of foreshortening, also noteworthy are the sorrowful expressions, the drapery and hairstyles - all of them the results of drillwork which creates dense, sinuous zones of shadow. Particularly interesting in this case is the "braided" edge of the horses' ears, the modelling of the somewhat protruding eyeball which is deeply undercut by the line round the cornea, and the hole for the pupil in the form of a very lightly-indicated crescent. The form of one of the horses' collars is also worth mentioning, being rounded with a little central ornament. Bianchi Bandinelli[17] regards this sarcophagus as the last great work of the so-called "baroque" of antiquity, extremely refined in its use of polished marble but somewhat mannered and uninspired.

Perhaps contemporary with the Ludovisi sarcophagus, but much more agitated in form, is the sarcophagus of Palazzo Giustiniani which represents another theme quite common in this period - the hunt (fig. 55). Here again is the characteristic way of rendering the hairs at the edge of the ears which is also found in the Venetian Horses.

The hunt is also a favourite subject of large mosaic cycles further on in the late classical period, such as the celebrated ambulatory floor in Piazza Armerina (fig. 57) and the mosaic in the Constantinian villa at Antioch (Louvre, Paris) in which the horses recall the powerful structure of the Venetian works.

It is worth comparing the Venetian Horses with a scene illustrated on a gold-glass plate in the Cleveland Museum, U.S.A.[18] It depicts a knight on horseback galloping to attack a wild boar, while two deer flee to the right. Lower down in the middle ground an attendant and a dog are shown running swiftly. The work is thought to date from about 275 A.D. Dense shading rendered by cross-hatching on the gold surface defines the volume of the figures - the only way to register the sculptural character of the composition and, in consequence, the spatial depth involved on the flat golden surface. The hatched lines of the horse in particular show striking similarities to the "scratches" on the Venetian Horses.

Circus races inspired certain ornamental motifs which were specifically Roman, as found in the mosaic from Baccano in the Museo Nazionale delle Terme, Rome (fig. 58). The four charioteers represent the four teams of the circus, each with his own distinctive colour - white, green, blue and red. The horses have been identified with those which were placed on the extreme left of the quadriga, that is in the most dangerous position because it was closest to the group of three conical posts marking the turning point in these chariot races [19].

This equine gallery suitably ends with the splendid polychrome inlay of the consul among the circus teams which decorated the Basilica of Julius Bassus (first half of the fourth century A.D.) (fig. 59). The new sculptural ideal of the late classical period by now is fully expressed in these massive, highly polished horses.

45. Circular Hadrianic relief on the Arch of Constantine, Rome.

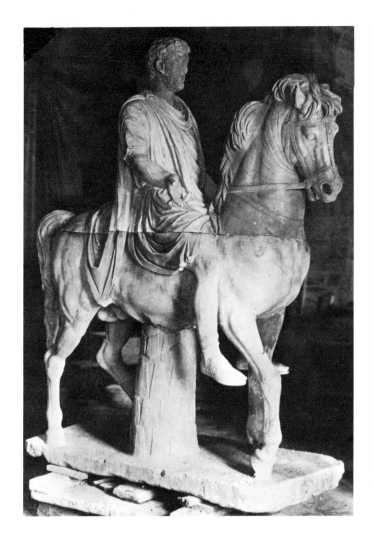

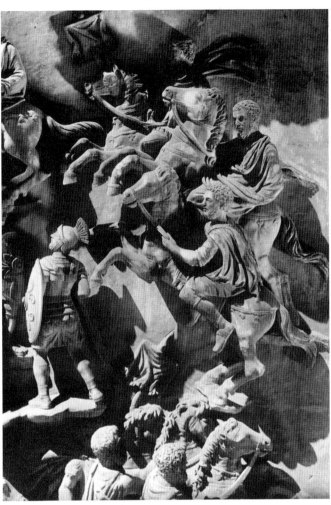

46. Equestrian statue, Villa Barberini, Castel Gandolfo.

47. Detail of the pedestal relief from the column of Antoninus Pius. Cortile della Pigna. Vatican Museum, Rome.

31

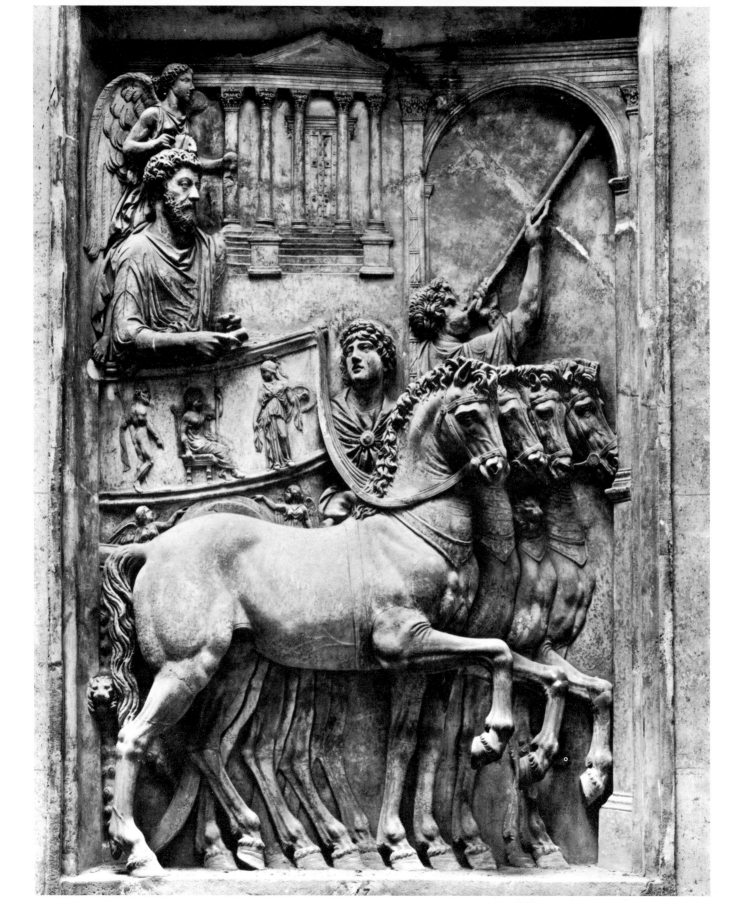

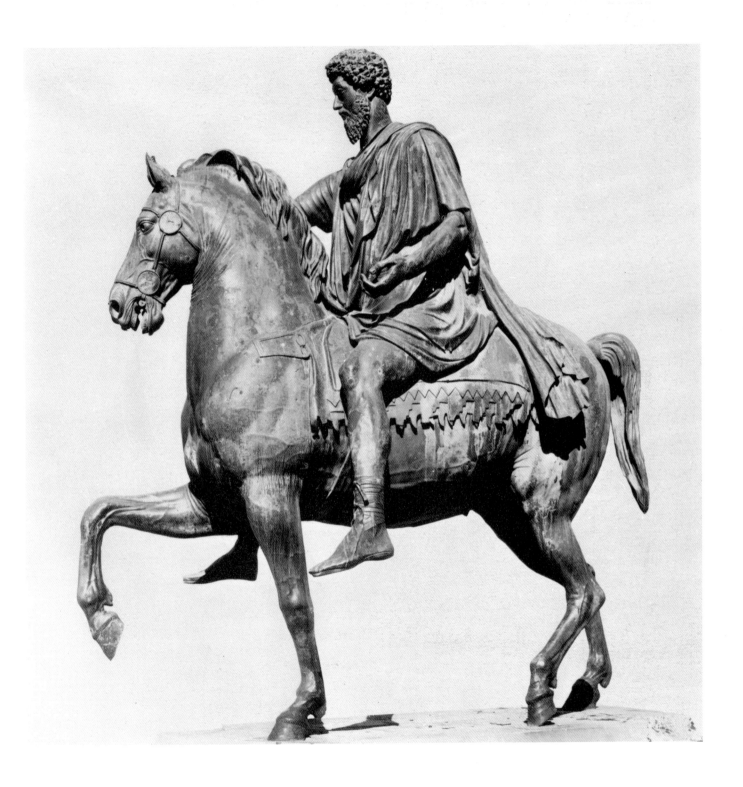

48. Relief of Marcus Aurelius. Palazzo dei Conservatori, Rome. 49. Equestrian statue of Marcus Aurelius. Piazza del Campidoglio, Rome.

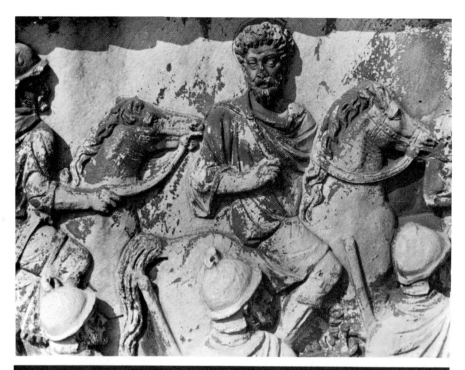

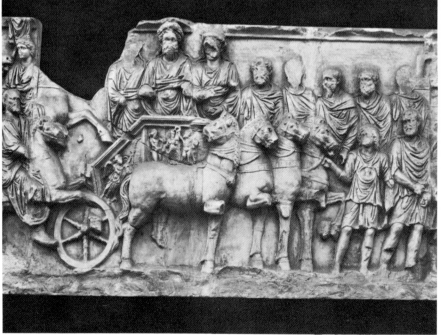

50. Detail of a relief on the Antonine Column, Rome.

51. Detail of a relief on the arch at Leptis Magna, Tripoli Museum.

34

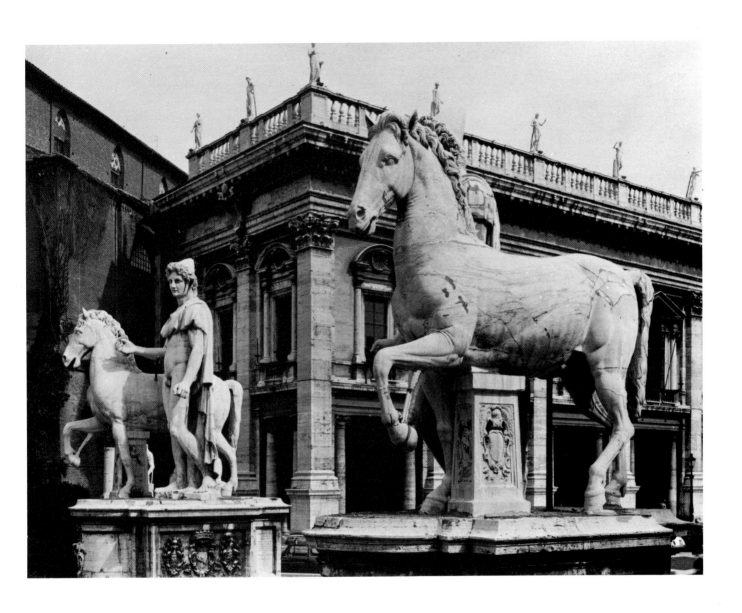

52. Dioscuri. Piazza del Campidoglio, Rome.

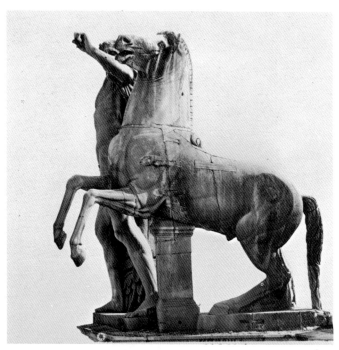

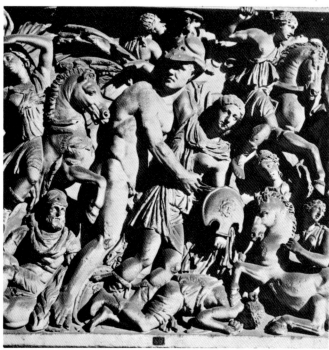

53. Dioscuro. Piazza del Quirinale, Rome.

54. Detail of a sarcophagus relief. Vatican Museum, Rome.

A stereometric vision is already in evidence but, at the same time it appears flattened and frozen owing to a lack of chiaroscuro, which was to characterise the brilliant advent of Byzantine art.

Some important points must be considered at the conclusion of this rapid survey of eight centuries of art history which certainly cannot be exhaustive, but has simply attempted to present a series of works for comparison with the enigmatic Horses of Venice.

On the technical side, it must be remembered that the alloy of the Horses of San Marco is particularly unusual. It has been pointed out that the excessively high percentage of copper supports their having a Greek origin. Nevertheless no Greek bronze so far analysed is similar, even if the samples examined show a high proportion of copper and less lead in comparison with those obtained from Roman bronzes. Neither is any affinity found with those samples of alloys taken from Roman bronzes. However, a full study of the ancient ways of casting alloys still remains to be done. Up to now research has only revealed some rare tesserae in a still unknown mosaic. Systematic analyses of ancient alloys have so far been carried out on works from remote periods [20], when, in fact, it was less likely that the metal examined was the product of recasting. In other words, first-hand metal was not used, but instead fragments of sculpture or pre-existing metal artefacts. It is this very fact which is one of the reasons for caution in forming any immediate connection between the percentage of the additives and the age of the works concerned.

Ancient writers, and Pliny in particular [21], refer to the many types of bronze alloys used by the ancients. Too little precise information concerning the four types of excellent Corinthian bronze, as well as Aegean and Delian bronze, exists for technical conclusions to be drawn, but enough to make it clear that varied technologies were used.

In the case of the Venetian Horses the bronze alloy has up to now been found different from all others. The type of casting used is the one usually termed the indirect lost-wax technique, that is, which makes use of moulds cast on the model [22]. While at one time this was considered to be a technique unknown to the Greeks, it has now been identified even in works dating from the fifth century B.C. [23] This feature, therefore, does not offer a reliable method for dating such a work. The mercury gilding, however, would appear to be characteristic of the late Roman era [24].

Stylistic features - those fragile links which are forged little by little with remote works in time, place and form - have been rapidly considered in the preceding pages. The form of the eyes, so perceptively observed by Magi, the powerful body structure, the classical stylisation of the manes, the scant anatomical traits (such as folds in the skin, veins, fetlocks, etc.) which are accurately observed but subordinated to a stereometric conception of the sculptural masses, seem to lead us away from the classical world and the nervous, dynamic rhythms found in Lysippus's work. They show no influence even from the pulsating expressionism of Hellenistic art. The comparisons are less tentative the further one advances into the Roman era; most similarities seem to be found with certain works of the second and third centuries

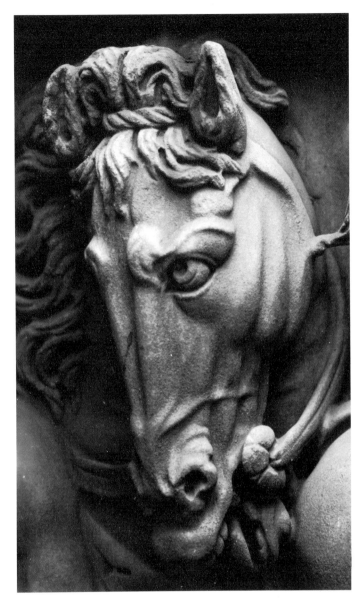

55. Detail of a sarcophagus relief. Palazzo Giustiniani, Rome.

56. Detail from the Ludovisi Sarcophagus. Museo Nazionale delle Terme, Rome.

57. Detail of mosaic pavement. Villa Imperiale, Piazza Armerina.

58. Baccano Mosaic. Museo Nazionale delle Terme, Rome.

A.D. The evidence of a classical awareness is more subtle and sensitive in the Venetian Horses. Indeed, the echo of "baroque" taste is subdued in them even though it still dominated Roman art at that time, and this could well be an indication that they belonged to a workshop carrying on persisting ancient Greek tradition. Nevertheless they still seem far from the frozen classicism of Constantine's era.

According to a fairly well-established hypothesis, the Horses of San Marco could be associated with the building activities of Septimus Severus at Byzantium. After having destroyed the city which had supported his rival Pescennius Niger, the emperor rebuilt it with new and sumptuous buildings. The long siege is described by Dion Cassius who records that "the stones of the theatres, the *bronze horses* and the bronze human figures" had been hurled from the walls as ammunition [25]. A colossal bronze statue of Helios was discovered in the Agora of Byzantium and as this place was on the site where the Milion was to be built, it is possible that it was part of a group representing the Sun with a quadriga mentioned by the Anonymous Banduri [26]. JohannisMalalae and Zosimus tell us that Severus "transferred" the statue to the Hieron of Apollo, built by him on the acropolis close to the temples of Artemis and Aphrodite [27]. Perhaps the original group had been destroyed together with the other statues mentioned by Dion so the image of the god and the quadriga were reconstructed by Severus in the likeness of the lost works in order to atone for their sacrilegious destruction [28].

Is this then the birthplace of our wandering quadriga? It is unwise to be categorical about it, but this historical and chronological situation, which is supported by most evidence available at the present time, could at least provide a hypothesis to be worked on in the future.

However, the problems still remain - depressing proof indeed of how little is actually known of the ancient world and, in particular, of the one from which our own history springs. Perhaps in the future a new series of analyses will be carried out to fix the date of the lead repairs, and of the remains of fireproof earth found inside the horses (despite the negative results so far reached), as well as to investigate the composition of a wider range of samples of bronze statuary, and undertake a more thorough examination of the horses from a stylistic point of view. Then a less conjectural date will finally be established for these trophies of San Marco.

At the same time fresh efforts must be made to find some trace which has escaped notice in ancient texts - a reference that might link these works to their original history. It seems incredible that no record should have survived of such a magnificent achievement. However, it should not be forgotten that ancient sources are exceedingly fragmentory and often indulge in collections of anecdotes which allow news of prime importance to us to slip by unnoticed by them. It must also be borne in mind that if the Horses were created some time between the second and third centuries A.D., those were times of great unrest and of fundamental and far reaching changes when overlapping events left little room for chroniclers to record them.

If every preceding memory of the sculptures has been lost and if the links with the world they came from appear to be severed and undecipherable, this is to a large extent due to their subsequent destiny. Even today the history of the Horses is still bound up with that of Venice and of the Basilica.

(1) CIRIACUS ANCONITANUS, *Itinerarium Florentiae*, 1742, p. 33.
(2) S.D. MARKHAM, *The Horse in Greek Art*, Baltimore, 1943.
(3) A. DE RINALDIS, *Di un'antica testa di cavallo in bronzo attribuita a Donatello*, "Bollettino d'arte", V, 1911, pp. 241-260.
(4) F. MAGI, *Ancora sulla data dei cavalli di San Marco*, in "Rend. Pont. Acc." XLIV, 1971-72, p. 214.
(5) S. STUCCHI, *Gruppo bronzeo di Cartoceto*, in "Boll. d'arte", XLV, 1960, pp. 7-42.
(6) See A. CAPASSO, in *Atti Convegno Spoleto sui Metalli ferrosi e non ferrosi*, 1964 (unedited).
(7) K. KLUGE - K. LEHMANN HARTLEBEN, *Die Antiken Grossenbronzen der Romischer Kaiserzeit*, Berlin-Leipzig, 1927, II, p. 77.
(8) K. KLUGE, *op. cit.* p. 78.
(9) P.M. (P. Moreno), in "Museo come-Museo perchè", *Mostra Associazione Nazionale Musei Italiani, Roma, 23rd September-31st October 1978*, p. 26.
(10) F. MAGI, *op. cit.* pp. 214-215.
(11) G. BECATTI, *L'arte dell'Età Classica*, Florence, 1961, pp. 404-405.
(12) See pp. 157-162.
(13) See p. 195.
(14) F. MAGI, *op. cit.* p.214.
(15) L. CICOGNARA, *Storia della Scultura*, Prato, 1824, III, p. 375.
(16) It is a question of a breed coming originally from the East and particularly suited to the type of war equipment used by the people inhabiting the areas around the Euphrates, and which was subsequently used by the Romans. (A.D. BIVAR "Cavalry Equipment and tactics on Euphrates", in *Dumbarton Oaks Papers*, 22) 1972, pp. 273-291, see also p. 161 (Azzaroli).
(17) R. BIANCHI BANDINELLI, Rome, *La fine dell'Arte Antica*, Milan, 1976, p. 59.
(18) J.D. COONEY, *The Gold-glass Alexander Plate*, in "Bulletin Cleveland Museum of Art", LVI, 1969, pp. 253-261. The plate was exhibited in the exhibition *The Age of Spirituality* held at the Metropolitan Museum, New York, in 1977.
(19) W. HELBIG, *Führer durch Samml. Rom.* Tübingen, 1969, III, pp. 421-22.
(20) S. JUNGHANS, E. SANGMEISTER, M. SCHRÖDER, *Studien zur Anfangen der Metallurgie*, Berlin, 1960; P.T. CRADDOCK, *The composition of Copper Alloys used by the Greek, Etruscan and Roman Civilisations* in "Journal of Archaeological Science" 3, 1976, pp. 93-113.
(21) PLINY, *Naturalis Historia*, XXXIV, 3-6.
(22) See p. 181.
(23) F. RONCALLI, *Il Marte di Todi*, Rome, 1973, pp. 48.
(24) See pp. 184-188.
(25) DION CASSIUS, LXXXIV, 10-14.
(26) See p. 128 and notes (12) and (13) on p. 134.
(27) JOHANNIS MALALAE (VI sec.) *Chronographia*, Bonn, 1831, L.XXI, p. 291; *Zosimus*, II, 30, 31.
(28) L. VLAD BORRELLI, *Some marginal observations on the Horses of San Marco*, in "Storia dell'Arte" (in press).

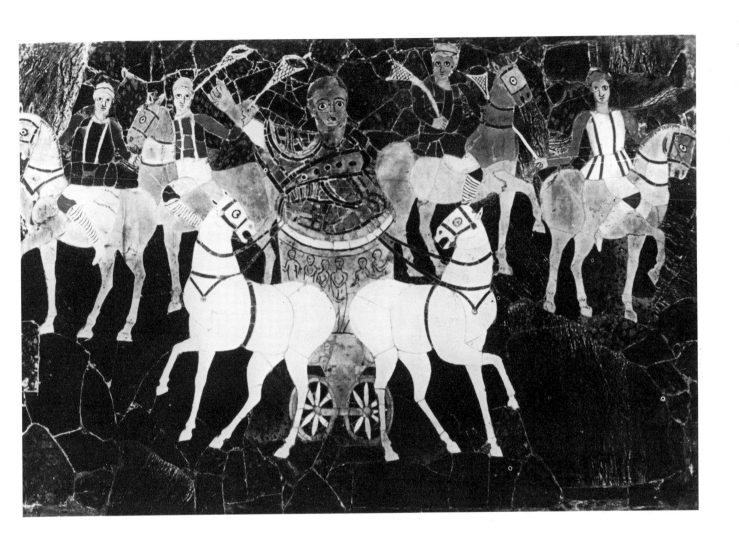

59. Detail of marble inlay from the Basilica of Junius Bassus. Formerly in Palazzo del Drago, Rome.

" The two horses' heads belonging to the famous gilded bronze group from Cartoceto di Pergola were restored in 1978-9 within the context of a more extensive restoration, started in 1975 and devoted to the entire group of statues which also includes two equestrian and two female figures. They have survived not only in an incomplete state but also considerably deformed, having been badly restored in the past. The present restoration is being carried out at the Centro di Restauro della Sopraintendenza Archeologica della Toscana on behalf of the Sopraintendenza Archeologica delle Marche. The better preserved female figure has already been reassembled and almost all the original positions of the other fragments have been identified. Consequently even the heads of the horses have been improved by the addition of some parts which had not been recognised at the time of the preceding restoration, carried out by private individuals during the 1950s. It has also been possible to determine precisely the state of preservation in quantitative terms of the two horses and to attribute the correct head to each animal with certainty.

Both the parts already reassembled, once the plates and bolts which had previously been used to fix them together had been removed, and those more recently acquired, have been cleaned with a scalpel on the external face and with a sander on the internal one, in order to strip off the earthy incrustations and the corrosion products.

A bicomponant resin, soluble in acetone and removable by mechanical means, has been used during the present reconstruction in order to complete the missing areas. Since the deformation of the fragments cannot be rectified, rather than separate one break from another, only one plane of fracture has been deliberately and carefully respected. For this reason there are differences in level which will be noticed above all on the neck of the head CH as well as in the presence of fragments revealing the side of the crushed neck.

The integration of the missing parts with the existing fragments require a basic need for support and continuity between the different elements. They also serve, however, to mask the exposed areas of the inner face which tends to interfere with understanding the work as a whole. These areas of infill should not, however, be considered as a restoration and are, therefore, not modelled but have been executed on a lower plane compared with the original surfaces''. (Pier Roberto Del Francia)

On June 26th 1946 an extraordinary treasure of Roman bronzes was excavated at Cartoceto di Pergola, a small community between Pesaro, Fano and Senigallia by the Via Flaminia.

The bronzes (as confirmed in an article by Sandro Stucchi - Bollettino d'Arte XLV, 1960, page 7-42) constitute one of the most important archeological discoveries of the post-war period, in Italy. They are currently preserved in the Museo Nazionale Archeologico in Ancona.

The monumental group from this find consists of riders on horseback, two female figures and innumerable fragments.

The two horses' heads prove to be outstanding examples of gilded bronze, perfectly preserved, rich in decorations and can be counted among the most important examples of their kind dating from Roman times.

According to Stucchi, the elaborate harness of these horses and the presence in the phalerae of divine symbols (especially those of Quirinus and Venus), coupled with the larger than life measurements and the noble posture of the human figures, indicate that both the men on horseback and the women on foot are members of the imperial household rather than being some personage or some honoured citizen.

Stucchi specifically identifies the most intact female figure as Livia, daughter of M. Livius Drusus, wife of Claudius and then of Augustus, and mother of Tiberius, who died in 29 A.D. He also identifies one of the horsemen as Nero Caesar, uncle of the famous emperor and son of Germanicus and Agrippina Maggiore.

The bronze group dates around 27 A.D.

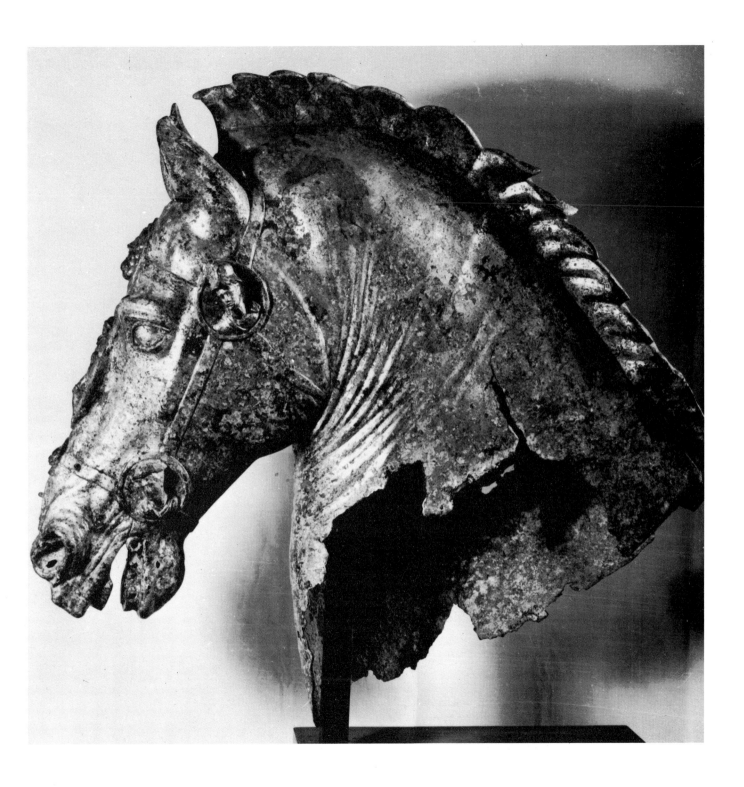

60. Horses' head from Cartoceto, Ancona, Museo Archeologico Nazionale.

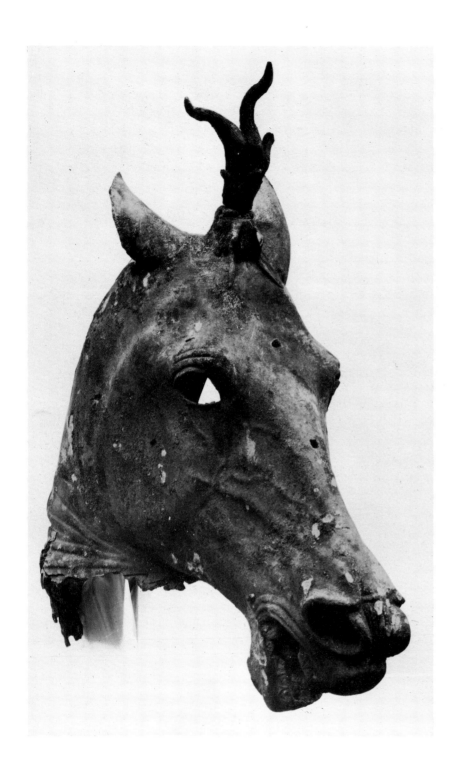

61. Bronze head of the horse

Equestrian Statue of Nerva from Miseno

Fausto Zevi

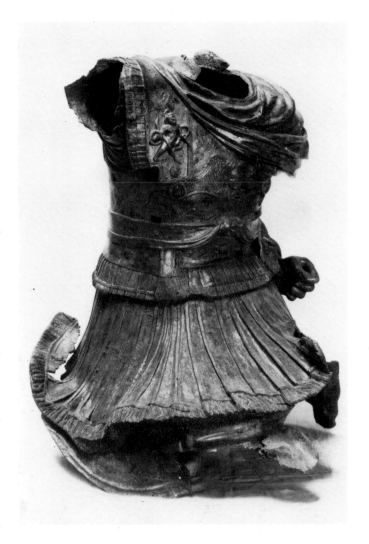

This reconstructed sculpture group, exhibited here, in public for the first time, was discovered about 10 years ago in a structure close to the shrine of the Augustales in the Forum of the colony of Misenum. The building containing the work probably collapsed during one of the frequent earthquakes in the Phlegrean region, burying the statue and thereby preserving at least part of it. Only the forelegs, a hind hoof and, fortunately, the head of the Horse remain. However, all parts of the rider survive although the inevitable deformation of the thin bronze wall of the cast has made it difficult to reassemble the various parts.

The head, which is one of the rare portraits of the Emperor Nerva (96-98 A.D.), is well preserved, although a clearly defined seam is visible around the dome of this head. This may have occurred because it is likely that the face of the new emperor was substituted for Domitian's after the latter had been killed in 96 A.D. and images of him systematically destroyed, but this matter requires further research. Extensive sectional repairs are clearly visible on the head in areas where the hair is defined by single incisions, these resulting perhaps from restorations or modifications carried out in antiquity. The emperor's eyes, as well as those of the horse, were attached with a vitreous paste.

Nerva is represented wearing a cuirass embellished with a strange form of Gorgon in relief, together with various animals and sea monsters in steel inlaid with gold or silver wire, which clearly refer to the commands of the sea - Misenum was in fact the home port of the Roman military fleet. On the emperor's shoulder bands Hercules is shown victorious over the hydra of the marshes symbolising control over the inland waters.

The remainder of the cuirass is decorated with a series of ornamental themes executed in steel, also inlaid with gold and silver wire. The short military cloak is wrapped round one arm and fastened at the neck. The senatorial ring inscribed with the letter S appears on his left ring finger. The emperor's right arm is raised above his head to support some kind of attribute, now missing, rather than a weapon.

The iconographical composition of the sculpture is most unusual. It appears to represent the emperor at the end of a victorious race with his body leaning backwards to counterbalance the animal's impetus forward, and his left arm, which vigorously reins in the horse, is abruptly and firmly bent back. The horse, thus checked while galloping, rears with its nostrils widely dilated, its ears

62. Bronze chest of the Emperor Nerva, detail of the equestrian group, with decorations in relief and damascening

45

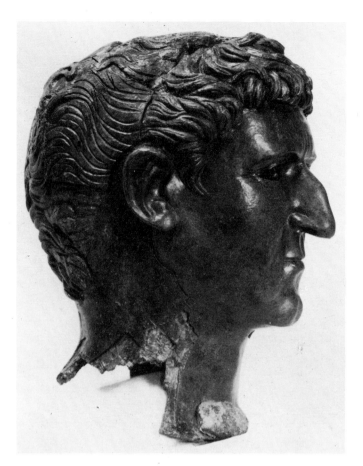
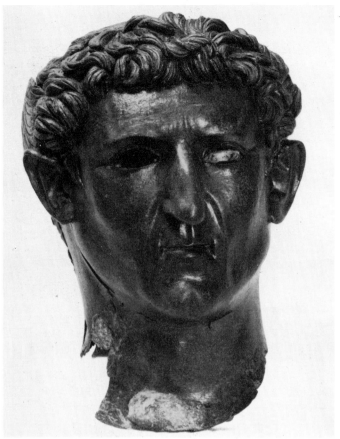

63-64. Bronze head of the Emperor Nerva (96-98 A.C.)

turned backwards, and its mouth forced open by the bit which pulls the head back to form folds in the neck.

The Misenum statue is the only surviving sculpture from antiquity with a lifelike image of a horseman actually galloping. The forelegs of the animal were both raised above the ground in a bold and majestic posture. It is not known how the sculptor overcame the problem of statics involved in the pose. The absence of any signs of bolts or soldering under the hoofs suggests it is unlikely figures of barbarians, struck down by the horse's charge were, used as a support. It is more likely that there was a strut under the horse's belly such as found in marble equestrian statues or in the small bronze of Alexander on horseback found at Herculaneum (fig. 32). This support could even have taken the form of either a symbol or of a river god. Equestrian figures of Alexander or other early Hellenistic work provided models not only for subsequent iconography but also for modes of sculptural expression. Here it is indeed found in an exaggerated form, seen in the decorative use of line, the folds in the neck as well as the stylized forelock and mane. The latter was made separately and inserted in a parallel series of ornamental flame-like tufts which do not follow the animal's impetuous movement forward. The sculpture's similarity with horses heads found at Herculaneum is undoubtedly seen not only in terms of style but also in the fact that they derive from the same models and from about the same period. This suggests that artists from Campania probably had their headquarters and workshop in a major centre like Pozzuoli.

BIBLIOGRAPHY

This work is largely unpublished. However, for details of its discovery and the first attempts to reassemble it, see A. Gallina, in *Fasti Archaeol.* No. XXIII 1972, col. 5049;
Ead Enc. Arte Ant. Suppl. C. ''Miseno''; A. de Francicis, in ''Atti del X Convegno Magna Grecia''. (4th - 11th Oct 1970); 1971, pp. 431 - 452; *idem* in *Campi Flegrei nell'Archeologia e nella Storia,* ''Atti Conv. Lincei'', 33, 1977, pp. 336 ff. figs. 3-5.

65. Porch of S. Alipio with mosaic, c. 1265. Basilica of San Marco.

The Horses of San Marco in Venice

Guido Perocco

The Horses of San Marco were transported to Venice in 1204 as a result of the conquest of Constantinople by the crusaders and the Doge Enrico Dandolo. In 1202 Venice had managed to divert the expeditionary force of the Fourth Crusade to Constantinople instead of the Holy Land, and to overcome the Eastern Roman Empire, which was reputed to be impregnable through its system of fortified defences towards both sea and land. The war booty, which included the Horses of San Marco, was of incalculable value and part of it is still preserved in the treasury of the Basilica in Venice.

This historic event, which was to have most important consequences, was judged from different viewpoints by the various religious movements which initiated the crusades; it was also regarded in terms of Europe's desire to open up the Mediterranean, since expanding populations were tending to spread from West to East. As it was, Venice gave precedence to well-considered political and economic calculations over and above the enthusiasm for great chivalric exploits which inspired medieval Christians, and in so doing was following an ancient pattern of mercantile policy which was to remain with the Republic until its decline.

The Republic of San Marco, like Genoa, Pisa and Amalfi, had for centuries taken for granted this link between Western Europe and the Eastern Mediterranean which ensured their commercial survival through extensive sea trade, mainly with the three big political powers of the time: the Holy Roman Empire in Central Europe, the Byzantine Empire centred on Constantinople and extending between the coasts of the Greek sea and Asia Minor, together with the dominions of Islam, reaching from North Africa towards Europe. Venice in particular, vaunted the title of the ''favourite daughter of Byzantium'', given to the city in 1000 by Basil II during the rule of Pietro Orseolo II as Doge, in recognition of its campaigns against the Saracens in the Adriatic and for its pacification of the Dalmatian coast.

In 1094 the Basilica of San Marco was solemnly consecrated in Venice. This building enshrined the Venetians' pride in possessing an edifice which shared the same magnificent architectural design as the ancient basilicas of the Twelve Apostles and of St. Sophia in Constantinople for their Doge's church and for their patron saint's mausoleum (fig. 76).

The Conquest of Constantinople

The reasons for the conquest of Constantinople are well known. After the failure of the Second and Third Crusades, a fresh one called by Pope Innocent III gathered in Venice in 1202, ready to embark for the Holy Land. Among those taking part were Baudouin, Count of Flanders, and his brother Henry, together with numerous noblemen from France and the Low Countries, some Rhineland Germans and Boniface, Marquis of Monferrato, leading some Southern Italian barons. The Doge Enrico Dandolo himself led the Venetian fleet; its payment was fixed at a sum of 85,000 silver marks from Cologne. Since the crusaders did not have sufficient money, the Doge decided that the entire army of 4,500 cavalry, 9,000 squires and 20,000 infantry should stay near the Port of S. Nicolò on the Lido until finance for the transport was secured. After a long and futile wait from June to November, the Doge laid down his conditions: they were to go and conquer the city of Zara, which had been seized from the Venetians by Hungary, and by this means they would be able to pay off a considerable amount of the money agreed on.

At this point there were a series of dramatic episodes in the Byzantine government at Constantinople caused by the crisis over the imperial succession. It seemed an opportune moment to Enrico Dandolo and various other commanders of the Crusade to concentrate the army on Constantinople rather than set sail for the Holy Land, in order to take advantage of this struggle for succession. They therefore decided to support Alexius Comnenus, who belonged to the imperial dynasty, and to back up his candidature for the throne of the Byzantine empire against other rivals (fig. 70).

The crusading fleet, which, according to Ramusio, had 480 ships, embarked from Venice on 8th November 1202, conquered Zara and, after the winter was over, set off again for Constantinople on 29th May 1203. Precise eye-witness accounts of the expedition not only came from Robert de Clary on the French side but also from Nicetas Coniatus on the Greek one, as well as from one of the crusader ambassadors in Venice, Geoffroy de Villehardouin. He, in fact, concluded the agreement with Doge Enrico Dandolo and shared responsibility for deflecting the crusade towards Constantinople. His function as an historian is of great importance since the events reported are carefully sifted by

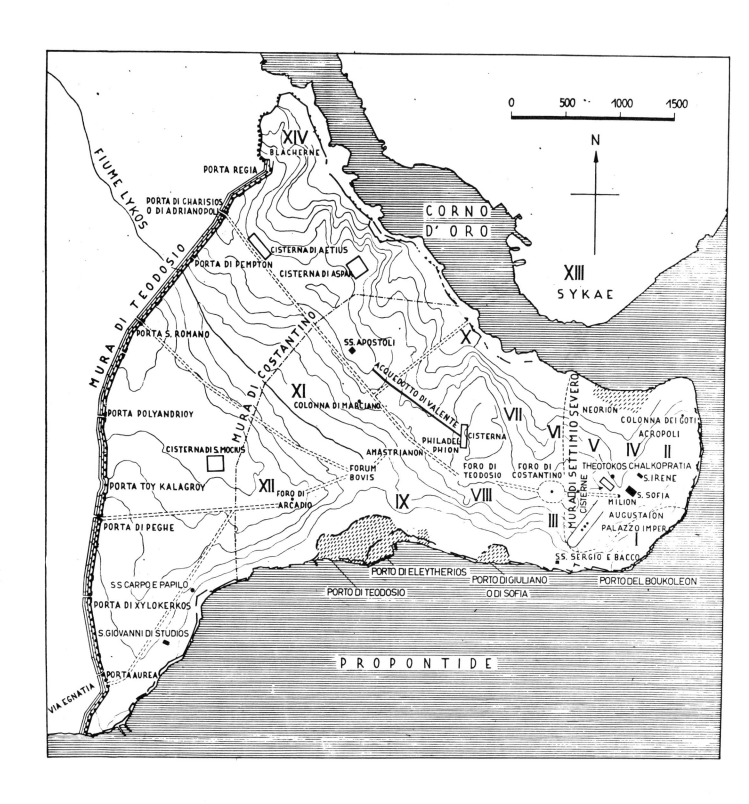

66. Map of Constantinople during the Imperial Roman era (from *Enciclopedia dell'Arte Antica* published by the *Enciclopedia Treccani*).

a skilled politician who knew how to evaluate accurately not only the various conflicting powers but also the most secret intentions. His account shows he was aware of the shrewd realism of the Venetians who weighed up the situation, placing commercial considerations before chivalric pride and the official declaration of lofty sentiments of "grandeur", to cite the actual word, by the allies. "Nobody could think", Villehardouin wrote, "that there was a city in the world so rich as Constantinople when they saw those high walls and rich towers which served it as a kind of cloister, together with the rich palaces and lofty churches rising in incredible numbers, the length and breadth of this city which was the "sovereign" of the whole world".

After vain and protracted efforts to settle the imperial dynastic question to their own advantage, the crusaders, who were encamped under the city walls, decided to seize the capital by force and to appoint one of the leaders of the expedition as head of the Eastern Latin Empire. In April 1204 a violent attack from the sea, led by the Venetians, and from land by the other crusaders, succeeded in overcoming the city's defences (fig. 71). Until now these had always withstood enemy attacks in past centuries when armies came to fight beneath the celebrated fortified walls of Constantinople - the Goths, Huns, Slavs, Persians, Arabs, Bulgarians, Russians, Magyars, Normans and Serbs. The sack followed the conquest of the city.

"The Sack of Constantinople", writes the historian of Crusades, Steven Runciman, "has no historical parallel. For nine centuries the great city had been the capital of Christian civilization. It was full of works of art inherited from ancient Greece and of masterpieces by its own artists. The Venetians effectively knew the value of such works and, whenever they were able, they took possession of the treasures carrying them away to adorn the squares, churches and palaces of their city"[1].

The Byzantine Empire was replaced by a new virtually improvised Latin one, with the old Doge Enrico Dandolo playing a key part in it. Among the various principal electors, one of the commanders of the Crusade, Baudouin of Flanders, was appointed emperor after lengthy negotiations on 9th May 1204. Baudouin inherited, together with the imperial crown, one of the most difficult and unforeseen problems which could face a crusader knight who had left his native land with the promise of liberating the Holy Sepulchre, but then, through a skilful manoeuvre, found himself at the head of one of the most important empires in the ancient world.

The Consequences of the Conquest

Enrico Dandolo's action proved to be a move of sheer realism which made him appear more like a Machiavellian hero or political Renaissance prince rather than a medieval man. It is strange that Villehardouin, his contemporary, made no attempt to modify the unreserved praise he lavished on the Venetian Doge who was working from a completely different attitude that contrasted with the shining spirit of adventure felt by the crusaders.

The turning-point which Enrico Dandolo manoeuvred with the

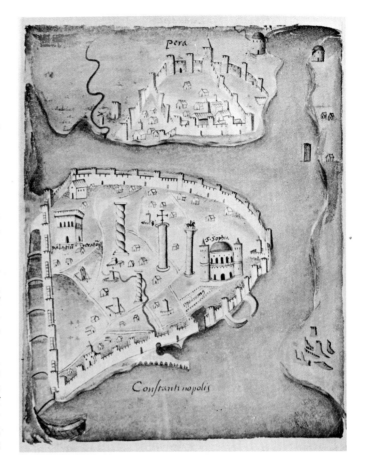

67. Map of Constantinople (from the *Liber Insularum del Buondelmonti*, 1422).

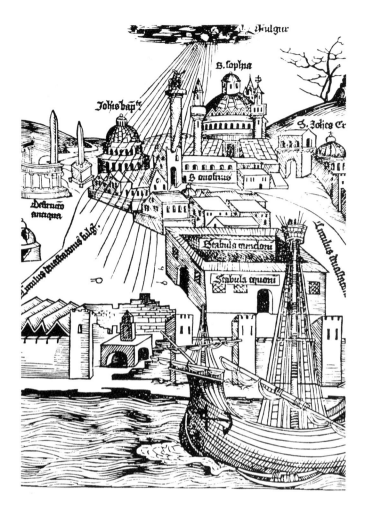

Labels on the illustration: Vulgur · S. Sophia · Johebap. · S. Johes Cr. · S. anothius · Deturno antiqua · Stabula cundoni · Stabula equoni

68. View of Constantinople by H. Schedel of 1493.

Fourth Crusade was to be of prime importance for Venice. Indeed, no historical, economic or artistic event of the Thirteenth century can be judged in its true light without taking this conquest into consideration. This is particularly true with the opening up of the new Venetian colonial territories and the exceptional influx of works of art included with the extremely rich booty taken from the city and brought back to the treasury of San Marco. The Horses were part of the spoils allotted to the Venetians - about a third of the rich booty accumulated by the crusaders and gathered together in the three churches in Constantinople - and were already designated as such before the decisive attack took place. It is unnecessary to dwell on the lengthy arguments over the division of this loot. ''Count Riant'' wrote Rodolfo Gallo, ''has published a rough inventory, which includes over four hundred items, of the religious booty from Constantinople sent to the East between 1204 and 1261 as a result of the Fourth Crusade''[2]. From the *Chronicle* of Doge Andrea Dandolo (1343-1354) we know what items of this religious booty were sent to Venice immediately after the fall of the capital and which are still preserved today in the Basilica's treasury and in some of the city's churches. In Paris, the king, Saint Louis IX had the Sainte Chapelle built in 1245 to shelter the most precious relics that had come from Constantinople (fig. 90). In 1231 a fire in San Marco, a theft in 1449, as well as the sad devastation of the treasury at the fall of the Republic in 1797, have partly been responsible·for dispersing this extremely valuable collection.

The choice of the Horses of San Marco already in 1204 and their transfer to Venice can now be seen as undoubtedly a conscious act to witness the triumph of the Republic - an idea conceived by Enrico Dandolo who knew Constantinople extremely well since he had been the Venetian ambassador at the court of the Byzantine emperor. The Doge could boast the new title of ''Lord of a quarter and a half of the Roman empire'' - as inscribed prominently on his official portrait in the Sala del Maggior Consiglio in the Ducal Palace. The ambition to have inherited the glory of Rome, which had indeed been nurtured by many other ancient cities during the Middle Ages, was to be commemorated in Venice with a monument which was both an expression of triumph and of the Roman spirit. No such combination seems loftier and more solemn to us than the Horses of San Marco which formerly watched majestically over the city of Constantinople.

In Ravenna too we know through engravings that there was in the 6th century a large bronze equestrian statue of an emperor (similar to the one of Justinian in Constantinople, where the Ravenna one may have come from). This was later transferred to Pavia in the eighth century as a spoil of war after the Longobards had destroyed the city. Placed like Justinian's statue on a column in front of Pavia Cathedral and called the *Regisole* (sun ruler), it provided a motive for the worship of Rome in the city. This boast was challenged by the rivalry which developed between the communes and the Milanese who managed to get hold of it and keep it for themselves as war booty between 1315 and 1335.

Among the various witnesses of the late Roman equestrian monument, Petrarch is outstanding; he described it in a letter of 1364 to

CIRCI five HIPPODROMI CONSTANTINOPOLITANI
à Conſtantino Magno excædificati reliquiæ, quæ centeſimo ante anno, quam ea urbe à Turcis capta eſſet, adhuc ſuperunt.

69. The Hippodrome of Constantinople in the 16th century (engraved view by Onofrio Panvinio in the *Corpus Bizantinae Historiae* by Anselmo Bondurio).

70. Andrea Vicentino, *Alexius Comnenus asking the Doge Enrico Dandolo and crusaders to help him drive his uncle Alexius from the throne.* Ducal Palace, Venice.

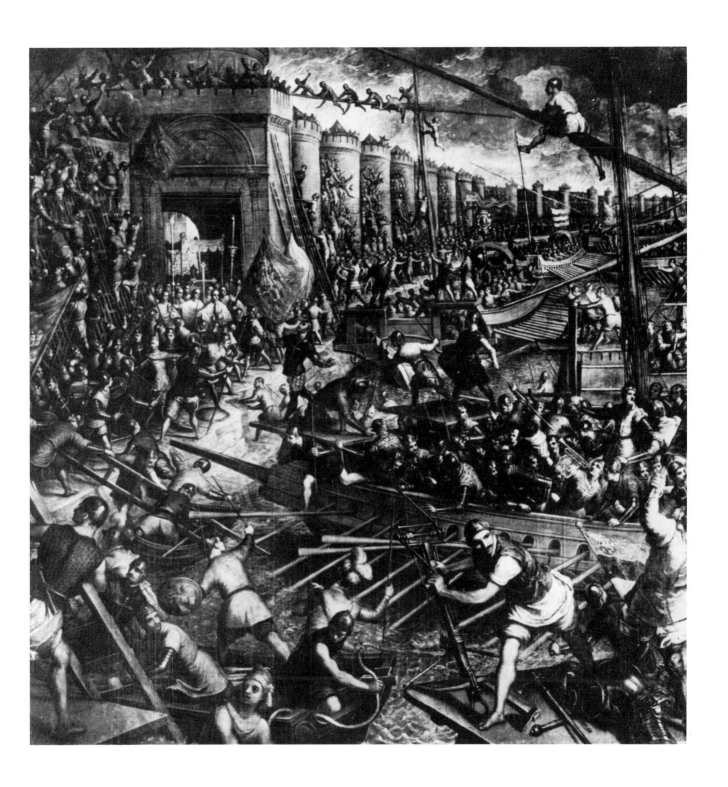

71. Jacopo Palma il Giovane, *The Sack of Constantinople*. Ducal Palace, Venice.

Giovanni Boccaccio. So was Leonardo, whose annotation of 1490 to the Codex Atlanticus observed that the horse "trots almost in the same way as an untamed horse". The equestrian monument of Pavia was destroyed in 1796 when the Horses of San Marco also ran the same risk through being carried off to Paris[3].

The Horses in Constantinople and Venice

Among other theories it is suggested that the Horses were found in the hippodrome of Constantinople (fig. 69). In his guide to the city, Mamboury states that the hippodrome was located on the site of the present Sultanahmet Square, near St. Sophia and, as with the Circus Maximus in Rome, horse and chariot races, together with mainly popular entertainments were held there. The hippodrome, St. Sophia and the imperial palaces were situated in the acropolis of Constantinople and formed the three most famous centres in the capital (fig. 66). According to a well-known saying, God had St. Sophia for himself, the emperor had the palaces on the side of the Bosphorous, and the people the hippodrome in the heart of the city.

The documentation concerning the hippodrome and the site of the Horses is mentioned elsewhere, the most important source being that of Niceta Coniate who gave an eye-witness account of the 1204 conquest from the Greek point of view. As in Roman circuses, at the centre of the hippodrome there was a large obelisk brought back from Heliopolis by Theodosius the Great, which still remains in its original position (fig. 210 a) (the one formerly in the Circus Maximus now stands in Piazza del Popolo in Rome and that from the Circus of Gaius and Nero is now in Piazza San Pietro, Rome). The hippodrome was decorated with celebrated works of art which, in addition to their aesthetic value, bore witness to historical events and triumphal assertions of the new Roman Empire with Constantinople as its capital. Not far away and close to St. Sophia was another famous equestrian statue dedicated to Justinian (or to Theodosius) placed high on a porphyry column, (fig. 81) which attracted the admiration of Byzantium through its simple yet powerful form derived from a commemorative type of Roman equestrian monuments. The impressive beauty of this statue, which rose above the palaces of the acropolis, was well known. A memory of this monument still remains in Venice with the two columns of San Marco and St. Theodore in the Piazzetta di S. Marco. Justinian's column was destroyed at the end of the Sixteenth Century and the bronze equestrian statue was first placed in a courtyard of the Sultan's Palace, the Serraglio, later to be melted down by the state foundries to provide further cannons.

Marin Sanudo tells us that the Horses were shipped in a Venetian vessel commanded by Domenico Morosini, and that a foot detached from one of the sculptures was to remain in the Morosini family house. A very interesting reference to this voyage was made by Marilyn Perry in an issue of the journal *Aquileia Nostra* (1974-75) concerning a circular relief with the galley and the four Horses, which is fixed on the façade of a house near the Church of

S. Francesco della Vigna[4]. The same composition appears on a terracotta plate from the neo-classical era, 54 cm in diameter, belonging to an art collection in Milan (fig. 74).

After the Conquest of Constantinople the Venetian warships returned to the Arsenal, where the four Horses were stored before being set on the façade of the Basilica of San Marco. Reliable evidence reveals that the Horses remained, in fact, for fifty years in the Arsenal and that during this time they were in constant danger of destruction.

Some structural works were carried out on the Basilica in this period. They justified a solution which at first had been considered impossible; namely to place the Horses as decoration in the centre of the façade above the appropriate triumphal archway of the principal door to the building. It was then that the loggia facing the square and running along the flanks of the Basilica as seen today was constructed, being deep enough to take the Horses (fig. 79). The five great arches which form the two-storied façade of the building serve to produce the architectural effect of a triumphal arch as seen from the Piazza (fig. 198) - a triumphal arch which had originated in Rome but was to become Venetian through the very richness of its ornament and magic of its colour. The arch crowning the main entrance to the Basilica was widened and embellished with sumptuous ornamental columns, together with a series of marble reliefs which are the pride and glory of Romanesque art (figs. 80 and 89).

The Horses of San Marco extend slightly beyond the curve of this arch and stand out against the background of a second arch higher up which bears on its summit the symbol of the Lion and the image of the Saint (fig. 118). So this composition was crowned by the emblems closest to the Venetians' hearts at the moment when the façade of the Basilica also assumed a new symbolic importance as a monument in its own right, overlooking the Piazza like a grand reliquary.

Works on the Basilica of San Marco

This hypothesis is confirmed by the studies of a connoisseur of San Marco, Ferdinando Forlati. "At the end of 1100" he writes, "or rather, at the beginning of 1200, they had to think about creating a new atrium to go round the church. Gombrosi was the first to show in his important study of 1934 that after the Fourth Crusade, work carried out on San Marco was no longer simply decorative but structural. In fact the first portico would not have had an upper storey because the inside walls on the north side of the church show traces of cornices, probably for windows which would have allowed light into the nave". Later on Forlati concludes that this was "a consequence, at least in my opinion, of the construction of the large narthex and the raising of the domes"[5].

Work continued ceaselessly and patiently for centuries to transform the appearance of the primitive brick structure, dating back to the Basilica's consecration in 1094, both inside and without until it finally achieved that fabulous appearance which developed through the characteristic fervour and enthusiasm shown by the medieval populace towards their great works of art. The

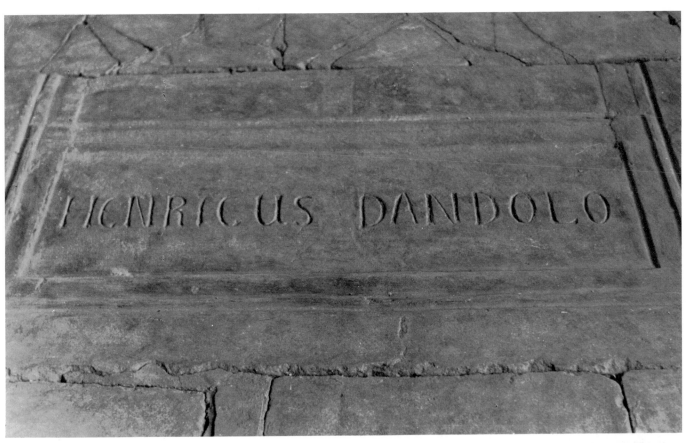

72. Tomb of Enrico Dandolo. Hagia Sophia, Istanbul.

73. View of the Gynaeceum in Hagia Sophia where Enrico Dandolo's tomb is situated.

74. A terracotta plate of around 1815 with an allegory of the transport of the Horses of San Marco

sculptural character of the building and the play of volume at the various spatial intersections radically change the feeling of the early Basilica. The effects of optical illusion derived from the decoration and the tone and variety of the mosaic areas, all enhance the primitive form of the Basilica with new pictorial values.

After the Fourth Crusade, the strengthening of the surrounding walls and the arrangement of the atrium made it possible to undertake an extraordinary transformation of the domes as well. By means of ambitious wooden structures covered in lead, they were to be changed from hemispheres- as found in St. Sophia and represented in a mosaic inside the Basilica from the first half of the thirteenth century (fig. 75), into the lofty profiles which they subsequently assumed (fig. 78). According to Demus, the works were carried out in 1231 and are shown completed in the mosaic of S. Alipio which was finished about 1265 (figs. 65 and 77). Half-way through the thirteenth century the Horses were placed on the façade as part of the embellishment of the Basilica and the Piazza. This decorative programme had been started before the Crusade and was completed in the form of the rare marbles, the statues and the capitals which were brought back to Venice on the regular voyages by the city's mercantile fleet, following on the first and most important war booty derived from the Fall of Constantinople. Particularly prized were the porphyry columns, in *verde antico*, together with Greek marble of the most varied and much sought-after colours which were used, like the Horses, to render the exterior and interior of the Basilica like a precious casket, equalling the pearls and emeralds adorning the great Golden Altarpiece behind the High Altar. The Horses with their vibrant gilding emphasised this taste and set a harmonious note in keeping with the strongly chromatic nature of the façade.

The beginning of this renewal of the Basilica can be dated to the period when one of the greatest Doges was governing Venice - Sebastiano Ziani (1172-1178). It was he who enlarged Piazza San Marco. According to tradition, in 1172 the two austere granite columns of St. Mark and St. Theodore, also brought back from an eastern Mediterranean city (perhaps Alexandria in Egypt) were placed in their present position. They were adorned with symbols of the two protectors of the city. That of St. Mark was converted from a Sassanian sculpture of a chimera to assume the image of a lion and was placed on the column halfway through the thirteenth century when the Horses too were placed on the façade of the Basilica (fig. 86). The statue of St. Theodore was made from a statue, partly Hellenistic and partly Roman, and assembled in the typical Venetian manner of adapting ancient works for new functions. This statue was placed on its column in 1329 (fig. 87).

Work continued during the rule of Sebastiano Ziani's son, Pietro, (1205-1229) who succeeded Enrico Dandolo as Doge. In 1256 the red porphyry stone with a proclamation inscribed on it was placed next to the arcade at the corner of the Basilica facing the Piazzetta (fig. 85). Subsequently, in 1258 the pillars, called after St. John of Acre, in so far as they were thought to have come from that town, were set up near the Porta della Carta (fig. 84). According to a recent publication (Wolfgang Müller-Wiener,

Bildlexikon zur Topographie von Istanbul. Byzantion - Konstantinopel - Istanbul: bis zum Beginn des 17. Jahrhunderts, Tübingen 1977, pp. 190-192), archaeological excavations in the ancient city of Constantinople have shown that these pillars, in fact, came from the church of Hagios Polyeuktos, built in the sixth century close to the Basilica of the Twelve Apostles.

This church had already been abandoned and partly destroyed at the beginning of the eleventh century. During the Latin period (1204-1261) the building was completely stripped of its architectural ornaments and the pillars in question, together with other elements were then reused in San Marco, Venice. The porphyry monuments of the Tetrarchs embracing one another must have been placed close to the other trophies also during this period (fig. 83). In 1266 the Piazza was paved for the first time with red bricks in a herring-bone pattern.

In this way Piazza San Marco over the centuries was to be enlivened with an almost legendary scenario involving the angels on the pinnacles of the Basilica, the saint protectors in their gilded niches, the capitals of the Ducal Palace, the Virtues embellishing the Porta della Carta, the Moors which strike the hour on the Clock-tower, the statues on Sansovino's Loggetta and on the Library balustrade. The Horses of San Marco are featured at the very centre of this elaborate stage-set and represent the living images of a decorative taste which spreads from the Piazza through the city, even into its every nook and cranny, with an inexhaustible flowering of artistic creativity that has continued spontaneously throughout the ages (fig. 88).

There are two outstanding literary documents recording the Basilica in this epoch. The first is by Geoffroy de Villehardouin who in 1202 was enchanted by the beauties of the city, and when taking part in the religious ceremonies in San Marco for the crusaders assembled in Venice, defined the church as "the most beautiful that can be". The second is found in a Venetian chronicle, *Les Estoires de Venise,* written in French, by Martin da Canal before 1275, the year in which the writer is thought to have died, when the Horses had only just been placed on the façade.

After describing the arrival of St. Mark's body, Martin da Canal illustrated the mosaics on the façade (including the one of S. Alipio) and, as a guarantee of his own veracity, added, "and if any of you wishes to check that things were as I have told you, come and see the beautiful church of our master St. Mark and look at the beautiful church from the front, because this history is written there exactly as I have recounted it; and you will have the considerable indulgence of seven years which our master the Pope has proclaimed for whoever goes into that beautiful church. And when they had constructed such a beautiful church, the Venetians decided and approved that it would be enriched every year and for ever, and this they do; that beautiful church belongs to our master the Doge'"[6].

Shortly after the election of Doge Ranieri Zeno in 1253, Martin da Canal described a festive tournament in Piazza San Marco, in which we could imagine the Horses transported there from Constantinople also taking part. He also stated that the Venetian patricians had stands erected in the Piazza, and that the pick of the

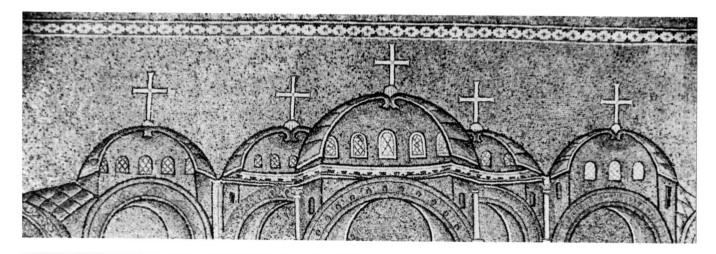

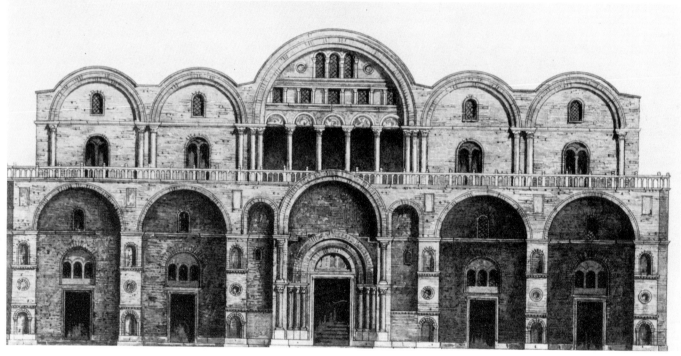

75. Detail of a mosaic inside the Basilica showing the cupolas of San Marco in the original byzantine form during the mid-13th century.

76. Façade of the Basilica of San Marco as it would have appeared during the era of the church's consecration (1098) and before the modifications carried out at the beginning of the 13th century (reconstruction by Antonio Pellanda).

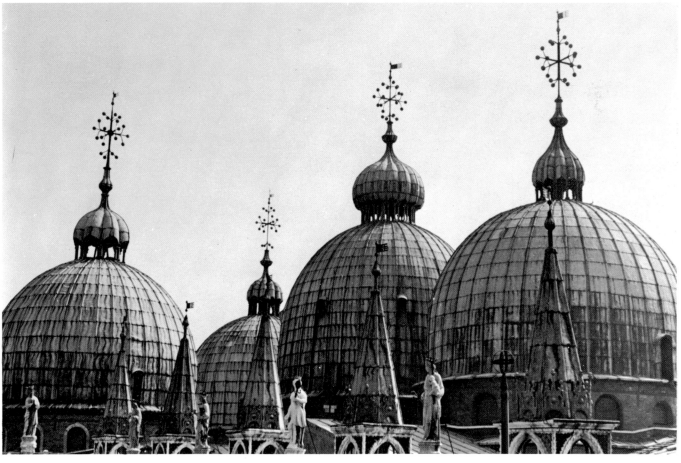

77 - 78. Detail of the mosaic c. 1265 above the Door of S. Alipio (77) which documents the placing of the Horses of San Marco and the new shape of the cupolas as formed by wooden structures (78).

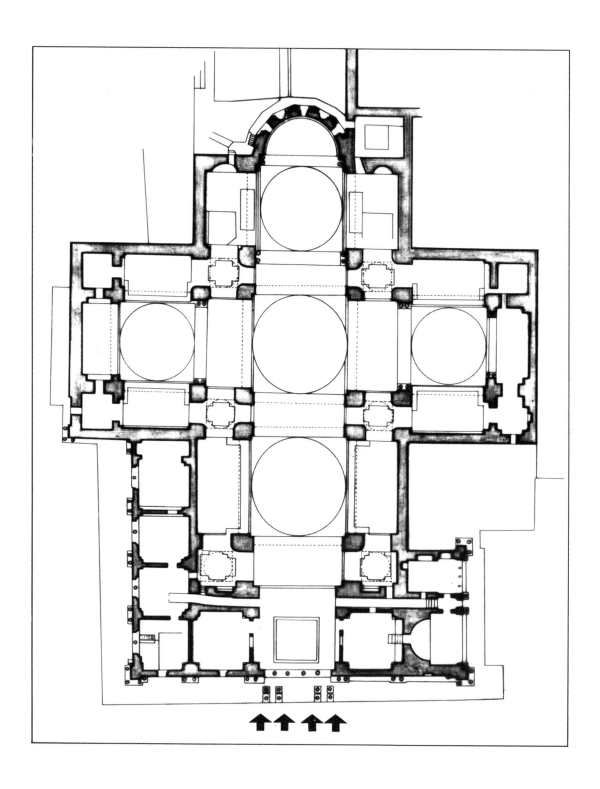

79. Plan of San Marco showing the location of the horses.

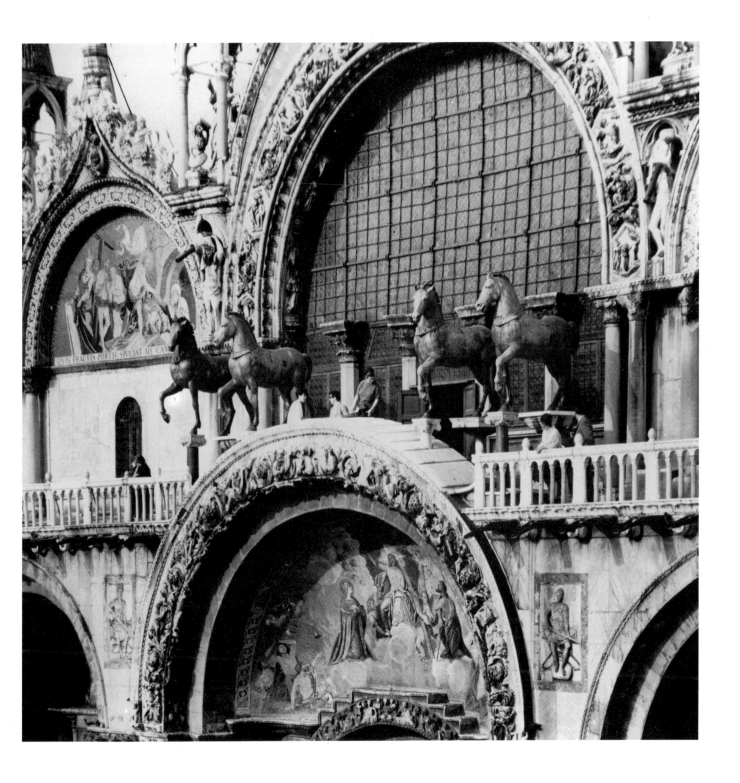

80. The Horses of San Marco between the two central arches of the Basilica façade.

81. The Column of Justinian (or Theodosius), Istanbul, according to Mambury's reconstruction.

German, Lombard, Friulian and Istrian cavalry was certainly represented in the brightly coloured parade featuring the Doge's two sons in particular. The chronicler also singles out the ladies and maidens on the stands and at the windows of the palaces surrounding the Piazza, and the Doge himself on the loggia of San Marco with the Venetian nobility[7].

It seems in any case more than likely that the Horses were placed on the loggia of the Basilica while Ranieri Zeno (1253-1268) was Doge when the façade took on the appearance it still possesses today and which, especially with the late fourteenth-century decorations, seems to be connected more with the actual Piazza than with the church itself. The smooth rhythms of the arcades around the Piazza are drawn towards the focal point of the five large two-story arcades of the façade as in the four-sided atria of early Christian churches and the courtyards of mosques. The Horses are not only at the centre of these façade arches but also at the heart of the pictorial composition of the Basilica, conveying a precise chromatic value which is easily distinguishable from the opposite end of the Piazza and is articulated in different ways according to the various viewpoints from the start of the Piazzetta up to the Clocktower.

In the history of Venice it should be pointed out that the "Discovery of Byzantium", as Otto Demus wrote, "resulted from the conquest of Constantinople. With the import of original works of Byzantine art and the migration of Byzantine artists to Venice, a rapid and turbulent movement suddenly began; in the course of a generation it was totally to alter the face of Venetian art, just as would happen some two hundred and fifty years later when Mantegna and Antonello da Messina's art became known in Venice"[8].

The Horses of San Marco before the Renaissance

No documents have yet been found referring to the Horses after their arrival in Venice until the famous reference by Petrarch in 1364 on the occasion of a chivalric tournament in Piazza San Marco, when the poet had the honour of sitting next to the Doge on the loggia of the Basilica. Shortly afterwards the words threatening "to curb the Horses of San Marco" were hurled by Pietro Doria during the Battle of Chioggia in 1378, when it seemed that the Genoese would get their hands on the city in order finally to dominate it.

One wonders what aesthetic influence was brought by the Byzantine sculptures plundered from the East such as those, for example, on the façade, in comparison with the completely Romanesque vigour derived from Antelami's style of decoration on the large arches, constructed during the early decades of the thirteenth century (fig. 80). An obvious comparison is invited between the style of Romanesque sculpture of the Byzantine mosaics and of the exaltation of "reality" offered by the famous Horses. It is a question of different ways of regarding reality and transforming it according to diverse aesthetic solutions - the Horses rendered in terms of classical idealism derived from Athens; the Romanesque and Byzantine sculptures together with

the mosaics as characteristic expression of the Christian Middle Ages in East and West. The formal innovations found in the varied styles of different epochs as first seen on San Marco - the most auspicious setting in the entire city- were later to inter-react and spread their influence outwards into the structural expression and ornamental idiom of the rest of the city.

The earliest examples of Romanesque, Gothic and Renaissance works were first to appear in Venice on the Basilica itself.

When the Horses were not regarded as sculptures in the round, they were perhaps appreciated as superlative examples of metal work by the goldsmiths and gilders, who were the artisans held in the highest respect in Venice. The Golden Altarpiece of San Marco was enlarged and further embellished with enamel-work and jewels which had been brought back as part of the booty from the Fourth Crusade, and re-arranged in 1345 as the undoubted masterpiece of Venetian goldsmith's work.

It is a fact that the golden colour came to be used increasingly on the Basilica façade, not counting the golden background of the mosaics, as can be seen in *The Procession in Piazza San Marco* (1496) by Gentile Bellini (fig. 105). The crowning Gothic ornament in marble begun in 1385, was completely gilded - the stylised leaves taking the form of flames - as were the niches, pinnacles, the angels' wings as well as the saints on the pinnacles and the winged Lion set against the blue background above the central arch. Even the Porta della Carta was gilded like a reliquary. The Horses, like a great jewel at the centre of the façade, were to form unusual relationships with the Gothic decoration so rich in oriental fantasy surrounding them.

The horse motif in fourteenth-century Venetian art does not stray from the conventional linearity of icons, as can be seen in the stupendous examples of the sculptures of St. George and St. Theodore in the Baptistery of San Marco (fig. 108). During the early fifteenth century this motif offered a pretext for formal elegance with Gentile da Fabriano, Pisanello and Michele Giambono (figs. 111 and 112). There is no proof that the Horses of San Marco served directly as models for these artists, even if we know that Gentile da Fabriano and Pisanello worked on the frescoes in the Sala del Maggior Consiglio in the Ducal Palace and Giambono on the mosaics of San Marco. However, they must surely have admired the Horses. The same question arises with the Tuscan artists working in the Basilica during the fifteenth century. In what way, one wonders, would Paolo Uccello have looked at the Horses of San Marco? Only Jacopo Bellini, half-way through the century, made some drawings directly of the Venetian Horses with the naturalistic observation already characteristic of the Renaissance (figs. 113 and 116). The painter studied the solemn, composed majesty of their movement as well as their type of compact hogged mane, even recording the finely-wrought work on the collars.

The quadriga in the figurative art of the fourteenth and fifteenth centuries is bound up with the concept of the ''Triumph'' as understood in the Petrarchan sense; the glorification of an allegorical figure with clear echoes of the Roman ''Triumph'', as superbly expressed by Mantegna. The four horses together

82. The Column of Constantine, Istanbul.

65

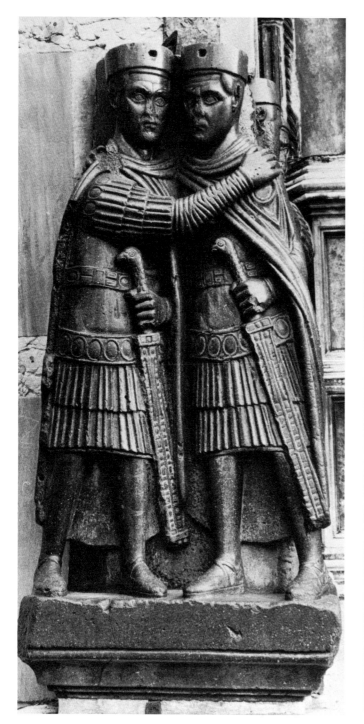

84. Pillars from the church of Hagios Polyeuktos, Constantinople, which were originally believed to have come from St. John of Acre.

83. The Tetrarchs.

85. The "Colonna del Bando".

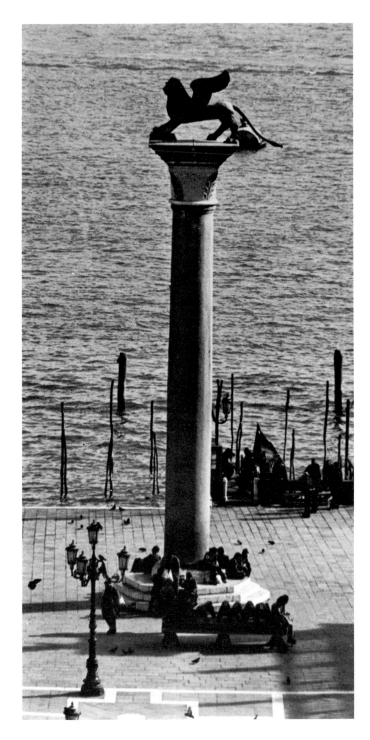

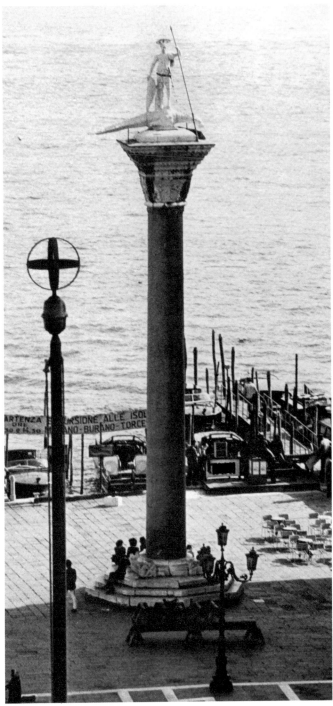

86. The Column of St. Mark.

87. The Column of St. Theodore.

harnessed to the triumphal carriage have the power to exalt a supreme idea such as Love, Fame or Death (fig. 94). The horse then appears as an ideal form symbolising strength, contained energy, power guided by reason and by a commanding vigour of the spirit. In a word, it is the incarnation of an aesthetic ideal transformed by the human mind into the nobility and beauty of the steed, sharing in human life through an encounter between the sovereignty of the idea and the contingent reality. The artist of the Horses of San Marco has materialised in pure form, as perhaps no other artist in the world, has done, this expression of beauty.

Pisanello was the incomparable interpreter of this motif with an aristocratic and refined sublimation of the elegance so characteristic of the International Gothic, but also with the sublime Renaissance sense of measure revealed in the perfect and coherent style of modelling in his medals (fig. 92).

The Horses of San Marco in the Renaissance

Towards the 1250's series of impressive and unusual tombs of equestrian warriors appeared among the monuments to the lords of Verona, Pisanello's native city (fig. 93). The horses on them appear as if possessed by a mysterious force fused with the fiery self-assurance and warlike vigour of Cangrande della Scala (fig. 91). In fact, one of the first equestrian monuments of the Renaissance which, when seen close at hand, recalls the Horses of San Marco, is found in Verona. Attributed to Nanni di Bartolo, it commemorates Cortesia Seregno (1424-1429) in the church of St. Anastasia. During the same period Paolo Uccello painted his celebrated fresco (1436) in S. Maria del Fiore, Florence, of the English *condottiere* Giovanni Acuto - Sir John Hawkwood - the victorious commander of the battle of Cascina. But it was in the Renaissance that the Horses of San Marco were observed in a closer and more penetrating way as living creatures, just as the human figure already was. The two celebrated monuments to the *condottieri* of the Most Serene Republic, namely that of Gattamelata in the Piazza del Santo in Padua, executed by Donatello between 1447 and 1453 (fig. 96), and that of Bartolomeo Colleoni in the Campo SS. Giovanni e Paolo by Verrocchio of 1487-88 (fig. 97), are extremely fine Tuscan contributions to the Renaissance in the Veneto and are essentially different from the Horses of San Marco.

The characters of these two warriors are expressed in a profound and indissoluble relationship with their horses. It is above all an agreement between man and nature achieved through a powerful and earthly realism as distinct from the idealised classical forms of the Venetian Horses. The noble pace of the latter takes one's mind back to the proud gait of the quadriga harnessed to the carriage which, placed high in the Constantinople hippodrome, must have recalled the flight of the chariot of Phaeton, the child of the Sun. Their vitality transcends the physical presence of men to enter the world of ideas alone.

Observed at close range the horses of Donatello and Verrocchio reveal many points of contact with the Horses of San Marco (and we must also remember, above all, the influence of Marcus

Aurelius's equestrian statue in Rome (fig. 49), which for centuries was the most revered of all monuments commemorating warriors). Both Donatello and Verrocchio must have minutely scrutinised the Horses of San Marco as it was the normal practice at that time for one great master to assess, as an equal, the masterpieces of another major artist from antiquity. Besides, therefore, marvelling at the perfect chisel work shown in the detailing, the artist's eye took in the monumental forms of the Horses of San Marco. He studied the vibrations of each individual part of the body with the keenest sensitivity both in the harmonious synthesis of complex volumes and through analysis, to catch the quiver of life in the muscles and veining.

Horse and rider form a single statement which gives the *condottiere* a heroic expression once reserved only for emperors. Donatello's figure is more severe and composed, filled with confidence in his own strength and nobility, while Verrocchio departs from the classical model both in his expression of barely-contained violence, and his attitude which goes from majestic poise to open defiance towards the presumed adversary.

The German Renaissance shows the influence of the Horses of San Marco in one of its first and most significant work - the engraving *Death, the Devil and the Soldier* (1513) by Albrecht Dürer (fig. 94), based on one of the Venetian Horses. Only the penetrating observation of a genius such as Albrecht Dürer could have covered the infinite links between the ancient and modern world during his stay in Venice.

For the first time between the Gothic and Renaissance eras in Venice, a free-standing sculpture of a horse appeared on the tomb of Paolo Savelli who died in 1405 (fig. 95). This work in the Chiesa dei Frari is attributed to Jacopo della Quercia as well as to Dalle Masegne. Later in the early sixteenth century other equestrian monuments to *condottieri*, connected in some respects with the "rediscovery" of the Horses of San Marco, feature in SS. Giovanni e Paolo (figs. 98-99). It is worth mentioning those by Leonardo da Prato, Nicola Orsini and the ones from the beginning of the seventeenth century by Pompeo Giustiniani and Orazio Baglioni (fig. 100).

The superb casting carried out for Verrocchio by Alessandro Leopardi in 1496 awakened a new interest in bronze sculpture. At the beginning of the sixteenth century the celebrated spear-throwing standard-bearers by Leopardi were put into position in front of the Basilica, initiating a whole series of bronzes probably carried out in the large workshops of the Arsenal. Still rightly admired are, for example, the well parapets in the courtyard of the Ducal Palace made by Alfonso Alberghetti and Nicolò dei Conti, the altar of the Zen Chapel and Sansovino's door in the Basilica of San Marco, not forgetting the enormous output of bronze weapons, the pride of the master founders of the Arsenal. Artists and artisans in bronze work must have examined the Horses of San Marco with keen interest as the casting technique used for them was so exceptional.

Forum maius D. Marci aliter prospectum cum eiusdem Basilica in extrema parte, nec non cum ædibus D. Marci Procuratorum ad dexteram, uulgo nouis, et alteris, uulgo ueteribus ad lævam.

88. Marieschi, *Piazza San Marco*, etching.

89. 13th-century relief depicting fishing on the central arch of San Marco.

90. The Sainte Chapelle, Paris, erected in 1245 by Saint Louis (Louis IX) to house the relics brought back from Constantinople.

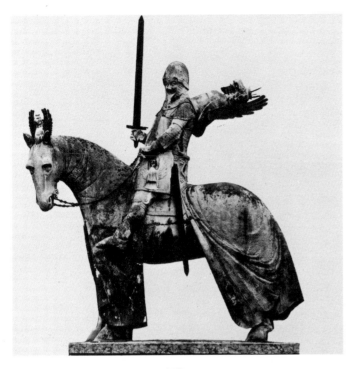

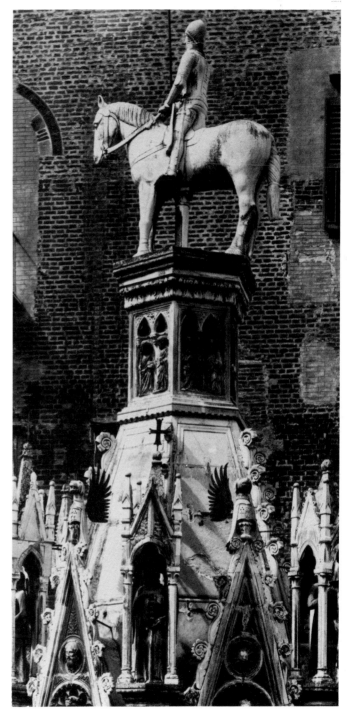

91. Statue of Can Grande della Scala, Verona.

93. The Scaliger tombs, Verona, with that of Can Signorio.

92. Medal by Pisanello depicting a mounted.

The Horses of San Marco after the Renaissance

The creative inspiration of the Horses of San Marco was to be grafted onto the Tuscan school of sculptors' humanistic and rational study of classical works, particularly in their way of perfecting volumes and forms. The most notable revival of interest in the Venetian Horses after that of Donatello and Verrocchio is again by a Tuscan, Francesco Mochi (1580-1654), with his equestrian monuments to Ranuccio Farnese and Alessandro Farnese at Piacenza (fig. 101), and to Carlo Barberini in Rome. While Mochi's equestrian monuments were indeed inspired by more distinguished models, they did however reject the perfect balance of the earlier monuments based on humanist ideals in favour of an imaginative power of invention which was typically baroque. Both horse and rider are given their own distinctive individuality, each independent from the other within that great spatial freedom which attracted Bernini so much later on. This freer interpretation was to lead to the most celebrated equestrian monuments of the eighteenth and nineteenth centuries which decorate our squares, especially those celebrating heroes and episodes in the Italian Risorgimento. The city of Turin, which occupies such an important rôle in the history of the unification of Italy, also possesses the most beautiful equestrian statues commemorating this national epic, such as the "romantic" interpretation of the monument to Emanuele Filiberto.

But perhaps the most attractive feature of the Horses of San Marco is the fact that they are free from the mastery and imposition of the human figure. The horse is therefore able to live its own life and is a felicitous expression of a particular mythical idea at the basis of those "historical roots of fairy stories", to adopt Vladimir Propp's idea; namely that myth favoured by the ancient Greeks and Romans as, indeed, by all peoples who lived with horses, sharing the day's labours with them, together with the ideal aims of great enterprises. The Greeks, in fact believed that horses were a gift from their god Poseidon.

Certain villas in the Veneto have examples of this free interpretation of the Horses of San Marco. In these instances the sculpture often loses the heroic and grandiose stature of the urban monument in favour of a less conventional and fanciful character with something of theatrical flavour, set against the scenery of trees and the perspective effects of the parkland surrounding the villa. An example is provided by the four horses carved in soft stone by Francesco Bonazza, formerly in the park of Villa Gradenigo, on the road between Venice and Treviso, and then placed in the grounds of Villa Sartorio Montebello in Trieste. Other examples in soft stone from the Marinali workshop can be seen in the extremely beautiful park of the Villa Revedin Bolasco, near Castelfranco, which is known as "The Paradise" (fig. 102). The horses of the Villa Sartorio Montebello, which are arranged in a line like those of San Marco, spring upwards as if to take flight and are supported in a strangely baroque manner on the shoulders of young Moors. Conceived in terms of the light and air of a park setting, they convey a sense of happiness and forceful energy recalling the idea of Ariosto's winged horse.

Francesco Bonazza's horses were produced around 1740 during the period when Anton Maria Zanetti revived the study of the Horses of San Marco in the august rooms of the Marcian Library with his fine book *On the ancient Greek and Roman statues found in the Ante-room of the Library of San Marco and in other places in Venice.* Zanetti's writings and engravings reflect the interest in scholarship and the historical study of documents characteristic of the emerging movement of Neo-classicism in Europe.

Napoleon Bonaparte, striving to rival the glory of the Roman emperors, wanted the Horses of San Marco for Paris as trophies to immortalise the glory of his Italian campaigns. The conception of the Venetian Horses had a profound influence on French culture in the second half of the eighteenth century through the studies of the Encyclopaedists and the research into ancient art which increasingly became the focus for heated debates.

When Napoleon, therefore, through his military exploits succeeded in seizing Venice's most precious trophy and setting it up in the French capital, Paris was given a halo of glory which made it equal to the most illustrious capitals in the ancient world (fig. 103).

During the eighteen years the Horses were absent from Venice, from 13th December 1797 to 13th December 1815, they were the focus of an international study involving a more profondly critical approach to the history of sculpture and of Greek and Roman art, often inspired by discussions over the origins of the celebrated quadriga.

The sculptor Canova competed on equal terms with the theme of horses in antiquity, both in his drawings and in creating the famous equestrian statue in Naples (figs. 142-144), which was first intended to celebrate Napoleon but later designated by Ferdinand of Bourbon to portray King Charles III of Spain (fig. 141). Canova shares with the Emperor Francis I of Austria the honour of restoring the Horses to Venice along with the Lion of San Marco from the Piazzetta, also removed to Paris as a trophy of victory. "Venice has more than one reason to remember Antonio Canova as the praiseworthy defender of our artistic patrimony", writes Bruno Molajoli, "in particular for those native Venetian qualities which this supreme artist showed while negotiating with a host of powerful rulers in August 1815 when sent, like a lamb among wolves, by Pope Pius VII to recover the works of art appropriated by Napoleon"[9]. According to Pietro Giordani[10], Prince Metternich asked the President of the Accademia di Belle Arti in Venice for a painting to be made recording the solemn ceremony to welcome the Horses of San Marco back to Venice. Documents show that this commission was given to the perspective painter Vincenzo Chilone, a pupil of Canaletto, who left the famous picture in the palace of Baron Treves de Bonfili at S. Moisè where it still remains.

Nineteenth-century literature on the Horses of San Marco took the form of a great international debate immediately after their return to Venice. It served a useful purpose in making the interest in classical archaeology more vital and effective, besides encouraging European museums to collect fresh examples of

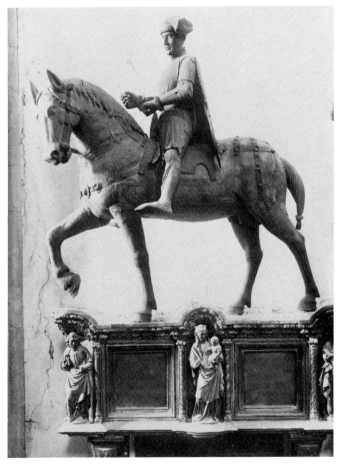

94. Fresco showing the Triumph of a Hero, attributed to Francesco Morone (end of 15th century). Chiesa dei Frari, Venice.

95. Funerary monument commemorating Paolo Savelli, attributed to Jacopo della Quercia (c. 1408). Chiesa dei Frari, Venice.

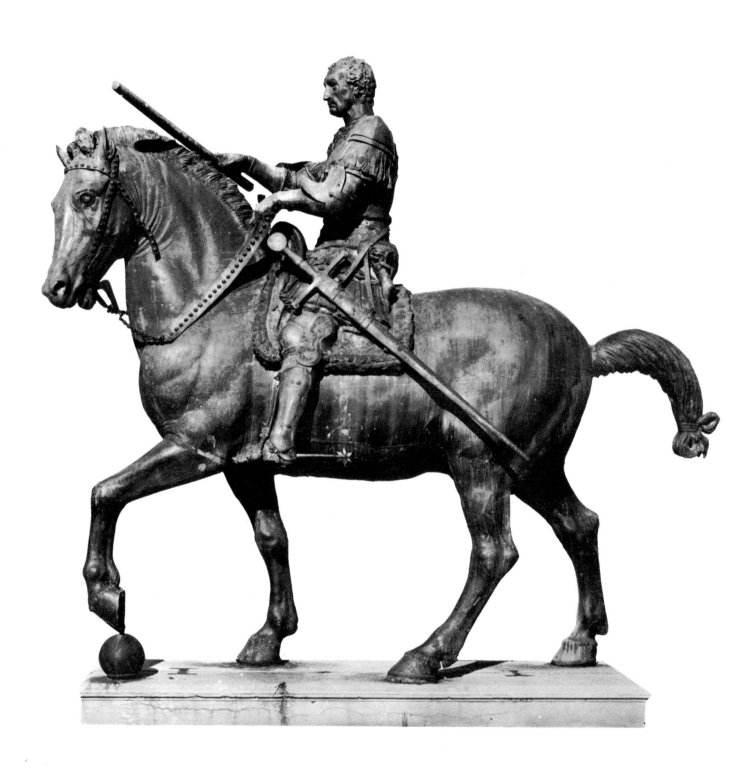

96. Donatello, Equestrian monument to Gattamelata (1447-1453), Piazza del Santo, Padua.

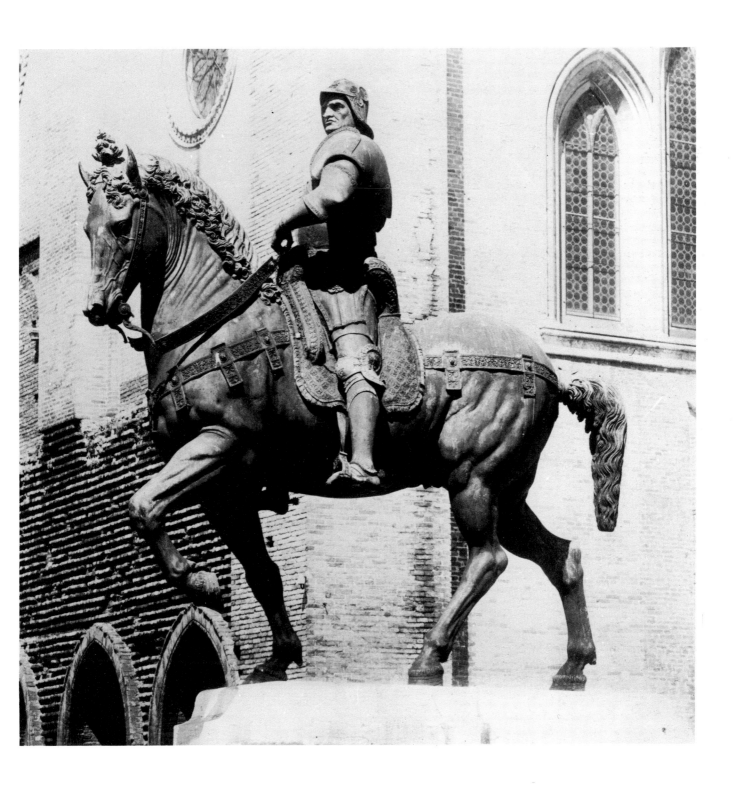

97. A. Verrocchio, *Equestrian monument to Bartolomeo Colleoni* (1487-1496). Campo dei SS. Giovanni e Paolo, Venice.

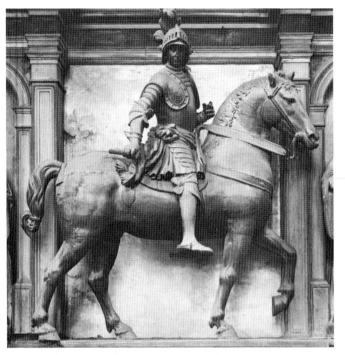

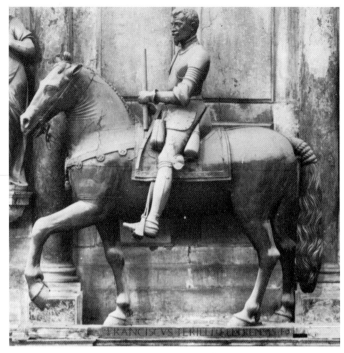

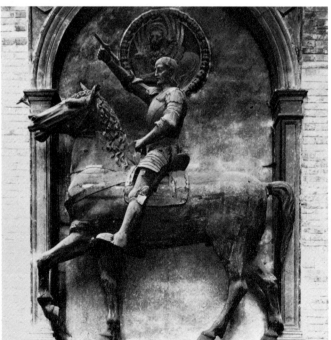

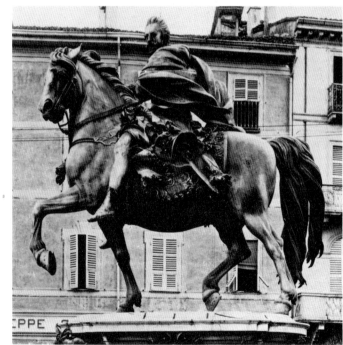

98. Funerary monument to Nicola Orsini, Count of Pitigliano (first half of 16th century). SS. Giovanni e Paolo, Venice.

99. Funerary monument to Leonardo da Prato (first half of 16th century). SS. Giovanni e Paolo, Venice.

100. Funerary monument to Pompeo Giustiniani (first half of 17th century). SS. Giovanni e Paolo, Venice.

101. F. Mochi, *Equestrian monument to Alessandro Farnese*. Piacenza.

102. Horses on the gate piers to Villa Bolasco, Castelfranco Veneto.

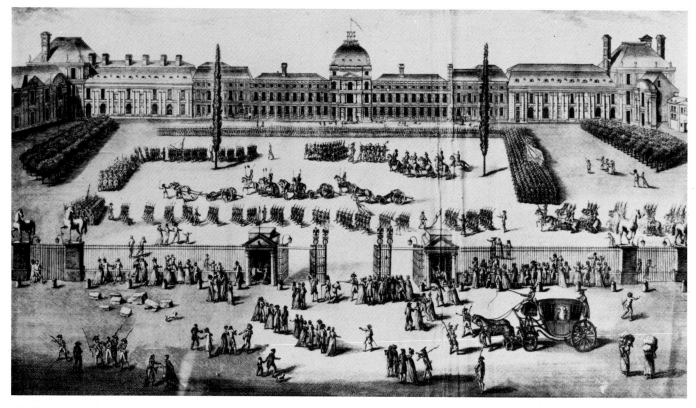

103. The Horses of San Marco placed on the gate piers to the Tuileries, Paris (1802-1807).

ancient works as well as to create new collections. This literature oscillated between a romantic-classical view of the ancient world, which spread everywhere in the wake of neo-classicism, and the desire for new scientific research requiring a more precise analysis and greater understanding of the actual material - in some ways it is even mysterious - used to make this outstanding military trophy.

The wars of the present century in 1915-1918 and 1940-1945 caused the Horses to be removed twice again from the façade of San Marco. In the first war they were stored securely in Rome and in the second one, both in the Benedictine Abbey at Praglia on the Euganean Hills and in the Ducal Palace. Today, although we are gaining further knowledge through new methods of studying them, the fascination aroused by this unique masterpiece is in no way diminished. The Venetian Horses have been observed in greater detail than ever before under the microscope and using other scientific methods. The most exacting physical analysis has been undertaken for perhaps the first time on a material infused with life, as splendid as an antique Attic vase, where the appeal derives not only from the modelling but also from the very striations found on the parts of the gilded surface which vibrate in the sun. We are encouraged in these studies by a fresh and broadly-based archaeological interest, and also, it must be admitted, by a sense of guilt felt by all when faced with the destructive effects of our own civilization threatening so many works of art.

(1) S. RUNCIMAN, Storia delle crociate, Turin 1966.
(2) R. GALLO, Il tesoro di S. Marco e la sua storia, Venice-Rome 1967.
(3) The sculptor Francesco Messina adapted the ideal concept of the equestrian statue in an extremely fine work situated in the centre of Pavia.
(4) M. PERRY, The Pride of Venice, in "Aquileia nostra", XLV-XLVI (194-75).
(5) F. FORLATI, La basilica di S. Marco attraverso i suoi restauri, Trieste 1975, p. 105-110.
(6) Martin Da Canal, edited and translated by Alberto Limentani, p. 21, Florence 1972.
(7) Ibid. p. 129.
(8) OTTO DEMUS, Oriente ed Occidente nell'arte del Duecento, in La civiltà veneziana del secolo di Marco Polo, Venice 1955.
(9) B. MOLAJOLI, Le benemerenze di Antonio Canova nella Salvaguardia del patrimonio artistico, in Quaderni di S. Giorgio, Venice, Fondazione G. Cini, n. 35.
(10) From the writings of Pietro Giordani, Vol. III, 1841, p. 67.

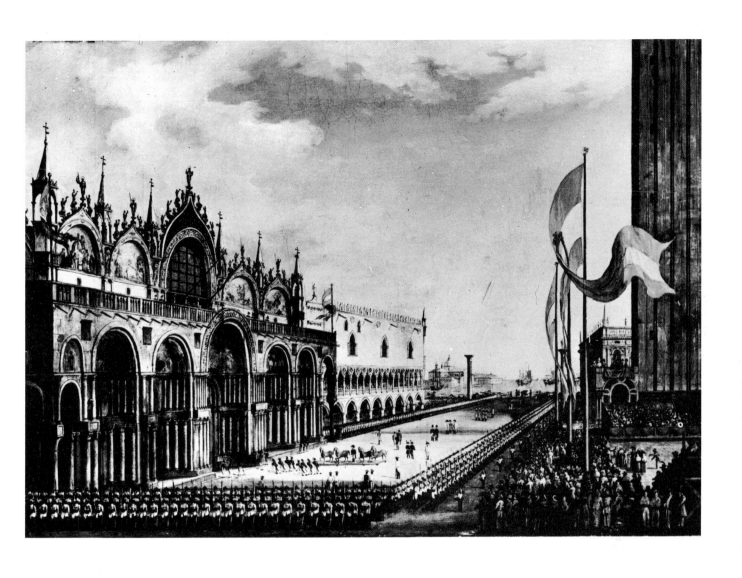

104. V. Chilone, *The return of the Horses of San Marco in 1815*, oil painting on canvas in the Collection of Baronessa Elsa Treves de Bonfili, Venice.

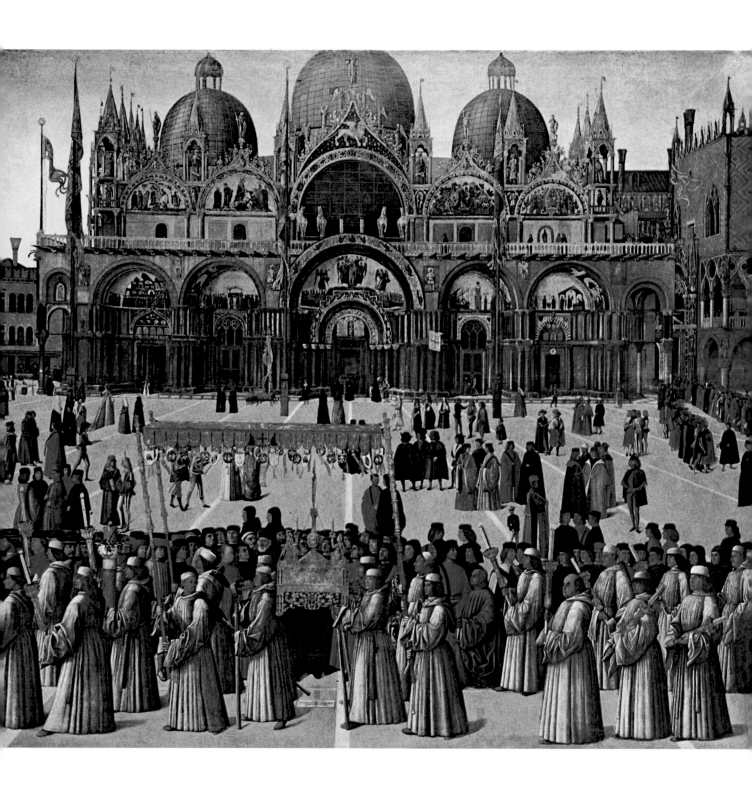

105. Gentile Bellini, *Procession in Piazza San Marco*, (detail). Gallerie dell'Accademia, Venice.

The Horses of San Marco in Venetian painting

Francesco Valcanover

In his introductory essay to the catalogue of the exhibition *Venice and Byzantium* in 1974, Sergio Bettini comments on the vital role played by the use of debris in the growth of medieval Venice. "Here one was obliged to make the best possible use of anything that could be picked up and carried away later from the islands with the earliest settlements in the lagoon then, as the ships went further across the seas, from the coasts of the Levant, and finally from Constantinople. To begin with the Venetians were probably not unduly fussy about what they salvaged. Later on they were able to select and by applying artistic as well as functional criteria, the situation was no longer purely a practical matter but also an aesthetic one with two particular consequences. It encouraged the Venetian sailors and merchants to collect and bring back to their native city whatever they had managed to obtain during their voyages, provided it satisfied their taste for colour But once these spoils had reached Venice, it was the same artistic sense of colour which determined the placing of the materials uniquely to show off their chromatic properties"

The Basilica of San Marco represents by far the most significant and symbolic demonstration of this "infallible colour sense", especially on the exterior of the building. The four gilded bronze horses brought to Venice from Constantinople in 1204 stand out in the midst of that highly refined and learned assemblage of innumerable objects surviving from different epochs, places and styles. By about 1250 when they had been placed at the centre of the sumptuous chapel of the Doge, they immediately became the most inspiring feature of its ornamental façade. Proof of this is provided by the anonymous mosaic artist who portrayed the early San Marco in the apse of the porch of S. Alipio. This image clearly shows the four gilded steeds within the arcaded windows which were later replaced by the large glazed lunette (fig. 106). This plainly represents the horses in a different position from that recorded in 1496 by Gentile Bellini in his *Procession in Piazza San Marco* (fig. 105) which agrees with their present setting. However, this dissimilarity should not be interpreted as a later modification of the sculptures' position which, among other things, would have involved the interchanging of the individual horses' heads. Rather the licence enjoyed by the mosaic artist is no less poetic than that shown by the unknown miniaturist of *The Book of Marco Polo* in the Bodleian Library, Oxford (fig. 107).

Here the scene follows a description provided by a tourist friend at the beginning of the 15th century which, in fact, is largely imaginary except for three identifiable monuments: the two columns of St. Theodore and the Lion of St. Mark and, in particular, the four gilded Horses emerging from the shade of the window arcade though placed differently from their actual position.

There was no lack of interest in the Horses of San Marco by fourteenth-century Venetian artists. Possibly the sculptor of St. Theodore (fig. 108), one of the two stone reliefs by different early fourteenth-century artists flanking the marble icon on the wall behind the baptistery of San Marco, was inspired by them. However, this particular artist converted their stylised "naturalism" into restrained sculptural energy influenced by Romanesque art. An emotional reaction of quite another kind was shown by Paolo Veneziano, the major Venetian artist of the fourteenth century, through his admiration of these masterpieces which had arrived in the lagoon from the Far East. Indeed, Roberto Longhi, with his customary perception, recognised this when he referred in the *Viatico* of 1946 to *St. George* (fig. 109) in the polyptych painted by Paolo Veneziano in the church of St. James in Bologna noting "it is not by mere chance that a Venetian achieved this sublime example of Hellenistic art in the first half of the fourteenth century, where one can find the elusive grace of an Attic vase set against a gold background or of a drawing by Raphael. Here too is an artist who had looked unwittingly at the Horses of San Marco". Paolo Veneziano had indeed studied them, as St. Martin's charger in the same polyptych shows (fig. 110), copying one of the Basilica's Horses in almost exactly the same pose. Even though these two panels are imbued with the courtly expression of fourteenth-century gothic, perhaps nowhere else in Venetian painting is the secret of the four animals so fully grasped - a unique aristocratic breed of horse created by the imagination of the great anonymous artist of antiquity.

It was in the fifteenth century when Venetian painting showed itself most responsive to the remarkable masterpieces on the façade of San Marco coming from a remote era. In the first half of the century this occurred through the new interest in naturalism, but later in the century through the involvement of Humanism - characteristic of the late fifteenth-century - in ancient monuments and through a concern with aspects of the city, then attaining its true artistic vocation with its inborn sense of colour. Paolo

106. Detail of mosaic depicting the removal of the body of St. Mark in the Porch of S. Alipio, San Marco, Venice.

107. *View of Venice* c. 1400 (detail) from a manuscript in the Bodleian Library, Oxford (Ms. Bodley 264).

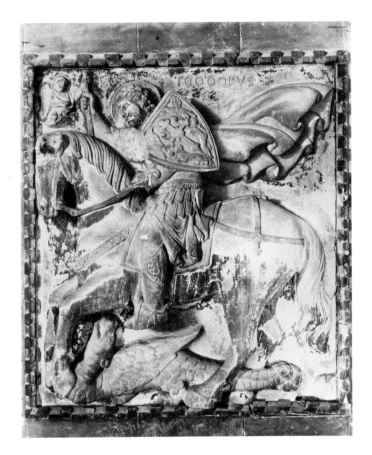

108. *St. Theodore*, c. 1330. Baptistry of San Marco, Venice.

109. Paolo Veneziano, *Polyptych* (detail showing St. George). San Giacomo, Bologna.

Savelli's wooden mount (formerly gilded) in the church of the Frari dating from the fourteenth century possesses much of the compact unity of form and idealised proportions derived from the restrained elegance of the Horses of San Marco. It would certainly be interesting to know whether Pisanello in the lost frescoes of the Sala del Maggior Consiglio in the Ducal Palace had found in the triumphant horses the simplified monumental expression reflected in his surviving frescoes, drawings and medals (fig. 111). There is only a faint echo of this monumentality in Giambono's delicate portrayal of S. Grisogono's horse (fig. 112) in the Venetian church of S. Trovaso, but it appears with a very different stylistic expression in the drawings of Jacopo Bellini. In at least two of the parchment leaves from the Louvre sketchbook, the elder Bellini hints at one of the four horses - the far right-hand one in fact. *The Flagellation* (fig. 113) contains only part of it, ridden by a Turk; in the second drawing (fig. 116) it recurs mounted by a *condottiere* on a very high pedestal with a Latin inscription, formerly in the church of Migliandino S. Fidenzio near Montagnana. It is interesting to note that in this particular composition there appears to be a fusion of two different works from antiquity. Jacopo Bellini seems to have been aware of Donatello's Gattamelata (fig. 114), erected in 1453 on the raised square before the Basilica del Santo in Padua, and at the same time anticipates the horseman's gesture in the equestrian statue of Colleoni (fig. 115), Verrocchio's last masterpiece, cast and gilded by Alessandro Leopardi and erected in the Campo di SS. Giovanni e Paolo in Venice in 1486, eight years after the death of the great Tuscan master. The comparison between Jacopo Bellini's sketch and the Paduan equestrian bronze by Donatello clearly reveals the diverse attitudes of the two artists towards the antique. The Venetian artist endeavours to recreate the sculptural balance contained in the flowing planes with regular figurative rhythms decreasing into indefinable space, derived from an acute sensitivity to Renaissance forms. The Tuscan, on the other hand, although still influenced by classical art, resolutely transforms the thematic concept into a naturalistic image set within a contained space by means of its human scale. In this respect Donatello was more sympathetic to the Roman equestrian statue of Marcus Aurelius than to the Venetian Horses.

Unlike his father Jacopo, Gentile Bellini was not inspired by the Horses as models inherited from a legendary antiquity appealing to his sense of spiritual values. They provided instead an essential focal point in Gentile's extraordinary vision of Piazza San Marco completed in 1496 as one of the large canvases recording the miracles of the Holy Cross for the Scuola di S. Giovanni Evangelista now in the Accademia Gallery. In *The Procession in Piazza San Marco* (fig. 118), the ceremonial heart of Venice, now so changed, has been preserved forever by Gentile Bellini with the care of an imaginative cartographer, quite unlike the naive fantasy of the illuminator of the Chantilly manuscript *Description de la Seigneurie de Venise* (fig. 117). Bellini has caught the chromatic qualities introduced to the square at the end of the fifteenth century, through a series of creative architectural modifications belonging to a scheme that never wavered in its aim. At the edge of the rose-coloured brick paving between the buildings of the Procuratoria and the Ospizi Orseolo rises the façade of San Marco with its rhythmic and chromatic effects, amplified by the ever-changing passage of light. It provides a kaleidoscopic spectacle outside the limits of time and space with its superimposed screens of marble columns, its gilded statues, the patterns of coloured marble, the dazzling mosaic surfaces and, finally, with the Horses themselves (fig. 119), recorded in every detail, their gold picked out against the cavernous gloom of the large window behind (fig. 118). Only this painting by Gentile Bellini can demonstrate how perfect was the early thirteenth century's choice of site for the Horses as a centre-piece for the ornamental scheme not only of the façade but for the entire Piazza. This painting was also to provide an emblematic warning to those who threatened the independence of Venice. The inscription running round the mosaic above the doorway of S. Alipio might also have a bearing on this: "COLLOCAT HUNC DIGNIS PLEBS LAUDIBUS ET COLIT HYMNIS UT VENETOS SEMPER SERVET AB HOSTE SUOS".

The four Horses could hardly be absent from the remarkable map of Venice by Jacopo de' Barbari published in 1500, where they are clearly but concisely indicated. Nor was Vittore Carpaccio indifferent to their presence and powerful influence. In the drawing attributed to him in a private Swiss collection which shows a procession in Piazza San Marco (fig. 121), they appear among the most distinct and individually treated elements in the façade decoration of the Basilica. Moreover, a miniature copy of one of the Horses can be distinguished among the objects on the shelf in that unforgettable interior of a late fifteenth-century humanist's study, depicted by Carpaccio with his characteristic pictorial and spatial clarity in the *St. Augustine* of the Scuola di S. Giorgio degli Schiavoni in Venice. The mount near the architectural background of Francesco Maria della Rovere's presumed portrait in the Thyssen Collection shows that Carpaccio was inspired at least once by the Horses of San Marco to adopt the idealised formal restraint of the late fifteenth century. This version even in its modified pose shares a poetic harmony with the precise formal composure, both pensive and aloof, of the antique prototypes, as in fact do many of those horses shown moving through the highly atmospheric backgrounds of the Venetian landscapes by Giovanni Bellini, Giambattista Cima and Bartolomeo Montagna. The Horses of San Marco were to lose much of their inspirational power during the fundamental regeneration of taste which occurred at the beginning of the sixteenth century when they were replaced by other models. Certainly Leonardo during his brief stay in Venice at the end of 1501 and the beginning of 1502 was fascinated by the vigorous dynamic movement of Verrocchio's charger in the Campo di SS. Giovanni e Paolo, which emphasises every muscle with realistic intensity. Traces of this careful study can be seen in Leonardo's preparatory drawings for the projected monument to Marshal Trivulzio made between 1506 and 1507. Even more evident was Dürer's admiration of the Colleoni Monument as revealed in the engravings, *The Small Horse* of 1505 and *Death, the Devil and the Horseman* (fig. 124) of

110. Paolo Veneziano, *Polyptych* (detail showing St. Martin). San Giacomo, Bologna.

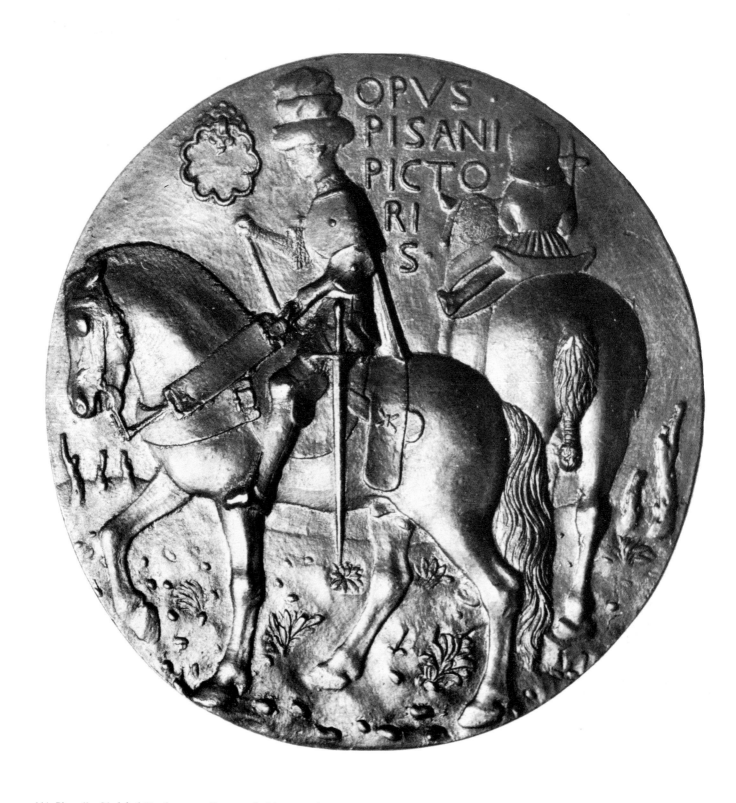

111. Pisanello, *Medal of Gianfrancesco Gonzaga, 1st Marquess of Mantua* (verso).

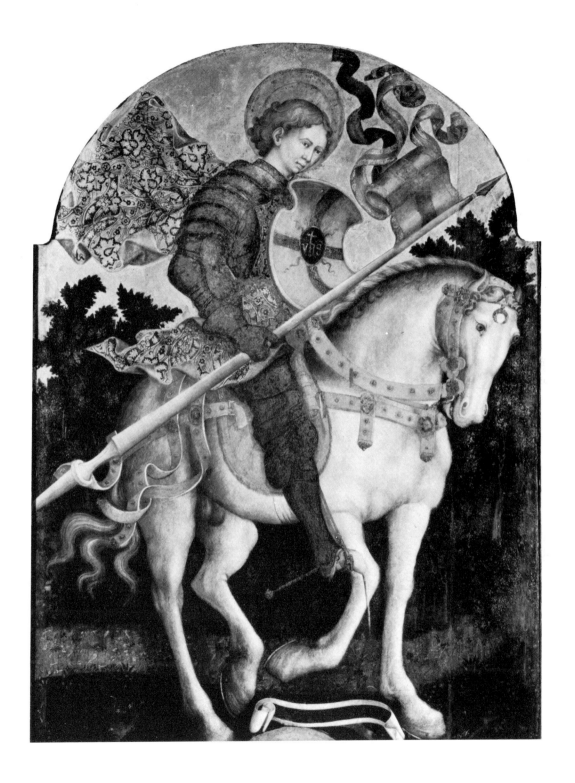

112. Michele Giambono, *San Grisogono on horseback*. San Trovaso, Venice.

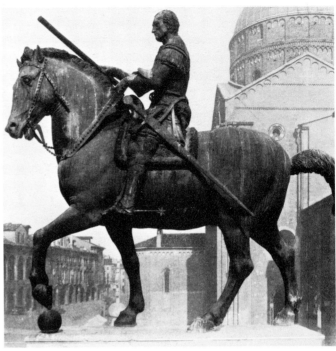

113. Jacopo Bellini, *Flagellation* (detail). Cabinet des Estampes, Louvre, Paris.

114. Donatello, *Monument to Gattamelata*. Piazza del Santo, Padua.

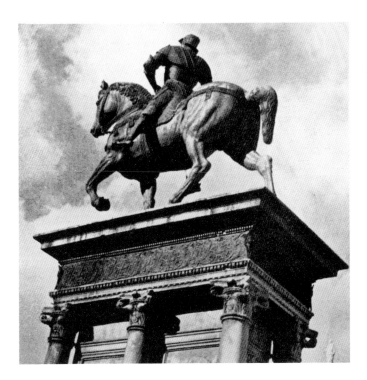

115. Andrea del Verrocchio, *Monument to Bartolomeo Colleoni*. Campo dei SS. Giovanni e Paolo, Venice.

116. Jacopo Bellini, *Studies of ancient monuments* (detail). Cabinet des Estampes, Louvre, Paris.

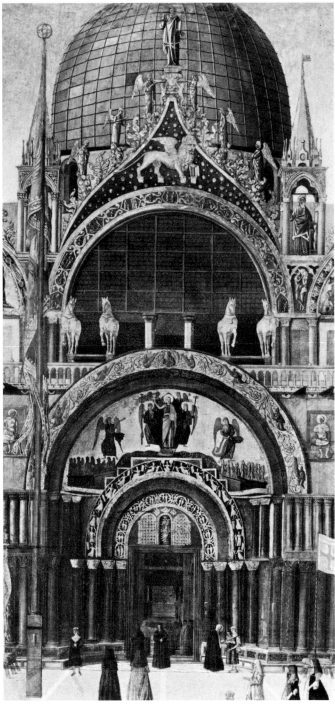

117. *View of Venice* (detail) from 15th century manuscript *Description de la Seigneurie de Venise*. Musée Condé, Chantilly.

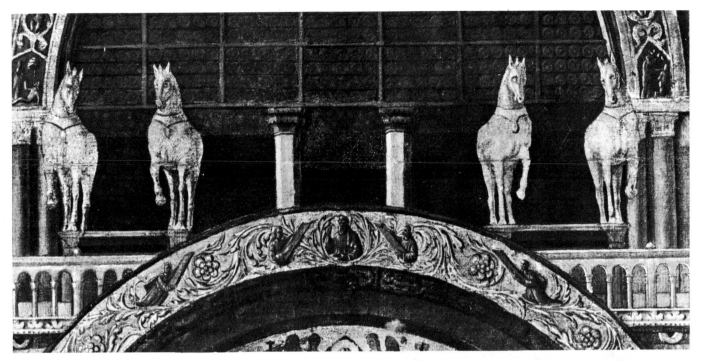

118 - 119. Gentile Bellini, *Procession in Piazza San Marco* (detail). Gallerie dell'Accademia, Venice.

120. Jacopo de' Barbari, *Map of Venice*, 1500 (detail).

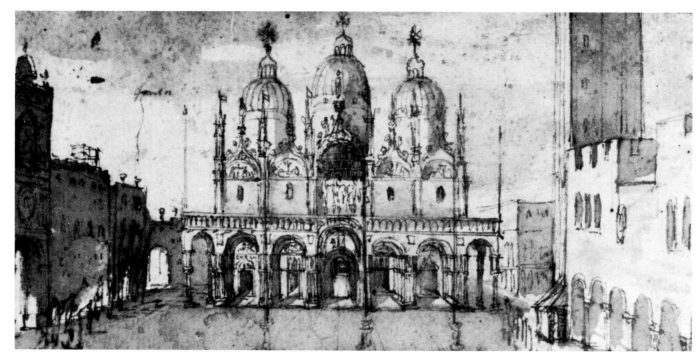

121. Vittore Carpaccio (attributed), *Procession in Piazza San Marco*. Private Collection, Zurich.

122. Vittore Carpaccio, *St. Augustine in his study* (detail). Scuola dei Santi Giorgio e Trifone, Venice.

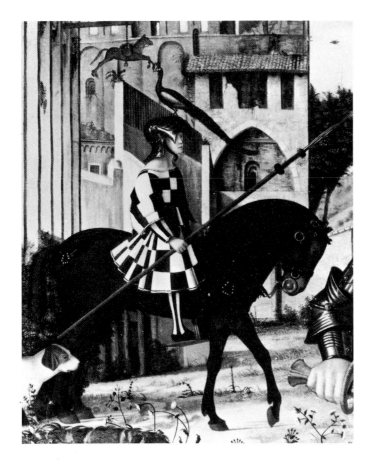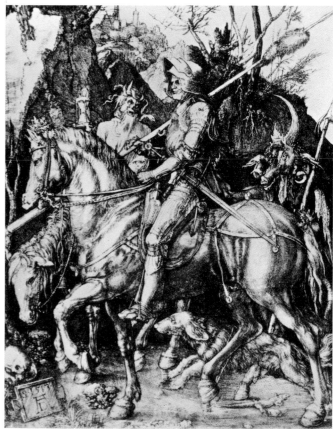

123. Vittore Carpaccio, *Francesco Maria della Rovere* (detail). Thyssen Collection, Lugano.

124. Albrecht Dürer, *The Knight, Death and the Devil*, 1513.

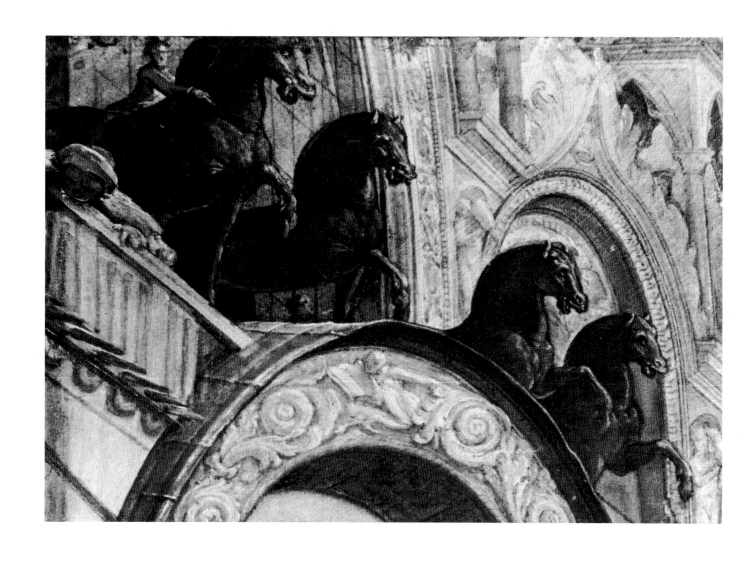

125. Federico Zuccari, *Barbarossa kisses the feet of Alexander III* (detail). Sala del Maggior Consiglio, Palazzo Ducale, Venice.

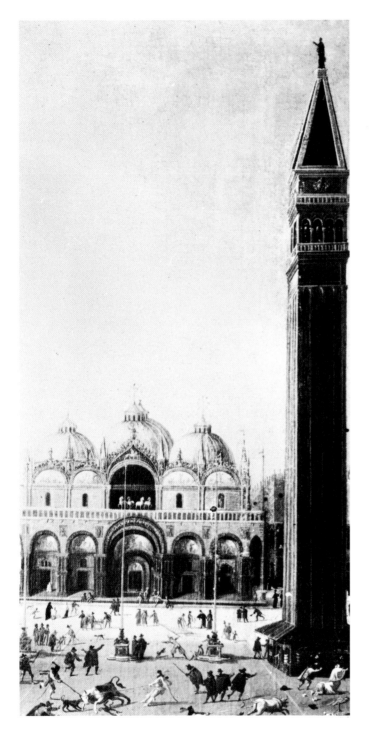

126. Joseph Heintz the Younger, *Piazza San Marco* (detail). Galleria Doria Pamphili, Rome.

127. Sebastiano Ricci, *Studies of horses*. Gallerie dell'Accademia, Venice.

128. Marco Ricci, *Courtyard of a palace*. Royal Collection, Windsor Castle.

95

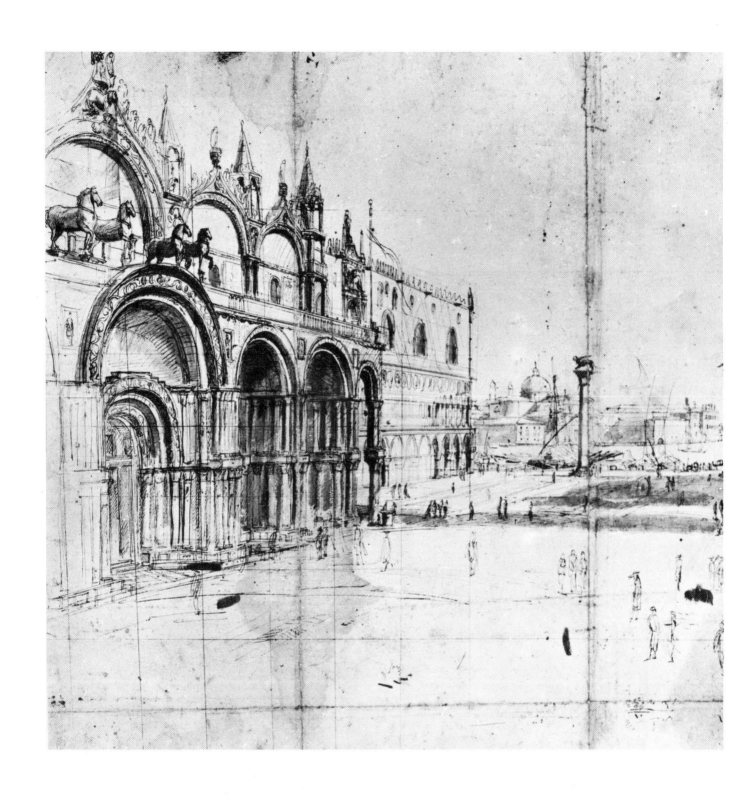

129. Gaspare van Wittel, *Basilica of San Marco and the Piazzetta* (detail). Biblioteca Nazionale, Rome.

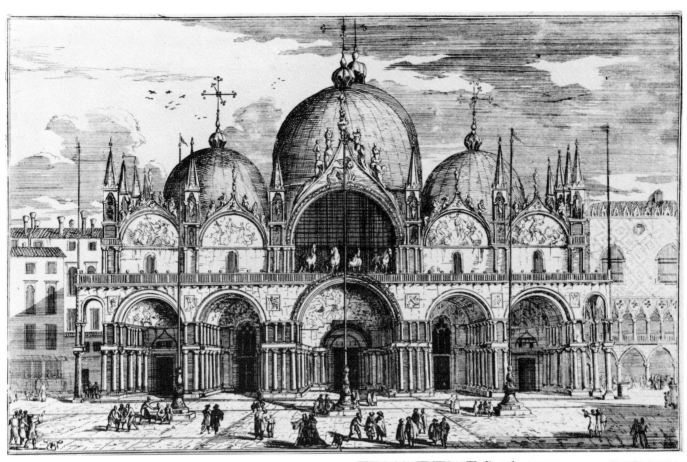

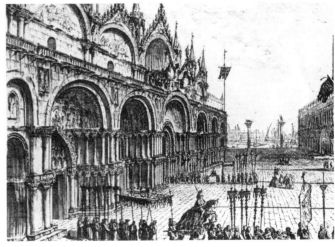

130. Luca Carlevarijs, *San Marco* from *Le Fabbriche e Vedute*.

131. Michele Marieschi, *Piazza San Marco* (detail).

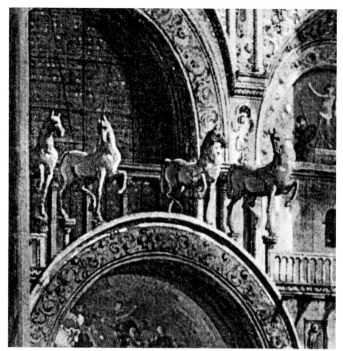

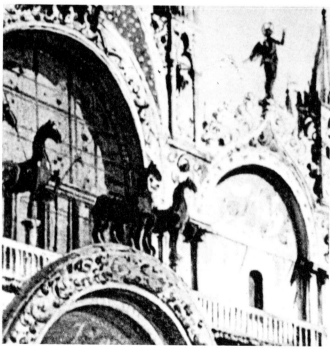

132. Canaletto, *San Marco and the Palazzo Ducale* (detail). National Gallery of Art, Washington.

133. Canaletto, *Piazza San Marco* (detail). Wadsworth Atheneum, Hartford, Connecticut.

1513. The spirit of this "parade expressionism" (cf Russoli, *Scultura Italiana,* III, Milan, 1967), so alien to the Horses of San Marco but which is found in Verrocchio's masterpiece, pervades the monuments of the *condottieri* Leandro da Prato and Niccolo Orsini (cf. illustrations in Prof. Perocco's contribution, figs. 98 and 99), erected during the 1520's in the Basilica of SS. Giovanni e Paolo, as well as in the steeds painted by Titian, Tintoretto and Paolo Veronese. Still within this interpretative tradition, however, the Horses of San Marco are recorded in the sixteenth-century views of San Marco; for instance, in the votive painting with Doge Pietro Loredan produced by Tintoretto's studio for the Senate Chamber or in Federico Zuccari's canvas showing Barbarossa kissing the feet of Alessandro III, which features in the Sala del Maggior Consiglio in the Ducal Palace (fig. 125).

Venice was slow to follow the new interest in topographical art which became so popular during the seventeenth century in the Netherlands, Rome and Naples. In the view of Piazza San Marco (fig. 126) in the Doria Pamphili Gallery, Rome, painted in 1648 by Joseph Heinz the Younger, the four Horses, indicated by a few rapid brush strokes, contribute to the richly picturesque scenes of festivals and Venetian customs typical of this northern artist which were to be revived in the eighteenth century by Gabriele Bella. The Horses assume quite another character in the "secundum veritatem" sketch by Gaspare van Wittel (fig. 129), made while studying in Venice between 1694 and 1695. In this one can even pick out the lost medals which formerly embellished the collars of the four Horses.

Gaspare van Wittel just precedes the prosperous age of the eighteenth-century Venetian *veduta* when each artist contributed his own interpretation of the sculptural treasure crowning the central arch of the Basilica. Luca Carlevarijs uses the Horses as the focal point in his panoramic conception of the façade of San Marco, being anxious to record every detail in its true dimensions on the etched plate (fig. 130) for the series *Le Fabriche e vedute di Venezia....*, published in 1703, as well as in his preparatory drawing in the British Museum, London. In marked contrast, Michele Marieschi's *Piazza San Marco* - one of the twenty-one etched views of Venice issued in 1741 - aims at scenographic effects by means of a strong and vibrant *chiaroscuro* where the horses are intentionally amplified beyond their actual scale (fig. 131).

The decorative vitality in Marieschi's interpretation of the Horses of San Marco was to have an indirect influence on Sebastiano Ricci's two drawings from an album belonging to the Accademia Gallery (fig. 127) and on one by his nephew Marco at Windsor (fig. 128), while the paintings of Canaletto were moving towards a poetic adherence to truth. In Canaletto's remarkable stylised recreations of reality the four gilded Horses are not overlooked, even if sometimes, as in the picture in the National Gallery, Washington (fig. 132), he changes their actual pairing, as indeed the mosaic artist of the door of St. Alipio had done centuries before. On another occasion, when particular lighting effects were required, he was to transform them almost into winged griffons in his wide-angled vista of Piazza San Marco at the

134. Ippolito Caffi, *Piazza San Marco*. Gallery of Modern Art, Venice.

Wadsworth Atheneum of Hertford, U.S.A. (fig. 133). However, one of Canaletto's *capricci* in the Royal Collection at Windsor Castle (fig. 135) celebrates the Horses as some of the most outstanding works of art in Venice, recording them in every detail in their real-life situation as well as in the relationship to their architectural setting on the façade of the Basilica, after having removed them from it and raised them on lofty pedestals in the Piazzetta. This observance of the exact character of spatial rhythms and colour relationships which determine the solution within the bounds of such an architectural fantasy are conspicuously lacking in Zanetti's contemporary images published in 1740 (fig. 181), but engraved with a lifelessness that detracts from the true formal values of the four sculptural monuments.

These key ornaments on the façade of San Marco are depicted even more realistically than by Canaletto in one of the extremely rare *vedute* of the Piazza by Bernardo Bellotto, from the Cleveland Museum of Art (figs. 136-7). Most critics have attributed this work to Canaletto, but it is, in fact, an early work by his nephew Bernardo, as revealed by the sure command of colour infused with a cold luminescence and by the simple naturalness of his direct observation which is always faithful to the truth, such as in his extraordinary rendering of the Horses of San Marco.

These are portrayed in a very different manner by Francesco Guardi. They always feature in his *vedute* of the Basilica (fig. 139) even when they are only glimpsed as in *The Parade of the Allegorical Floats in Piazza San Marco* from the Cini Collection in Venice. But they are blended swiftly and economically by means of a rapid short-hand into the concise expression used by Francesco Guardi to emphasise the over-riding aims in his magical illusion, not allowing even the most transient touch of colour, the slightest reflection or the subtlest shadow to escape him. The four Horses of the Basilica of San Marco are given new life in the image Francesco Guardi evokes through his powerful theatrical expression of every place and monument in Venice with unequalled intensity. Even in *The Feast of the Sensa* in the Gulbenkian Foundation (fig. 138) the artist's intention is to place them in direct relation to the temporary porticoes rather than to raise them to the level of their normal background.

During the nineteenth century the Horses were still treated as the focal point of the Basilica's decorative scheme, although by now they appear frozen in airless space as in Caffi's *View of Piazza San Marco* of 1858 in the Gallerie d'Arte Moderna at Ca' Pesaro (fig. 140).

Throughout its very long history Venetian painting in innumerable images and highly varied interpretations has always understood how shrewd the designers of the façade decoration of San Marco were in setting the four gilded Horses, which arrived from Constantinople in 1204, at the centre above the principal entrance. Their vital importance to the embellishment of the entire Piazza as organic features in the rich and highly chromatic decoration can be understood from engravings and photographs (fig. 104) testifying to those sad periods when San Marco was stripped of its triumphant Horses, witnesses of centuries of Venetian history.

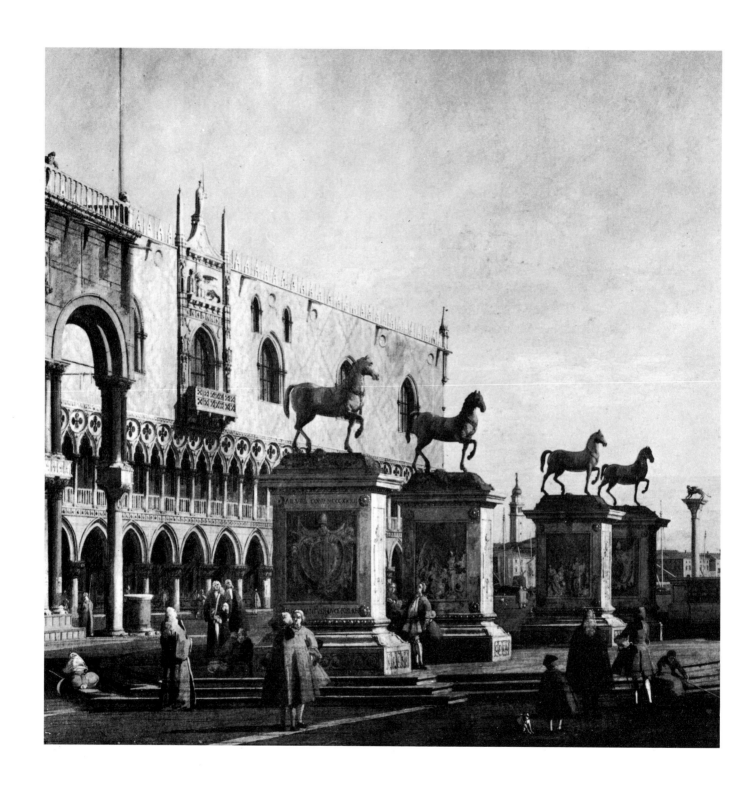

135. Canaletto, *Capriccio with the Horses of the Basilica of San Marco* (detail). Royal Collection, Windsor Castle.

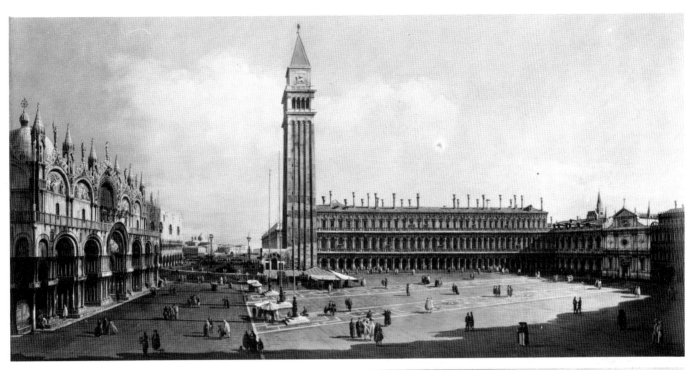

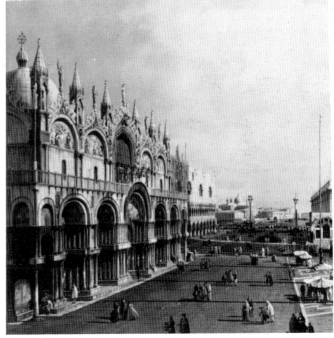

136 - 137. Bernardo Bellotto, *Piazza San Marco* (detail). Cleveland Museum of Art.

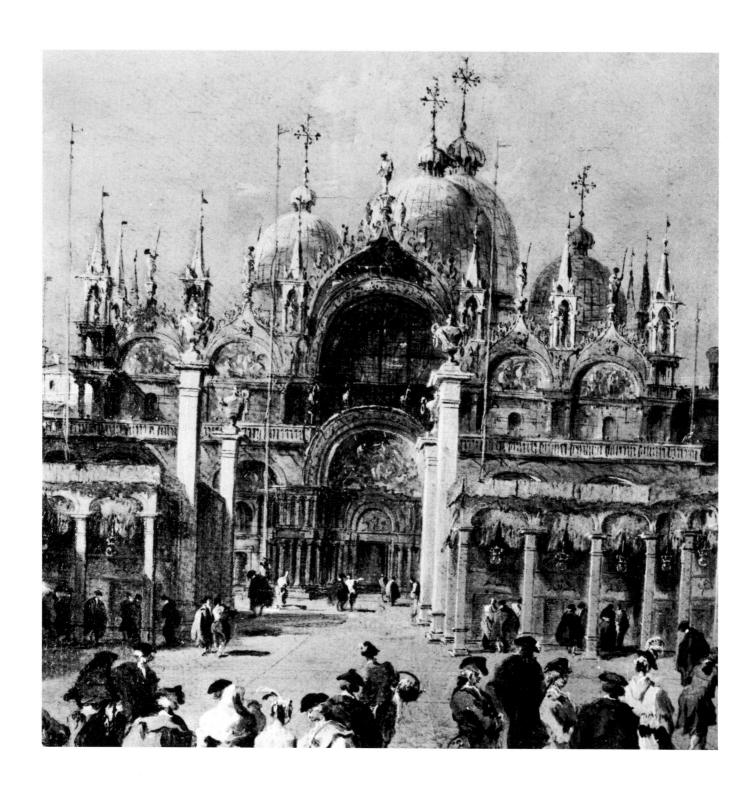

138. Francesco Guardi, *The Festa della Sensa* (detail). Gulbenkian Foundation, Oliras, Lisbon.

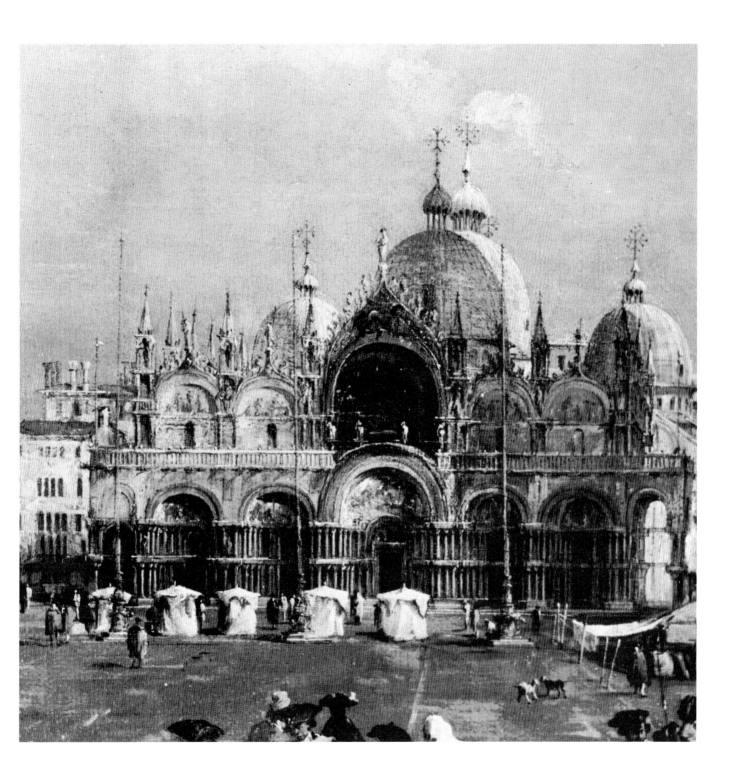

139. Francesco Guardi, *Piazza San Marco*. National Gallery, London.

The trophies of San Marco: Legend, Superstition, and Archaeology in Renaissance Venice*

Marilyn Perry

In Italian cities of Roman origin, and in the Greek East, monumental statues to pagan gods and heroes often outlived antiquity as objects of fear and folklore in a superstitious Christian age.[1] Even in Venice, where the few classical sculptures were actively imported, conscientious legends were invented to "explain" the most conspicuous Constantinopolitan war trophies on the Basilica of San Marco—the life-sized bronze quadriga and the twin pairs of porphyry swordsmen. With notable tenacity, these popular medieval tales survived late into the Renaissance to challenge and sometimes defeat the nascent skills of the first archaeologists.

A Stable for Bronze Horses

Tradition records the names of two Venetians involved with the removal of the four bronze horses to Venice after the Sack of Constantinople in 1204: Marino Zeno, the Podestà who sent them[2], and Domenico Morosini, the naval commander who transported at least one of them[3]. They were among the first cargoes of post-Crusade spoils, and it seems the Venetians were initially uncertain of their use; deposited at the Arsenal, the quadriga, for a time, risked the foundry furnace[4]. By mid-century, however, it was decided to raise the *cavalli* onto the façade of the newly re-decorated Ducal Chapel[5] where, poised as if on parade, presiding over the Piazza di San Marco as formerly over the Hippodrome[6], they are still to be seen today[7].

The opinions of Renaissance writers notwithstanding[8], the decision to locate the quadriga on the Church of San Marco was fundamentally political, based less on the elegance of the sculptures than on their unique suitability as war trophies symbolizing the recently conquered wealth of the eastern Mediterranean. While the horses were certainly admirable, in medieval eyes, for their lifelike quality, far greater value lay in their provenance, monumentality and rarity as gilded bronze, and care was taken to achieve an appropriate impression of dominance in their display. Set on small columns at the front of the balcony on either side of the great central arch, they form two matched pairs where each horse lifts his outer forefoot and slightly inclines his head towards the other; although sporting harnesses from which small bearded heads or masks originally depended (fig. 165)[9], they are bridleless and proudly free[10]. It may have been intended that the statues would be dramatized by the dark central window and framed by its intercolumniation (fig. 107)[11], but any such artistic motives were secondary to the demands of triumphal state spectacle. Here, between the elevated golden horses, the Doge of Venice in solemn splendour confirmed his claim of *Dominator quartae et dimidiae partis totius Romaniae*[12].

A letter by Petrarch describing the lavish victory tournaments of August 1364 furnishes first-hand testimony to the link between the quadriga and medieval Venetian pageantry:

> Now the Doge himself with a vast crowd of noblemen had taken his place at the very front of the temple above its entrance—the place where those four bronze and gilt horses, the work of some ancient and famous artist unknown to us, stand as if alive, seeming to neigh from on high and to paw with their feet. Where he stood on this marble platform it had been arranged that all should be under his feet, and multi-coloured awnings were hung everywhere as protection against the heat and glare of the setting summer sun[13].

As part of the privileged ducal company, the poet had studied the sculptures from close at hand; his admiration is remarkable as much for its emphasis on their antiquity as for its appreciation of their beauty. Although isolated by more than half a century from other antiquarian accounts, it implies that, at least during his residence[14], the classical origin of the *cavalli* was a point of discussion in learned Venetian circles.

A second specific reference to the quadriga survives from the Trecento, and although semi-legendary in nature it, too, clearly reflects the degree to which the bronze horses were then identified with the Republic. In 1379 the Genoese, allied to Padua, were seriously threatening the Venetians in their home

*This essay is extracted from *Saint Mark's Trophies: Legend, Superstition, and Archaeology in Renaissance Venice,* ''Journal of the Warburg and Courtauld Institutes'', XL (1977), by kind permission of the author and editors.

territories. The Senate sent ambassadors to treat for a peace which would save the city, but they were rebuked by Pietro Doria's disdain:

> By faith! You will never have peace from the lord of Padua nor from Genoa until we first put bridles on those unreined horses of yours which stand on the royal house of your Evangelist Saint Mark [15].

Doria's threat complements Petrarch's praise in illustrating the medieval association of the bronzes with the political independence and power of the Serenissima [16]. In this same guise the *cavalli* entered the popular imagination, though not, as might have been expected, with regard to the conquest of Constantinople [17]. Rather, they were attached to an earlier event, more flattering to the city's pride: the *Pactum Venetum* which had brought Pope Alexander III and the Holy Roman Emperor Frederick Barbarossa to Venice to treat for peace in 1177 [18].

There is no telling when the legend first appeared. In a simplified form it may have been a fairly common oral tradition locally from the late Middle Ages; the fact that it was not reported by any Venetian writer suggests that it was very much a popular story, discounted by those more knowledgeable about the quadriga's antiquity and provenance. The tale survives because it was told to travellers, who recorded it to explain a notable oddity.

By far the most elaborate version is that of a young German knight from Cologne, Arnold von Harff, in Venice prior to a pilgrimage to the Holy Land in 1497:

> Item in front of the church of St. Mark westwards is a very fine square. On this square over the church doors stand four gilded metal horses. I asked one of the gentlemen (who are the nobles of Venice) why the horses were put up here. He informed me that the lords of Venice had caused the horses to be set up there as an everlasting memorial.

Von Harff's informant expanded:

> In the year as one counts from the birth of Christ 1153 there was a Roman emperor born in Swabia called Emperor Frederick Barbarossa, red-beard, who was intent on finding a way to conquer the Holy Land...

To determine the best means of conquest, Frederick planned to journey disguised as a messenger. Before setting out, however, he travelled to Rome to make confession and seek counsel from the Pope, who reacted with fear and suspicion:

> The Pope thought in his mind: if the Emperor should conquer the Holy Land, the people would cease to seek licence to go there. They would look more to the Patriarch of Constantinople than to the Pope, he being nearer to Jerusalem. Moreover the Emperor would be master of the seas, so that the Pope would cease to receive tribute from the merchants or from Lombard bankers...

To avert these consequences, the Pope "caused a picture to be made of the Emperor Frederick with his red beard", which was sent to the Sultan with an appropriate warning. Thus when Frederick arrived he was captured and informed of his betrayal. The Sultan held him prisoner for a year and a day and then returned half of the ransom of 200,000 ducats to his captive "so that with it he might punish his Christian brother who had betrayed him". Accordingly, the Emperor marched on Rome and took it; the Pope "fled secretly by night in a monk's habit to a monastery in Venice, where he became the cook-brother". More than a year passed before a pilgrim from Rome recognized the Pope-cook and alerted the Venetians, who "prepared a great procession and fetched the Pope out of the monastery with great reverence".

The Emperor, hearing of these events, wrote to the Venetians demanding that they deliver over the Pope. The Venetians refused. "Thereupon the Emperor was wroth and became their enemy, and swore by his red beard that he would destroy Venice, and turn San Marco into a stable for horses." Accompanied by his son Otto, Frederick gathered a great army and besieged Venice. However, when the Emperor subsequently withdrew north to recruit more men, the Venetians, seizing their advantage, stealthily conquered his army and captured Otto.

> Item when the Emperor heard this he was full of mistrust. But he was forced to make terms with them and to give them what they demanded. The terms were that the Emperor should come to Venice and kneel down in the church of San Marco before the Pope, and suffer the Pope to put his foot on his neck. They would then deliver his son to him again. Item this happened. The Pope put his foot on the Emperor's shoulder, the Emperor saying *non tibi sed Petro*, not to your honour, but St. Peter's. So the pact was carried out but on account of the great oath which the Emperor had sworn by his red beard, which could never be undone, that he would make the church of San Marco into a stable for horses, therefore the Venetians, out of respect for him and by reason of his oath, caused to be set up four gilded metal horses in front of the church of San Marco as an eternal witness of these things, a picture whereof, painted with great art, hangs in the Palace in the Council chamber[19].

So Germanic is the bias of von Harff's tale that one might imagine it his invention, did it not appear elsewhere. However, a decade previously the friar Felix Fabri from Ulm had also noted:

> Above the door of the church of San Marco towards the west one sees four great Horses fused in bronze and gilded, works placed there as a result of the siege of Venice undertaken by Frederick I. Since he had sworn not to lift the siege until he had set his horses on the church of San Marco, and ploughed up the Piazza, so, in consequence, we will say, it was done. The horses were fused of bronze, and the whole length of the piazza was paved in various marbles, to record the threatened furrows [20].

Later visitors to the city heard other variants, with Frederick

replaced by "ung empereur non crestien" or by the Sultan himself. In 1518, it was reported by a pilgrim from Douai that:

> On the portal of San Marco in the place of the piazza there are many beautiful, very rich columns. And on the said portal, four horses of copper gilded with fine gold. These are as tall as a horse of fifteen palms. They are set there in memory of a non-Christian emperor who came before Venice and boasted that he would stable his horses on the church of San Marco; but on the contrary his son was taken by the Venetians who conquered all and thus the said horses were made in memory [21].

Perhaps the Emperor's nationality was changed to allow for the Constantinopolitan provenance of the quadriga, as in the account by Denis Possot, a pilgrim of 1532:

> (The church of) San Marco is the richest and most beautiful that I have ever seen, as regards ornaments, paving, painted vaults and images... Above the entrance, there are four horses of bronze greatly elevated, very beautiful, as a symbol of the victory won formerly against the Sultan who had sworn, if he gained the victory, to make the church of San Marco the stable for his horses; but he failed, because his son was taken by the Venetians and he himself fled confused; in memory of which, these three bronze horses imported from Constantinople were set above the portal of the said church [22].

It will be noted that the antiquity of the sculptures does not figure in the legendary tradition, although it was naturally a point of the greatest interest for more learned inquirers. When Ciriaco d'Ancona visited Venice in 1436, he enthusiastically attributed the *cavalli* to Phidias:

> Then after we had looked at all the major sites of the city for three days we finally made our way to the holy and highly decorated temple of San Marco, where first we were allowed to inspect—not once, but as long as we liked—those four bronze chariot horses which are so splendid a work of art and most elegant design, the noble work indeed of Phidias, and once the glory of the temple of warlike Janus in Rome [23].

A more extended antiquarian description, echoing Petrarch's canons of praise, appears in Bernardo Giustinian's posthumous *De origine urbis venetiarum* (1492):

> Moreover, above the entrance to the temple there is a wide terrace in the open, in the middle of which can be seen from below four bronze and gilded horses set on little columns making a great show of themselves with such a motion and stride that all of them seem to be wanting to jump down into the square together. A rare and exceedingly ancient work— they were all made for the chariot of the sun—the skill of their construction is amazing. They are all similar to each other, so that you can find nothing in any one unlike the others, yet such is their stance with neck and feet that

although they strain forward in step together, their stride and movement are wholly dissimilar. I once saw the same engraved on a gem, and also sculpted on the triumphal arch of Constantine in Rome, where Apollo sitting in his four horse chariot is carved in marble. It is said that they were brought from Constantinople, as were almost all the precious marbles on the temple [24].

Apparent in these Quattrocento speculations is an incipient curiosity about the quadriga's antique origins and purpose which intensified in succeeding generations. The ingenious result was a complete, if remarkably romantic, pedigree for the bronze horses, with a lineage of illustrious connections and an odyssey over the classical world. In effect, the humanists of Venice contrived an archaeological legend of their own.

An early and ill-defined version was recorded by Marin Sanudo in his life of Arrigo (Enrico) Dandolo. The *cavalli* are mentioned as part of the Crusaders' spoils from Constantinople:

> These were made in Persia, and when the Romans took Persia they removed the four horses and had them transported to the harbour. They had the four horses put on the reverse of their coins and medals, and then carried to Rome. *Demum* the Roman Emperor Constantine, when he went to live at Constantinople, that is to build that city, removed the four horses from Rome and took them with him. They are an excellent work, well cast and polished [25].

Like Bernardo Giustinian, Sanudo sought to clarify the mystery of the quadriga by reference to apparently similar antique representations, adapting a well-established technique for comparative identifications of imperial Roman portraits [26]. Later writers, more ambitious still, settled upon the reverse of a Neronian sestertius (fig. 140) as the key. The coin was illustrated by Sebastiano Erizzo in his *Discorso sopra le medaglie antiche* (1559) with the commentary:

> The large medal of Nero, of an exceptionally fine metal, with letters which say NERO. CLAVD. CAESAR. AVG. GER. P.M. TR. P. IMP. P.P. On the reverse it has a very beautiful triumphal arch with four horses on top of it, with some figures on either side of the horses, with S.C. I believe that this was the triumphal arch erected by Nero for the victory over the Parthians, as described by Tacitus and other historians. And this medal was stamped to honour Nero at that time. It is believed that those horses which one sees upon the Church of San Marco in Venice, a rare work of excellent artifice, may be the same as those on Nero's arch in the medal. These were imported to Venice from the East, perhaps first transported to those regions from Rome, after the decline of the Roman Empire [27].

Once this identification was proposed, a "history" of the quadriga could be culled from literary sources. Erizzo, reading Tacitus, connected the arch on the coin with Nero's victory over the Parthians (an interpretation still followed today) [28], while

maintaining a cautious reserve in regard to the Venetian horses. Others were less circumspect, and an elaborate hypothesis was repeated with regularity—if never with absolute conviction—by local authors. Pietro Giustinian's *Rerum venetarum ab urbe condita historia* of 1560 provides a typical summation:

> In a high place on the arch directly over the entrance stand four unbridled horses, glistening with gold; in a remarkable and lively posture they move together stride for stride in such a way that they seem to be springing down into the open space of the enormous square below. They say they are the work of Lysippus, and come from a long past age; they also say that they were a gift to Nero from Tiridates King of Armenia, and later taken by Emperor Constantine from Rome to Byzantium. Then Ziani brought them to Venice and set them in a permanent place on the firm upper part of that most famous temple. Paolo Rammusio, the son of Giambattista, a young man of exquisite intelligence and a great lover of antiquity, showed to me horses of a very similar form to these incised on the reverse side of a medal of Emperor Nero [29].

Although never argued at length, the probable genesis of these proposals can be plausibly reconstructed. According to Pliny, Lysippus "fecit et quadrigas multorum generum" [30]. The Greek sculptor never worked in Rome, but since the quadriga on the favoured Arch of Nero was erected, by Tacitus's account [31], in honour of victories over the Parthians, the *cavalli* might well have come from Parthia—either as war spoils [32], or as a gift from Tiridates, the King of the defeated Parthians who according to Suetonius was lavishly entertained by Nero in Rome [33].

The latter interpretation was half-heartedly repeated by Francesco Sansovino in his *Venetia città nobilissima et singolare* of 1581. Among the notable events of the reign of Doge Pietro Ziani was the arrival of the bronze horses from Constantinople:

> ...sculptured indeed by Lysippus, donated to the Romans by Tiridates, King of Armenia, and subsequently transported by Constantine to Byzantium, as some have written. But what the truth may be is uncertain to everyone [34].

Another, longer passage presents his own more reasoned view:

> ...the four ancient horses of bronze... were ordered to be made by the Roman people, at the time when the Emperor Nero was victorious over the Parthians; they were dedicated to him and set on the arch consecrated to his name. They drew the four-horse chariot of Apollo, as one sees even now on the reverse of some of Nero's medals, on which are depicted the said horses with those same movements and attitudes of heads and legs, and harnesses around their necks, as have these. But when Constantine moved from Rome to re-establish the imperial seat in the East, he took them with him to Byzantium where, displayed on the Hippodrome, as the Greek Nicetas Choniates writes, they

140. Arch of Nero on the reverse of a Neronian sestertius.

107

stayed until that time when the Venetian Republic conquered Constantinople.

Convinced by the visual evidence, Sansovino drew his archaeological conclusions accordingly, avoiding extraneous theories. This reserve did not, however, extend to his judgment of the quality of the works—"four antique horses of such rarity that even to this day they have no equal in any part of the world"[35]-an elaboration of his more modest opinion, twenty years previously, that they were among the most beautiful sights of Italy [36].While such boastful pride was a constant Venetian theme, Sansovino seems to have been the first to propose specific "proofs", comparing the *cavalli* with the bronze equestrian monuments to *Marcus Aurelius* on the Capitol in Rome and Verrocchio's *Colleoni* at SS. Giovanni e Paolo in Venice.

Delle cose notabili della città di Venezia, the brief guidebook of 1561, is structured as a dialogue between a Venetian and a visitor to the city, a classicizing format which allowed a greater freedom for opinion than the straightforward, factual organization of the more exhaustive *Venetia città nobilissima*. In the passage in question we find the visitor and his guide in the Piazza, gazing up at the quadriga. The Venetian explains how the horses, originally on the Arch of Vespasian in Rome[37], were taken by Constantine to Constantinople. Following the Sack they arrived in Venice, where, after some delay, they were eventually placed on the church.

> *Veneziano* ...It is true that they are difficult to appreciate at that height, but up there they do not obstruct the piazza and are out of the way of the people.
> *Forestiero* I confess to you that truly the *Cavallo* of the Campidoglio in Rome is of less beauty than these, though it is larger, and that of SS. Giovanni e Paolo is not to be compared with them[38].

Here, in a few lines, is a distinctly Renaissance approach, at variance with the medieval, the legendary and even the antiquarian view. The political symbolism of the quadriga's display is of no special interest to Sansovino, who admits the disadvantage of the location for the lover of art (while nonetheless allowing its security value). He is concerned, in passing, with the provenance of the statues, but it is their beauty—demonstrably superior to famed antique and modern works—which commands his highest praise.

In defending the position of the bronzes, Sansovino responded to a recently published proposal by Enea Vico regarding the display of:

> ...the noble Quadriga of four extremely beautiful and undamaged horses, set over the main entrance of the Temple of San Marco in Venice, a very rare work which both in art and all else is a stupendous thing, and marvellous, and perhaps the most beautiful in all Europe. Being against some large windows of dark glass, they are so greatly deprived of their viewpoint that they are not given that

consideration which such great art and such creations of beauty should merit. From which it seems to me that their dignity requires a very prominent, high base of beautiful marble, to be set between the flag-poles in the great piazza, or at the other end of the piazza opposite to the Church; this might be so majestic and confining that it would be hard to see the feet of the horses, but unimpeded by the height of the pedestal, outlined against the sky, they would appear grander to the sight of onlookers[39].

Counter to both practicability and Venetian tradition, Vico's suggestion was received with sympathy, but no active support (however, see fig. 135). The *cavalli* remained on the Basilica where, by the end of the century, the universal appreciation of their beauty and antiquity[40] effected one curious final transformation in their symbolic associations. No longer, or only very rarely, evocative of the political power of the Serenissima[41], they now, as matchless archaeological pieces, represented Venetian wealth—and a new "legend" was invented accordingly.

Once again, it is in the pages of a travel journal that the story is preserved —this time the *Crudities* of Thomas Coryat, an energetic Englishman who spent six enamoured weeks in Venice in 1608. Impressed by the "remarkable monument, four goodly brasen horses made of Corinthian mettal[42], and fully as great as the life", he recorded, with appropriate qualifications, a version of the familiar antiquarian "history":

> Some say they were cast by Lysippos that singular statuary of Alexander the great above three hundred years before Christ; some say that the Romans made them at what time Hiero King of Syracuse triumphed of the Parthians, and placed them in a certaine arch that they dedicated to him. It is reported that Tyridates King of Armenia bestowed them on the Emperour Nero, when he was entertained by him in Rome with such pompous magnificence, as is mentioned by Tacitus and Suetonius.

Constantine's role in transporting the horses to Constantinople is mentioned, and of course the Venetians' acquisition of them after the Conquest. Concluding more personally, Coryat described the display and value of the sculptures:

> These horses are advanced on certaine curious and beautiful pillars, to the end that they may be the more conspicuous and eminent to be seene of every person. Of their forefeete, there is but one set on a pillar, and that is of porphyrie marble, the other foote he holdeth up very bravely in his pride, which maketh an excellent shew. The two hinder feete are placed upon two pretty pillars of marble, but not porphyrie. Two of these horses are set on one side of that beautiful alabaster border full of imagery and other singular devices, which is advanced over the middle great brasse gate at the coming into the Church, and the other two on the other side. Which yeeldeth a marvailous grace to this frontispice of the Church, and so greatly are esteemed by the Venetians, that although they have beene

offered for them their weight in gold by the King of Spaine, as I have heard reported in Venice, yet they will not sell them [43].

Predictably, even necessarily, the evidence for the changing Venetian view of the bronze quadriga is exclusively literary. Yet a visual echo also survives (in a modern reproduction tucked away in an unlikely corner of Venice) to complement the Renaissance humanists' pride: an allegorical commemoration, *all'antica*, of the importation of the *cavalli* to Venice (fig. 74 in a terracotta version) [44]. On a floating scallop-shell a warrior-Doge in antique costume stands with the Constantinopolitan horses and enacts a sea-borne triumph, complete with accompanying nereids and tritons. A dextrous hovering Victory at once unfurls the banner of Saint Mark on the Ducal standard and crowns its bearer with a classical wreath while he, with dramatic aplomb, presents the quadriga [45] to a figure Venice allegorizing who sits in regal splendour with cornucopia, staff, and languid winged lion on a high pedestal sporting garland, trident and anchor. The event is dignified by an encircling band of trophies and formalized by a coat of arms surmounted by a Ducal *cornu* [46].

Despite the disappearance of the Renaissance original, there can be little doubt of its appil as political propaganda, especially since the image was subsequently adapted for a nineteenth-century print celebrating the Austrian retrieval and restitution of the quadriga and the bronze lion of San Marco from their Napoleonic exile in Paris (P1.3b) [47]. No longer is it a Christian Doge, but the Genius of the House of Habsburg who, trumpeted by an advance Fama, delivers the sculptures to the Piazza di San Marco—trimphantly, as has always befitted the great gilded horses [48].

1. For the Roman world, see J. B. Ross, *A study of Twelfth-Century Interest in the Antiquities of Rome, Medieval and Historiographical Essays in Honor of J. W. Thompson*, Chicago 1938 pp.308 ff. More recent bibliography is in Roberto Weiss, *Lineamenti per una storia degli studi antiquari in Italia dal dodicesimo secolo al sacco di Roma del 1527*, Rinascimento, IX, 1958, pp. 141-201, and *idem, The Renaissance Discovery of Classical Antiquity*, Oxford 1969. Similar traditions in Byzantium are discussed by Cyril Mango, *Antique Statuary and the Byzantine Beholder''*, Dumbarton Oaks Papers, XVII, 1963, pp. 55-75.
2. For example, Francesco Sansovino, *Venetia città nobilissima et singolare*, Venice 1581 (hereafter *Venetia*) p. 31r: "Marino Zeno che vi fu il primo Podestà per la Signoria, li mandò a Venetia insieme con diverse tavole di porfidi, de serpentini, & di ricchi marmi…"
3. Marin Sanudo, *Vite de' Duchi di Venezia*, ed. L. A. Muratori (*Rerum italicarum scriptores*, XXII, Modena), 1733 (hereafter *Vite de' Duchi*), p. 534. Sanudo's narrative is unclear as to whether more than one of the horses was under the care of Domenico Morosini; later writers assign them all to him. See for example Stefano Magno's chronicle of 1555, as cited in *La Ducale Basilica: Documenti per la storia dell'augusta Ducale Basilica di San Marco in Venezia dal nono secolo sino alla fine del decimo ottavo*, ed. Ferdinando Ongaria, Venice 1886 (hereafter *La Ducale Basilica*), p. 11, no. 87.
4. See F. Sansovino, *Venetia*, p. 31r, and the remarks by Sebastiano Erizzo cited in note 8 below.
5. On the extensive embellishment of the Basilica during the 13th century see especially Otto Demus, *The Church of San Marco in Venice: History, Architecture, Sculpture*, Washington, D.C. 1960 (hereafter San Marco), *passim*.

6. See Rudolphe Guilland, *Etudes de topographie de Constantinople byzantine*, I, Berlin-Amsterdam 1969 (hereafter *Études de topographie*), pp. 385-6, who concludes that on the north façade of the Hippodrome "s'élevait une haute tour au sommet de laquelle était érigé sur quatre piliers de porphyre le fameux quadrige de Lysippe".
7. At present, one of the horses has been removed to facilitate the study of conservation techniques. It will also be remembered that the quadriga was forcibly transferred to Paris from 1797-1815, and sent to Rome for safekeeping during the First World War.
8. They maintained that the beauty of the *cavalli* had won them their places on the Basilica: "… ma finalmente conosciuta la loro bellezza: furono collocati per più commodo e sicurezza sopra alla Chiesa …", F. Sansovino, *Venetia* p. 31r. According to Sebastiano Erizzo, *Discorso di M.S.E. sopra le medaglie antiche, con la particolar dichiaratione di molti riversi…*, 4th ed., Venice n.d. (hereafter *Discorso*), p. 98, it was owing to the finer sensibilities of some Florentines that the bronzes were saved from the Arsenal forge in the 13th century: "… e andarono spesso à rischio d'essere disfatti, per fondere artigliàrie, tanto erano poco conosciuti dagli uomini di quei tempi. Ma veduti poi da certi ambasciatori Fiorentini, intendenti della scultura, e grandemente lodati, furono cagione, che si traessero dall'arsenale, e si mettessero sopra la Chiesa, come in luogo sicuro, accioche non fossero guastati".
9. Illustrated by the cousins Anton Maria Zanetti il *vecchio* and il *giovane* in their *Delle antiche statue greche e romane, che nell'Antisala della Libreria di San Marco, e in altri luoghi pubblici di Venezia si trovano*, I, Venice 1740, pl. XLIV. (On which see M. Perry, "The Statuario Pubblico of the Venetian Republic", *Saggi e memorie di storia dell'arte*, VIII, 1972, App. I, pp. 114-16). When the quadriga was returned from Paris in 1815, the pendants were no longer attached. See Filippo Magi, *Ancora sulla data dei cavalli di San Marco*, Rendiconti degli atti della Pontificia Accademia Romana di Archeologia (hereafter *Rendiconti/Archeologia*) XLIV, 1971-72, p. 217.
10. Once, however, the horses wore silver bridles. See Ottavio Vittori and Anna Mestitz, *Artistic Purpose of Some Features of Corrosion on the Golden Horses of Venice*, Burlington Magazine, CXVII, 1975, pp. 132-9.
11. An interpretation by O. Demus, *San Marco*, pp. 113-14, based upon the 13th-century mosaic view of the church on the Porta Sant'Alippio.
12. See *ibid.*, p. 114, for the medieval association of the quadriga with antique triumphal traditions. On the Ducal title, which was retained until 1356, see Roberto Cessi, *Storia della Repubblica di Venezia*, Milan-Messina 1968 (hereafter *Storia*), I, pp. 185-7, 194; and Samuele Romanin, *Storia documentata di Venezia*, Venice 1853-61 (hereafter *Storia documentata*), II, p. 185.
13. *Senili* IV: III.
14. Petrarch was in Venice from September 1362 to the spring of 1368, though not continuously. Several studies focus specifically on his Venetian sojourn; the most recent is Lino Lazzarini, "Francesco Petrarca e il primo umanesimo a Venezia", *Umanesimo europeo, e umanesimo veneziano*, ed. Vittore Branca, Venice 1963, pp. 63-92.
15. See Antonio Dall'Acqua Giusti, *Quattro cavalli sulla facciata della Basilica di S. Marco*, Venice 1894, p.9. For the historical circumstances, S. Romanin, *Storia documentata*, III, pp. 269ff., esp. p. 276.
16. Lord Byron returned to the same association, and the old tale of Pietro Doria, to lament the final downfall of the ancient Venetian Republic in *Childe Harold's Pilgrimage*, Canto IV, XIII:

> Before St. Mark still glow his steeds of brass,
> Their gilded collars glittering in the sun;
> But is not Doria's menace come to pass?
> Are they not *bridled?*—Venice, lost and won,
> Her thirteen hundred years of freedom done,
> Sinks, like a sea-weed, into whence she rose!
> Better be whelm'd beneath the waves, and shun,
> Even in destruction's depth, her foreign foes,
> From whom submission wrings an infamous repose.

17. Not that the provenance of the sculptures was ever forgotten by the learned. As early as 1433 a French traveller to Constantinople, Bertrandon de la Brocquiere, *The Travels of B. de la B., … to Palestine, and his Return from Jerusalem overland to France during the years 1432 and 1433*, trs. Thomas Johnes, Hafod 1807, p. 226, took note of three columns in the city which had formerly supported "three gilt horses, now at Venice".

18. S. Romanin, *Storia documentata*, II, pp. 103-18; R. Cessi, *Storia*, II, pp. 413-22.

19. *The Pilgrimage of Arnold von Harff, Knight from Cologne, through Italy, Syria, Egypt, Arabia, Ethiopia, Nubia, Palestine, Turkey, France and Spain... in the years 1496 to 1499*, trs. and ed. Malcolm Letts, London 1496, pp.

20. *Venezia nel MCDLXXXVIII* descrizione de Felice Fabri da Ulma, Venice 1881, p. 66.

21. *Voyage de Jacques le Saige, de Douai a Rome, Notre-Dame-de-Lorette, Venise, Jérusalem et autres saintes lieux*, ed. H. R. Duthilloeul, Douai 1851, p. 54.

22. *Le voyage de la Terre Sainte composé par Maitre Denis Possot et achevé par Messire Charles Philippe—1532*, ed. Charles Schefer, Geneva 1971 (reprint of ed. Paris 1890), p. 75. Possot certainly saw four horses on the Basilica; his reference to three as from Costantinople may be derived from, another source, as for example Bertrandon de la Brocquiere, cited in note 17 above.

23. Kyriaci Anconitani: *Itinerarium nunc primum ex ms. cod. in lucem eretum ex Bibl. Illus. Clarissimque Baronis Philippi Stosch*, ed. Laurentius Mehus, Florence 1742, p. 33. Why Ciriaco should have associated the bronze horses with the Temple of Jesus in Rome I have not been able to determine.

24. *La Ducale Basilica*, p. 232. Giustinian's work is celebrated as the first serious history of Venice. See Marco Foscarini. *Della letteratura veneziana ed altri scritti intorno ad essa*, Venice 1854, pp. 263-4.

25. M. Sanudo, *Vite de' Duchi*, p. 534.

26. See, for example, the remarks in *Filarete's Treatise on Architecture: Being the Treatise by Antonio Piero Averlino, Known as Filarete*, trs. and ed. John R. Spencer, New Haven and London 1965, p. 316, for mid-15th-century praise of the pleasure, consolation, and historical utility—"to recognize by means of this skill Caesar, Octavian, Vespasian, Tiberius, Hadrian, Trajan, Domitian, Nero, Antoninus Pius, and all the others"—of collecting ancient coins and gems.

27. S. Erizzo, *Discorso*, ed. 1559, pp. 171-2.

28. See Harold Mattingly, *Coins of the Roman Empire in the British Museum*, I, London 1923, pp. CLXXVIII and 234, and Samuel Ball Platner and Thomas Ashby, *A Topographical Dictionary of Ancient Rome*, Oxford and London 1929. p. 41. Erected by Nero on the Capitoline between 58-62, the *Arcus Neronis* was probably destroyed shortly after the Emperor's death, since it is not mentioned by later authors.

29. P. Giustinian, *Rerum venetarum ab urbe condita historia*, Venice 1560, p. 50.

30. Pliny the Elder, *N.H.*, XXXIV, 64.

31. Tacitus. *Ann.*, XIII, 41; XV, 18.

32. Pliny's account of the works of Lysippus, *N.H.* XXXIV, 61-66, would have provided sufficient confirmation of this possibility, plus supplying immediate examples of other works by the sculptor in Rome.

33. Suetonius, *Nero*, XIII; XX.

34. F. Sansovino, *Venetia*, p. 223r.

35. F. Sansovino, *Venetia*, p. 31r.

36. *Idem, Delle cose notabili della città di Venezia*, Venice 1561 (hereafter *Delle cose notabili*), p. 27r.

37. Apparently influenced by the sestertius, Sansovino had converted to the Arch of Nero by 1581, as noted above.

38. F. Sansovino, *Delle cose notabili*, p. 27r. The latter comparison, followed by a brief defence of Verrocchio's *Colleoni*, is a pertinent reminder of the influence of the *cavalli* on Renaissance artists. See, in this context, Francisco da Holanda's *De la pintura antiqua (1548) versión castellana de Manuel Denis (1563)*, Madrid 1921, p. 69, where he stresses the value of studying ancient statues of horses for an understanding of their anatomy: "... come en Venecia en los cuatro hermosos caballos de bronce antiquos..." More recent remarks will be found in John Pope-Hennessy, *Italian Renaissance Sculpture*, London 1971, pp. 52-60.

39. Enea Vico, *Discorsi sopra le medaglie degli antichi divisi in due libri*, Venice 1558 (hereafter *Discorsi*), p. 40. Despite Vico's criticism, the quadriga was not inaccessible to detailed study. Both Ciriaco d'Ancona and Sebastiano Erizzo, for example, recorded indecipherable markings found on the bronzes.

40. The most widely held theory identified the quadriga as from the Neronian Arch, but other opinions appeared occasionally, such as F. Sansovino's reference to the Arch of Vespasian, noted above, or Laurentio Schrader, *Monumentorum Italiae, quae hoc nostro saeculo et à Christianis posita sunt*, Helmstadt 1592,

p. 290v: "... et eo primum ex urbe Roma ex arcu Triumphali Tito Vespasiani allatae."

41. For a Frenchman visiting Venice in 1593, the quadriga evoked the Venetian

Quel temple que celuy ou il est adoré
Et porte de Sainct Marc le nom tant révéré?...
Temple oeuvre merveilleux d'art richesse, . et beauté
Tous autres surpassant qui soient en Chrestienté.
Vous luy voyez monstrer la haute auguste face
A un bout spacieux de la plus belle place
Qu'aye ville du monde, au haut du front portant
Quatre chevaulx de front d'airain qu'on vante tant
Que de Corinthe on dit, enrichis de dorure
D'un or qui du soleil rayonne la brillure:
Chevaulx que croire il faut estre opime butin
De la ville, qui tient nom du grant Constantin:
Et la posez pour marque, et tiltre que Venise
Alliée aux François, cest ville a conquise: ...

(and French) conquest of Constantinople:

Claude-Enoch Virey, *Vers itinéraires allant de Venise à Rome*, 1593, quoted from Beatrix Ravà, *Venise dans la littérature française. Depuis les origines jusqu'à la mort de Henri IV*, Paris 1916, p. 586.

42. Another issue regarding the *cavalli* which much interested the Renaissance humanists was the composition of their bronze, assumed to be the Corinthian type praised by Pliny (*N.H.* XXXIV, 5-7). See, for instance, E. Vico, *Discorsi*, p. 40.

43. T. Coryat, *Coryat's Crudities: Hastily Gobled up in Five Moneths Travells in France, Savoy, Italy, Rhetia... Helvetia... some Parts of High Germany and the Netherlands*, ed. Glasgow 1905, I, pp. 348-9.

44. Relevant information, including discussion of the probable Renaissance original, appears in M. Perry, *The Pride of Venice, Aquileia nostra*, XLV-XLVI, 1974-75, cols. 785-802. To be added to the theories there proposed is Dr. Jennifer Montagu's suggestion that the original might have been of silver.

45. Drawn to my attention by Prof. Andrew Martindale is the fact that the horses are shown with the pendants on their harnesses, a further argument in favour of a Renaissance original, since the pendants disappeared in the early 19th century (see note 9 above).

46. Probably of the Morosini della Tressa. See M. Perry, *loc cit.*

47. The *cavalli* were returned to their places, with elaborate ceremony, on 13 December 1815, as described in Fabio Mutinelli, *Annali delle province venete, 1801-40*, Venice 1843, pp. 212ff. For the Venetian reaction see C. Musatti, *Dei quattro cavalli riposti sul pronao della Basilica di S. Marco, lettera inedita di Giustina Renier Michiel*, Nozze Musatti-Coen, Venice 1893.

The Horses of San Marco in the neo-classical and romantic epochs

Massimiliano Pavan

It was inevitable that the transfer of the Horses of San Marco from Venice to Paris in 1798 and their eventual return to their place above the central arch of the basilica in 1815, should revive discussions about their setting and genesis. The issues in question involved arguments for and against the removal of works of art as well as the matter of replacing the Horses in their previous position; also the more specific question relating to the objective and, therefore, artistic value of the monuments and the perennial debate about their origins.

The significant point about this controversy was the fact that it was revived at a critical moment in European culture when Neo-classicism was maturing, inaugurated in Rome half-way through the eighteenth century by Winckelmann's insistence on Greek supremacy. It also occurred at a time when that period of neo-humanism involved a whole range of inter-related themes common not only to classicism but also to romanticism. The discussion which developed round the Horses of San Marco inevitably reflected on a smaller plane a broad cultural climate of fundamental significance to the history of Europe.

When Winckelmann arrived in Rome he was not only aware of the neo-platonising movement which had emerged from the Cambridge school of philosophy (Shaftesbury), but also possessed a firm opinion, which had matured while he was still at Dresden, that the excellence of classical art was rooted in Greece and had reached its perfection there. He regarded Roman art as mainly repetitive, both in the actual works of art as well as in the rules governing them, and he was able to confirm in Rome itself the effectiveness of those very models and precepts. This explains how Winckelmann could formulate his theory of Greek art as providing a paradigm of taste without ever going to Greece or even to Sicily. The praise of "Greekness" in classical art, implied, for contemporary opinion, a critical position towards the sumptuous kind of expression (and consequently its baroque tendencies) which was encouraged above all by the Papal and French courts, and which was inspired by Imperial Roman art with all its Hellenistically inspired polychromy.

When in 1764 Winckelmann published his *History of Art,* the debate concerning the origins and authorship of the Venetian Horses was still a local issue (Zanetti, 1740, Cornaro, 1749), but the German scholar himself avoided taking part, confining his comments to the fact that the four animals were "unique of their kind" (but he considered that they were made of copper and not of bronze). The discussion was taken up with characteristic thoroughness by the very master of those who were to become the chief exponents of German neo-humanist culture (such as Herder, Wolf, Humboldt, etc.) - Christian Gottlieb Heyne, the celebrated Göttingen professor and enthusiastic supporter of Winckelmann. Heyne wanted to prove on the basis of learned studies that the Horses of San Marco, taken from Constantinople to Venice in 1204 were, in fact, not those in the Byzantine Hippodrome described by the 12th-13th century historian Nicetas Acominatus Coniatus as being in the act of galloping with their heads lowered, instead of walking like those of San Marco. This theory is typical of the way erudite philologists of the period, mainly from Germany, sought to establish the genuine features of the Greek world, and therefore the original models in literature, and in figurative art. It is, indeed, significant that both Heyne and Herder, should have condemned the habit of contemporary artists in Rome, notably Cavaceppi, of tampering with ancient works of art by arbitrary restorations. Meanwhile, one of the many other visitors to Italy was Wolfgang Goethe. He arrived in Venice on the evening of 28th September 1786, and according to the evidence of his *Diary* and *Italian Journey,* reacted to the Horses as any average cultured visitor usually did. Not without a touch of romanticism, he considered the Horses "like sheep that have lost their shepherd", their magnificence prompting somewhat conventional praise - "What a magnificent group of horses!" - and words of consolation - "Praise God that Christian zeal did not melt them down to make candelabra and crucifixes" - although he also expressed a keen desire to examine them more fully - "I should like to hear what a good connoisseur thinks of them". It was to be a decade or two later, however, before he gained a deeper insight by means of a famous comparison.

What transpired in Europe during the following years was extremely important not only in political circles but also in cultural ones. The wave of Jacobin enthusiasm involved a strong desire to return to ancient exemplars (Greek democratic freedom, the Roman republicanism of Brutus and Collatinus, the symbols of the plebean tribunate), not only in France but also in Germany (prompted by the facile comparisons between the Greek epics and German Volkslied, and between the autonomy of the *polis* and the aspirations towards independence of the German *Länder*). In

141. Antonio Canova, *Monument to Charles III of Spain*. Naples.

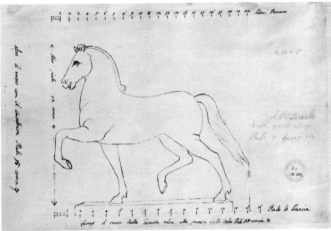

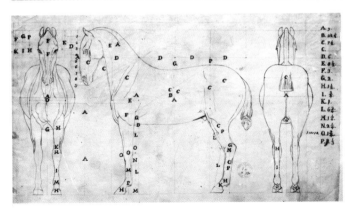

142 - 144. Antonio Canova, *Drawings of horses*. Museo Civico, Bassano.

addition, Winckelmann's promotion of Hellenic art in his aesthetic theories, together with the exportation from Rome and Italy of important antique works sold off by aristocratic families in financial straits throughout the 18th century, gave further impetus to the need to understand the surviving works of art in Greece itself, and also in those Mediterranean lands influenced by Hellenistic civilisation. This in turn brought about the consequent attractions and, therefore, temptations to salvage Greek culture, even in the material sense, by removing as many works of art to Europe as possible.

This explains why the transfer to Paris of the Horses of San Marco and their placing on the triumphal arch of the Place du Carrousel - an action intended to glorify the rising Napoleonic empire - could only have been undertaken when French scholarship had insisted on their particular artistic and moral values, and, therefore, on their Greek origin (as works preceding Phidias, by Myron or Polycletus in Millin's view; by Lysippus according to Choiseul-Daillecourt). In fact, one of Louis XIV's ambassadors to Constantinople, Choiseul de Gouffier, had already, some years earlier, initiated the drive to remove Greek art (including a metope from the Parthenon) thus opening the way for a whole series of competitors as well as controversies. It was clear that the fundamental problem had to be faced, not only of the nature of Greek influence on the history of European culture, but also of the destiny of modern Greece itself. In the meantime, following the example of the French and in rivalry with them, the English were also active, the culminating event being the ambassador Lord Elgin's removal of the marble sculpture from the Parthenon.

Despite the violent polemics in Elgin's native land (Byron) and outside it (Chateaubriand), the arrival of his marbles in Europe caused a decisive reassessment of historic and artistic values which was inevitably to affect any judgement on the Horses of San Marco. Therefore, while the Italians, on the return of the Horses, resumed the debate on their Roman (Cicognara, Dandolo, Ciampi) or Greek origins (the Greek-Venetian Mustoxidi), not only A.W. Schlegel defended the Greek craftsmanship on the anti-Roman assumption that "the Romans have never possessed any talent", but Antonio Canova, visiting London to see the Elgin marbles, expressed an opinion in a letter to his friend Quatremère de Quincey which was to echo round Europe:"those innumerable statues which we possess, with all their exaggeration, must have been copies made by the many sculptors who reproduced the beautiful Greek works to send them to Rome. The works by Phidias are truly flesh and blood, that is, with the beauty of nature itself, as are also the other celebrated sculptures of antiquity ..." In Paris itself, where Canova had been sent to arrange the return of the works expropriated from the Pontifical State, he was present when the Venetian Horses were removed by the Austrians from the arch in the Place du Carrousel, witnessed by the highly despondent Parisians. The English doctor, Sir Henry Holland, gave an eye witness account in his diary: "the excitement increased into a veritable tumult when the Austrian engineers came to remove the Venetian Horses". On the 24th September 1815 Canova had written to Consalvi, "the first time I

was presented to the Austrian Emperor, he told me that the Venetian Horses should definitely return to their place ...'' Although these works were not in fact involved in Canova's negotiations, the Venetian artist felt that he was particularly responsible for the fate of works which over the centuries had become the emblem of Venice. Even in his first encounter with Napoleon, then First Consul, when modelling his portrait bust in Paris in 1802, Canova had expressed his immense grief at the removal of the Horses from the Venetian Basilica, as well as his sorrow at the overthrow of the ancient Serene Republic. But when Francis of Austria became ruler of the ''Venetian provinces'', conscious of his undertaking to restore the Horses to Venice he discussed with Canova the possibilities of placing them in a different setting, and was offered the somewhat original idea of placing them ''beside the door of the Ducal Palace, two on either side facing towards S. Giorgio (as Canova informed Cicognara, who was not particularly enthusiastic about it). This solution was not followed up because it wounded Venetian feelings, since the Horses' position on the Basilica was so intimately identified with the Republic's history, and it was against Francis of Austria's interests to offend the Venetians in this respect. The very fact that Napoleon had placed the Horses on his triumphal arch after the victories of Ulm and Austerlitz (1805) emphasised not only their association with symbols of victory and empire (the Venetians themselves had carried them off from Constantinople in this spirit) but proclaimed the acquisition of a classical masterpiece as a contemporary seal of prestige.

But quite apart from the Parisians' dismay and the Venetians' natural pride in the event, Canova's idea for the new setting was also significant within the context of the debate concerning the origins and, therefore, the function of the Horses. The controversy broke out again in Venice on their return, Schlegel taking part in it with his *Letter ... on the Venetian Bronze Horses* (June, 1816). In this publication he cited, among other things in support of the Greek workmanship (Lysippus) of the quadriga, the example of the one in the Propylea of the Acropolis in Athens as an architectural solution from the best period in classical Greece - a revealing comparison with the entirely independent proposal made by Canova to Francis of Austria.

There is another significant point, however, of greater importance in the comparison between Canova and Schlegel. The latter, in fact, emphasised how ''sculpture ... must limit itself to the imitation of beautiful forms''. Canova, on the other hand, had admired in the sculpture of Phidias in London ''the truth to nature allied with the choice of beautiful forms''. Here, therefore, the relationship between nature and beauty - a fundamental theme in the debate involving comparisons with the ancients - was bound to treat the horses once again as points of reference, particularly after the arrival in Europe straight from Greece of the first celebrated works from Phigaleia, Aegina and elsewhere, as well as from the Parthenon.

This consideration of the values of classical antiquity, therefore, provided an essential opportunity to clarify the concept of the presence of the ideal in reality, as well as of reality in the ideal,

145. Detail of the façade of the British Museum, London, (1821-1847), designed by R. Smirke.

which actively concerned Canova in his own art. This also provoked the sculptor, irritated by Fernow's criticism in 1806, to write to his friend A. Quatremère de Quincey about his conviction that, ''it is better to study Greek examples day and night, entering into the spirit of their style, in order to fix it firmly into one's mind, making it part of oneself while still always having the beauty of nature before one's eyes, reading it with the same maxims''.

In the heat of these discussions and reflections, a London painter, Robert Benjamin Haydon, whose admiration for the Elgin marbles had led to his close friendship with Canova, published a *Comparaison entre la tête d'un des Chevaux de Venise et la tête du Cheval d'Elgin du Parthénon* (1818).

Why did he make this comparison? It was because the temporary presence in Paris of the Horses of San Marco had revived, within the wide range of concern and confrontation with classical antiquity shared by Neo-classicism and Romanticism alike, such an interest in these works as to spread plaster copies and drawings of them all over Europe. Haydon, who wrote his pamphlet in French with the aim of achieving a wider circulation on the continent as well as diffusing his belief in the superiority of the Parthenon sculpture (''Convinced as I am that by comparing the head of the horse from the Elgin marbles with that by Lysippus, I could prove how remarkably superior the Elgin marbles are to all works of art''), was not alone in this opinion. Goethe, who possessed his own plaster copy of the Venetian head, at first considered excessive, even ''unjust'', the exaltation of the Elgin one. But when he later obtained a similar plaster copy and drawing of the latter, he was forced to conclude that the Elgin work appeared to contain ''supernatural power as if it had been modelled contrary to nature. However'', he added, ''in consequence, the artist has created the original ideal of the horse''. Nevertheless he confirmed that he did not have, ''as scant consideration (for the Venetian head) as had the English painter Haydon'', noting rather that, ''at the moment there are so many plaster casts in Germany of these incomparable heads (the Venetian and Elgin ones) that among intelligent people there could be no question that through these works we are presented with a new conception of nature and art''. On the other hand, W.R. Hamilton, the Secretary of the Foreign Office, one of the key agents of Elgin's undertakings in Greece, managed to obtain from Cicognara, through Canova, a plaster cast of the Venetian head.

The fact is that, on the one hand, the Horses' journey to and from Paris inspired a more direct approach to their study and, on the other, the arrival of the Elgin marbles in London supported by the removal of other works from Greece to Europe, prompted a series of comparisons and deeper critical insights which the polemics only helped to increase.

In 1771 Falconet in his pamphlet *Observations sur la statue de Marc Aurèle,* which was dedicated to Diderot and attacked Winckelmann's theories, had given limited praise to such works as the Farnese Bull, the Montecavallo group and the Venetian Horses. Now the mentioned Haydon wanted to know from Canova if the Montecavallo group was or was not (as seemed evident to him) from the ''most beautiful'' period of Greek art. Canova had to reply cautiously that these works which contained ''the elements and, I would almost say, the geometric proportions of the human form'', were however, ''lacking in the ultimate perfection which rightly ... all true connoisseurs desire''. It was these same two colossal works that Canova, during his first visit to Rome, had sketched in order to acquire an artistic command of classical art. But the arrival of the works of Phidias and his school forced him to make further comparisons, and inevitably the same was true for the Horses of San Marco.

However, in the heat of these confrontations, the important fact remains that the debate, inspired both by phil-hellenism derived from Winckelmann as well as by the romantic view-point stemming from Herder, over the value of the works of classical art individually and in general, had, at the turn of the eighteenth and beginning of the following century, to come to terms with positive and negative reactions. These concerned, on the one hand, Jacobinism (consequently Napoleonic imperial ideals) and, on the other, the cultural as well as the social impact in a world where the art collecting was passing from private hands to public museums (the British Museum, the Louvre in Paris, the Glyptothek in Munich, together with the Museo Pio-Clementino in Rome). The arrival of authentic masterpieces from Greece met a complex but also conscious need for Europe to rediscover the Greek world, either through the removal of monuments (by Elgin and Ludwig of Bavaria in particular) or through the recovery of its freedom (Foscolo, Byron). In particular, these two tendencies seem to have been united in the fact that it was the possessor of the Aegina marbles, Ludwig of Bavaria, who recognised the independence of the Greeks in giving his son, Otto of Wittelsbach, to be their king.

The Horses of San Marco from the fall of the republic to the present day

Anna Guidi Toniato

After more than five hundred years of peaceful inactivity, the four horses of San Marco were directly involved in the new political situation following the Treaty of Campoformio of 17th October 1797. The Most Serene Republic not only lost its independence, but was also to suffer the loss of many works of art which were carried off to France [1].

On the 13th December of the same year the four horses were removed from the loggia of the Basilica amid the sorrowful silence of the Venetian crowd (fig. 146). They first went to Ancona and continued by sea to Leghorn where, together with other works of art forcibly appropriated from Italy, they were loaded onto a frigate bound for Toulon. From here as many as ten boats transported the numerous works of art to Paris by way of an inland canal, then northwards on the Rhone, Saone, the Canal du Centre, the Loire and Seine [2]. The journey ended on 2nd of Messidor in the 6th revolutionary year (17th July 1978) and the booty was officially presented to the Parisians some ten days later on 9th of Thermidor (27th July), when a long procession bearing the horses of San Marco at its head paraded through the city [3] (fig. 147). They were then lodged in the Wardroom corridor of the Invalides until 1802, when they were transferred to four pedestals forming part of the railings that surrounded the courtyard to the Palace of the Tuileries (fig. 103). However, once again this was only a provisional setting since in 1807 the horses were considered to be the only ornaments worthy of the Arc du Carrousel, which had just been completed in honour of Napoleon's triumphs. The designers of the new arch and its decoration did not want the horses to be separated any longer, but to be harnessed to a golden chariot driven by two golden Victories. It seems that they then proceeded to place the Emperor's statue on the chariot as well, but this did not please Napoleon who immediately ordered it to be removed [4].

The horses' stay in Paris was bound up with Napoleon's fortunes. Once the French ruler had disappeared from the political scene in Europe, the Emperor Francis I of Austria, who had obtained control of the Lombardy and the Veneto regions under the aegis of the Restoration and Congress of Vienna, had the four horses returned to Venice. They were, in fact, removed from their Parisian setting on 1st October 1815 under the direction of Austrian and English engineers. According to the Wiener Zeitung of 12th October, the operation was carried out smoothly [5], although elsewhere it is stated that their removal was done in haste by people who were utterly careless in breaking stones, wrenching off the lead fittings, mutilating the two Victories and destroying the ornaments on the chariot [6]. An account is also given of a hostile crowd kept at bay by two Austrian battalions [7].

The horses remained in barracks occupied by imperial troops until 17th October, when they began their journey back to Italy. After travelling overland to Fusina, the four horses crossed the lagoon on large rafts and triumphantly reached the Venetian shore on 7th December. Both Cicognara and Dandolo state that one of the heads became detached during this journey [8], and it has been suggested that the horses lost the decorations on their collars while in Paris [9]. However, one thing is certain: the horses badly needed restoration so that they were kept for a week in the main workshop of the Imperial Naval Artillery, that is the Arsenal, for the necessary repairs [10].

On 13th December 1815, Pietro von Goess, Governor of the Venetian Provinces, officially handed over the horses to Mayor Gradenigo, in the presence of His Sacred Majesty, the Emperor Francis I and Prince Metternich. The horses left the Arsenal at 10 a.m. on a barge towed by tugs to a salute of twenty-one cannon shots. When they had been disembarked (fig. 149), the horses were replaced high on the loggia of the Basilica "with ingenious machines" invented by the engineer Salvini to the sound of musket salvoes and cannon shots [11].

The horses remained undisturbed for a whole century as they were unaffected by the war of Italian independence. However, at the beginning of the twentieth century the horses began to reveal their first infirmities when, on 29th August 1902, Horse B was noticed [12] to be "tilting over to a considerable degree, causing the horse itself to lean outwards" [13]. The front hoof resting on the plinth was on the verge of collapsing so the sculpture was propped up with a wooden structure while awaiting bureaucratic decisions to be made through the usual procedure. Authorisation for the necessary repairs, requested on 13th October 1903, was granted by Prefecture on 15th January. Then the three arcades of the Portico of S. Nicoletto at the side of the Staircase of the Giants in the courtyard of the Ducal Palace had to be closed up with wooden partitions to house the horse during its restoration. By the 14th February the Surveyor of the Fabric, Manfredi, was able to report as follows: "I hasten to inform Your Highness that last

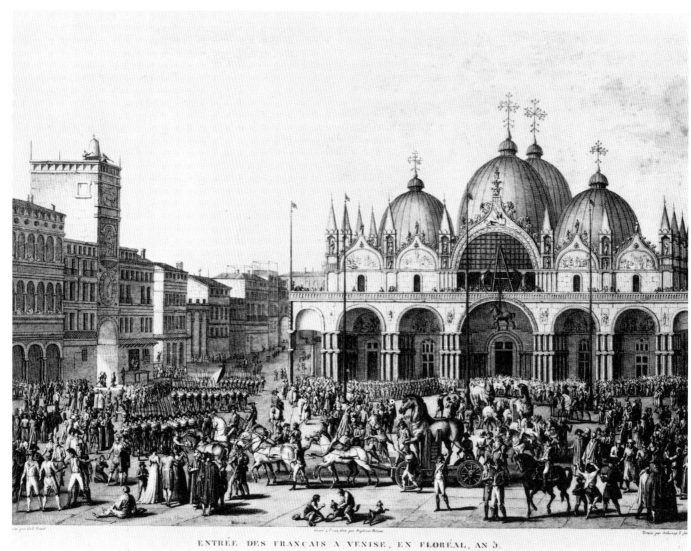

ENTRÉE DES FRANÇAIS A VENISE, EN FLORÉAL, AN 5.

146. The four horses being taken down from the loggia of the Basilica of San Marco, Venice, 13th December, 1797.

118

147. The Horses paraded before the Parisian people as trophies of Napoleon's victories, Paris, 27th July, 1798.

148. 19th century engraving showing the Apotheosis of Francis I on the occasion of the horses' return to Venice.

night the bronze horse was taken down from the façade of the Basilica and transferred to the enclosure prepared for it, everything proceeding exactly to order''[14].

The restoration (fig. 179) carried out by the master-founder Cavalier Munaretti, strengthened the front left-hand foot of Horse B, and replaced the ''unworthy lead sectional repairs with bronze ones which perfectly fitted the modelling, the patina and the ancient gilding and prevented water seeping in''. The horse was replaced on the loggia during the night between 23rd and 24th April, and the workmen, who had already done a day's work beforehand, were given two extra days' pay for their night shift. So by the 25th April, the Feast day of St. Mark, the façade of the Basilica, according to the Mayor's wishes, had regained its normal appearance. The four horses were now in place and so the ceremony took place of laying the first stone of the Campanile (which, as is well known, had collapsed on the preceding 14th July) in this faultless scenario.

Coinciding with the outbreak of the First World War, the loggia of the Basilica of San Marco was stripped once more. Although Italy had not yet declared war, on 22nd May 1915 the Office for the Defence of Venice ordered the Office of Works responsible for the fabric of San Marco to remove the horses. Thus for the second time the horses came down from the loggia on 26th May (fig. 150). As time was short, the bolts fixing the hooves to the supporting capitals were sawn through in order to remove the sculptures from their setting. The bronze group remained in a storehouse in the Ducal Palace [15], protected by sandbags, until November 1917, when it was considered advisable to take them away in a large boat belonging to the Military Engineers. This craft sailed south to the mouth of the Po where, after navigating the river as far as Cremona (Ostiglia) [16], the horses were transferred to flat railway waggons under the direction of the architect Forlati. Then, protected by large sheets of waterproof canvas and with an escort of two soldiers and Doni, the Curator of the Ducal Palace, they were taken to Rome. There they were sheltered in Hadrian's Mausoleum, that is Castel Sant'Angelo, until there was talk of returning them to Venice. War was about to end and people were beginning to think about the future. Cavalier Munaretti who was then in Rome, was again summoned to remove the ''small iron bolts'' from inside the twelve hooves resting on the ground, which had been sawn through in 1915, together with the lead which secured them.

As the shed put at Munaretti's disposal in Castel Sant'Angelo proved inadequate, the horses were transferred to Palazzo Venezia in December 1918. Here, however, they were put on public display (fig. 151) and work could only begin in February 1919. Munaretti first made plaster casts of the hooves and then began to remove the lead from inside them. He also removed the ''small iron bolts'' which, if they had remained in place, would have made it utterly impossible to find any way of securing the horses to a pedestal. After the hooves had been hollowed out in this way, new bolts of phosphorous bronze and of coin metal (''Munz-Metal'') were placed there and retained in position presumably with lead. Although these new bolts were originally square in

119

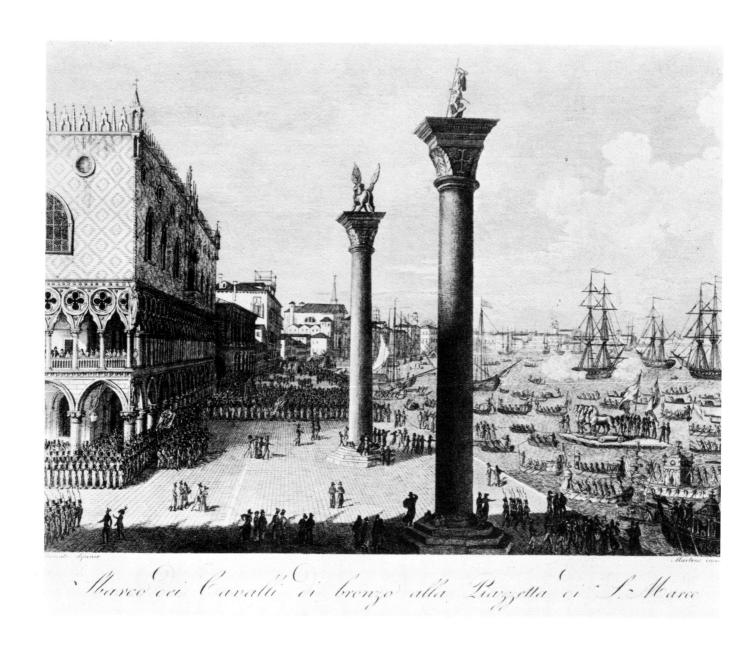

Sbarco dei Cavalli di bronzo alla Piazzetta di S. Marco

149. The arrival in Venice of the four Horses after their Parisian ''stay'', 13th December 1815.

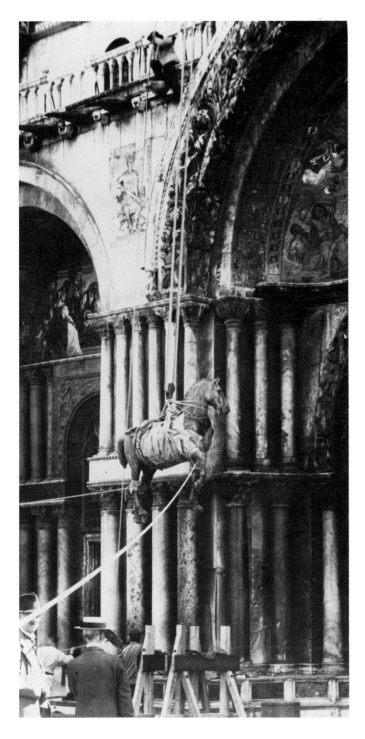

150. The Horses taken down from the loggia of the Basilica of San Marco for the second time. Venice, 26th May 1915.

section, they were later filed down - an act much criticised subsequently - and became rounded to allow for threading to be added to them. This provided a fixed place, now projecting from the hooves, to which other supports could be attached. However, even if these bolts were to be sawn off flush with the hoof, a part would still remain which could be unscrewed and substituted without further disturbance to the hooves.

Meanwhile in Venice the capitals which were used to support the four bronzes on the loggia of the Basilica were reinforced. In particular, the marble slabs directly beneath the hooves were strengthened, and clamps were used to transfer the weight on to the small porphyry columns which lay underneath everything in order to avoid the weight falling excessively on to the ancient and fragile capitals, commonly held to be byzantine. Besides, Munaretti records that he removed the collar from one of the horses to repair a defect and, after replacing it with soldering, he did something to the sectional repairs, although no more precise information on this can be found [17].

The horses, therefore, returned to Venice in April 1919 and once again were housed under the portico in the courtyard of the Ducal Palace next to the Staircase of the Giants (12th May). However, once the packing materials had been removed, considerable dents, which had not been there when the horses left Venice, were clearly visible. Apart from this new factor, all the necessary work had been completed, inspected and approved by October of the same year. Finally at 10.30 a.m. on 11th November 1919, the four horses were lifted simultaneously by two sliding cranes borrowed from the Arsenal and put back in position. The area of operation was guarded by two companies of the Royal Italian Army and by two companies of Engineer Cadets from the Royal Italian Navy [18].

The Second World War also necessitated the removal of the horses of San Marco (figs. 152-153). This time, however, the military operations were of a very different kind and the front some distance away, so in December 1942 it was considered sufficient to shelter the horses first at Praglia, and then in the cellars of the Ducal Palace, still under the direction of the architect Forlati [19]. They were returned to the loggia between 8th and 10th August 1945 with the aid of the Italian Navy in collaboration with the technical staff of the Procurators of San Marco [20].

(1) A. DALL'ACQUA GIUSTI, *I quattro cavalli sulla facciata della Basilica di San Marco*, Venice, 1894, p. 12.
B. FORLATI TAMARO, *Nuove ipotesi sui cavalli di S. Marco*, in Rend. Pont. Acc. XXXVII (1964-65) pp. 85-86.
E. VITTORIA *I cavalli di Venezia*, Venice, 1972, pp. 57-59.
(2) L. MOREL D'ARLEUX, *Les tribulations des chevaux de Venise*, in Bull. Soc. d'Hist. et d'Archéol. XXXIV (1933-34), pp. 373-77.
M. PAVAN, *Canova e il problema dei cavalli di San Marco*, in Ateneo Veneto, XII (1974), II, p. 90.
(3) M. PAVAN, *ibid*.

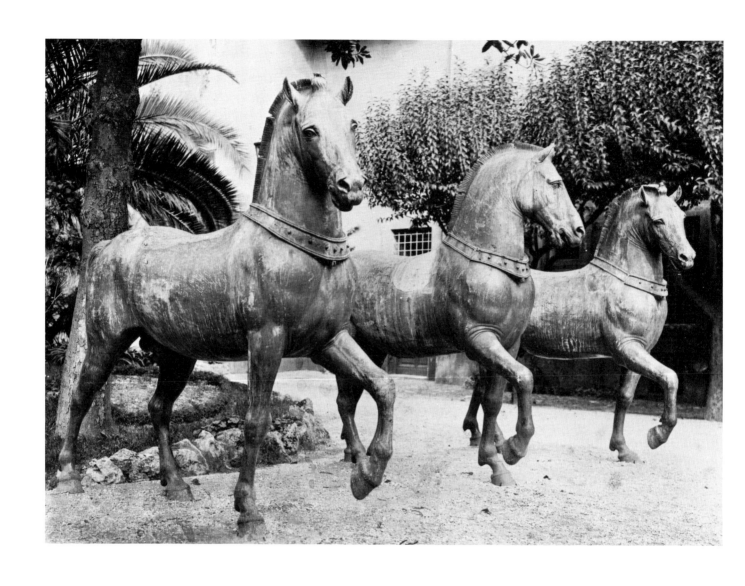

151. The Horses in the garden of Palazzo Venezia, Rome. December 1918.

(4) This information is found in A.W. SCHLEGEL, *Lettre aux éditeurs de la Bibliothèque Italienne, sur les chevaux de bronze de Venise*, Florence, 1816, p. 14. L. MOREL D'ARLEUX, *op cit.*, p. 376; M. PAVAN, *op. cit.* p. 92. On the other hand DALL'ACQUA GIUSTI (*op.cit.*) states that it was Napoleon himself who wanted his own statue on the chariot, but that the scheme was not carried out. As there is such disagreement, we can only share in the uncertainty already shown by FORLATI TAMARO (*op.cit.*)

(5) M. PAVAN, *op. cit.*, p. 93.

(6) L. MOREL D'ARLEUX, *op.cit.*, p. 377.

(7) M. PAVAN, *op.cit.* p.95.

(8) L. CICOGNARA, *Dei quattro cavalli riposti sul pronao della Basilica di S. Marco. Narrazione storica.* Venice, 1815, pp. 35-36 (Addition).
G.A. DANDOLO, *Sui quattro cavalli della Basilica di S. Marco Osservazioni*, Venice, 1817, pp. 38-39, nota 26.

(9) A. DALL'ACQUA GIUSTI, *op.cit.* p. 22.
cf. the descriptive analysis in this catalogue, p. 156.

(10) G. RENIER MICHIEL, *Dei quattro cavalli riposti sul pronao della Basilica di S. Marco* (Letter dated 16th December 1815), Venice, 1893, p. 13.

(11) *Programma per la celebrazione del ripristino de' cavalli di metallo corinzio sulla Chiesa di S. Marco*, Venice, 10th December 1815.
Processo verbale della funzione ch'ebbe luogo ... nel ricondurre e riporre nell'antica loro sede i quattro cavalli sul pronao della basilica di S. Marco, Venice, 13th December 1815.
G. RENIER MICHIEL, *op.cit.* p. 13.

(12) Looking at the façade, Horse B corresponds to the second horse starting from the left.

(13) Information from documents found in the archives of the Procuratoria of San Marco.

(14) Letter in the archives of the Procuratoria.

(15) VITTORIA (*op.cit.* p. 84) states that on this occasion a copy was made of one of them.

(16) B. FORLATI TAMARO, *op.cit.*, p. 86.

(17) All the information given was deduced from letters and documents of various kinds in the archives of the Procuratoria of San Marco.

(18) Documentation provided by the Procuratoria.
A. CAMBIE, *Il cavallo nella scultura attraverso i secoli*, Milan, 1934, p. 14.

(19) B. FORLATI TAMARO, *op.cit.*, p. 86.

(20) E. VITTORIA, *op.cit.*, p. 86.

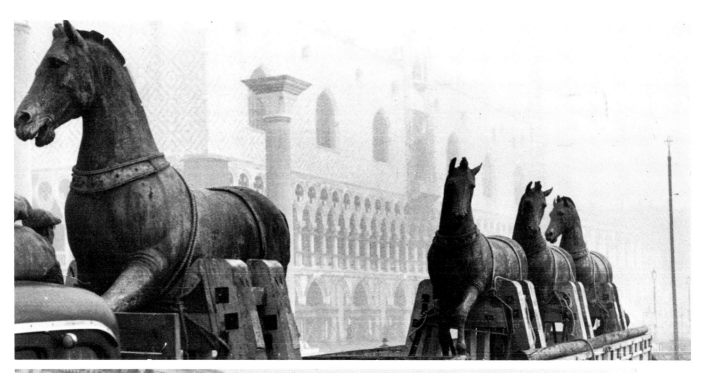

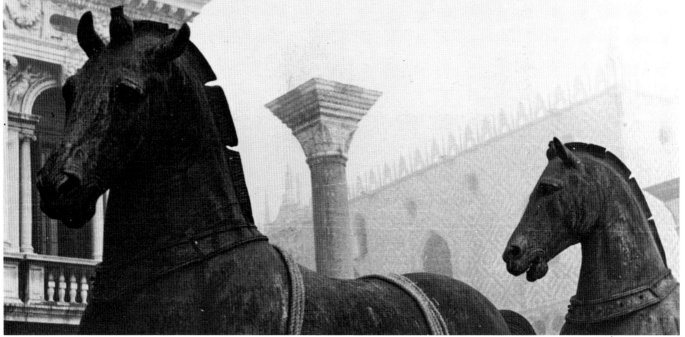

152 - 153. The Horses leave Venice for the third time on their way to refuge in the Abbey of Praglia. Venice, December 1942.

The Basilica, the Horses and Piazza San Marco

Renato Padoan

If after gazing for a few moments at the Basilica, one were to close one's eyes, what would be recreated in the imagination would almost certainly be, first the great domes, then a long base supporting them, and three large niche-like porches - only a few would see them as exactly five - and finally, points standing out against the sky, shining and golden - the finials of the domes and the cusps rising over the rectangular base. Only with difficulty would an observer with normal powers of perception call to mind the four Horses. Of course in the days when they were fully gilded, echoing and amplifying the rich colour harmonies of this focal point in Piazza San Marco, they would certainly have been more prominent. But then, as now, they had no important architectural function. And although it may seem paradoxical, I think it is true that the Horses of San Marco belong principally to the Piazza.

Try viewing them from the gallery: here they stand in the foreground. With their fine anatomical modelling, and graceful movements enlivened by sudden accents of light, they interweave freely with patches of sky and frame, with their clear-cut silhouettes, a mosaic of views of the architecture and the space of the Piazza. Here the gilded Horses find again some of the atmospheric qualities which were certainly those of their original site - such as clear skies and brilliant sunshine - and thus regain something of their original expressiveness, though their original purpose is still unknown.

This leads us to the question of what these Horses mean to Venetians and why they are so strongly opposed to their removal. In the first place they are exceptional works of art, but this is by no means all. From their lofty place in the heart of the city's religious and political power, the Horses, over the long span of their Venetian history, have gradually become deeply associated with Venice's triumphs, and festivals, and her magnificent ceremonies, and eventually even shared in the final collapse of the Republic. Being thus intimately connected with the history and civilization of Venice, the Horses were to become in time a symbol of the city itself.

Much has been said about the possibility of conserving the Horses in a museum and replacing them with more or less accurate copies. It should be emphasised, however, that a work of art is not only an aesthetic product of human civilization, but an historical, cultural, political and moral one. "If an object is false it

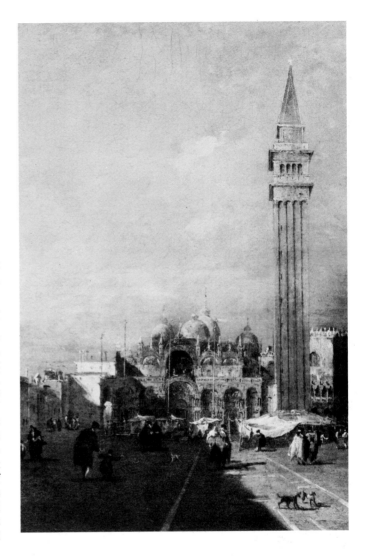

154. Francesco Guardi, *Piazza San Marco* (detail). National Gallery, London.

155. The Horses of San Marco seen from the loggia looking towards the Piazzetta.

125

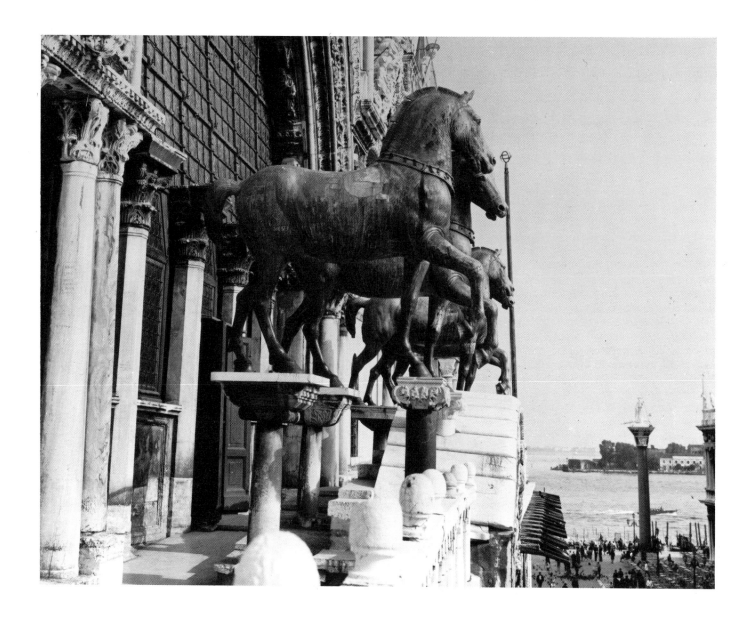

loses, even without altering its outer appearance, so much of its ethical associations as to bring about an aesthetic change.''[1] If this statement is true, the copies of the four Horses to be placed on the gallery of the Basilica, though they might provide interesting examples of the techniques of modern copying and the aesthetic values involved, would certainly be devoid of any creative inspiration or emotional power. Therefore it only remains for me earnestly to wish that the distinguished experts, who have been studying the Horses for some time now, might explore every

means available to allow these statues to maintain their vigil from the high gallery over the fate of the Venetian people for as long as possible, without risking at the same time further damage or deterioration.

1 From the catalogue of the exhibition ''Forgeries and Scientific Research'' by Professor Peter Bloch, Director of the Galleries in West Berlin.

The origins and documentary sources of the Horses of San Marco

Licia Borrelli Vlad and Anna Guidi Toniato

"But whatever the truth, it is uncertain for everyone"
Sansovino

The mystery surrounding the origins and artistic attribution of the quadriga of the Basilica of San Marco is still not resolved to any definitive degree. There are too many unanswered questions since the only really certain news about them - namely that the four horses reached Venice from Constantinople - occurred in a fifteenth-century manuscript codex saying that "…. from 1204 onwards many marble and porphyry slabs ……. were brought from Constantinople as well as four excellent bronze horses"[1]. The horses then were in Constantinople and, therefore, the attention of scholars has concentrated on those ancient documents containing information relating to the topography and monuments of this magnificent city of the Eastern Empire in order to discover in them a reference to the celebrated quadriga[2]. Research began with the *Patria Sive Origines Urbis Constantinopolitanae*[3], an anonymous work dating from the end of the tenth century, but attributed by some scholars to Hesychius of Miletus (sixth century A.D.).

The Byzantine Origins

In the passage describing the statues of the hippodrome it is stated that, "…. the four horses decked out in gold, which we see above the starting positions, came from Chios during the reign of Theodosius II[4]". It, therefore, appears that there were four gilded horses overlooking the starting positions in Constantine's hippodrome. This passage was faithfully copied in a fifteenth-sixteenth century manuscript which is wrongly attributed to Giorgius Codinus, for it is nothing more than a repetition of passages from the older *Patria*. It will, therefore, only be indicated it in the footnotes. Four gilded horses at the starting positions are also mentioned by Nicetas a native historian from Chonae living in the twelfth and thirteenth centuries[5], in a curious anecdote concerning one of those people who in every age seem impelled to imitate Icarus's dream: "A man from Agara …. after climbing onto the tower of the theatre, which overlooks the starting places of the various tracks (literally "parallel circumferences") for the competing athletes, having at the top four, firmly-set, bronze horses, covered in gold, with slightly curving necks, which look at each other, snorting and anxious to race to the finishing post, announced that he was about to fly across the stadium".

When these lines[6] were read towards the mid-sixteenth century in Europe and, particularly in Italy, these horses from Chios facing one another over the starting positions of the hippodrome were immediately identified with the horses of the Basilica of San Marco. This was a hasty conclusion, since by reading on in the *Patria*[7] it is not difficult to realise that in the hippodrome of Constantinople, besides an infinite number of statues of men and women, horses and charioteers, there was also a second group of four horses, also gilded[8]:
"There are some other statues in the hippodrome. In the so-called Neolea[9] there are four horses shining like gold with a chariot bearing a driver who holds in his right hand a statuette of a woman, an image which appeared to run; some say that this work only was Constantine's invention, while the rest is ancient and not erected by Constantine. Furthermore, until the time of Theodosius the Great the citizens witnessed the following spectacle in the hippodrome; all wearing cloaks and bearing white candles, they would accompany this statue on the chariot, or rather, on a two-wheeled carriage, to the imperial throne, having begun from the starting positions; and this took place when the birth of the city was commemorated".

There are two other passages[10] referring to this same group, which make it clear that the statuette in the charioteer's hand was venerated by Constantine as Túyn, that is, the Fortune of the City, and that the ceremony took place every year. From this evidence it is possible to say that in different parts of the Constantinople hippodrome there were at least two groups of four horses, one consisting of horses only situated by the starting positions and the other was connected to a chariot with a driver[11]. Another two passages[12] confirm the existence of four "flame-coloured" horses with chariot together with a driver and the statuette of Fortune. They formed the sun-god's two-wheeled chariot which was in the Milion Aureo Square - the hub of the roads radiating to the various provinces[13]. It becomes clear from the same pages that this group was then transferred to the hippodrome where it was a feature in a particular ceremony[14], virtually the same as that described above involving the Neolea chariot. At the end of the celebrations the image of Fortune was placed in the Senate. There is also some information about the subsequent fate of this statuette. As Constantine had caused a cross to be put on its head, Julian the Apostate had it thrown out on to a scrap heap; nothing is

known about the Sun-god's chariot. Despite the different locations of the two quadrigas referred to, there are undeniable similarities in the references to the quadriga of the Sun located in the Milion and the other situated in the so-called Neolea area of the hippodrome. Indeed, it is not impossible that they represent the same group which, in the course of time, occupied two different places in Constantinople.

From these documents the only possible conclusion is, therefore, that there were probably at least two groups of four horses in Constantinople - those by the starting places in the hippodrome and those harnessed to the chariot of the Sun, first placed in the Milion and later in the Neolea. In our opinion there is not enough evidence yet to identify with sufficient accuracy which group of horses is the Venetian one. Nothing, however, prevents one from speculating about the two groups. The one coupled to the chariot of the Sun was quite ancient, only the statuette of Fortune created on Constantine's orders, being new. This particular quadriga would have commanded a certain respect belonging as it did to an important deity, the Sun God. In fact, according to Constantinian iconography, the Sun often assumed the function of symbolising imperial strength. Not for nothing did the father of the Euseban Church compare Constantine to the Sun in his eulogy celebrating the thirtieth year of his reign [15].

It is possible that four horses from Chios, which dominated the hippodrome high above the starting positions, did not attract great attention. If, in fact, the opposite were the case and one accepted that they became the quadriga of San Marco, we should then have to explain how the island of Chios ever came to possess such a masterpiece and why it was only noticed during the reign of Theodosius II (405-450 A.D.), when it was transferred to the New Rome. The fact that the horses placed over the hippodrome's starting positions looked at one another, does not necessarily imply that they are Venetian works, since as has already been pointed out, it is not at all certain that their current arrangement is an accurate reflection of the way they were placed so many centuries ago [16]. It is also possible that a change of heads took place during one of the many vicissitudes that befell them.

The research carried out on the origins of the horses in Constantinople has not led to any startling discoveries. Even if it were possible to pin-point the very place where the four Venetian horses stood in Constantinople, the names of the sculptor and founder (who cannot be the same person) together with the reason for commissioning these bronzes would still remain unknown.

Hypotheses Concerning the Horses from the Thirteenth to Seventeenth Centuries

The examination of its origins in Constantinople leads to the conclusion that it must be a mysterious quadriga indeed. The Venetians of the thirteenth century themselves who were the first to see it placed on the Basilica's loggia have left behind no information at all, and in the next century the situation is very much the same.

It was not until 1304 in fact that the four horses were mentioned in a now celebrated letter written by Francesco Petrarch. He said that they were ancient works and sculpted by an excellent artist, "whoever he may have been" [17], but this reference in fact gives us very little to go on. Significantly perhaps it was only in a fifteenth-century manuscript that the provenance of the horses from Constantinople was first recorded [18]. However, already in the fourteenth century they had become a symbol of power, as Forlati observed, since after the defeat at Chioggia in 1379, Doria could reply to the Ventian Senate's request for peace in the following manner:

"Truly, you will never have peace from the Lord of Padua, nor from Genoa, if we don't first of all rein back those unbridled horses which are on top of the palace of your evangelist, St. Mark" [19].

M. Perry has drawn attention to the role of the horses in a legend related in the *pactum venetum* - the peace treaty arranged in Venice between Pope Alexander III and Frederick Barbarossa in 1177, and depicted in Federico Zuccaro's painting in the Sala del Maggior Consiglio. According to various versions of this legend recounted by foreign visitors, the Venetian horses were to witness and preserve the memory of the emperor's impiety when he had proposed to transform San Marco into stables for his horses [20].

It was during the enthusiastic studies promoted by Humanism and the spread of Greek culture after the Fall of Constantinople in 1453 that the first clues to the origins of the quadriga of San Marco appear. Around 1437 the famous merchant, Cyriac of Ancona, during his travels to the East over some thirty years when he often stayed at Constantinople wrote that, "We have admired the famous four bronze horses not once but to our heart's content. They are marvellous from an artistic viewpoint, (they are excellent works by Phidias), and they once were a splendid ornament on the temple of the war-like Janus in Rome" [21].

Cyriac, therefore, is the first of those who attribute the Venetian horses to a famous Greek sculptor, but in the same spirit that the names of the greatest Greek artists, Phidias and Praxiteles, were inscribed on the pedestals of the two equestrian statues of the Dioscuri in the Piazza del Quirinale, Rome.

Cyriac was also the first to state that these four horses were in Rome for a time, an idea which was suitably elaborated at the end of the century by Sanudo in his *Vite de' Duchi Di Venezia* [22]: "…. the four, huge, bronze gilded horses ……. were made in Persia, and when the Romans conquered Persia they took the four horses and carried them to the coast. They put the four horses on their coins and the reverse of their medals and eventually took them to Rome. The Roman Emperor, Constantine, when he went to live in Constantinople so that he could build the city, took the four horses with him from Rome". It seems more like a myth than fact and his phrase, "…. and they then put the four horses on their coins and on the reverse of their medals", makes one suspect that this scholar, as a loyal Venetian, having noted a quadriga on the back of some Roman coins, had hastily identified it as the horses seen in Piazza San Marco, and so concluded they had been in Rome for a period [23].

In the sixteenth century, Pliny was being read again, (it should

not be forgotten that it was Ghiberti who first translated him into Italian), and this Roman author mentioned that a "quadriga of the Sun made for Rhodes" was one of the creations of Lysippus (*Naturalis Historia*, XXXIV, 63).

Thus the erroneous identification was also linked with the name of Lysippus [24], as well as several new facts, apparent from Antonio Stella's testimony [25] dating from 1558: ".... the four, famous bronze horses placed on the loggia stand out impressively from the church's façade; they are excellent works by Lysippus and were, in an earlier age, given to Nero by Tiridates, King of the Armenians. After that they were taken to Byzantium by the Emperor Constantine and, finally, thanks to Dandolo, they reached Venice; they are a marvel to all who see them".

As for the later development of this story, Pietro Giustiniani [26], relates the same tale as Stella, without, however, rationing the frequent "it is said". Sebastiano Erizzo, however, does not mention Lysippus but to compensate for this he feels it necessary to clarify the situation, albeit with new flickers of doubt, as follows:

"It is believed" that the horses of San Marco "are the same as those on the medal above Nero's triumphal arch" - a triumphal arch which he, yet again, believed had been erected to commemorate the emperor's victory over the Parthians [27]. Erizzo added that the horses remained in the Arsenal for a long time and were in danger of being melted down until "they were seen by some Florentine ambassadors who knew about sculpture and were greatly praised". Afterwards they were placed in the Basilica.

Even though Michel de L'Hospital, Chancellor to Catherine de' Medici, mentioned the name of Praxitiles as the sculptor of the horses in a mid-century poem [28], most writers of the period concentrated on the horses' stay in Rome. In 1561 Pierre Gilles's posthumous work appeared with the sensational revelation, hitherto ignored in the West, that the Venetian horses had been in Constantinople's hippodrome [29]. "Before the French and Venetians took Constantinople, there were many horses of marble and bronze as well as four splendid gilded ones in the hippodrome; these last are similar to those which stand today on the Pronaos of the Venetian Basilica of San Marco and which are said to have been taken away from Constantinople".

The horses were moved, therefore, from Nero's triumphal arch to the hippodrome in Constantinople; in fact, according to Niceta whose work had only just been published, the quadriga was "firmly placed above the starting positions" [30]. But since in another place [31] Gilles mentioned the golden chariot of the Sun which, as is known, was placed in the Milion and vas drawn by four horses, things became more complicated: the various hypotheses became blurred and inextricably linked as in the case of Sansovino's all inclusive evidence. In 1581 he wrote:

".... the Roman people had (the horses) made in honour of the Emperor Nero's victory over the Parthians; they were then dedicated and allotted to positions on the triumphal arch consecrated to his name. They pulled the quadriga of the Sun, as can be seen down to our times on the back of some of Nero's medals where the said horses are sculpted with the very same movements of their heads and legs, and with breast-bands around the neck, as the horses of San Marco today. But when Constantine left Rome he took them to Byzantium in the hippodrome as Nicetas writes" [32]. In another passage. Sansovino says, "The (horses), according to some, were sculpted by Lysippus for the Rhodians and were then sent to Soria and, later, to Rome [33], where Augustus placed them in the Mausoleum; later they were dedicated, as we said above, to Nero. Finally, they were taken to Constantinople and from there they arrived in Venice where they were placed on the Church of San Marco". He concluded sadly that ".... but whatever the truth is, it is uncertain for everyone".

At this point it is not possible to follow all the various theories springing up everywhere; the most extreme case is Ramnusius who enthusiastically relied on his imagination. Starting from the assumption that the Venetian horses were on a triumphal arch in Rome, since he had seen triumphal arches with horses on the coins of Augustus, Nero, Domitian and Trajan, Ramnusius went on to say that the quadriga of San Marco was first placed by Augustus on the triumphal arch erected in honour of his triumph over the Parthians. After that it was transferred to Nero's triumphal arch, then on to Domitian's, and then to Trajan's. It remained there until Constantine took it to Constantinople's hippodrome and from there it went to Venice where, "after having eliminated the charioteer", it was placed on the loggia of San Marco. During this account, Ramnusius mentioned with a certain nonchalance that "some believe that Lysippus (sculpted) the horses of the quadriga of the Sun for the inhabitants of Rhodes" [34]. This was evidently still referring to Pliny's passage.

About half-way through the sixteenth century the work, wrongly attributed to Giorgius Codinus [35], was published in Paris; it stated that, ".... the four horses above the hippodrome's starting positions had come from the island of Chios under Theodosius II". It was a novelty kept in circulation by Du Cange, who in his *Historia Byzantina*, after having correctly quoted Codinus together with an anonymous author (later republished by Banduri in 1711 in his *Imperium Orientale*), Nicetas and Gilles, affirmed that above the starting positions of Constantinople's hippodrome were to be found four gilded horses which had been taken from Chios in the time of Theodosius [36].

In 1683 Charles Patin, having identified the horses as those on Nero's triumphal arch, asserted that the same horses were, according to Pausanius, those which Cynisca had placed at Olympia to give thanks for a victory [37].

There were, therefore, three theories concerning the origins of the horses of the Basilica of San Marco. Firstly, they were regarded as the masterpiece of Lysippus created for the Rhodians; secondly, they were considered as forming a quadriga destined to be placed on the triumphal arch of some emperor (Nero's name was most commonly mentioned); and thirdly, they were believed to have been plundered from the Island of Chios by Theodosius II, half-way through the fifth century A.D.

A characteristic common to all these hypotheses is the lack of any in-depth research. They mostly stemmed from subjective opi-

nions forming a complex blend of interpretations regarding the horses' ancient origins, together with a number of worthless inferences and, why not, many popular legends. All this must, therefore, be viewed with extreme caution.

Studies from the Eighteenth Century to Today

In the next century, the age of the Enlightenment, the situation was to change and the problems were brought into focus. The eighteenth-century Enlightenment encouraged scholars to break free from the contemplation of the past and to approach the present with humility. The Zanetti cousins and Winckelmann carried out their enquiries with new methods. After many centuries the Venetian horses were scrutinized and studied in terms of their actual condition. A thorough description was made and the sectional repairs examined, together with the gilding and the cut of the mane. The technique of casting was considered and, when the alloy was analysed, it was discovered that almost pure copper was used. For the first time the Basilica's horses were depicted in their own right rather than as anonymous elements in the church's façade. Although the ancient hypotheses survived, they were now subjected to criticism and serious doubts. In fact, Anton Maria Zanetti expressed himself in this manner even after attributing the quadriga to Nero's era: "Whether they were created in Rome or brought back by Nero amongst his other plunder from Greece, it is hard to say, since one can reasonably believe both theories", and further on he added: "As far as the journey of the horses from Rome to Constantinople is concerned, having been taken there by Constantine and placed in the hippodrome, even though this conjecture is not completely without sense, there is no more certain proof than popular tradition"[38].

An extremely clear synthesis was provided in a passage by Flaminio Corner who, after having emphasised that the horses were made of copper and that nothing was known about their origins, gave a succinct list of the various hypotheses then in fashion and concluded: "Whether the horses were taken to Constantinople by Constantine or Theodosius, the one certain fact is that they arrived in Venice in 1204"[39].

Winckelmann, who established the foundations of modern archaeology, could not fail to give his opinion on the horses. In his work, *The History of the Pictorial Arts* (1764), he was of the opinion that the horses were made in Nero's time when, according to Pliny, the art of casting was already in decline. He also accurately noted the casting technique used the resulting faults[40]. Elsewhere he wrote: "In my opinion the four ancient, bronze horses on the portico of the Basilica of San Marco in Venice are the most beautiful that can be found of this type"[41].

In 1771, Falconet at first dismissed the Venetian horses and the equestrian monument to Marcus Aurelius on the Capitoline Hill (the Campidoglio), Rome, thereby earning himself the scorn of Stendhal: "A French sculptor, M. Falconet, has produced a book against it (the equestrian group of Marcus Aurelius) and, in passing, abuses Michelangelo. Diderot promised Falconet immortality but the sculptor couldn't have cared less about it. Sixty

years have passed since then. Have you ever heard of M. Falconet?"[42]. In 1768 Octave Guasco considered the "four horses of Nero" to be among those works which were gilded, reflecting the bad taste of contemporary (Roman) decadence".

By now Winckelmann's worship of the Greek creative spirit exalted as the inimitable expression of ideal beauty, had impregnated the cultural climate of the times.

From the end of the eighteenth to the beginning of the nineteenth century those writers who were interested in the horses continued to examine the hypotheses advanced in previous eras, choosing to follow one solution or another.

In 1778 Tomasa Temanza considered them to be "some of the most excellent Roman casts"[43], while Christian Gottlieb Heyne doubted that the quadriga was the same one mentioned by Nicetas[44]. Apart from these general interests aroused at the end of the century by Winckelmann's work and the new archaeological explorations, certain events attracted the attention of scholars and connoisseurs to the horses: their temporary exile in Paris (1798), their triumphal return home (1815), and the discovery of the Elgin Marbles which were carried off to London from Athens by Lord Elgin (1812), and which re-opened the debate on the nature of classicism itself.

In France Joseph Leitz (1806) considered that the stylisation and stiffness of the manes were ancient characteristics and attributed the horses to either Myron or Polyclitus, whereas M. de Choiseul-Daillecourt (1809) re-emphasised their association with Lysippus and, Sobry (1810) reiterated that they came from Chios[45].

By now the quadriga of San Marco had become the object of numerous monographs. Both Canova's impassioned efforts to ensure their return to Venice and their re-installation and the new cultural influence which the great artist inspired in his contemporary society will be discussed in another sections.

At least six pamphlets, often in fierce disagreement with one another, tackled the problem of the horses with polemical vigour. Apart from the Byzantine sources, they used evidence from Pliny, Varro and Zenodorus to affirm their Roman or Greek character. By now the controversy had divided supporters into two opposing camps. On one side were Cicognara and a descendant of the Dandolo who had brought the horses to Venice from Constantinople, supporting their Roman origins, against the Greek Mustoxidi and Schlegel who defended their Hellenic character.

According to Count Leopoldo Cicognara[46], the horses in question were made in Rome, precisely the Rome of Nero; the proof for this was related to the composition of the alloy, (almost pure copper), Nero's taste for gilt, the imperfect casting considered typical of the first century A.D. and the bull-like or Italic structure of the animals. For Cicognara even Roman coins showing triumphal arches surmounted by quadrigas supported his theory; even more so as, in his view, the Greeks did not celebrate victories nor erect triumphal arches to honour them.

Cicognara's publication did not pass unnoticed and, if Giustina Renier Michel in a letter of 16th December, 1815 only com-

MAravigliofi fempre fi reputano e degni di fomme lodi gli avanzi della più colta antichità : e comechè informi frammenti, ovvero da maeftri non molto infigni lavorati, fogliono nondimeno a fe trarre la venerazione di chi gli mira; poichè in effi o fi comprende quello che dovean effere prima di fofferire le ingiurie del tempo, o vi fi fcorge una innocente e nobile leggiadria, ed una traccia delle più belle forme della natura, pregi comuni ad ogni artefice di que' tempi felici. Ma quanto di maraviglia e diletto rechino all' intelletto ed agli occhi de' riguardanti quelle illuftri opere, che non potè il vorace tempo difformare, e che da que' divini maeftri lavorate furono, non fi può fufficientemente fpiegare. Un raro efempio dimoftrafi ne' quattro prefenti CAVALLI, la fomma bellezza e la diftinta confervazione de' quali coloro particolarmente fanno apprezzare che delle antiche cofe hanno contezza; e poffono fra gli altri far chiaro teftimonio della ineftimabile rarità di pezzi così fingolari ed infigni.

Ma poichè non fi può col femplice difegno ogni pregio di effi rapprefentare, convenevol cofa è il formarne una efatta defcrizione; fpiegando a parte a parte quanto v'è d'offervabile. E primieramente il metallo, di cui fono formati, non è bronzo, ficcome falfamente fi dice, ma puro rame; certamente come materia più atta a ricever l'oro, del quale con ricca foglia erano tutti ricoperti. Erano in vero, perciocchè le rapaci mani, perfino dove hanno potuto giugnere fenza pericolo, ne l'hanno indegnamente levato: e appunto avvenne a quefti, quanto accadde alla Statua d'Aleffandro, fatta dorar da Nerone, che nondimeno comechè cicatrizzata per l'oro levato, preziofiffima cofa era riputata [1]. Sono tutti e quattro con due fole forme compofti; effendo talmente congiunte le parti, che ognuno, come fi vede, un diverfo atteggiamento dimoftra. Il getto è molto rinettato e lavorato, fpezialmente nelle tefte e nelle gambe. Offervabili fono alcuni pezzi di lamine tuttavia di rame dorato, e indubitabilmente antiche, rimeffe in diverfi luoghi, e per lo più nel ventre, nel collo, e in quelle parti che reftano vote dopo il gettare. Sono quefte fitte con chiodi di rame, e conneffe con particolar modo di figure angolari, le quali per ifpiegar con chiarezza abbiamo accennate col difegno nel Cavallo pofto al num. XLV. Simili rifarcimenti, che tali probabilmente ftimar fi poffono, vengono confiderati

da

(1) Plinio lib. XXXIV. cap. VIII.

43

156. Page from the volume *Delle antiche statue....* by A. M. Zanetti, published in Venice in 1740, concerning the Horses of San Marco.

mented that the horses of San Marco ''... show they have been created by Lysippus's hands'' [47], much more cutting was Schlegel's monograph [48], which dealt with Cicognara's theory point by point proving it untenable. By means of documents he demonstrated that the Greeks as well set up quadrigas as isolated monuments or as decorations for temples and other major buildings; they too gilded their statues and knew about different breeds of horses, etc. So Schlegel affirmed that the Venetian horses were of Greek origin, that they were possibly sculpted by Lysippus and that, indirectly, they probably represented a monument in honour of a winner of the quadriga race in the Olympic games. Andrea Mustoxidi [49], a scholar, philologist and historian from Corfu, had the credit of redirecting scholars to the historial evidence found in Byzantine historigraphers such as Nicetas Papia, the Anonymous Writer and the Pseudo Codino. These sources enabled him to assert that the Venetian horses came from the island of Chios where they had commemorated a victory by the inhabitants at Olympia or at some other pan-Hellenic games. While the works of Schlegel and Mustoxidi were published in 1816, the following year appeared some *Observations on the Horses of San Marco*, briefly set out by the then extremely youthful Count Girolamo Andrea Dandolo [50]. Following 'Mustoxidi's example, he had examined the Byzantine documents and was convinced that the four Venetian war horses were harnessed to a chariot. We rediscovered the particular passages referring to the gilded chariot of the Sun driven by a charioteer holding a statuette which symbolised the city's fortune. This group, according to the young Count, was made in Rome to decorate Nero's triumphal arch. Originally, even the charioteer had resembled the emperor and, only after Enobarbus's *damnatio memoriae* was the statue decapitated and transformed into the Sun-god, the whole group being later taken to Constantinople by Constantine.

The pamphlet was not favourably received by the critics and was attacked with fierce irony by an anonymous author in *Small Observations*. This demolished Dandolo's arguments and relaunched Mustoxidi's theory, pointing out that the collar's only function was to hide where the head joined the body and did not necessarily indicate that a chariot was involved [51].

Only a few months had gone by before Dandolo issued a second pamphlet in reply to the anonymous author. In this he staunchly defended his theory, but still based his reasons on the arguments already noted above [52].

The English painter Haydon's publication of a comparison between a horse's head from the Parthenon and one of the horses of San Marco is particularly interesting. He concluded that the works, by now known in England as the Elgin Marbles, were superior to the Venetian horses being the ''work of Lysippus'' [53]. This opinion would have seemed unjust to Goethe who had written that, ''I have observed the horses of San Marco closely. From below one can easily see that they are stained and that parts of them are covered by a beautiful copper-green colour. But from a close-up view one sees and realises that they were scored with lines because the barbarians, not content with stripping the gold

off with a file, used chisels instead. However, it could have been worse; at least the shape has survived But what two magnificent pairs of horses! I would like to know what a reliable connoisseur thinks about the strange fact that from a close view they give the impression of being heavy sculpture, whereas when seen from the Piazza, they seem as slender as deer'' [54].

His observation shows that he had noticed the famous scored lines, attributing them to acts of vandalism. Above all, he perceptively stressed that the horses were created to be viewed from a certain distance and angle and so their bodies' dimensions had been modified according to their original site which, therefore, must have been a high one.

The scientific and technological interest of the nineteenth century is shown by the pioneering analyses carried out by Klaproth, Darcet and Bussolin on the alloy of the horses [55], while a frivolous contrast in the second half of the century is represented in an ode by Giacome Zanella where the horses are transformed into mundane orators celebrating a Venetian patrician's wedding [56].

Nor can Ruskin's lyrical description be forgotten: ''these horses are symbols to Europe of the destruction of the Greek Empire by the Latins. They are draught-horses, the horses of a Greek quadriga which became part of Enrico Dandolo's trophies''[57], and elsewhere he affirmed: ''The Greek horses' chests extend themselves into the fullness of their golden strength'' [58].

At the end of the century a recapitulation of all the preceding theories was provided by Dall' Acqua Giusti who, however, found none of them credible [59]. More recently, early twentieth-century scholars have increasingly concentrated on anatomical and technical peculiarities, with a taste for naturalism typical of contemporary archaeological research.

In 1913 Schloezer reviewed the breed and stance of the horses and minutely examined the ears, eyes, manes, tail and legs of the horses of San Marco, without reaching a firm conclusion: ''.... the characteristics of the horses of San Marco do not indicate with any certainty either the hand of a Roman or of a Greek artist before the time of Alexander the Great'' [60].

With Kluge and Lehmann Hartleben, new insights have been gained from research into stylistic comparisons. In fact the former scholar, who was an expert on the technical problems relating to bronze-working, after having decided that each horse was cast in eleven pieces as the result of a study of sectional repairs, the later patch repairs, the mane, the horses and the scoring, observed that, ''.... the four marvellous horses are totally similar to the Roman horses of Naples in terms of casting method, sculpting and mounting''. Lehmann Hartleben also found that some bronze horses and equine heads dating from the Augustine era and largely originating from Herculanum, had several similarities with the Venetian horses, especially in the sculpting of the upper parts of the legs and head, the folds of skin found on the neck and on the raised front leg, the rendering of the eyes, the nostrils, the forelock, etc. ''Because of their imposing structure, their prominent bellies and lightly modelled chest the horses of San Marco belong to Roman art of the Augustan era'' [61]

Many of the scholars who followed these studies took over the above conclusions as if they were indeed conclusive, and advanced the theory of the Roman origins of the horses of San Marco. The only ones not to accept this trend were Richter, according to whom the Venetian horses were".... probably a Roman work inspired by a Greek masterpiece from the second half of the fifth century B.C.''[62], and Markman[63], who in 1943, with a reasoning similar to that of Lehmann Hartleben, asserted the Greek origins of the horses and placed them between the frieze of the Mausoleum of Halicarnassum (350 B.C.) and that of the Pergamon altar (180 B.C.). Apart from these two hypotheses, the period from 1930-1960 produced a series of monographs mainly on Venice and the Basilica. Their authors, obliged to discuss the loggia's four horses, suggested a few possible dates for them and made bare observations which repeat centuries-old information[64]. ''The situation, however, was to alter in the early 1960's[65]. In fact, in 1961 and 1963 two interesting articles by the German scholar, Crome, were published. In the first place, using the collection of sources from Constantinople, he identified the horses as those which drew the chariot of the Sun-god in the Milion of Constantinople. Then he associated the horses with a high pedestal in the Sanctuary at Delphi, next to the golden tripod offered to Apollo by the victorius Athenians at Platea. This pedestal had supported a votive offering by the Rhodians and he identified this gift as the quadriga of Lysippus, mentioned by Pliny (*Naturalis Historia, XXXIV, 63*). Finally, Crome considered that the precious gift was dedicated to celebrating the victory over Demetrius Poliorcetes in 304 B.C., the same event commemorated in Rhodes by the famous Colossus.

Since the tripod was taken away from Delphi in Constantine's time and placed in the hippodrome of Constantinople, Crome assumed that the nearby chariot of the Sun had suffered the same fate, and thus the chariot of the Rhodians became the chariot of the Sun in the Milion[66]. This fascinating theory was adopted by Forlati Tamaro who, however, altered the date to the first half of the third century B.C., believing that one of Lysippus's pupils was responsible for the horses[67].

Other scholars were interested in the horses of San Marco at the same time as Crome, but their interest was focused on the corrosive phenomena found on their surfaces[68]. Various new metallographic analyses were completed[69], and in 1965 Pasquale Rotondi, Director of the Central Institute for Restoration, published an article entitled, ''Concern for the Horses of the Basilica of San Marco in Venice''[70]. Investigations into the presence of certain alterations and the causes of deterioration in the horses were set in motion, laying the foundations for the current highly productive collaboration between archaeologists, chemists, physicists, restorers and metallurgical experts of various kinds.

Results are appearing swiftly. Already in 1967 Leoni, rejecting the legend of the gold thieves, put forward the hypothesis that the scoring visible on the horses was carried out intentionally by the artist himself to reduce the excessive uniformity and brightness of the horses' gilded surfaces[71]. Recent studies by Filippo Magi and Giovanni Becatti could well indicate a new direction in critical research, since they have examined and assessed certain stylistic details hitherto neglected by most scholars. In fact, Magi draws attention to the pupil in the eyes of the horses of San Marco which is enlivened by a half-moon shaped furrow called a *lunula* - a technical device known to have been employed since the middle of the second century A.D. and common in Constantine's time, that is during the first decades of the fourth century A.D. Thus, Magi believes that the horses date from this era but, it should be emphasised that he only ascribes the horses' casting and gilding to the late third and fourth centuries A.D. and not the creative idea behind the quadriga. As the horses' structure and harness show undeniable Hellenic characteristics, Magi assumes that some extremely skilled craftsmen of the third or fourth century A.D. were inspired in their creation of the horses by late Hellenic originals, already infused with Roman solemnity[72]. The same author repeats his theory of the Roman origins of the horses in a second article published a little later. The new proof offered relates to the actual working of the ears which, as will be seen later, consist of a very neat, symmetrical hairy border with a central parting resembling, for example, that found on Marcus Aurelius's horse; this could even shift the dating of the horses back to the second century .A.D.[73].

After Magi, Becatti as well, having taken the *lunula* into account, proposes that the horses were created in Constantine's time. However, the sculptors of the Venetian horses, rather than being inspired by a Hellenistic model, actually reproduced the horse mechanically, taking the cast from non-gilded originals identifiable as those which pulled the Lysippus quadriga at Delhpi, referred to by Crome.

This hypothesis would not explain the presence of the *lunula* and so Becatti thinks that the copyists of the third and fourth centuries A.D. modified the cast's pupils to enliven and emphasise the expression of the eyes. This change was indeed made necessary by the later gilding, a practice which was more common in the imperial era[74].

For the time being this critical review of the various hypotheses advanced to explain the origins of the horses of San Marco can be concluded. However, the most recent publications of Vittoria, Pavan and Vittori should also be mentioned.

Vittoria[75], in a monograph dealing with all the horses found in Venice, including nineteenth-century equestrian monuments and adopting Leitz's theory, says that the San Marco quadriga is of Greek origin because of the way the manes are cut and the high percentage of copper in the alloy. However, he attributes the work to either Polyclitus or Myron rather than to Lysippus. Of particular interest in this study are the items of information and the photographs relating to the horses' movements during the First and Second World Wars, discussed in more detail in another section.

Pavan[76] has gathered the sources and evidence relating to the Venetian horses up to 1817 in a thorough critical study which was most helpful in preparing the preceding text. Above all, he examines the activities, ideas and writings of Antonio Canova

who was personally involved in restoring the horses to the Most Serene Republic of Venice.

Finally, Vittori [77], with the aid of electronic instruments, has examined the scored lines which are clearly visible on all four horses. He has been able to confirm that these marks were not produced by gold thieves as imaginatively suggested, even by Goethe (see p.159), but were made intentionally by the craftsmen to lessen the brilliance of the gilt which, if it had remained uniform, would have produced a blinding reflection under the sun's rays, obliterating the quadriga's sculptural form. Sometimes parallel and sometimes intersecting, the scoring must have had the same function as hatching in a drawing.

This is the situation today. Studies will continue to produce alternative theories taking advantage, as is only beginning to happen, of help provided by various disciplines, including many new ones. While this is certain, however, such studies will not prevent ancient legends persisting when poets and writers consider the palimpsest of the façade of San Marco which is the horses' setting.

"Masterpiece of the collection - the four bronze horses above the principal entrance, the only ancient quadriga surviving, a Greek work probably from the fourth or third century B.C., a work which has fired debates throughout the ages, no doubt already picked out by Nero to crown his triumphal arch, transferred by Constantine to his New Rome where it dominated the hippodrome, and appropriated by Napoleon for the Arc de Triomphe du Carrousel where it remained until returned to Venice on the orders of the Congress of Vienna. *In spite of all this, their secret remains intact*" [78].

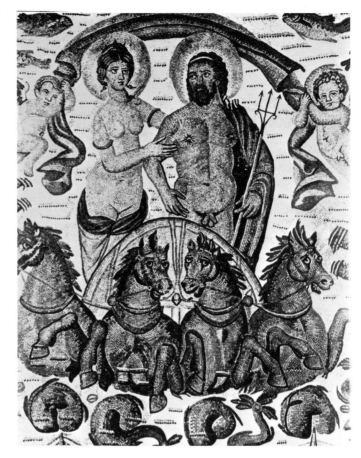

(1) *La ducale basilica di San Marco. Documenti per la storia dell'augusta ducale basilica di S. Marco in Venezia dal nono secolo sino alla fine del decimo ottavo*, Venice 1886, p. 210, document n. 812.

(2) A. MUSTOXIDI, *Sui quattro cavalli della Basilica di S. Marco in Venezia*, Padua 1816.

A.G. DANDOLO, *Sui quattro cavalli della Basilica di S. Marco. Osservazioni*, Venice 1817.

J.F. CROME, *Die goldenen Pferde von San Marco und der goldene Wagen der Rhodier*, in Bull. Corr. Hell, LXXXVII (1963), pp. 209-228.

(3) Works consulted: P. GILLES, *De Topographia Constantinopoleos, et de illius antiquitatibus libri quatuor*, Lugduni 1562.

SVIDAS, *Lexicon*, Coloniae Allobrogum 1619.

P. LAMBECIUS HAMBURGENSIS, *Georgii Codini et alterius cuiusdam anonymi Exerpta de Antiquitatibus Constantinopolitanis*, Paris 1655.

A. BANDURI, *Historia Byzantina. Imperium Orientale Tomus XXII sive Antiquitates Constantinopolotanae in quatuor partes distributae*, Venice 1729.

NIKHIA TOU XONIATOU, τάεϑριοκόμεγα πάγτα quoted by J.P. Migne, in *Patrologia Greca*, vol. CXXXIX, Turnholti 1865.

T. PREGER, *Scriptores Originum Constantinopolitanarum*, Lipsiae Teubner 1901-1907.

157. Mosaic from Constantina. Louvre, Paris.

(4) A. BANDURI, *op.cit.*, vol. 1. part III, p. 37, 114, p. 91, 302. These passages are also mentioned in the Pseudo Codino cf. P. LAMBECIUS HAMBURGENSIS, *op.cit.*, pp. 29 and 104. It was then believed that Theodosius II had brought back the Horses from Chios in order to restore the artistic character of Constantinople, severely damaged by an earthquake in 447. See C.A. MUSTOXIDI, *op.cit.*, p. 3, and M. MACLAGAN, *The City of Constantinople*, London, 1968, p. 35.

(5) NIKHTA TOU XONIATOU, *op.cit.*, book III, p. 458, 156.
The third book is titled *De Manuele Commeno*.

(6) The first edition of Niceta's work appeared in Basle in 1557.
M. PAVAN, *Canova e il problema dei cavalli di San Marco*, in Ateneo Veneto XII, 1974 part II, p. 85.
Among those who support this attribution are the following:
P. GILLES, *op.cit.*, book II, chap. XIII, pp. 92-93.
M.F. SANSOVINO, *Venetia città nobilissima et singolare*, Venice 1581, II, p. 31.
P. RAMNUSIO, *De bello costantinopolitano Historia*, Venice 1634, book III, p. 129.
C. DU FRESNE DU CANGE, *Historia Byzantina*, Venice 1729, part II, book II, pp. 84-85.
T. TEMANZA, *Vita di Alessandro Vittoria*, Venice 1828, p.7.
A. MUSTOXIDI, *op.cit.*, p. 19-20.

(7) A. BANDURI, *op.cit.*, book I, part III, p. 37, 115.

(8) A. BANDURI, *op.cit.*, book I, part III, p. 38, 118.

(9) The term Neolea is not mentioned in any byzantine lexicon, only the word "youth" is given, however, its origins remain obscure and evidently it was the place where young people sat. A. VOGT, *L'Hippodrome de Constantinople*, in Byzantion X (1935), pp. 471-488. A. PIGANIOL, *La Loge impériale de l'hippodrome de Byzance et le problemè de l'hippodrome couvert*, in Byzantion XI (1936), pp. 383-390. R. JANIN, *Constantinople byzantine, développement urbain et répertoire topographique*, Paris 1950, p. 105, G. BECATTI, *Costantinopoli*, in E.A.A. II (1959), pp. 880-914. G. FORNI, *Circo*, in *E.A.A.* (1959), pp. 647-649.

(10) A. BANDURI, *op.cit.*, vol. I, part III, p. 72, 222. These passages can also be found in the Pseudo Codino. Cf. P. LAMBECIUS HAMBURGENSIS, *op.cit.*, p. 32.

(11) See p. 156.

(12) A. BANDURI, *op.cit.*, vol. I, part III, p. 13, 35; p. 79, 259. These passages can also be found in the Pseudo Codino. Cf. P. LAMBECIUS HAMBURGENSIS, *op.cit.*, pp. 21-22 and p. 93.
P. GILLES, *op.cit.*, book II, chap. XXIII, pp. 125-126.

(13) The Milion was a double arch from which the various imperial roads spread out to the provinces. It was the twin to the Miliario Aureo of Rome but was much larger. However, the word Milion here is used to refer also to the surrounding square.
R. JANIN, *op.cit.*, pp. 104-105. J.F. CROME, *op.cit.*, p.220.

(14) The following passage, quoted in full, throws more light on this question: "From ancient times, a sun-chariot with four fire-horses, each of which appeared to fly from two columns, was placed on the *Milion aureo*; when this sun-chariot was carried into the Hippodrome, a new statue was placed inside it representing the fortune of the city which had been built by Constantine and which was considered to be carried by the sun. It was borne before the throne, accompanied by many important men, and there received the prizes of the contest from Constantine's own hands. It would then be crowned and taken to be placed in the Senate until the City's next birthday. Subsequently, because of the cross that was inscribed upon it, this statuette was cast down into the pit, joining many other such statues worthy of admiration which had been thrown there by the orders of Julius" (A. BANDURI, *op.cit.*, vol. I, part III, pp. 79, 259).

(15) J.F. CROME, *op.cit.*, p. 221.

(16) See p. 151 and J.F. CROME, *op.cit.*, pp. 210-211.

(17) F. PETRARCA, *Epist. rer. senil.*, IV, 2.

(18) *La ducale basilica di San Marco, Documenti.....*, Venice 1886, p. 210, document n. 812.

(19) B. FORLATI TAMARO, *Nuove ipotesi sui cavalli di S. Marco*, in Rend. Pont. Acc. XXXVII (1964-65), p. 85.

(20) M. PERRY, *St. Mark's Trophies: Legend, Superstition and Archaeology in Renaissance Venice*, Journal of the Warburg and Courtauld Institutes 40. 1977, pp. 27-33.

(21) CYRIAC OF ANCONA, *Itinerarium*, Florence 1742, p. 33. Towards the end of 1400 Mark Antonio Sabellico called the Horses of St. Mark's "beautiful but not of their time". M.A. SABELLICO, *Historia Rerum Venetarum ab urbe condita*, Basle 1556, decade I, book VII, p. 203.

(22) M. SANUDO, *Vite de' Duchi di Venezia*, in Rer. Ital. Script, vol. XXII, Mediolani 1733, part IV, column 534 b-c.

(23) This method, afterwards adopted by Giustiniani and Ramnusio, was already being questioned at the end of the last century by the following author: A. DALL'ACQUA GIUSTI, *I quattro cavalli sulla facciata della Basilica di San Marco*, Venice 1894, p. 11.

(24) The name of Lysippus was mentioned by Stella (opus est illud Lysippi), by Giustiniani (Lysippi, ut aiunt, opus), by Sansovino (secondo alcuni, furono scolpiti da Lisippo), by Ramnusio, Sivos and Corner. For the references see elsewhere.

(25) A. STELLA, *Elogia Venetorum navali pugna illustrium*, Venice 1558, p. 82.

(26) P. GIUSTINIANI, *Rerum venetarum ab Urbe Condita ad annum 1575 Historia*, Venice 1576, book II, p. 36.

(27) S. ERIZZO, *Discorso sopra le medaglie antiche, con particolare dichiaratione di molti riversi*, Venice 1559, pp. 171-172.

(28) M. HOSPITAL, *Carmen*, Amsterdam, 1732, p. 431.

(29) P. GILLES, *op.cit.*, pp. 92-93.

(30) Niceta was published in Basle in 1557, cf. M. PAVAN, *op.cit.*, p. 85 and p. 137 of this publication.

(31) P. GILLES, *op.cit.*, pp. 125-126.

(32) M.F. SANSOVINO, *op.cit.*, II, p. 31. Echoed by Sanudo, Erizzo and Gilles.

(33) F. SANSOVINO, *op.cit.*, XIII, pp. 232-233. One also finds here: ".... given to the Romans by Tiridates, King of Armenia...."

(34) P. RAMNUSIO, *op.cit.*, book III, p. 129. See also B. DE MONTFAUCON, *Diarium Italicum*, Paris 1702, p. 51. *La Ducale basilica di San Marco. Documenti....*, Venice 1886, p. 11, document no. 86 of Sivos.

(35) M. PAVAN, *op.cit.*, p. 87.

(36) C. DU FRESNE DU CANGE, *op.cit.*, part II, book II, pp. 84, 85, 111.

(37) C. PATIN, *Thesaurus numismatum*, Venice 1683, p. 94.

(38) ANTON MARIA DI GEROLAMO ZANETTI, ANTON MARIA ALESSANDRO ZANETTI, *Delle antiche statue greche e romane, che nell'antisala della Libreria di San Marco, e in altri luoghi pubblici di Venezia si trovano*, Venice 1740, vol. I, pls. 43-46.

(39) F. CORNER, *Eccleiae venetae antiquis monumentis... Illustratae*, Venice 1749, decade XIII, pp. 124-125.

(40) G.G. WINKELMANN, *Storia delle arti del disegno presso gli antiche*, Milan 1779, vol. I, pp. 299-300; vol. II, pp. 25, 26, 27, 29, 36-37, 283-284.

(41) G.G. WINKELMANN, *Storia dell'Arte nell'antichità*, Turin 1961, p. 208.

(42) STENDHAL, *Promenades dans Rome*, 28 Dec. 1827, p. 223; in H. DIECKMANN and J. SEZNEC. *The horse of Marcus Aurelius. A Controversy between Diderot and Falconet*, in Journal of Warburg and Courtauld Institutes, XV, 1952, pp. 198-228.
Cf. M. PAVAN, *op.cit.*, p. 89.

(43) T. TEMANZA, *op.cit.*, p. 7.

(44) Cf. M. PAVAN, *op.cit.*, p. 90.

(45) Cf. M. PAVAN, *op.cit.*, p. 92.

(46) L. CICOGNARA, *I quattro cavalli riposti sul pronao della Basilica di S. Marco. Narrazione storica*, Venice 1815.

(47) G. RENIER MICHIEL, *Dei quattro cavalli riposti sul pronao della Basilica di S. Marco*, Venice 1893.

(48) A.W. SCHLEGEL, *Lettre aux éditeurs de la Bibliothéque Italienne, sur les chevaux de bronze de Venise*, Florence 1816.

(49) A. MUSTOXIDI, *Sui quattro cavalli della Basilica di S. Marco in Venezia*, Padua 1816.

(50) G.A. DANDOLO, *Sui quattro cavalli della Basilica di S. Marco. Osservazioni*, Venice 1817.

(51) ANONIMO, *Osservazioncelle sulle osservazioni del Conte Girolamo Antonio Dandolo Viniziano Patrizio sui quattro cavalli della Basilica di S. Marco in Venezia*, Venice 1817.

(52) G.A. DANDOLO, *All'autore delle osservazioncelle. Riposta*, Venice 1817.

(53) R.B. HAYDON, *Comparaison entre la tête d'un des chevaux de Venise, et la tête du cheval d'Elgin du Parthénon*, London 1818.

(54) J.W. GOETHE, *Italienische Reise*, Leipzig 1913, vol. I, pp. 87-88.

(55) P. BUSSOLIN, *Lettera al Signor Direttore dell'I.R. Zecca di Venezia Dottore Leopoldo Berchet socio dell'Ateneo di Treviso, ecc. Esponente l'analisi chimica del metallo, di cui sono composti i quattro cavalli esistenti sul pronao dell'I.R. Basilica di S. Marco*, Venice 1843.

(56) G. ZANELLA, *I cavalli di S. Marco*, Venice 1877.

(57) J. RUSKIN, *Venezia*, Florence 1901, p. 111.

(58) J. RUSKIN, *Le pietre di Venezia*, Rome 1910, p. 97.

(59) A. DALL'ACQUA GIUSTI, *I quattro cavalli sulla facciata della Basilica di S. Marco*, Venice 1894.

(60) L. VON SCHLOEZER, *Die Rosse von San Marco*, in R.M. XXVIII (1913), pp. 129-182.

(61) K. KLUGE, K. LEHMANN HARTLEBEN, *Die Antiken Grossbronzen der Romischer Kaiserzeit*, Berlin-Leipzig 1927, II, pp. 78-79 (KLUGE) and p. 85 (LEHMANN HARTLEBEN).

(62) G.M.A. RICHTER, *Animals in Greek sculpture*, London 1930, p. 59, pl. XXIII, fig. 70. She points out that Bieber too considered it to be a Roman copy of IV century B.C. Greek originals.

(63) S.D. MARKMANN, *The horse in Greek art*, Baltimore 1943, pp. 130-131.

(64) L. MOREL D'ARLEUX, *Les tribulations des chevaux de Venise*, in Bull. Soc. d'Hist. et d'Archéol. XXXIV (1933-34), pp. 373-377.
A. CAMBIE, *Il cavallo nella scultura attraverso i secoli*, Milan 1934, pp. 1-32.
E. BRESSAN, *La basilica di S. Marco in Venezia*, Venice 1943, pp. 13, 26, 30-31, 33, 89.
G. MARIA CHER - T. PIGNATTI, *San Marco di Venezia*, Florence 1950, pp. 5, 14, 21, 27, G. MUSOLINO, *La basilica di San Marco*, Venice 1955, p. 670.
L. LORENZETTI, *Venezia e il suo estuario*, Rome 1956, p. 168.

(65) The horses are also considered in O. DEMUS, *The Church of San Marco in Venice*, Washington 1960, pp. 27, 113.

(66) J.F. CROME, *Der goldene Wagen der Rhodier, Die Reiterwelt*, 1961, issue 7, p. 8.
J.F. CROME, *Die goldenen Pferde von San Marco und der goldene Wagen der Rhodier*, in B.C.H. LXXXVII (1963), pp. 209-228. This theory was repeated by I. BALDASSARRE, *Venezia*, in E.A.A. VII (1966), pp. 1128-1129.

(67) B. FORLATI TAMARO, *Nuove ipotesi sui cavalli di S. Marco*, in Rend. Pont. Acc. XXXVII (1964-65), pp. 83-104".

(68) S. LIBERTI, *Indagini sullo stato di conservazione dei cavalli di bronzo della Basilica di San Marco in Venezia*, Rome 1962.

(69) C. PANSERI - M. LEONI, *Esame metallografico dei cavalli di bronzo della Basilica di San Marco in Venezia*, Rome 1962. A symposium was held in Venice in October 1964 on "The Conservation of bronze and ancient non-ferrous metals".

(70) P. ROTONDI, *Allarme per i cavalli della basilica di San Marco a Venezia*, Boll. Ist. Centr. Restauro 1965, pp. 6-20.

(71) M. LEONI, *Indagini metallografiche sui cavalli bronzei della Basilica di San Marco di Venezia*, in Enc. Scienza e Tecnica, 68 (1967), pp. 392-3, caption to fig. 3.

(72) F. MAGI, *La data dei cavalli di S. Marco*, in Rend. Pont. Acc. XLIII (1970-71), pp. 187-201.

(73) F. MAGI, *Ancora sulla data dei cavalli di San Marco*, in Rend. Pont. Acc. XLIV (1972), pp. 209-217.

(74) G. BECATTI, *Interrogativi sui problemi dei cavalli di San Marco*, in Rend. Pont. Acc. XLIII (1970-71), pp. 203-206.

(75) E. VITTORIA, *I cavalli di Venezia*, Venice 1972, pp. 13-87, 167-173.

(76) M. PAVAN, *Canova e il problema dei cavalli di San Marco*, in Ateneo Veneto XII (1974), II, pp. 83-111.

(77) I. VITTORI, A. MESTITZ, *Quattro cavalli d'oro al sole*, Venice 1974.

(78) M. BUTOR, *Description de San Marco*, Paris 1963, pp. 14-15.

Part Two Description of the Horses of San Marco

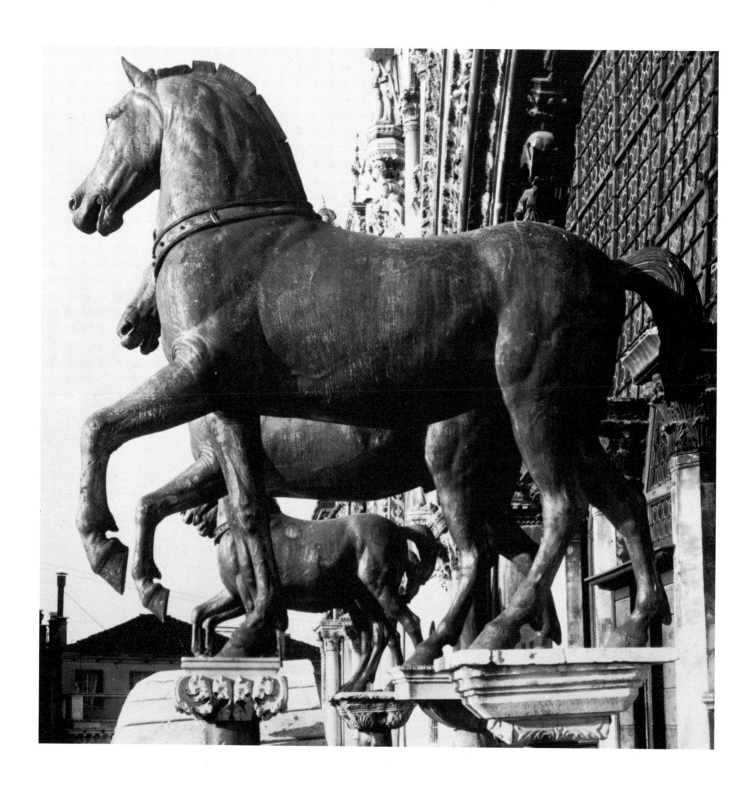

158. The four Horses of gilded bronze on the loggia of the Basilica of San Marco.

A descriptive analysis of the Horses of San Marco

Anna Guidi Toniato

It is fairly difficult for the visitor to observe and admire the horses of San Marcos on the loggia of the Basilica. As more than sixty years have passed since the first and last complete descriptive study of the horses [1] this analysis needs to be brought up to date. The four gilded bronze horses (fig. 158) form the only quadriga from the classical era which has survived the ravages of time. In ancient illustrations of four-horse chariots (fig. 159) the two outside horses generally have heads turning outwards, while the inner horses have inward-looking ones. In this case, however, the normal arrangement was abandoned because of the Basilica's central arch which determined the sub-division of the four horses into two pairs. The unusual nature of this arrangement as compared with the traditional pattern is one of the most original aspects of the San Marco quadriga. The similarity of the two couples does not mean that the two pairs were cast from identical moulds, even if it had been technically possible (see Leoni, p. 175). This problem will only be solved when all four horses have undergone photogrammetric analysis (see Sena, p. 229); this could reveal much important information concerning ancient technology.

The Heads

The heads of the four horses (figs. 160-161) are exceptionally expressive. When one looks at them, one senses their intimate, vibrant, dynamic power, which is intense though firmly restrained. They consist of extensive luminous surfaces delicately enlivened by a complex network of veins and by robust muscular contours which are more in evidence where the skin is tightly stretched. The bone structure of the skull is difficult to distinguish since it is covered by a layer of fairly thick skin, and the profile of the head is arched in line with the nasal bone system (see Azzaroli, p. 155). The head itself is composed of many extremely interesting features; the fact that one is bent to the right and another to the left is not an end in itself, for this movement directly governs the opposing positions of the ears (fig. 162). In fact, if an ear points forwards, the other points outwards, always following the direction in which the horse is looking. But all this is of secondary importance when compared to the unusual treatment of the ears themselves. Along the outer edge there is a wide, hairy border having a clearly marked parting and a series of wavy incisions creating a pattern of ordered and symmetrical tufts on either side. This is certainly not a realistic representation but is, in fact, an instance of extremely elegant stylisation. It is this very feature which convinced Magi that the horses dated from the Antonine era onwards (second century A.D.) because this type of stylisation is the "trade-mark" of the era concerned [2]. The forelock is tied together betwen the ears by a narrow band with its ends falling down each side. It probably terminated in a final tuft which, although missing today, appears in an engraving by the Zanetti cousins (fig. 165) [3] who were faithful students of all Venetian matters during the eighteenth century. Also of interest are the delicate folds in the skin, emphasising the protuberance above the eyes (fig. 163) and also resembling similar effects found in the heads of the gilded bronze horses of Cartoceto from the first century A.D.

The eyes in particular have recently been the subject of study [4]. This is largely because of the characteristic *lunula*, that is the half-moon type of incision which gives the pupil a vivacious quality and creates certain effects of light and shadow. The actual depth of the eye socket enhances this impression as do the thickness of the upper eyelid and the projection of the vigorous, arched eyebrow. "Far from being naturalistic it attempts to convey a pictorial effect involving a gleam of light at the top of the cornea; the darker the half-moon shaped cavity is the brighter the gleam ... However, the deep corneal furrow is strongly realistic and anatomically correct ... The half-moon cavity ..., which we observe in the Venetian horses' eyes, is a way of representing the pupil which was a common practice in Constantine's time ..." [5]. The *lunula*, therefore, could be used to date the horses.

The mouth is half-open (fig. 164) with folds evident at its extreme corners; the lips partially reveal the precisely sculptured, even teeth; the tip of the tongue curls upwards. All these indicate that the mouth is being stretched by the bit, only its ring ends still being visible. In fact, in a letter written in 1815, a Venetian noblewoman wrote that the bit was broken off by her fellow Venetians, so that nothing capable of restraining the horses should be seen since they were a symbol of the power wielded by the Most Serene Republic of Venice [6].

The holes visible above the bit and on the cheek (fig. 161) indicate where the nails, which formerly fixed the now lost straps of the harness, were originally driven into the head [7]. Fortunately

139

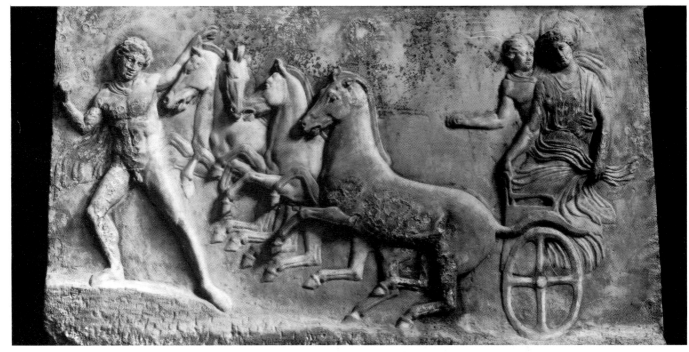

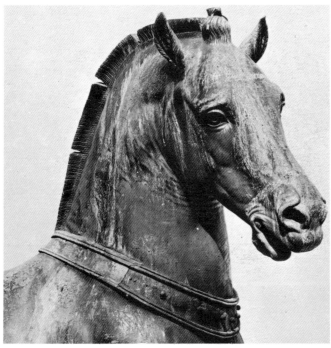

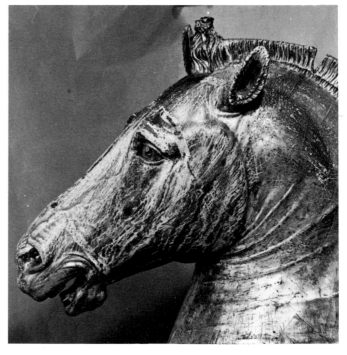

159. Attic relief of a quadriga. End of 5th century B. C.

160. Head of Horse ''D'' seen foreshortened.

161. Head of Horse ''A'' seen in profile.

140

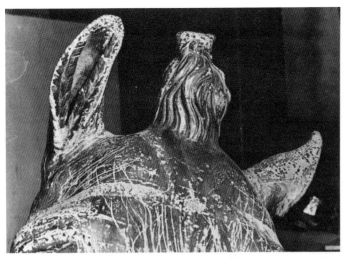

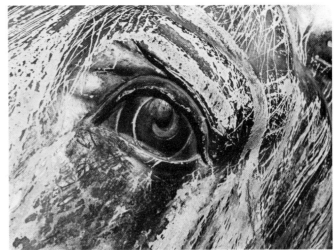

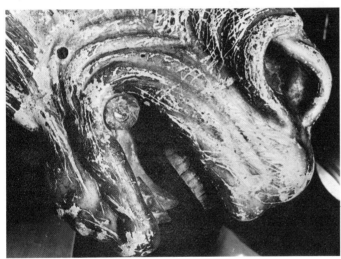

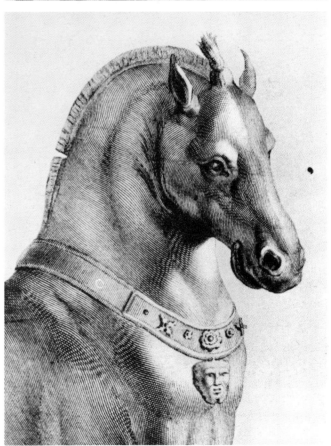

162. Detail of head of Horse ''A'' showing the ears and forelock.

163. An eye of Horse ''A''.

164. The nostrils and mouth of Horse ''A''.

165. The head of Horse ''C'' in 1740.

one can reconstruct the original arrangement (fig. 166) because the horses were gilded after the separately cast parts of harness had been attached [8]. Therefore, the areas which were formerly covered by the harness are now without gilding and thus fairly easy to identify (see Azzaroli, pp. 161-162). Two low fringes cut the same length on either side of the mane are relieved by an undulating pattern (the width varies from 4--6 cm. (figs. 167-170). The manes do not follow the shape of the neck in an unbroken curve but, instead, have gaps in various places; in particular, horses A and C[9] have similar manes with three notches, whereas horses B and D have four of them. There are other differences to be found in the treatment of the mane; for instance, in three cases, (horses A, C and D), the side of the mane is marked by flowing lines, whereas in the case of horse B, this portion of the mane is characterised by rather coarse and rigid, slanting lines that converge at the tip and base of the mane. A similarly odd divergence is to be found in the way the top of the mane is defined. The manes of horses A, B and D, with their criss-cross slanting lines, are inexplicably different from the perpendicular line pattern found on horse C (figs. 171-174).

As far as the technical aspects of the manes are concerned, Kluge thought that what one now sees is a badly executed repair, done in order to hide the loss of the original long and undulating mane [10]. The unimpaired state of these parts already recognised by Crome [11] is, however, certain and represents a style which supports the "classicism" of the horses. In fact, the highly-curved forelock bound upright and the hogged mane are Greek characteristics. As these elements were to be frequently imitated in subsequent centuries, they could just as much represent a surviving fashion as provide accurate clues for dating.

The horses have a collar at the base of the neck (fig. 175). This is well modelled and is entirely surrounded by a double border with a roundish outline. The part at the back was cast with the rest of the body, whereas the front part consists of a separately-worked band which serves to soften the transition from the neck muscles to those of the chest. Today the collar is ornamented with six spherical studs on horses A and C; whereas on horses B and D there are actually seven small spheres. The engraving described above (fig. 165) shows that these decorative elements are simple replacements for the four-petalled flowers and roses which were lost not all that long ago since the Zanetti cousins were able to see and record them in the mid-eighteenth century [12].

There are signs indicating that even the front part of the collar is a substitute for the original which was lost (see Leoni, p. 175). Evidence from Bellini's painting (fig. 119) showing the horses with what seem to be pointed, not circular, collars, completed by an indistinct appendage, certainly supports this theory. The graphic evidence left behind by the Zanettis enable us to identify the two rings which today hang from the lower edge of the collar (fig. 178) as part of a hinge for attaching some kind of decoration similar, perhaps, to the small bearded mask which belongs to the Procuratoria of San Marco (fig. 176). From Figure 175 it is evident that the collar juts out over the horse's chest. This could mean that the collar is not an original part of the sculpture, and

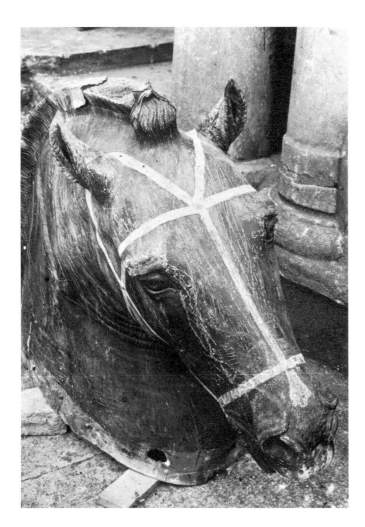

166. Photograph taken during the restoration of 1903 showing a reconstruction of the head harness of one of the Horses.

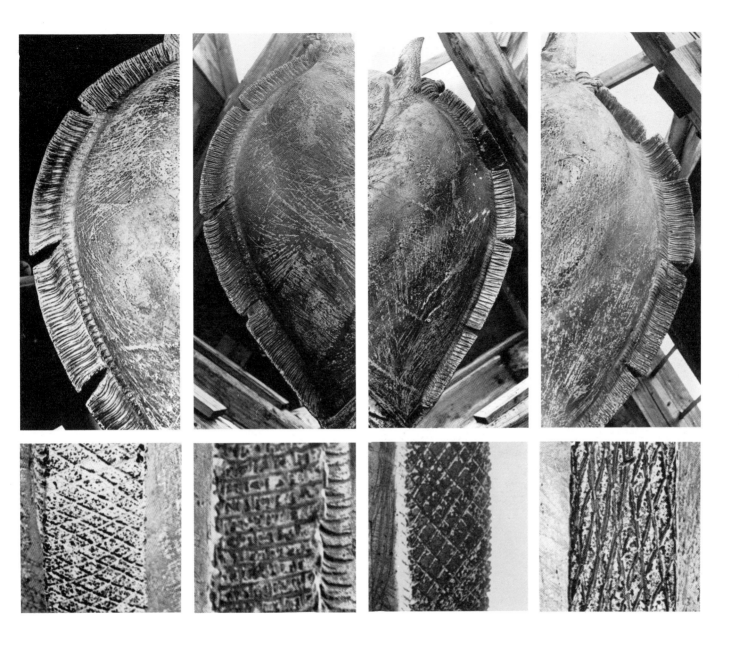

167 -168. The manes of Horses ''A'' and ''C'' seen in profile.

169 - 170. The manes of Horses ''B'' and ''D'' seen in profile.

171 - 174. The manes of Horses ''A'', ''C'', ''B'' and ''D'' seen from above.

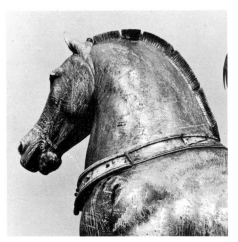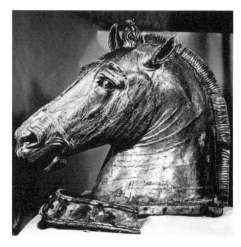

175. The projection of the collar on Horse ''B''.

176. Probable copy of an ornamental feature which originally hung from the collars of the Horses of San Marco.

177. Head and collar of Horse ''A''.

178. Detail of collar of Horse ''A'' showing rings projecting from the lower border.

179. Horse ''B'' during the restoration in 1903.

that the mask through its convex shape served to disguise the unevenness between adjacent surfaces.

Apart from these considerations, there is no doubt that the presence of the collar and harness proves that the horses of San Marco were at one time drawing a chariot which has unfortunately long since disappeared.

It should be emphasised that the collar's function is also to hide where the head joins the body, since it is not soldered but attached by a series of screwed-on bolts. In fact, every horse can be separated into three parts (figs. 177-179) - the front part of the collar, the head and the body.

The neck is very muscular; its unnatural position depends, perhaps, on the pulling action of the bit. The large area of the neck includes lightly indicated creases in the skin which turn into real folds under the throat, then becoming more numerous and pronounced on the side the head is turning.

The Body

The rounded chest muscles (fig. 184) are sensitively joined; the broad mass of the shoulder is particularly marked while the muscles underneath slant slightly inwards. From a comparison between horse B's right flank and horse A's left one (figs. 182-183), it is evident that the muscular patterns of the shoulder and thigh alter according to the positions of the legs. As far as anatomical accuracy is concerned, the abdomen, corresponding to the false ribs, is broad and formless, without that prominent line from the breast bone to the groin region which definitely makes horses look slimmer and is particularly evident in the representation of restless Greek horses rearing or impetuously galloping.

Besides this, the loins are rather too long and the rump not sufficiently high to compensate for a certain sagging effect in the structure of the body in each horse. But, as Goethe had already noticed[13] when they are observed from the Piazza the horses appear much thinner than when seen from the loggia itself. These presumed defects were, therefore, technical expedients intentionally used in order to counteract the elongated appearance of all objects viewed from quite far below. This would suggest, therefore, that the horses must have been placed in a high position from the very beginning, perhaps on pedestals[14] or on a triumphal arch[15] or, indeed, as has already been suggested, perhaps overlooking the starting point in Constantine's hippodrome[16].

Underneath the belly of each horse and close to the front legs there is a square aperture (fig. 185), somewhat roughly plastered over. This relates to the main support which held the complex structure of core, wax, potter's clay, inlets and small vents together during the casting (see Leoni, p. 175).

The tails (fig. 180) are full and flowing, arched gracefully and held well out from the body of each animal. Their surfaces are broken up by a series of highly worked, long and soft strands of hair which are prevented from getting tangled by a tight band at the end of the tails. There is a hypothesis concerning even the tail; namely that its extremity has been lost. Once again, the Zanetti

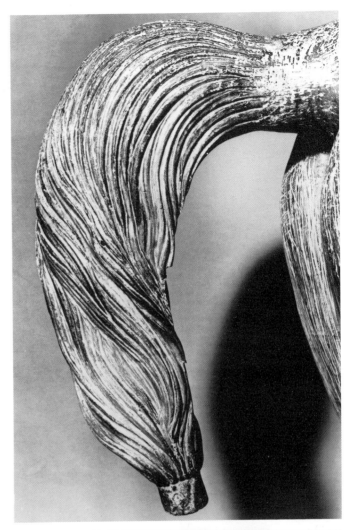

180. Tail of Horse "A".

181. The chestnut of the rear leg on Horse "B".

145

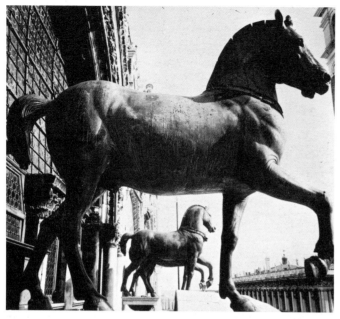

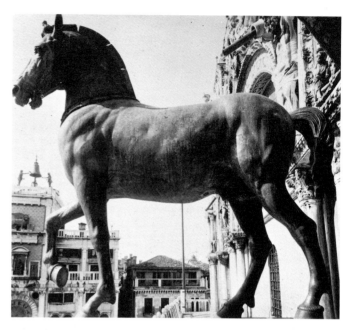

182. The right flank of Horse "B".

183. The left flank of Horse "A".

184. Pectoral muscles of Horse "A".

185. Rectangular aperture under the belly of Horse "C".

cousins provide the evidence [17] since one of their engravings (fig. 188) clearly shows an unusual extension to the final binding in the horse's tail. Could this represent the only remaining element of an even more splendid tail?

The Legs

Various folds of skin which tend to shift in relation to the animal's position (fig. 158) are found both in the regions of the groin and upper part of the inside foreleg. One life-like detail is shown in all the horses - the chestnut (fig. 181) - a well-hidden, horny lump which is seen inside the leg. In the forelegs it is located just above the knee, while in the hind ones it occurs just below the hock [18]. The legs, which are long and muscular, are particularly thin around the cannon bone; here the taut skin reveals bones, muscles, veins and tendons, although close to these accurate details there is evidence of various kinds of damage, coarse surfaces and sectional repairs (fig. 16). After all, it should not be forgotten that the very position and delicacy of the legs made them particularly vulnerable during the casting process as well as to the ravages of time. In fact, some of them have been broken and repaired; in one case at least a completely new piece has been substituted, as the following passage records: ''Four large gilded, bronze horses, which were at Constantinople, were brought to Venice …. One of these horses was on the ship of Ser Domenico Morosini Sopracomite, and through misfortune a hind foot broke off … the said Ser Domenico Morosini wanted to keep that as a memento. Thus, the Signoria ordered another one to be made and added to the appropriate horse'' [19].

The front leg, which is raised in a very life-like way, reveals the supple tendons of the foot; on account of this, the hoof which is no longer bearing any weight, bends backwards (fig. 189) revealing the under part made smooth by a plaster finish. The unshod hooves are broad and rounded, being framed by a raised fringe of hair known as ''the coronet'' rendered by a series of small, oblique lines which curve slightly, still keeping roughly the same distance apart. This is a particularly unusual stylisation, especially when compared, for example, with the equivalent parts of the horse in the Palazzo Dei Conservatori (fig. 188) or of the horse belonging to the equestrian statue of Marcus Aurelius (fig. 191), both in Rome.

Above the hoof there is a horny protuberance inside the fetlock covered in the case of all four animals by more tufts of hair. This particular feature is found on other ancient horses, both Greek and Roman. On some of the hooves (fig. 192-197), as on the back of the neck, certain Roman numerals are visible, but their significance is still obscure, even though it has been suggested that these numbers refer to a certain measurement, perhaps the weight.

Passing now to other observations, it is worth mentioning that, while one leg is being raised, the others firmly rest on the ground. Since only when walking can a horse have three feet on the ground together, the horses of San Marco must consequently be walking. The front leg is raised to an average height which consequently limits the forward thrust of the horses. There are no

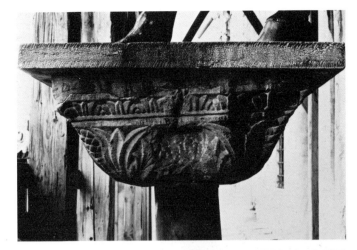

186. Capital supporting the hind legs of Horse ''B''.

187. Capital supporting the unraised foreleg of Horse ''B''.

147

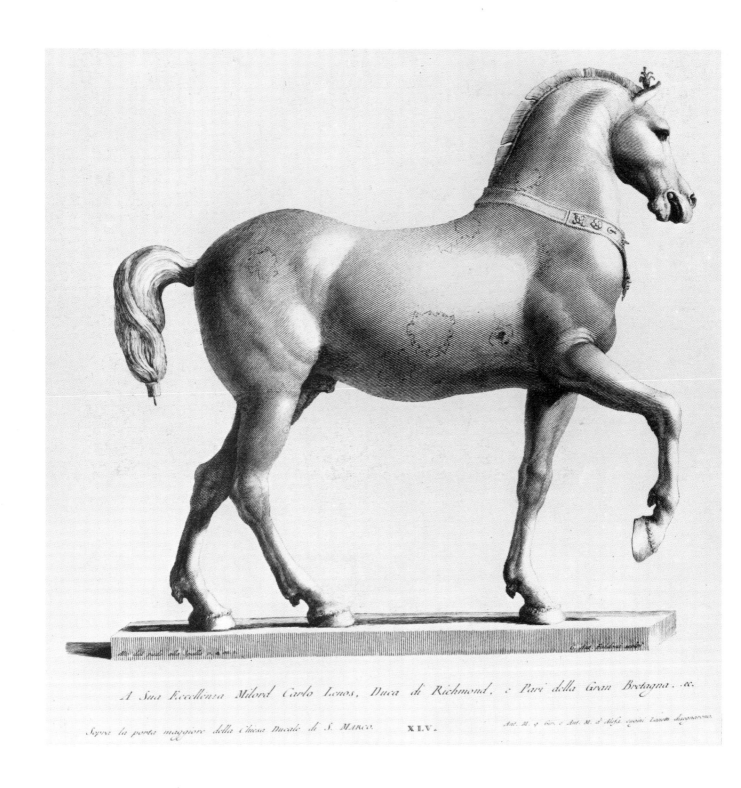

A Sua Eccellenza Milord Carlo Lenos, Duca di Richmond, e Pari della Gran Bretagna. ec.

Sopra la porta maggiore della Chiesa Ducale di S. Marco. **XLV.** *Ant. M. g. Gio. e Ant. M. d' Alise cognti Zanetti disegnavano*

188. Horse ''B'' in an engraving published in 1740.

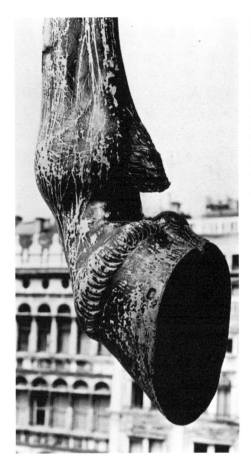 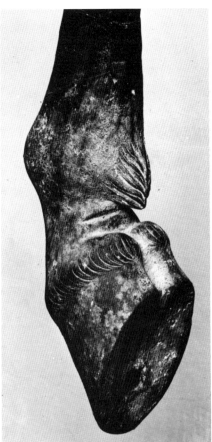 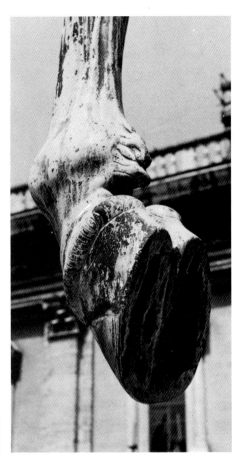

189. Detail of raised front hoof of Horse ''D''.

190. Detail of raised front hoof of bronze Horse in the Palazzo dei Conservatori, Rome.

191. Detail of raised front hoof of horse in the equestrian monument of Marcus Aurelius, Piazza del Campidoglio, Rome.

192 - 197. Examples of numerals visible on the collars (190-191) and hooves of the Horses of San Marco.

150

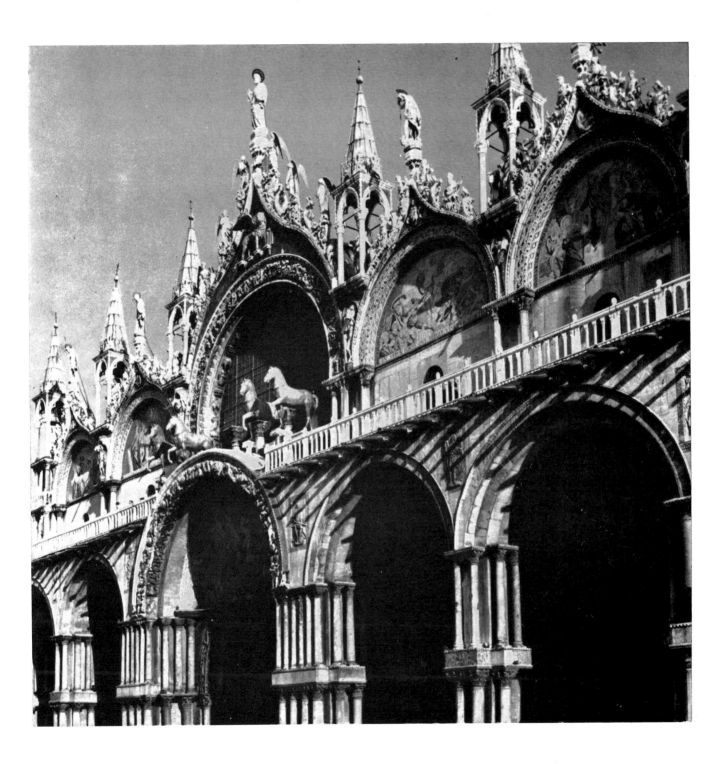

198. The Horses of San Marco in the loggia.

particular signs of haste or liveliness in the rhythm of these slow-moving animals which advance with short, measured steps; according to Schlegel, their progression is solemn, magnificent and ceremonial [20]. The position of the forelegs inevitably affects that of the hind ones; in fact, if the horse raises the right foreleg, the right hindleg advances (horses A and B), and once the limbs on the right-hand flank have completed their forward movement, those on the left begin their advance (horses C and D). The horses of the San Marco quadriga have captured two moments in this action and frozen them in time. In fact, as we have already seen (p. 141) the horses' bodies are paired by the position of their legs. This, however, does not result in two pairs of exactly identical animals in their posture since the bodies and heads are related in such a manner as to represent four diverse horses.

This analysis cannot be considered complete without paying some attention to the pedestals (fig. 186-187) which, oddly enough, have not as yet been seriously studied. They consist of eight small capitals on short, slender columns; the ones which support the unraised foreleg are delicate and smaller, while those holding two hind-legs are larger, sturdier and more massive [21].

As for the weight, both Mustoxidi and Bussolin [22] agree that each horse weighs 834.75 kgs., but during the most recent examination the weight was found to be 897 kgs.

Although the gilding and alloy of the horses will be discussed later, it is worth observing in advance that the four horses of the Basilica of San Marco are made of almost pure copper. Finally, the dimensions of the four sculptures are as follows: the total height is 2.33 ms., the length 2.53 ms. and the width varies from 71-75 cms [23].

(1) L. VON SCHLOEZER, Die Rosse von San Marco, in R.M. XXVIII (1913), pp. 129-182.
(2) F. MAGI, Ancora sulla data dei cavalli di San Marco, in Rend. Pont. Acc. XLIV (1970-71), pp. 209-217.
(3) ANTON MARIA DI GEROLAMO ZANETTI, ANTON MARIA DI ALESSANDRO ZANETTI, Delle antiche statue greche e romane, che nell'antisala della libreria di San Marco, e in altri luoghi pubblici di Venezia si trovano, Venice 1740, vol. 1, tab. 44.
(4) F. MAGI, La data dei cavalli di S. Marco, in Rend. Pont. Acc., XLIII (1970-71), pp. 187-201.
G. BECATTI, Interrogativi sul problema dei cavalli di San Marco, in Rend. Pont. Acc. XLIII (1970-71), pp. 203-206.
(5) F. MAGI, La data dei cavalli di S. Marco, in Rend. Pont. Acc. XLIII (1970-71), pp. 188-191.
(6) G. RENIER MICHIEL, Dei quattro cavalli riposti sul pronao della Basilica di S. Marco, Venice 1893, p. 10.
(7) The harness was dispersed by Dandolo's soldiers in the Sack of Constantinople (G. DAMERINI, I cavalli sulla Basilica, Amor di Venezia, Bologna, 1920, p. 96).
(8) "The harness was cast separately" (K. KLUGE, K. LEHMANN HARTLEBEN, Die Antiken Grossbrozen der Romischer Kaiser-zeit, Berlin-Leipzing 1927, II p. 83).
(9) The horses have been allotted the following letters A, B, C and D, beginning with the first animal on the left as one looks at the façade of the Basilica of San Marco.

(10) K. KLUGE, K. LEHMANN HARTLEBEN, op. cit., p. 83.
(11) J. F. CROME, Die goldene Pferde von San Marco und der goldene Wagen der Rhodier, in Bull. Corr. Hell. LXXXVII (1963), p. 214.
(12) ANTON MARIA DI GEROLAMO ZANETTI, ANTON MARIA DI ALESSANDRO ZANETTI. op. cit., tab. 44.
These ornaments disappeared when the horses were carried off to Paris (A. DALL'ACQUA GIUSTI, I quattro cavalli nella facciata della Basilica di San Marco, Venice 1894, p. 22).
(13) J. W. GOETHE, Italienische Reise, Leipzig 1913, I, pp. 87-88.
(14) J. F. CROME, op. cit. p. 221 and ff.
(15) P. GIUSTINIANI, Rerum venetarum ab Urbe Condita ad annum 1575 Historia, Venetus 1576, II p. 36.
(16) P. GILLES, De Topographia Constantinopoleos et de illius antiquitatibus, Lugduni 1562, liber II, cap. XIII, pp. 92-93.
(17) ANTON MARIA DI GEROLAMO ZANETTI, ANTON MARIA DI ALESSANDRO ZANETTI, op. cit. tab. 45.
(18) A horse's knee corresponds to the wrist of a human being while the hock corresponds to the human ankle. The hoof, however, is little more than an enlarged and highly developed equivalent of the nail on our third finger.
(19) M. SANUDO, Vite de' Duchi di Venezia, in Rerum Italicarum Scriptores tomus XXII, pars. IV, columns 520-526.
(20) A. W. SCHLEGEL, Lettre aux éditeurs de la Bibliothèque Italienne sur les chevaux de bronze de Venise, Florence 1816.
(21) Of the front capitals I is the same as IV, while II is the same as III. Those at the rear are all different.
(22) A. MUSTOXIDI, Sui quattro cavalli della Basilica di S. Marco in Venezia, Padua 1816, p. 53. P. BUSSOLIN, Lettera al Signor Direttore dell'I. R. Zecca di Venezia Dottore Leopoldo Berchet socio dell'Ateneo di Treviso, ecc. Esponente l'analisi chimica del metallo, di cui sono composti i quattro cavalli esistenti sul pronao della I.R. Basilica di S. Marco eseguita da Pietro Bussolin capo assaggiatore presso la Zecca stessa, Venice 1843, p. 6.
(23) G. PIAZZA, La R. Basilica di S. Marco, Venice 1835, p. 3. The horses C and D at their broadest are 75 cm. while A and B are 71 cm. (J. F. CROME, op. cit. p. 222).

Hippological observations

Augusto Azzaroli

While all artists agree on the beauty of the quadriga of San Marco, these celebrated statues make a more complex impression on horse specialists. There is no doubt about the aesthetic effect, but there is something unusual about their actual appearance which is perplexing. In fact a morphological analysis of these works certainly justifies this uneasy state of mind.

The horses of San Marco stand 171 cm. high at the withers. They are large but not unusually so considering horses nowadays. In antiquity, however, the stature of horses was generally smaller, and despite the improvements in breeds achieved by the Romans, it seems that their horses were never taller than 155 cms., or perhaps 160 cms.

The proportions of the Venetian horses, however, do not correspond to any particular known breed and certainly represent a deliberate departure from the norm. An interesting comparison may be made here between the average proportions of the Arab, the English thoroughbred and a heavy draught horse (see table I and fig. 200).

The horses of San Marco have long bodies though less so than found in heavy draught horses. Their heads are normal in proportion, with broad foreheads. Their necks are very long, even more so than in the English thoroughbred, and are excessively thick. Their bodies are broad, though less disproportioned; they are, however, a little distorted with short backs and over-long croups. Their shoulders and hindquarters are wide owing to the thickness of the body.

To compensate for the excessive thickness of body and neck, their legs are exaggeratedly long. The artist, nevertheless, took care to respect their proportions so that in consequence the forelegs and gaskins, cannon bones and hooves are large.

The details of the statues display a highly refined art though not, however, without certain flaws. Anatomical characteristics are rendered with care, but the bodies show little modelling in the loins. Details are carefully rendered on their heads, the mouth, teeth, nostrils and ears are all faithfully depicted, including the fold in the skin dividing the false from the true nostril. Only the eyes are faulty; the pupils are defined by means of an incision in the shape of a half-moon, which is a sculptural device for effectively rendering the round pupil of a human eye, but not for the horizontally elongated pupil of a horse.

So the horses of San Marco do not conform precisely to any particular breed, but were inspired by a well-defined ideal. They can be compared to various models found in ancient iconography.

It was a lightly-built horse that inspired artists during the Hellenic period of ancient Greece. The head was rather heavy in sixth and early fifth-century Greek figures and sculptural compositions (fig. 201), but towards the end of the fifth century the Greek horse corresponded quite closely to the oriental type and was probably derived from it (fig. 199). These horses are depicted in different stances, sometimes appearing at rest, or collected in an effortless and supple manner. In the later periods they are shown being urged on with their heads tossing in the wind as in the celebrated Parthenon sculptures. In the Hellenistic era more robust horses with ample necks and bodies were preferred (fig. 33). A certain taste for more agitated postures, such as having their leap forward checked by a violent action of the bit, was common at that time.

Some time later, towards the second and third centuries A.D., a distinctly robust, large-sized horse with strong, arched neck and muscular body, although not really massive, appears in Roman sculpture.

It is not at all clear where these particular horses come from. In antiquity horses were usually small, between 135 and 140 cms. high at the withers, even sometimes less. Larger horses appear only in isolated instances. One found in the fortress of Buhen in Nubia - the oldest horse known in Egypt (seventeenth century B.C.) - was about 150 cms. high at the withers. A stele from Xanthus in Lycia from the sixth or seventh century B.C. shows a saddle-horse led by hand. Judging from the accompanying groom, its height could be between 145 and 150 cms. Then there is the unsolved case of the large horses from the Celtic (or Veneti) tomb of Canal Bianco, near Adria, where the saddle-horse discovered was found to measure 155 cms. in height (Azzaroli, 1975) and dates from the third century B.C. But undoubtedly in the last centuries preceding the Christian era horses were significantly small in stature in central Europe, the situation being much the same in Italy and the Balkans. An improvement in breeds, together with a noticeable increase in the average size can be seen as a result of Roman influence at the beginning of the Empire. Perhaps this was the outcome of a wise upbreeding of local stock. The Romans were, in fact, the first people in Europe to keep stud books, and they improved not only their horses but also their

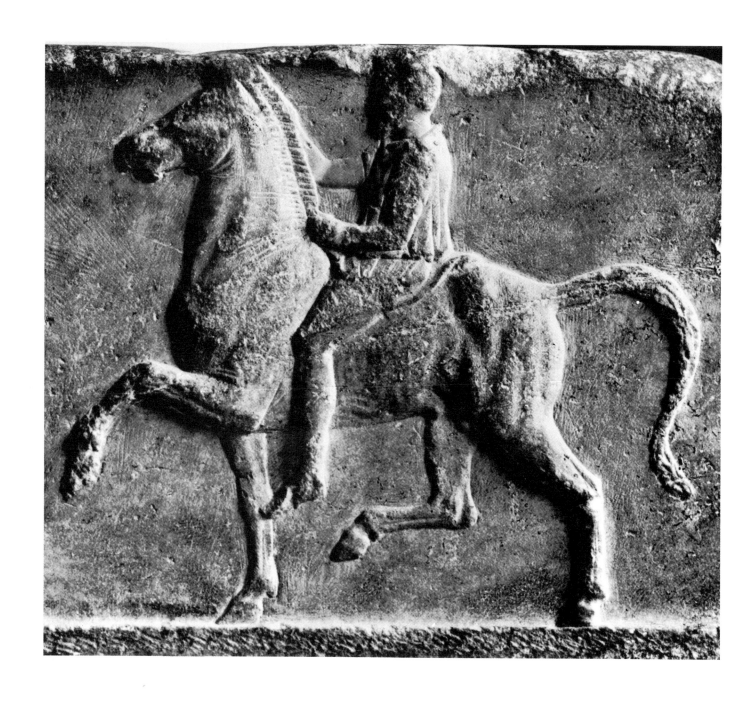

199. Detail of Stele of Briassides showing Greek horseman (Greek c. 350 BC.).
National Museum, Athens.

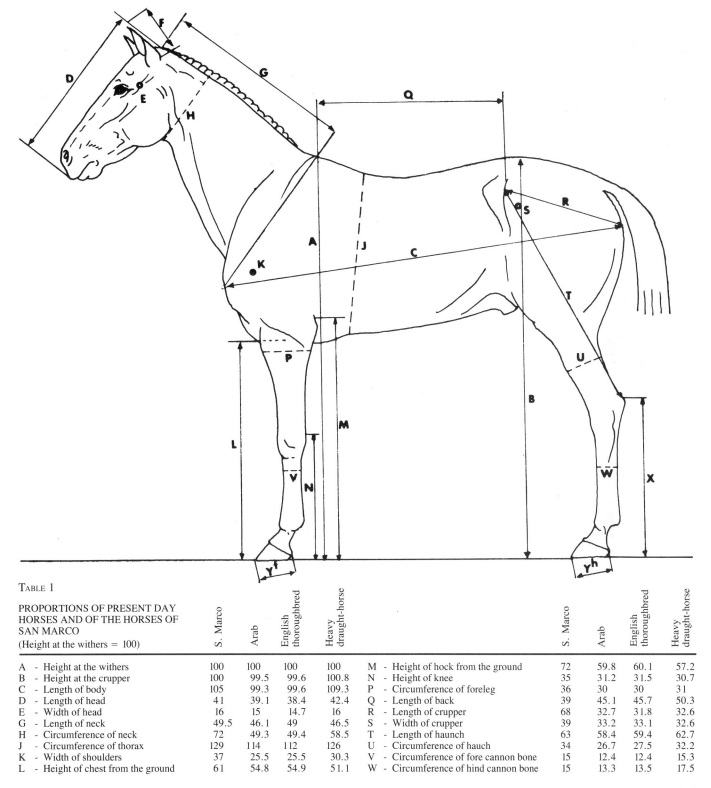

TABLE 1

PROPORTIONS OF PRESENT DAY HORSES AND OF THE HORSES OF SAN MARCO (Height at the withers = 100)	S. Marco	Arab	English thoroughbred	Heavy draught-horse			S. Marco	Arab	English thoroughbred	Heavy draught-horse
A - Height at the withers	100	100	100	100	M - Height of hock from the ground		72	59.8	60.1	57.2
B - Height at the crupper	100	99.5	99.6	100.8	N - Height of knee		35	31.2	31.5	30.7
C - Length of body	105	99.3	99.6	109.3	P - Circumference of foreleg		36	30	30	31
D - Length of head	41	39.1	38.4	42.4	Q - Length of back		39	45.1	45.7	50.3
E - Width of head	16	15	14.7	16	R - Length of crupper		68	32.7	31.8	32.6
G - Length of neck	49.5	46.1	49	46.5	S - Width of crupper		39	33.2	33.1	32.6
H - Circumference of neck	72	49.3	49.4	58.5	T - Length of haunch		63	58.4	59.4	62.7
J - Circumference of thorax	129	114	112	126	U - Circumference of hauch		34	26.7	27.5	32.2
K - Width of shoulders	37	25.5	25.5	30.3	V - Circumference of fore cannon bone		15	12.4	12.4	15.3
L - Height of chest from the ground	61	54.8	54.9	51.1	W - Circumference of hind cannon bone		15	13.3	13.5	17.5

155

breeds of cattle. This phenomenon is quite noticeable in central Europe and takes place during the expansion of the early Empire. However, historical sources also indicate that prized horses were imported from Spain and from the territories of Gaul.

In fact, various sculptures from Spain appear to record a kind of horse, usually termed occidental, which is sturdy with an arched neck and sometimes a ram-nosed head together with a long drooping croup (fig. 202). This appears very likely to be a breed that had survived in its wild state in the far west of Europe. The really heavy-weight type of horse had not evolved by this time; it was to appear later in the Middle Ages as a result of selective breeding, but these examples may well have been their ancestors. However, the problem concerning the origin of the sturdy, though not heavy, breed of horses is more complex and many aspects still remain obscure. While some historical and archaeological documents suggest that they come from the most western parts of Europe, other sources surprisingly reveal that there was also a sturdy breed of horse in the East, in Persia to be precise. Already certain sculptures at Persepolis in the Achaemenid period show horses with heavy features and ram-nosed heads, but they do not appear to be very big in stature. Later under the Parthian and Sassanian kings, a really heavy cavalry was developed; the riders were protected by breastplates and charged with long lances as weapons to unseat their adversaries. The reliefs of the Sassanian kings clearly depict sturdy horses, large in size and already fairly heavy in build. The sculptures concerned, however, are not photographic in their realism and are always stylised to a certain extent (fig. 203).

The riders and horses of the Persian heavy cavalry were protected by tough metal breastplates. Their technique, nevertheless, differed from that of the medieval cavalry. Stirrups were unknown, saddles had pommels and cantles which did not, however, reach the almost exaggerated size of medieval saddles. Even in battles with lances, the Persian saddles had ample quivers attached which gave firm support to the rider's thighs and greatly increased his stability (Vigneron, 1968; Ghirschman, 1973). There was no rest for the lance and it was carried by hand. Herodianus mentions that during the charge it was bound to the horse's neck and crupper so that the rider was not unbalanced by the jolting of the weapon. This practice is not shown in Persian sculpture perhaps because of the tendency to stylise or because the technique described by Herodianus was only true of isolated cases.

The history of the Persian heavy cavalry draws to a close between the fifth and seventh centuries B.C. when the Huns brought the bow back into favour. It would not therefore have been the forerunner of the medieval European heavy cavalry, which developed between the seventh and tenth centuries A.D. (Lefèbvre des Noëttes, 1931; Lynn White, 1962). The selective breeding of heavy strains began in Europe from this time onwards.

The Romans were to encounter the Persian cavalry several times and so were able to assess its effectiveness to their own cost. During the late Empire they tried to imitate it. Ammianus Marcellinus has left us a vivid account full of admiration for it: "the completely armoured riders, which are usually called *clibanari*

201. Bronze statuette of harnessed horse. Greek c. 470 BC. Olympia.

202. Iberian sandstone relief showing a heavily-built horse of a western type. El Cigarralejo, Murcia, 5th century BC.

156

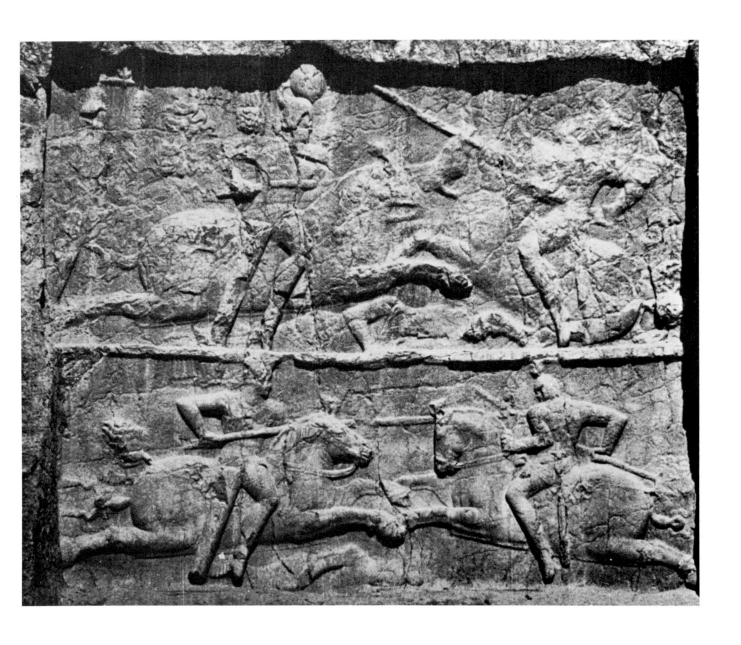

203. Relief of Bahram II (276-293. BC.) showing Persian heavy cavalry. Sassanian period. Naqsh-i-Rustam, Iran.

are cavalry soldiers wearing armour with their faces covered by personati visors and protected by breastplates, their limbs being covered by iron armour so that they appear to be the shining statues of Praxitiles rather than men''. Such cavalry necessarily implies the use of sturdy horses, even if, as Vignaron points out, the Romans never succeeded in acquiring enough tactical skill to resist the Asiatic cavalry. Only later was Byzantine cavalry able to hold its own in a military sense.

Unfortunately historical sources give no useful indication to enable us to unravel the origins of the sturdy horses. Not even Vegetius Renatus (fourth century A.D.) refers to horses suitable for heavy cavalry in his list of horse breeds.

Whatever their origins may have been, a particular preference for strongly but not heavily built horses was evident in Rome during the imperial period, and it can be assumed that both the contacts with the Persian cavalry as well as the results of their own breeding experiments had contributed to this evolution in taste. It is precisely this type of horse that is reproduced in the equestrian monument of Marcus Aurelius.

The horses of San Marco are substantially of this type too, but their sculptor also wishes to instil in them the elegance of the light horse from the classical era by employing the age-old method of falsifying their proportions.

The harness and trappings

Harness has been modified in the course of history thus providing a basis for dating archaeological finds.

In classical antiquity the bit, made of bronze, was fashioned like our snaffle with the mouthpiece either unbroken or more often jointed. The bronze bit was invented in the Middle East during the second millennium B.C., and quickly spread throughout Europe in the first millennium. The cheekpieces to either side of the bit, which prevented it sliding from one side of the mouth to the other, were sometimes artistically decorated.

Unfortunately the bits of the horses of San Marco have been broken off at the sides and so it is impossible to reconstruct their specific type in any detail. It is certain, however, that they were simple snaffles without curb-chains. The headstalls go round the nose, up the sides of the head and round the ears to meet at the centre of the forehead, rather than continuing in the usual manner over the top of the head.

No other traces of harness remain on the bodies except for the richly-modelled collars. These were used to attach the horses to the yoke fitted onto the chariot shaft. The harness was generally completed by a girth or strap underneath the belly and, more rarely, by a breeching. No signs of these remain on the Venetian horses. In some instances the yoke was attached to the collar alone, without any girth.

It cannot be excluded that the horses of San Marco originally bore harness which was later removed. In any case, the presence of collars presupposes that they drew a chariot; similarly, the fact that there are four identical horses implies a team of that number. Throughout antiquity the harnessing system remained largely the same, except for slight variations. The chariot shaft was attached at the yoke, which rested on the horses' withers, generally by means of a small rudimentary yoke-saddle formed by a forked stick and held in place by the collar and girth (fig. 201). The latter only served to keep the yoke in position. In some cases, as has been seen, this was omitted. The collar bore the entire brunt of the weight so that when the horses were pulling, it pressed against their windpipes and thus impeded their breathing. They reacted by raising their heads and stiffening their neck muscles. It seems that it was not realised in antiquity how uncomfortable this was for the animals. At the time people preferred the high head carriage because it conveyed a dashing impression of pride, and this is often depicted almost with a feeling of satisfaction. The system also found favour with Greek riders who deliberately taught their mounts to hold their heads high.

In effect the ancient way of harnessing teams of horses was extremely impracticable. Only a small part of the horses' potential strength could be exploited in order to draw the chariot and therefore only light-weight vehicles with teams of two or four horses were possible. The teams of four, on the other hand, were also very inefficient. The horses were always harnessed in a line beside the shaft with the result that the quadriga was difficult to manoeuvre. Wide yokes with four horses broke easily and so were rarely used. Chariots with two shafts were equally rare; some are known from Cyprus and are also depicted on the Sahara rock reliefs, but they were cumbersome rigs and proved impracticable in Europe, although they had more success in Libya. The most common solution for the team of four was to harness two horses only to the shaft, attaching the two outer horses to them with simple leather straps. It is easy to imagine that the horses upset one another, and also that the drawing power of the outer ones was minimal. In war they ended up using the light two-horse chariot only and the quadriga was confined to races and, above all, to parades.

In the ninth century the Byzantines tried to lessen the disadvantages of the collar by adopting a false breast-band, fixed to the girth just below the withers. It proved largely ineffective as the weight still fell mostly onto the yoke and the false breast-band finished up by constricting the windpipe as well. The ancients were curiously uninventive when it came to developing techniques for horse-drawn chariots. The breast-band or the stiff collar fixed to the traces, which transmitted the load to the shoulder blades without preventing the horses from breathing freely, only appeared in the tenth century A.D., and shortly after the team in single file appeared as well. It is strange that the Chinese adopted the breast-band and traces under the Han dynasty, about ten centuries before the West.

The horses of San Marco have the ancient method of harnessing. There is not trace of the yoke attachment on the collars. Perhaps some part of the harness has been lost, or else the sculptures represent four horses already released from chariot, perhaps indeed to be carried in a triumphal procession celebrating a victory.

The hooves show no signs of horse-shoes or of nails. Horse-shoes

first appeared among the Celtic peoples in central and western Europe during the first century B.C., but for many hundreds of years their use was extremely limited. It seems that the first horse-shoes were really "snow-shoes" (Azzaroli, 1978). Shoeing became a current practice in the Carolingian era and in the tenth century A.D. was adopted by the Byzantines. Sculptures and illustrations from that period accurately represent the horse-shoes, or at least the nails on the wall of the hooves. It was a novel mark of prestige and therefore to be shown off. The types of harness and the lack of horse-shoes would clearly serve to date the Venetian horses earlier than the tenth century A.D.

Bearing

Although the horses of San Marco possess an almost noble restraint, their bearing, however, betrays a certain temperament. They carry their heads high, but their taught necks are counterbalanced by the arching of the crests, the total impression being one of undeniable elegance. Their graceful form is emphasised by their necks which are over-thick and exaggeratedly arched. The position of their legs is determined by the mood which controls the whole composition. Here also is an example of perhaps intentional falsification on the part of the sculptor. The horses are walking and Muybridge observes that they constitute an excellent study of a natural action. This, however, is not strictly true. The positioning of the raised foreleg is slightly forced, but the artist certainly knew how to express the movement without revealing any sense of strain or stiffness. The end result is elegant, but no actual movement of a walking horse reproduces at any moment the exact position of the Venetian horses' limbs.

The bearing of the horses of San Marco recalls the four horses on a relief depicting the triumph of Marcus Aurelius (fig. 48) - the significance of this comparison can be left to the art historians to interpret; here it is enough to draw attention to it. The unknown artist of the Venetian horses knew how to infuse the bronze with a sense of movement lacking in the clumsy and disproportioned horses seen in the Roman relief.

Footnotes

AZZAROLI A. *Il cavallo nella storia antica*. L. L. Edizioni Equestri, Milan, 1975.
AZZAROLI A., "Perché fu inventato il ferro di cavallo", *Lo Sperone*, 7, No. 2. Milan, 1978.
BIVAR A.D.H., "Cavalry Equipment and Tactics on the Euphrates Frontier", *Dumbarton Oaks Papers* 28, Washington, D.C. 1972.
GHIRSCHMAN R. "La selle en Iran", *Iranica Antiqua* 10. Teheran 1973.
LEFEBVRE DES NOËTTES R. *L'Attelage. Le Cheval de Selle à travers les âges*, 2 vols., (ed. A. PICARD) Paris 1931.
MUYBRIDGE EDWARD, *Animals in Motion* (ed. by L. S. BROWN), Dover Publ. Inc., New York, 1957. Revised edition. Original edition, 1898.
VIGNERON P., *Le cheval dans l'antiquité Gréco-Romaine*, 2 vols. (*Annales de l'Est. No. 35*), University of Nancy, 1968.
WHITE L. jr., *Medieval Technology and Social Change*, Oxford University Press, London, 1962.
WILLOUGHBY D.P., *The Empire of Equus*, A. S. Barnes & Co., South Brunswick & New York: T. Yoseloff Ltd., London, 1974.

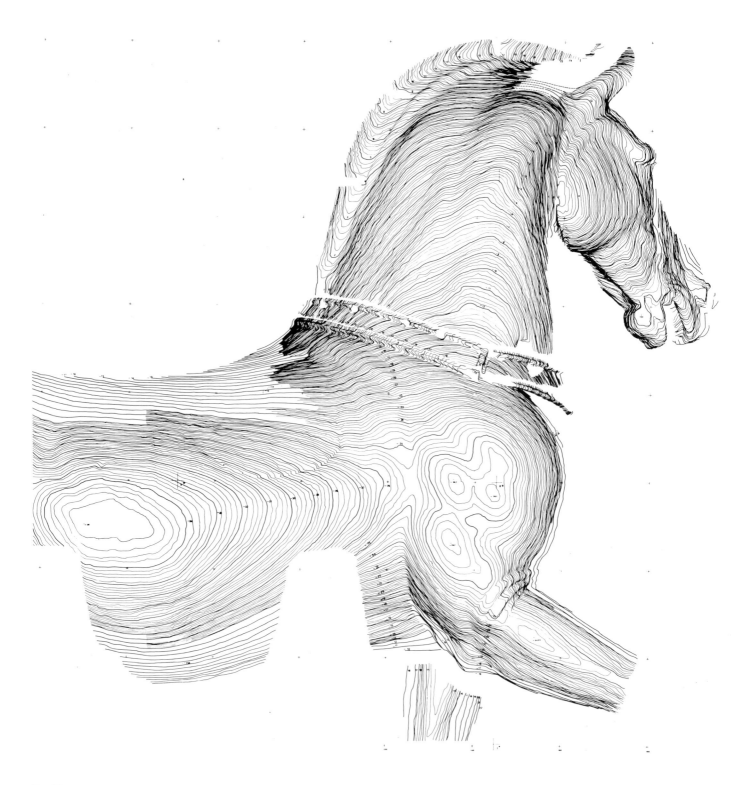

204. Photogrammetry of Horse ''A''.

The photogrammetric survey and the contour map of the surface of Horse «A»

Licia Borelli Vlad

The technique of photogrammetric survey enables a precise morphological study of the surface contours of Horse «A» to be made while the map, as will be shown later, provides the outline and projection on one plane.

Photogrammetry

The photogrammetric survey enables the three-dimensional character of an object to be shown by means of contours registered by special photographic apparatus in the form of a metric or stereometric camera. The three-dimensional features of the object are then recreated - that is they are translated into a linear, numerical or photographic relief - by co-ordinating all the points appearing in the stereoscopic image registered on two photographic plates. Photometric surveys are more commonly used for the planimetric or aerial surveys of the landscape but for over a century since the Frenchman Laussedat introduced the idea in 1850, the technique has also been used to register the relief character of monuments. Since the 1950's this approach, however, has been used far more extensively and in many different ways to document and aid the conservation of the cultural heritage. Photogrammetric surveys can be made of aerial or submarine areas and of historical places or individual monuments, as well as archaeological sites without interfering with the ground surface or hindering excavations in progress. The technique is also used to measure the structural deformation of monuments, to analyse the successive layers of materials involved and certain modifications in paintings (microphotogrammetry, stereoradiography), to discover whether a stolen object is false or the original, also to enable copies of objects to be made without using plaster casts, and so on.

The uses of photogrammetry in the field of the plastic arts are not that numerous, but it is worth mentioning the surveys of the sculpture of S. Michele at Pavia (1943, by Ing. Cassinis), the subterranean statues of the temple of Oya, the Great Buddha of Kamakura, the statue of Ashura at Kofukuji, various statues of Nara in Japan (Institute of Industrial Science, Tokio and Nara, Research Institute), the statue of Rames II, not to mention the frescoes of prisoners at Abu Simbel (National Geographical Institute and Centre for the Study and Documentation of Ancient Egypt, Cairo), a Roman statue from Perge (Technical University of the Middle East, Ankara), a statue of St. Helen at Amsterdam (by Waal Archifoto of Holland), and the monument of Adamklissi (Romania).

Professor Sena, who carried out the photogrammetric survey of Horse «A», illustrated its practical application on pages 233-243. Meanwhile I am limiting myself here to emphasising the general importance of its uses which, as already mentioned, are still relatively unexploited for the study of sculpture and which enable a thorough survey to be carried out free from subjective interpretations. There is also another reason for supporting such a sophisticated method in this particular case. When the photogrammetric survey of the other three horses is undertaken, it may perhaps be possible to decide whether the same moulds were used to cast the equivalent parts of each horse, by juxtaposing and comparing the curvature of the planes which represent the elevations. As has been said, given the method used for the casting, this could have been technically possible. Then these linear signs - a system of tortuous and obsessive lines recalling some of the more highly labyrinthine graphic art of Cagli (p. 166) - may enable us to decipher a still obscure page in the history of ancient technology.[1]

The Surface Contour Map

While the image of the Horses are eloquently conveyed by photographs a thorough examination of the surface of the sculptures, now sheltered inside the museum of the Basilica, is facilitated by a life-size contour map of the principal views (figs. 211-214). The map provides the starting point for all the physiochemical research and the action taken to preserve the Horses. These charts show with the greatest accuracy the countless injuries suffered by the surface of these bronze sculptures. Elsewhere the principal causes of the damage will be discussed and shown to be largely due to the very nature of the alloy used in their manufacture (see page 175). Here we will confine ourselves to examining them objectively and to making some general observations.

Most of these defects were caused during the casting process itself; the tiniest holes were left open since they were later to be covered over by the gold leaf, while the larger ones were cut out altogether and covered over by various loose pieces with

161

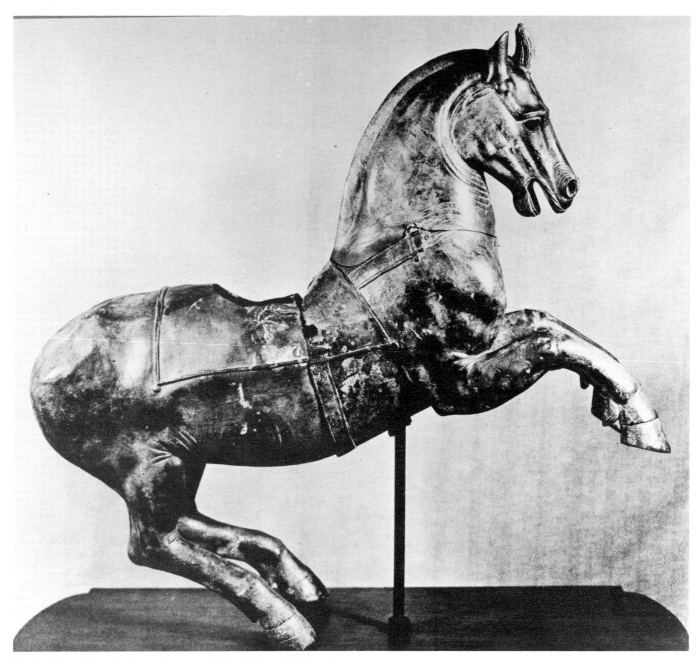

205. Small horse from the Yemen (Dumbarton Oaks collection, Washington). This bronze horse, almost half life-size, originates from the North Yemen (Ghayman?), the remote Roman province of Arabia Felice. Its suggested date, hitherto varying within the period from the fifth century B.C. to the fifth century A.D., has now been fixed at the end of the second century A.D., as a result of various historical, anatomical, epigraphic and stylistic clues. (J. Rykmans in Dumbarton Oaks Papers, 29, 1975, pp. 287-303). It is not only a coincidence in tentative and controversial dating which suggests a comparison between this work and the Horses of San Marco, but also a characteristically Roman eclecticism which they appear to have in common. The small, southern Arabic horse possesses a Hellenistic style in the shape and naturalism of its shoulders and chest while the stylisation of the head is rather more oriental in nature.

The horse was probably completed with a rider, now lost, and was associated with another identical equestrian statue.

The analyses of the bronze used gives the following results. (1) Samples taken from the folds and from the inscriptions on the body - Cu 80-84%; Pb 6-8%; Sb 3.5-5%. (2) The sample taken from the nostril - Cu 74%; Pb 18%; Sb 2.3%.

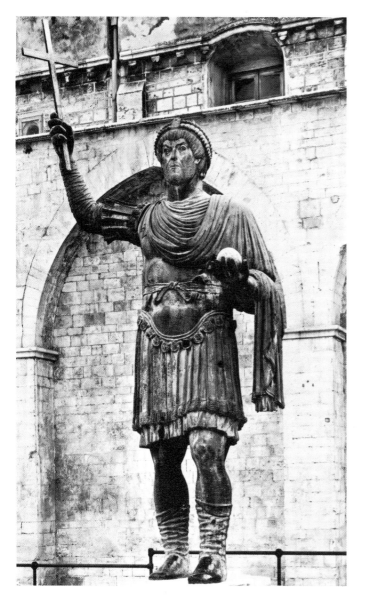

206. The "Colosso" at Barletta. Statue of Valentian (?). This bronze statue, five metres high, is situated next to the Cathedral at Barletta and originated from Constantinople, being included among the war booty taken away at the fall of the city in 1204. The statue was put on board a Venetian ship which was wrecked near Barletta. This work by a fourth-century Byzantine sculptor probably represents the emperor Valentian. The legs and hands were refashioned in the fifteenth century. The percentage of tin and lead elements in the metal is high compared with that of the Horses of San Marco.

207. B. Cellini, *Perseus*, Piazza della Signora, Florence. This bronze masterpiece by Cellini, was commissioned by Cosimo de' Medici and made in 1554. The quantity of copper in the bronze alloy (95.37%) is extremely similar to that in the Horses of San Marco. The difficulties encountered during the casting of this work are described in Cellini's famous autobiography *La Vita*, which was written in 1558.

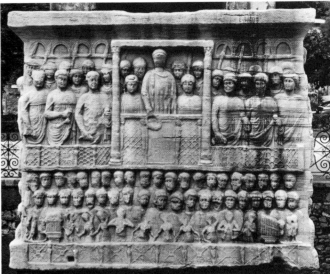

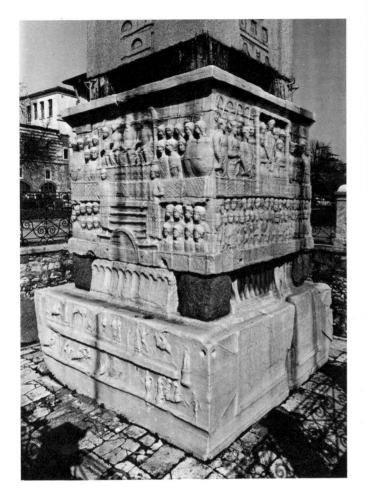

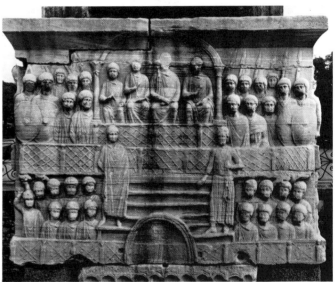

208. *The base of Theodosius's Obelisk in the hippodrome of Constantinople.*
The Emperor Constantine in order to decorate the hippodrome sent for two
obelisks from Egypt. The one erected by the Emperor Theodosius (379-395 A.D.)
dates back to the reign of Tutmos III (1471 B.C.) and originates from Karnak, via
Alexandria in Egypt. Particularly important is the base which Theodosius had
constructed at the end of the fourth century A.D. at a critical time for classical
sculpture which clearly assumes more Byzantine characteristics. The relief shown
here on the base represents the emperor and his sons between their guards and
courtiers watching the games from the height of the royal box. The date of the
creation of the Horses of San Marco varies among scholars from the fourth
century B.C. to the fourth century A.D.

209. *The base of Theodosius's Obelisk: east side.*

210. *The base of Theodosius's Obelisk: south side.*

164

210a. The Hippodrome Square, Constantinople in a late nineteenth-century photograph. Surrounding the hippodrome, which was founded by Septimus Severus and embellished by Constantine, were gardens and a loggia reserved for the emperor. The latter was placed close to where the Turks built the Sultan Amhet Mosque (at the centre). Theodosius's Obelisk can be seen at the centre. To the right in the enclosure can be glimpsed the Greek spiral column of bronze which was set up in memory of the Persian wars in the fifth century B.C. The horses of San Marco were most probably located on the far left towards the church of Hagia Sophia.

quadrilateral or irregular edges, etc. This operation was clearly carried out before the gilding stage. Similar sections are found on many other bronze statues, the closest being those on Roman works from the second century A.D. onwards (for example, see the Marcus Aurelius on the Capitoline Hill in Rome, the large statue presumed to be Trebonius Gallus in the Metropolitan Museum, New York, the colossal figure of Constantine in the Museo dei Conservatori in Rome, etc.), while the casts of the first imperial era (the Cartoceto group, for example) are more free of sectional repairs. It should, however, be mentioned that square and rectangular sections are also found in Greek bronzes. It is, above all, a technical matter closely connected to the composition of the alloy and it is still not possible to draw up a chronological list of comparative material. This list might eventually be compiled but only after more intensive examinations in this direction on a very large number of antique bronzes[2]. There are, in fact, about a hundred repairs on the particular Horse being examined. That these were probably made of a different alloy from the one used for the main cast is suggested by the behaviour of the gilding and appearance of the corrosion products on the metal which are noticeably different from those evident in the adjacent areas. This added metal must, therefore, have been of harder bronze which is less rich in copper.

There are also present, however, many bronze and copper nails, some of them used to fill the holes caused by inefficient casting, others to attach large sections. By way of compensation most of the sections are sufficiently well fixed to have become integral parts of the rest of the metal casting. The lead patches, on the other hand, are quite a different matter. These must belong to a series of subsequent repairs, though for the time being it is impossible to establish their place in the chronological sequence[3]. Some of them have been used to fill up certain section or casting vents. Some pieces of iron, which have been used as repairs, and also some iron nails are present[4].

2 For the loose pieces, see: K. KLUGE, *Die Antiken Grossenbronzen*, Berlin-Leipzig 1927; T. I. pp. 152-154.

I would like to thank the architect, Elisabetta Pagello who has carried out a thorough examination of the bronze statues in the Archaeological Museum of Athens in order to identify the dowels.

3 We propose in the future to be able to establish a tentative date for at least the most prominent of these repair patches.

The dating of lead and the identification of its source may be possible by applying isotope radioactive dating techniques to the repair patches.

4 The drawings were done by Sig. Giuseppe Penello of the Istituto di Archeologia at Padua University.

1 I would like to thank Ing. Lucarelli of the International Centre for Conservation for some most valuable information. The following is a recent bibliography on the subject:

M. CARBONNEL, *L'histoire et la situation présente des applications de la photogrammétrie à l'architecture*, ICOMOS, 1968.

G. BOAGA, *Introduzione al rilievo fotogrammetrico dei monumenti*, Rome, 1970.

H. FORAMITTI, *La photogrammétrie au service des conservateurs*, Rome, 1973.

M. CARBONNEL, *Quelques aspects du relevé photogrammétrique des monuments et des centres historiques*, Rome, 1974.

Y. BADEKAS, *Photogrammetric surveys of Monuments and Sites*, Amsterdam, 1975.

F. ACKERL AND H. FORAMITTI, *Empfehlüng für die Anwendung der Photogrammetrie* in "Denkmalschutz in der Architectur und Archeologie", Vienna, 1976.

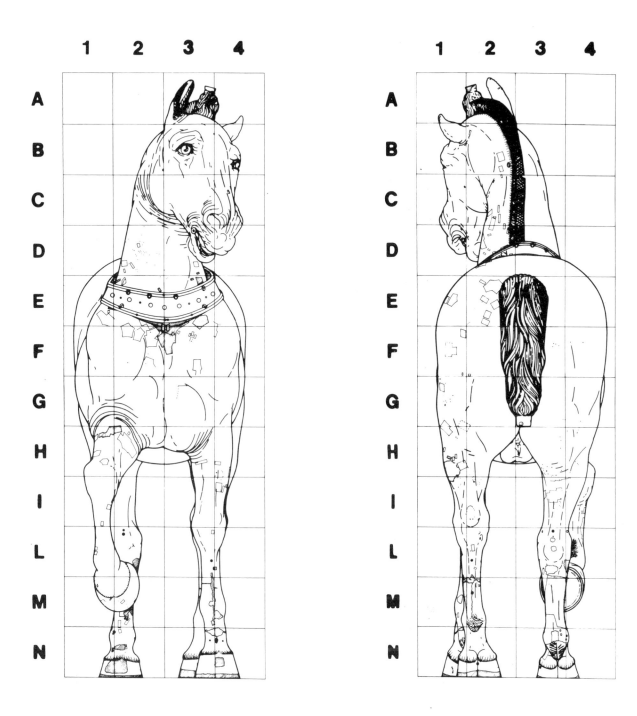

211 - 214. Contour map of Horse "A".

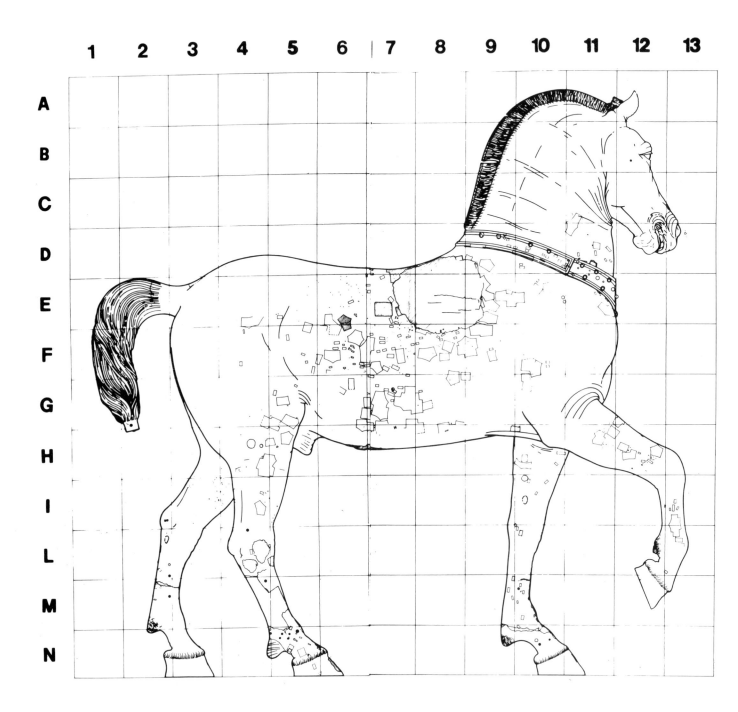

	1	2	3	4	5	6	7	8	9	10	11	12	13

A
B
C
D
E
F
G
H
I
L
M
N

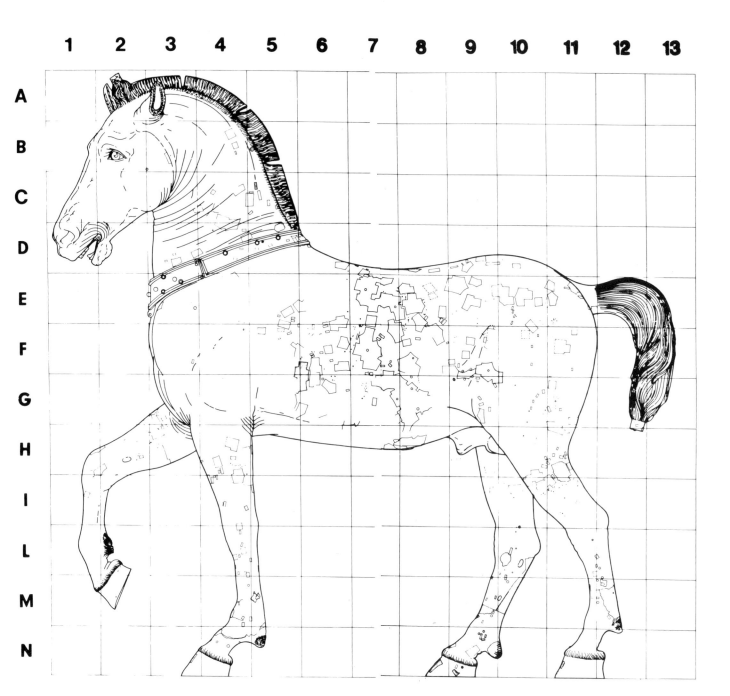

169

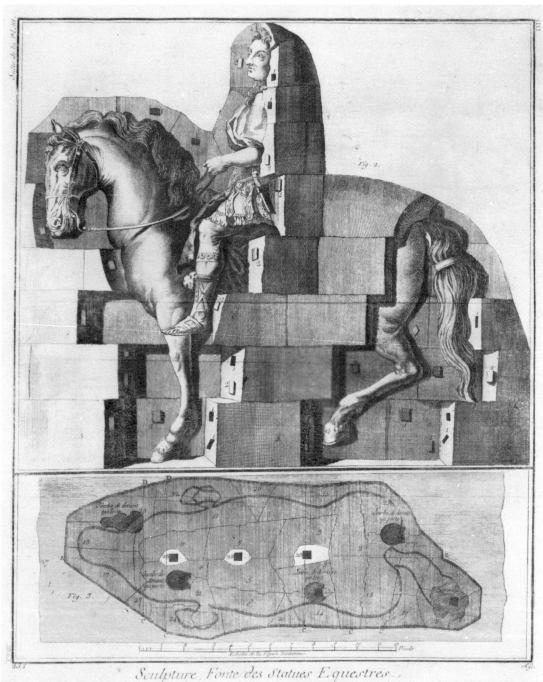

Fig. 2.

Fig. 3.

Echelle de la Figure Troisieme. _____ *Pieds*

Sculpture, Fonte des Statues Equestres.

Moule de Plâtre, qui est le creux du Modele de Plâtre de la Figure Equestre, et Plan de la premiere assise du Moule de Plâtre.

215. Construction of the negative form by means of concave sections.

Techniques of casting

Massimo Leoni

Without any doubt the casting of works of art is the metallurgical technique that has changed the least throughout the centuries. Only in recent years, in fact, have some innovations been introduced, such as the use of silicone rubbers for the reproduction of models, the use of special refractory oxides for the construction of moulds and the use of naphta, gas or electrically fired furnaces, without, however, having caused any substantial modifications.

At a foundry for casting works of art, the ovens for firing moulds are built in the same way as they were thousands of years ago, while the procedure of the artists and the founders is completely identical to that depicted on Greek or Etruscan vases.

The work carried out inside such a foundry is clearly depicted on the Kylix of Vulci which has a wide-angle view of a foundry for works of art from the 5th century B.C. surrounding it.

To cast a hollow metal figure in the round, the technique used is the so-called "lost wax" process, which was already found in Italy during the Iron Age to make buckles in the form of a leech or other small bronze works.

The technique consists of modelling the figure or object to be cast directly in wax, or pouring molten wax in a countermould of the object or figure previously modelled by the artist in plaster, clay, wood or another solid material.

The second method has the advantage of enabling more wax models to be taken from the same work, whenever further examples are wanted or the casting has been unsuccessful. Besides, by preserving the model, the finishing of the cast may be carried out by workshop assistants who can do repairs and finishing work from the artist's model directly in front of them. Moreover, with the first method, the whole work would be lost if the casting process went wrong.

To understand the technique used to cast the horses of San Marco, the various methods followed in antiquity using the "lost wax" technique should first be summarised, and this brief outline completed by a rapid description of the modern technique, just to show how little change there has been.

Casting by means of the "Cellini Method"

Although used in the first days of metallurgy, this method is called after Cellini because he described it in minute detail in his *Treatise on Sculpture,* as well as in his autobiography where he relates how his Perseus was cast.

First, the artist used sufficiently porous refractory material to make a rough model slightly smaller in size than desired for the final figure; "thinner by a spare finger-width" as Cellini put it. This sketch, called in sculptors' slang, "core", "kernel" or "male", is made from a mixture called *luto*, or "mud", consisting of thoroughly powdered clay mixed according to the artist's whim, with clothes clippings, horse dung, the burnt horns of rams, iron flakes, urine and so on, which is left to steep for a long time in water. This mixture is meant to obtain an easily worked modelling medium which does not crack while drying and which, after having been fired at a high temperature, remains sufficiently permeable to air and vapours that develop while the molten metal is being poured into the mould.

The inside of the core can be reinforced and held up by means of a framework of iron bars which is more or less complex according to the size and shape of the work.

After completely drying out and firing, the artist covers the core with a layer of wax to the thickness of the metal required; he moulds it and finishes it carefully until the final work is achieved.

At this point the wax must be covered with other refractory material capable of reproducing its most delicate details in negative, once the wax has been removed. That is done through an extremely fine and fluid suspension of *luto*, more or less of the same composition as the core. Sometimes egg whites were added to increase adhesion to the wax. This first layer, called "tunic" or "shirt", is applied with a brush in several layers, taking care that the following layer is only applied when the first is completely dry. Once the thickness of a finger-width is reached, coarser and more resistant layers of *luto* are applied obtaining in this way the "cape" or external form which, according to the dimensions, must be reinforced by winding wire around it or circling it with iron bands as on wooden casks. Through the drying, heating and firing of the mould, the wax melts and flows out, leaving inside the mould a cavity with the shape of the work of art.

Naturally it is vital that the core does not move with regard to the external form once the wax has been melted out. This can be achieved in various ways: metallic nails in bronze or iron may be inserted into the core through the wax, and later be removed or left in according to the nature of the work: or else iron bars may be inserted into the framework of the core which, by projecting from

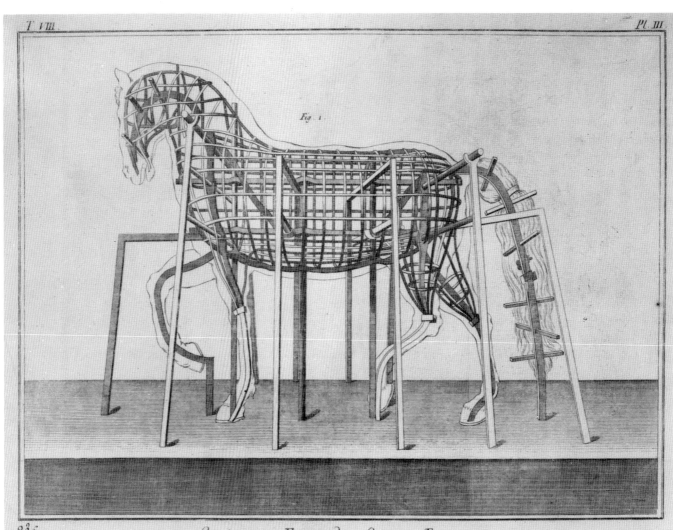

Pl. III.

Fig. 1.

234

Sculpture, Fonte des Statues Equestres.

c c

Armature de fer qui a été faite dans le Corps du Cheval, avec les Pointails et Piliers butants pour soutenir la Figure Equestre

216. Iron framework to support the core.

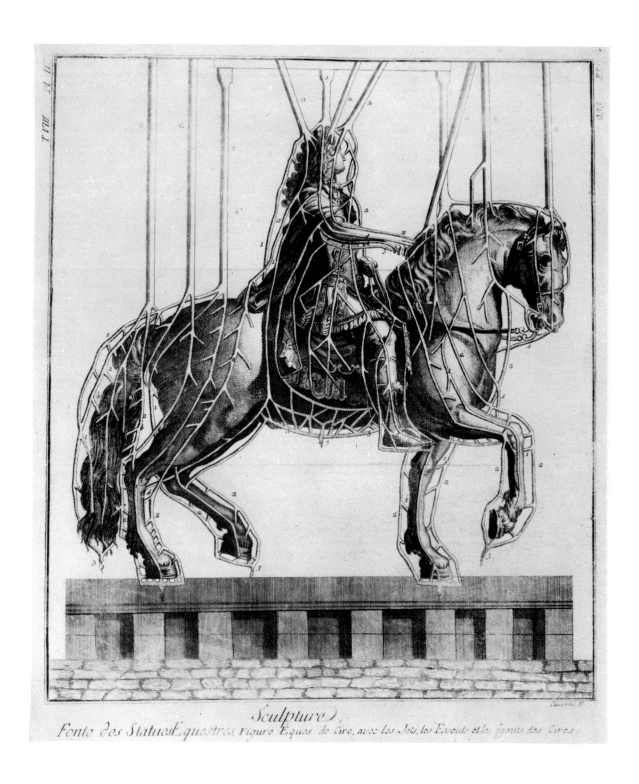

Sculpture,
Fonte des Statues Equestres, Figure Equen de Cire, avec les Jets, les Events et les égouts des Cires.

217. Wax model with runners, vents and drain pipes attached.

it, become attached to the external form or are fastened to appropriate external supports. That is the case with works of large dimensions, as for example the statue of Louis XIV which will be discussed later on.

Another device for making the internal core stable with regard to the outer form consists in removing some centimetres of wax in sections, thus revealing the refractory material of the core. In this way, after moulding, a continuity is created between the core and the external form which ensures that they do not move together.

This technique is described by Cellini who notes that the small openings which are created in this way in the walls of the cast are used to remove the core and subsequently must be closed by using repair patches.

The movement of the core in relation to the external form, if it happens, leads in fact to the formation of walls of different thickness or even to the lack of metal where the core touches the external form. Besides assuring the stability of the form and core, it was also necessary to put feeders called "runners" or "channels for casting", to the mould. Vents had to be put in to allow the very hot air which had expanded through the high temperature heating to escape from the mould and also pipes to enable the molten wax to drain out during the heating of the mould. These channels were obtained by fitting a complex system of wax rods of the right diameter or elder branches to the wax model, as elder wood burned and went completely into ashes during the heating of the mould.

The runners were attached to various points of the wax model according to the founder's skill in using them to enable the mould to be filled easily; they met at the top in one or more funnels where the molten metal would be poured in.

The vents were mainly put in the upper areas of the mould to make it easier for the air to escape; they too met at the top of the mould, slightly lower than the funnels for the molten metal so that, while the casting was taking place, it was certain that the mould had been filled when molten metal came out of the vents.

The drain pipes were connected instead to the lower parts of the model and turned downwards to allow the molten wax to drain off completely during the early stages of the heating of the mould and some of the wax to be recovered by means of suitably placed vessels. After the firing of the mould the drain pipes had to be carefully sealed.

If the mould was large in dimension it was rapidly lowered into a pit in front of the firing oven and covered with earth so as counterbalance the hydrostatic thrust of the molten metal and to avoid the mould bursting.

It is vital that as little time as possible should pass between placing the form into the pit and pouring the metal to avoid the form being broken through the absorbing of moisture, which also could lead to blow-holes forming in the cast.

Indirect Casting using "Concave" sections

Another casting method used when an original was available in solid material such as plaster, clay, terracotta, wood, marble or metal, was the indirect one using "concave" sections or a primary mould.

This method is also described both by Biringuccio in his book, *Pirotechnia* and by Cellini in his *Treatise on Sculpture*. The most complete description is, however, the one published by Boffrand in 1743 with the title *Description de ce qui a été pratiqué pour fondre en bronze, d'un seul jet, la figure équestre de Louis XIV élevée par la ville de Paris, dans la place de Louis Le Grand en 1695.*

The 6.8 metre high statue was cast in a single piece by J. Baltazar Keller after the model by François Girardon.

As this method is, as will be seen, very close to the one followed by the ancient founders for the casting of the horses of San Marco, it will be described in greater detail relying on Boffrand's account.

To obtain the casting mould from Girardon's plaster statue, the latter was generously covered all over with a mixture of oil and tallow as a detaching agent. After that, a plaster countermould was created, consisting of horizontal rows of separated blocks, letting each part dry before beginning the next. The various blocks had corresponding tenon and mortice joints so as to be able to reassemble them exactly and firmly once they had been detached from the mould, obtaining a complete countermould, as illustrated in fig. 215.

The authors previously mentioned also indicate that separation may be achieved by the use of thin tin, silver or gold foil, applied to the model with flour paste, as well as with oil or tallow.

The copy of the smooth parts of the model being more easily treated, was made with solid blocks of the same height as the row, while the more detailed areas such as the horse's mane, the drapery and so on, were formed out of many small and thin sections which, in their turn, were slotted into a regular block and fixed to it with small cords threaded through tiny brass rings set into the back of the small sections.

Once the impression had been obtained, the sections were taken off the artist's model and used to obtain a wax model, exactly the same as the original one in plaster.

For this purpose, the sections were separately brushed over with hot wax composed of 100 parts of beeswax, 10 parts of turpentine and 10 of tallow. When this wax had been brushed thinly on (to the thickness of one "line"[1]), the wax wall was thickened as desired by the application of wax leaves of the same composition, heated so they would stick on more easily. The thickness of the wax varied from one place to another on the figure. The hooves were filled with wax up to the fetlock, while up to above the hock the wax was an inch thick and on other parts of the statue it was half an inch thick[1].

In all, 5326 pounds of wax were used, the corresponding weight of bronze being 10 times greater.

When the wax linings had been taken away, the sections were re-assembled from the base upwards so that the framework of the core could be put together with metallic bars.

Some of the iron rods forming the framework of the core were meant to be left in the bronze to hold up the statue, such as those

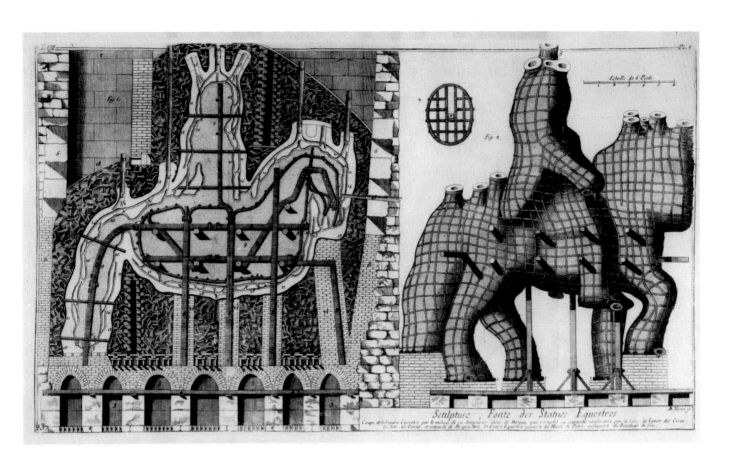

Sculpture , Fonte des Statues Equestres

218. Finished mould reinforced with iron bands.

of the legs standing on the ground, while the others were removed after the casting (fig. 216).

The core was made out of a mixture of sand taken from the St. Jacques's district with one third of dung and cloth clippings. When they were finished in every detail, the wax sections were applied to the core; next the pipes for the wax to drain away, the runners and vents were fixed by means of hollow wax rods in order to reduce the overall weight and to avoid the danger of the mould becoming detached (fig. 217).

Next the external mould was made by applying successive layers of *luto* used for the inside of the mould. The *luto* consisted of 3/6 of Chatillon earth which had been left to stand all winter in a pit, 1/6 horse dung, to which later were added 2/6 of powder obtained from grinding broken white crucibles and from drying urine; finally egg whites were added and the mixture was then brushed on to form a primary coat four layers thick.

The *luto* was made thicker in consistency through added clothes clippings; it was then used for another twenty layers to give 1½ inch thickness. Then fuller's earth was added and again several layers were applied until the mould became 8 inches thick in the lower part and 6 inches in the upper. The mould was then bound round with iron bands to give it the necessary firmness. (fig. 218).

Solid walls were built around the form, the space between the walls and the form being then filled with earthenware.

Next a moderately hot coal fire was lit in the three tunnels which had previously been hollowed out under the base support for the mould; this was to cause the wax to melt, about 50% of it being saved. Then the fire was built up to increase the heat and kept at this temperature for fifteen days until the mould was red in colour. It needed eight days to cool down.

When the earthenware had been removed the empty space left was filled with pebbles, mixed earth and chalk to absorb the dampness. After burying the mould until only the three gates protruded, a basin 15 x 2½ ft. was made for the molten metal from the furnace, conveniently placed higher than the level of the buried mould. (fig. 219). The casting metal used came to a total of 83,752 pounds, made up of old cannons, copper, brass and tin ingots as well as an ingot coming from the fusion of the statue of Sextus Marius, carried out in the workshop.

Casting method with gelatine or Silicone Rubber Moulds

It is now worth considering the way in which modern castings are produced.

The artist's model is usually made in plaster and then covered with a coat of clay or plasticine-like material, 2-4 centimetres thick, which simplifies the shape by not having to go into the deepest undercuts at this stage. Therefore, this coat is not pressed on to the model, but instead a plaster shell is made around it with two or more valves according to the dimensions and the complexity of the work to be cast.

After the master model has been taken out of the plaster, the various parts of the shell, which already have mortice joints on

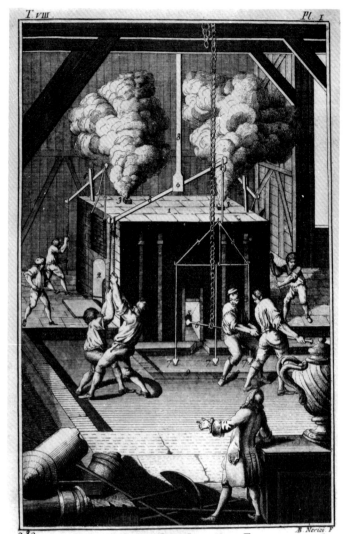

Sculpture, Fonte des Statues Equestres. AA
Attelier de la Fonderie et l'Opération de Couler la Figure en Bronze

219. The furnace built specially for the casting of this statue.

176

them so that the shell can be easily and accurately re-assembled, are put together and the layer of clay removed from the surface of the model.

After careful cleaning, the outside shell is re-assembled around the model and the space, previously occupied by the clay, is filled with liquid gelatine poured into the appropriate funnels prepared in the shell.

As the gelatine fills the space between the model and plaster shell, it makes a perfect negative reproduction of all the details of the model. Once it has been allowed to set, the gelatine maintains a good mechanical resistence and elasticity long enough for the following stage to be carried out. After the plaster shell has been taken away, the gelatine is cut along the junction lines of the shell; it is then easily detached as its elasticity enables it to be safely withdrawn from the deep undercuttings.

The various parts of the gelatine coat are then replaced in their respective parts of the plaster shells, thus obtaining the negative of the original.

A layer of wax, as thick as the metal wall required (4-6 mm), is spread on the inside of the gelatine mould. The various parts of the wax model are then re-assembled and touched up carefully by the artist before the mould for the casting is made.

The wax is nowadays made up of a mixture of beeswax, paraffin, resin, mineral oil and red aniline, so as to obtain the fluidity required by the operator.

For large-sized monuments different parts of the work can be made into moulds separately and cast; then joined by soldering or some other method.

For an average-sized figure which can be cast in one piece, the inside core is made by filling the wax with small pieces of chalk and powdered refractory brick. Once the core has been made, the cast gates and the wax or elder wood vents are inserted into the outside surface of the wax and the spacers, usually made of nails or pins according to the size of the cast, are placed in it.

A very fluid mixture of chalk and finely powdered refractory brick is brushed on to form a thin coat over which the mould is constructed with exactly the same material but thicker and coarser in texture. The firing of the mould and the casting of the metal are done exactly as has been previously described.

An alternative to the gelatine are the silicone rubbers which, after the casting and polymerisation, acquire a rubber-like consistency and last considerably longer than the gelatine impression. This enables a greater number of wax models to be taken from the same master model.

These costly materials are particularly suitable for the making of plaster casts from low reliefs.

Repairing Technique using sections

Most metal castings, in particular those for works of art, contain surface flaws which spoil the aesthetic effect. These defects may be caused in different ways, but usually because of their complex geometry and the very way the casting is carried out; they come from the entraining of oxides, localised over-heating of the mould, or porosity arising either through the metal not adequately filling all parts of the mould or through the formation of gas bubbles, as in the case of the Venetian horses.

Nowadays these defects can be quickly rectified by chiselling the defective area and building up a new metal layer with welding techniques. In antiquity the castings had to be repaired with sections, as they knew no easier way to make metal repairs. Where the defect was evident on the surface, a slot was chiselled out, usually rectangular in form and about 2-3 mm. deep, the walls at the edges slightly inclined in a dove-tail form. A section of the same dimensions taken from a plate, having roughly the same composition as the casting, was inserted into the slot and hammered there. Such a repair using sections is shown in the diagram of fig. 220.

0This method is amply documented through examples from most antique statues. Repair sections can be found on the Zeus from Cape Artemesion, the Ephebe of Marathon, the Artemides from Pireus, the horse from Cape Artemision (Archaeological Museum, Athens), the Chariot from Chianciano (now in the Florence Archaeological Museum), the large fragment of the Fiesole lioness, the head of Trebonius Gallus, the Marcus Aurelius of the Capitoline Hill, Rome, the colossal head of Constantine in the Museo dei Conservatori, and so on.

In the Renaissance, local defects were generally repaired by taking away the whole thickness of the defective cast wall which was then repaired with a patch roughly the required shape riveted on and often nailed round the edge as well. This type of repair can be seen near the right shoulder of horse ''B'', just under the original part of the collar. It is, however, a more recent repair than the original ones using dove-tailed sections.

1 Line: a French unit used in the 18th century, equal to 0.22555 cm; 12 lines formed an inch (2.707 cm) and 12 inches formed a foot (32.48399 cm) from ANGELO MARTINI, *Manuale di metrologia ossia misure, pesi e monete in uso attualmente e anticamente presso tutti i popoli*, Turin, 1883, Rome 1976 Ed. E.R.A., p. 466.

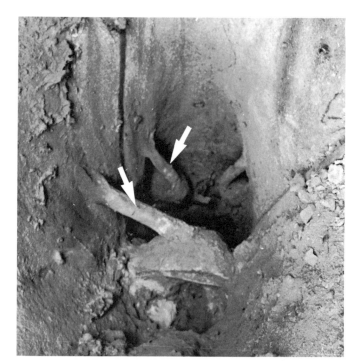

221. Internal feeders present in the Horse's muzzle.

222. Detail showing the interior of the Horse's neck. Traces can be seen of the striations made by the tool used to spread the wax as well as rough surfaces produced by cracks occurring in the core during firing.

Foundry techniques used in casting the Horses of San Marco

Gianni Frigerio and Massimo Leoni

The numerous experiments conducted on the four horses, in particular on Horse A, have led to the formulation of some sound hypotheses concerning the technology adopted by the bronze founders of antiquity when casting these sculptures. The casting method involved was certainly an indirect lost-wax technique, very similar to that previously described in connection with the casting of the equestrian statue of Louis XIV. The process in this case, however, was not carried out in a single cast but in many parts, such as the head and torso, similar to the method used in the casting of a warrior on the Kylix of Vulci. This is demonstrated, for example, by the numerous internal gates, some of which still exist both inside the muzzle (fig. 221) and close to the right haunch where a slightly curved piece of about 25mm. in diameter is clearly visible. The junction of a similar gate can be seen, situated symmetrically on the corresponding left side. These gates which were intended to make it easier to fill the mould, could only be employed if the inside surface of the wax model was accessible, but this would have been impossible in the case of Cellini's method of casting. The lines scored on the interior surface of the cast which were left by the small pieces of wood used to spread the wax inside the concave sections can also be observed (fig. 121).

Radiographic examinations have clearly revealed those areas where the various inlets were attached, and it is clear that a large number of them were applied to the outer surface of the wax model. The traces of these are elliptical in shape and they indicate that the inclined channels were placed longitudinally in rows, about 25 cm. apart, along the side of the model. It can be observed that this arrangement is exactly similar to the method used for casting the statue of Louis XIV.

The greatest number of imperfections in the walls of the casting can be seen close to these external inlets. As has already been noted, this is due to the extremely high temperature of the metal and the consequent increase of gas in the molten metal in addition to the overheating of the mould where the metal entered it. During the firing of the mould numerous fissures occured in the core wherever the metal had penetrated it, thus forming seams which can be clearly seen inside the horses (fig. 222). The considerable areas of porosity which had appeared on the surface, together with the small apertures left behind by the spacers and core supports - the latter being exceptionally large under the

223. Sectional repairs present in the surface of the cast (Mag. x 1.5).

horse's stomach, were repaired by using the technique of sectional repairs already described (fig. 223).

After careful finishing, the surface was then gilded by applying gold leaf using a mercury amalgam, as plainly demonstrated by the spectrographic examination.

179

Observations on ancient bronze casting

Massimo Leoni

Our knowledge of the exact quantities of the chemical composition in the alloy of a bronze monument is of fairly limited importance since a cast, particularly a large one, would inevitably show significant variations in different areas owing to the phenomenon of segregation. Furthermore, the actual methods of casting can result in appreciable variations of chemical composition between different parts of the cast.

In his *Treatise on Sculpture,* Cellini, in fact, refers to the practice of adding pure tin to the molten metal before casting in order to improve the flow when in contact with the runners which are much colder than the liquid metal. This consequently avoids the metal solidifying or becoming too viscous.

A monument could have been cast using metals taken from different crucibles or furnaces or might well have been repaired with metals of a different composition during its manufacture. Samples for the analysis of works of art are generally taken in difficult circumstances which make it extremely hard to obtain representative specimens with an average composition. Since, for obvious reasons, one is obliged to take as limited a number of such samples as possible from inconspicuous areas on a work of art, the results obtained are bound to be incomplete. Under such circumstances they could vary, even to a considerable degree, from one area to another of the same sculpture, as well as from the average value. Moreover, non-destructive methods of chemical analysis which can be used over bigger areas of antiquities, for example X-ray, gamma-ray or florescence, are likely to produce information strongly dependent upon the state of the surface, in particular upon the presence of corrosion products.

Bearing in mind the above factors, however, it is possible to distinguish certain differences in composition among monuments made by various schools of bronze sculptors in the past. These differences must therefore be considered in so far as they provide further evidence in the wider field of scholarship, even though of limited value if viewed in isolation. Taking the established data relating to the chemical composition of some of the most celebrated Greek, Etruscan, Roman, Medieval and Renaissance statues (Table I), it has been possible to note the preference for certain compositions of alloys according to the historical period and the metallurgical knowledge available when the objects were produced. It can be observed, for instance, that the Roman works made during the Empire represent a fairly well defined range of compositions involving a high percentage of lead, greater than that of tin. This range has been found to be notably wide as far as the percentage of lead is concerned, perhaps because of the marked tendency to segregate, so that it is not easy to maintain its percentage within the prearranged limits during the melting, casting and solidifying of the alloy.

Fewer differences are found among other groups of monuments. However, one can note a certain similarity in composition, for example, in the great Etruscan bronzes, such as the Chimera, the Minerva, the Orator, the Wolf of Fiesole and others, where tin is always present in a higher percentage than lead. Greek bronzes are also distinguished by a fairly high proportion of tin and a lower one of lead than found in the preceding Etruscan examples. Medieval and Renaissance bronzes are closer to Greek ones in so far as they have lower percentages of lead and quite a high content of tin. The lower percentage of lead could be related to the influence of cannon founders who, for reasons of resistence, used a binary bronze containing 10% tin, known in fact as bombard bronze, for the casting of artillery pieces.

It is significant that neither Cellini nor Biringuccio refer in their treatises to the use of bronze containing lead to cast figures. However, there is no lack of monuments with an alloy composition substantially different from those mentioned above, such as, for example, Cellini's *Perseus*. In that particular work the reasons for the very low percentage of tin present in its alloy are well known. The panels of Ghiberti's "Gates of Paradise" also have a low percentage of additives, though higher than 6%.

The four horses of San Marco on the other hand possess a composition which, to date, has not been found comparable to that of any other monuments which can be accurately dated. It is only by continuing these researches into the practices of metallurgy in antique art that it will be possible to apply the resulting knowledge to the solution of this fascinating problem.

180

TABLE 1

CHEMICAL COMPONENTS OF VARIOUS BRONZE MONUMENTS

Monuments			Cu %	Sn %	Pb %	Zn %	Fe %	Ag %	Ni%
*	Horse's head	Arch. Museum, Florence	86.99	11.61	0.06	abs.	tr.	tr.	tr.
*	Poseidon	Ugento	86.78	8.47	3.58	tr.	0. 14	tr.	tr.
	Chariot of Chianciano	Arch. Museum, Florence							
	——— human chest		82.90	11.95	1.66	abs.	tr.	tr.	tr.
	——— lock of chariotter's hair		84.07	11.59	0.73	abs.	tr.	tr.	tr.
*	Chimera of Arezzo	Arch. Museum, Florence	79.69	13.89	1.02	0. 16	0.33	tr.	tr.
*	Ephebe of Selinunte		88.66	8.99	0.70	abs.	tr.	tr.	tr.
*	The Beautiful Door of Hagia Sophia	Constantinople							
	——— oldest part of right leaf		86.61	10.15	2.98	tr.	tr.	tr.	tr.
	——— upper part of left leaf		71.44	6.17	20.05	0.11	0.21	tr.	0.05
*	Horse of Cartoceto	Ancona Museum	67.06	3.85	27.62	n.d.	n.d.	n.d.	n.d.
*	Door of San Zeno	Verona							
	——— 1st master		90.86	6.49	2.49	abs.	tr.	tr.	tr.
	——— 2nd master		79.83	0.07	6.31	13.56	tr.	tr.	tr.
*	Griffin	Palazzo dei Priori, Perugia	88. 15	10.23	0.44	abs.	tr.	tr.	tr.
*	Lion	Palazzo dei Priori, Perugia	9 1.35	7.54	0.77	abs.	tr.	tr.	0.08
*	Gates of Paradise	Florence	93.70	2.20	1.30	1.80	tr.	n.d.	n.d.
º	Artemis	Arch. Museum, Pireus	86	12	1	—	—	—	—
º	Idolino	Arch. Museum, Florence	87	10	1	—	—	—	—
º	Athena	Arch. Museum, Pireus	87	11	1	—	—	—	—
º	Kouros	Arch. Museum, Athens	9 1	8	1	—	—	—	—
º	Torso	Arch. Museum, Florence	87	12	—	—	—	—	—
º	Apollo	Arch. Museum, Pireus	87	10	—	—	—	—	—
º	Minerva of Trasimeno	Arch. Museum, Florence	85	11	4	—	—	—	—
º	Woolf of Fiesole	Arch. Museum, Fiesole	83	12	5	—	—	—	—
º	Marcian emperor	Arch. Museum, Barletta	64	8	24				
º	Grocer's table	Arch. Museum, Velleia							
	——— inscription		74	5	20	—	—	—	—
	——— cornice		67	5	27	—	—	—	—
º	Head of young girl	Arch. Museum, Velleia	77	7	15	—	—	—	—
º	Statues of the Fontana Maggiore	Perugia	84.87	13.65	1.46	—	—	—	—
º	The Judith of Donatello	Florence	9 1.30	8.17	0.16	—	—	—	—
º	The Neptune of Giambologna	Bologna	88.98	9.87	0.98	—	—	—	—
º	Cosimo I of Giambologna	Florence	89. 15	10.47	0.16	—	—	—	—
º	The Perseus of Cellini	Florence	95.37	2.29	1.5 1	—	—	—	—
º	Medusa of Cellini's Perseus	Florence	92.65	6.32	0.45	—	—	—	—

* Analyses carried out by the author (small percentage of As-Bi-Sb are almost always present).
º From B. Bearzi, *Il bronzo nella antichità*, "La Fonderia Italiana", n. 2, 1966, pp. 65-67
tr. = traces abs. = absent n.d. = not determined

The gilding of bronze statues in the Greek and Roman world

W.A. Oddy, Licia Borrelli Vlad and N.D. Meeks

Among the bronze statues which survive from antiquity, those which were originally gilded on the surface are not very numerous. As far as can be ascertained, the gilding of bronze statues seems to have been rarely practised in the Greek world, although a statue portraying himself and said to have been either gilded or made of solid gold, was consecrated at Delphi by the rhetorician Gorgias. Also at Delphi was a golden statue of Phryne by Praxiteles [1]. The evidence of both the documentary [2] and archaeological records suggests that the gilding of statuary was more in keeping with Roman taste but, nevertheless, Pliny criticised Nero for importing an ungilded bronze statue of Alexander the Great from Greece and then spoiling it by attaching a layer of gold [3].

> The emperor Nero was so delighted by this statue of the young Alexander that he ordered it to be gilt

It seems, however, that opposition to Nero's "improvement" was so great that the gold was removed, but grooves remained on the surface which disfigured the statue. The text continues:

> but this addition to its money value so diminished its artistic attraction that afterwards the gold was removed, and in that condition the statue was considered yet more valuable, even though still retaining scars from the work done on it and incisions in which the gold had been fastened.
>
> Plinii. *Naturalis Historiae*, XXXIV.XIX. 63-4

This quotation from Pliny has often been interpreted as indicating that the statue of Alexander was gilded by the method known in France as "a l'hache" [4] in which the surface of the metal was extensively roughened and then gold foil was laid on top and hammered or burnished into position [5]. Working the surface in this way tended to flatten the roughened surface, trapping the gold foil in the grooves as the edges were pressed down. Although the bond between the gold foil and the base metal is purely physical, this method was used in certain circumstances until recent times.

Recent discoveries in Athens, however, have made it seem unlikely that Nero's goldsmiths used the "a l'hache" method, as some fragments of a newly discovered equestrian bronze statue from the Athenian Agora [6] have grooves cut in the surface which retain traces of gold foil. Unlike bronze gilded by the "a l'hache" method, these grooves do not criss-cross the whole surface, but

delineate areas over which sheets of gold foil were applied. Analyses of the bronze [7] has shown that these fragments are made of heavily leaded tin bronze which is consistent with a date subsequent to the end of the fourth century B.C. [8]. Another bronze which bears traces of the same type of gilding is a small head of Nike in the Agora Museum in Athens [9]. This head, which is about half life-size, is dated to the late fifth century B.C. [10], and Craddock has shown that it is cast in an 8% tin bronze [11], which is entirely consistent with this earlier date. It has long been realised that the grooves around the edge of the areas to be gilded were a means of attaching gold foil to the face of the goddess, and it has been postulated that a sheet of gold foil was laid over the face and pressed into the details of the sculpture. The edges of this foil were then inserted into the grooves in the bronze which were hammered to trap the gold. It has been assumed that this method of gilding was adopted so that the gold could be put in place on special occasions and later removed [12].

It seems probable, however, that the gilding of large metal sculptures was a relatively new innovation in Nero's time and that the only other method of gold application which was practical on a large scale, that of sticking gold leaf to the surface of the bronze with a suitable adhesive, did not provide a very durable layer of gilding which would withstand long exposure to the weather. This, of course, is conjecture, but it remains a fact that life-size gilded bronze sculpture is uncommon until well into the Roman imperial era, when examples such as the equestrian statue of Marcus Aurelius in Rome [13] or the portrait busts of various third century A.D. emperors, now in the musem at Brescia [14], may be cited.

In contrast to the relative scarcity of large gilded bronzes, small gilded statuettes and jewellery are common, and have their origin in the Bronze Age [15]. One of the earliest representations of a goldsmith at work is a relief in the necropolis of Sakkarah, which is dated to about 2500-2000 B.C. (fig. 225). The earliest methods of gilding involved the wrapping of gold foil around the base metal, but as techniques of making thin gold leaf improved, gilding techniques changed so that the thin leaf could replace the thicker foil, with a consequent saving of gold. According to Pliny [16] 750 leaves each ten centimetres square could be made from one ounce of gold. The gold leaf was produced by beating it between small squares of parchment, a process described in some detail by

Theophilus[17], and its fineness inspired poets to compare it with a cobweb[18] or with mist[19]. A relief of the Roman period in the Vatican Museum illustrates an aurifex brattiarius at work. He holds a plate with his left hand on an anvil and is beating this with a hammer held in the right hand. Beside him are the packets of gold foil ready for use (fig. 224). Modern research on ancient techniques of gilding is in its infancy, but a start has been made by Lechtman[20] and Lins and Oddy[21]. The most difficult period to understand in the Old World is the first millennium B.C. and the first one or two centuries A.D. During this period gold foil was applied to small silver and bronze objects by methods which have not yet been characterised by scientific examination, although in some cases they must have involved a diffusion type of bond which was made under the influence of heat and pressure[22].

The introduction of the use of mercury revolutionised the process of gilding and from about the third century A.D. the process of fire- or mercury-gilding was the standard method of covering copper alloys or silver with a thin layer of gold until the invention of electroplating in the mid-nineteenth century. There are two practical approaches to the use of mercury for gilding. In one of these, gold is dissolved in boiling mercury to form on amalgam with a pasty constitency which is spread onto the clean surface of the metal. Subsequent heating causes the mercury to evaporate, leaving behind a layer of gold which is very firmly bonded to the surface. In the second method, the mercury is applied directly to the surface and the gold leaf is laid on top. It immediately dissolves in the mercury to form an amalgam and then, as before, the mercury is eliminated by heating. Although these two methods of gilding differ in the technique of application of the gold, the appearances of the gilded layers which result are visually indistinguishable from one another, although it seems likely that thicker layers of gold are derived from the application of the gilding in the form of a ready-made amalgam[23].

One problem which remains as far as fire-gilding is concerned is when and where it was invented. Lins and Oddy carried out a survey of gilded antiquities in the British Museum and found evidence for the use of the technique in China in the third century B.C., but could not identify any unequivocally fire-gilded objects from the Mediterranean area before the second or third century A.D.[24], although Craddock has since found a group of gilt copper rings of the fourth to the first centuries B.C. which have traces of mercury in the gold[25]. However, with one exception, all the late Greek and early Roman gilded silver objects which were examined by Lins and Oddy[26] did not contain mercury in the gilded layer, and this created a problem for these authors because there are clear allusions to the use of mercury for gilding in the first century A.D. in the works of two Roman authors.

Pliny says[27]:

> The regular way to gild copper would be to use natural or at all events artificial quicksilver.... The copper is first subjected to the violence of fire.... after a thorough polishing

224. Funerary stele of an "aurifex brattiarius". Vatican Museum, Rome.

with a mixture of pumice and alum, it is able to take the gold-leaf laid on with quicksilver.

Plinii, *Naturalis Historiae*, XXXIII.xx. 64-5

and Vitruvius, writing about the same time, gives similar information[28]:

Quicksilver is adopted for many uses. Without it neither silver nor brass can be properly gilt.

Vitruvii, *De Architectura*, VII.VIII.4

Until recently almost nobody had ever questioned that these quotations referred to mercury- or fire-gilding in one of the two forms which were described above. Only Moran seems to have had some doubts[29] which were intensified by the failure of Lins and Oddy to find any mercury-gilded Roman objects from the first century A.D. Now Vittori seems to have found the answer with his re-interpretation of part of Pliny[30]. Vittori has looked again at Pliny's description of a fraudulent method of gilding[31] and come to the conclusion that when mercury was used for gilding the object was NOT subsequently heated to expel the mercury, but that the latter diffused to the surface and evaporated of its own accord at room temperature during the first few days following the gilding process. Vittori now postulates that when Pliny and Vitruvius refer to the use of mercury for gilding, the process involved the application of a very thin layer of mercury to the base metal surface, onto which gold leaf is applied. The gold becomes bonded to the surface by partial dissolution, but the lack of any significant amount of excess mercury on the surface prevents complete formation of a gold amalgam. The surface is said to take on a milky appearance which gradually disappears as the mercury evaporates, leaving a matt yellow layer of gold which can be polished with a burnishing tool.

Pliny also points out that a cheaper and inferior method of gilding was to use the white of an egg to stick the gold leaf to the surface[32]. This is the standard method of attaching gold leaf to other materials which is still used today by bookbinders for gold blocking leather bindings, and has been the traditional method for gilding stone and wooden sculptures for centuries. If Pliny is to be believed[33] this method was also used on items for which the goldsmith charged the customer for using mercury when he had, in reality, only used the white of an egg[34].

Because the cold mercury-gilding process, postulated by Vittori[35], would be expected to retain analytically detectable traces of mercury in the gold, the failure of Lins and Oddy[36] to identify mercury in gilded objects from the time of Pliny should probably be attributed to the fact that this form of gilding was costly, as Pliny said[37], and therefore reserved for special articles. For cheaper, everyday items, gilding must have been carried out by some sort of diffusion bonding technique[38], or by sticking gold leaf onto the surface with an organic adhesive, and this situation continued until the second or third century. A.D. after which mercury is almost invariably detected in gilded metal objects. This must be interpreted to mean that new and prolific sources of mercury had been discovered, or more likely that the metal had become much more readily available due to improvements in techniques for its extraction and purification. It seems reasonable to associate the widespread use of gilding with the change in the technique to what we now know as fire- or mercury-gilding, and this is in agreement with the meagre historical sources which survive.

In late Roman, Medieval and Renaissance times the technique of fire-gilding is mentioned several times in the existing technical treatises. The earliest known account is contained in the late third century A.D. manuscript known as the Leyden Papyrus X[39] which describes the manufacture of gold amalgam for spreading over the cleaned base-metal surface. Embers are then mentioned as part of the finishing process, so it is presumably safe to infer that the objects were heated to eliminate the mercury. The eighth century A.D. *Compositiones Variae*[40] and the similarly dated *Mappae Clavicula*[41] both contain almost identical descriptions of fire-gilding in which it is quite clear that the technique being described is that which remained in use until the invention of electro-plating in the mid-nineteenth century.

The most important of these descriptions from the point of view of understanding the gilding technology of the horses of the Basilica of San Marco is that written in the early twelfth century A.D. by Theophilus[42]:

To gild a censer of bronze[43], proceed in the same way that you gilded the silver chalice above, (i.e. by fire-gilding), but more cautiously, since silver and ordinary[44] copper can be more easily gilded than bronze....... If, when it begins to show a yellow colour (i.e. during final heating), you see white stains emerge on it so that it is not disposed to dry evenly, this is the fault of the calamine, because it was not evenly mixed, or of the lead, because the copper was not purified and extracted by heat.

Theophilus, *De Diversis Artibus*, III.LXVII.

This passage clearly states that the presence of lead and zinc in copper make fire-gilding on the surface very difficult to carry out. This must have been common knowledge by the twelfth century, and Vittori has collected together other references which demonstrate that mercury-gilding was usually confined to high purity copper alloys[45].

If it can be said that the medieval craftsmen knew that it was impossible to fire-gild large sculptures which were cast in the highly leaded bronze alloy which was normal in Roman times for bronze statuary, it is important to ask whether this fact was also known to the Roman metalworkers. In their studies of Roman bronzes from Gaul, Picon, Condomin and Boucher noticed a correlation between an unusually "high copper/low lead/low tin" composition and the presence of gilding and they postulated that this composition was due to the necessity of keeping the hardness to a minimum[46] so that the gold could be attached by a technique described by them as "placage sur rayures" (i.e. "a l'hache"), which they thought was the one described by Pliny for the gilding of the statue of the young Alexander on the orders of Nero[47]. They completely missed the possible connection of the

unusual composition with one of the other methods of gilding described by Pliny - that of using mercury at normal temperatures. Furthermore, although eight of the gilded bronzes which were analysed by Picon, et al-were low in tin and lead, two were cast in normal highly leaded tin bronze and these must have been gilded by attaching gold leaf with an adhesive. The statue of a horse (fig. 42) from Cartoceta provides another example of the use of this latter technique, which has been confirmed by scientific examination. A sample obtained from this horse [48] was examined in the scanning electron microscope (SEM). The metallographic structure shows that the bronze is heavily leaded and a non-continuous layer of gold with an average thickness of 2 to 3 microns is visible on the surface. Between the gold and the body metal lies a thin layer of corrosion products derived from the bronze. Analysis of the specimen with the x-ray fluorescent analyser attached to the SEM indicated the presence of tin in the body metal. Analysis of the surface layer of gold by both x-ray fluorescence and by emission spectrography indicated that no mercury is present and it can confidently be concluded that this statuary group was gilded by glueing leaf to the surface of the metal. This conclusion can be confirmed by an examination of the statues themselves. In many places a network of gold lines is visible forming a pattern of squares over the surface and these lines indicate the areas where the adjacent squares of gold leaf overlapped, resulting in a double thickness of gold which has been preserved better than the centre of the squares where the gilding was only one leaf thick.

Identical results were obtained from the examination of a sample of a gilded life-size bronze arm, found in a well near Rheims [49]. This is thought to date from the first or second century A.D. and Craddock has shown that this alloy contains 17% of lead and 5% of tin [50]; SEM examination revealed a gold layer with a thickness of 4 to 6 microns. Analysis has again shown that no mercury is present in the gold, which must have been attached to the surface with an adhesive. A further example of a gilt leaded tin bronze is the horse's hoof. This alloy contains 8% of lead and 3% of tin [51] and again no mercury was detected in the gold layer by either x-ray fluorescence analysis or by emission spectropraphy. The lead can be seen to occur between the grains of copper-rich phase, where it segregated as the alloy cooled. The gold layer varies in thickness from about 1 to 5 microns and there is evidence for the application of several layers of gold leaf.

These various investigations show that where gold leaf contains no mercury and has been applied to the surface with an adhesive the alloy used for the casting invariably contains tin and a large amount of lead. In contrast, however, the small gilded statue of Hercules [52] which was examined by Lins and Oddy [53] was found to be entirely different. This statue, is dates to the third century A.D. and is said to have been found on Hadrian's Wall in the north of England. It has been shown by analysis to have been fire-gilded and Craddock has since shown that the alloy is a 2% tin bronze [54]. The figure is modelled in a stiff and unnatural looking pose, and this may be attributed to a desire by the artist to minimise intricate details in the mould which could only be filled with difficulty by the high melting point alloy used to make it.

Data presented elsewhere in this volume by Professor Leoni has shown that the composition of the horses of the Basilica of San Marco corresponds to that of this statue of Hercules, in that they are cast in a copper alloy containing only about 1% each of tin and lead. Examination of a sample from the tail of horse B [55] in the scanning electron microscope shows a small amount of lead concentrated at the grain boundaries of the copper-rich phase and the gilding can be seen to form a layer which varies between 10 and 20 microns in thickness. Very little corrosion has taken place beneath the gilding, except for one area of the sample where there is a break in the gilding which has enabled moisture and oxygen to penetrate into the body metal. Examination in greater detail of the gilding in this area has shown that several distinct layers of gold are visible and analysis with the x-ray fluorescence spectrometer attached to the SEM has shown the inner one contains a little copper and mercury, while the other four layers consist of pure gold. This examination has confirmed the results of the previous examination [56] which showed that the Horses of San Marco were first gilded with the aid of mercury and that gold leaf was added subsequently. It seems very likely that these further layers were burnished into position without the use of an adhesive, but the examination cannot determine whether they represent part of the original gilding operation or whether they have been applied subsequently in an attempt to improve the appearance of the surface after weathering.

There can be no doubt, as a result of these examinations, that the Horses of the Basilica of San Marco were deliberately made of an alloy which was suitable for gilding by using mercury, and it is pertinent, therefore, to ask whether this fact is of any significance for dating the manufacture of the horses. The earliest known objects which were made of a high copper alloy for the same reason are the Hellenistic bracelets and finger rings which were examined by Craddock [57], but the evidence discussed above has shown that the use of mercury for gilding was an expensive and rare technique until well into Roman imperial times. What is most significant is the total absence of any other high purity statuary whose composition is strictly comparable with the Horses of the Basilica of San Marco, except for the small Hercules described above, and until some similar dated pieces are discovered, the date of the Horses, from a scientific point of view, must remain in doubt. In view of the enormous technical difficulties which would result from casting the Horses in a 98% copper alloy, it seems most likely that they should, like the Hercules, be attributed to the later part of the Roman imperial period.

(1) Pausanius, *Periegesi*, X, 18,7.

(2) G. Becatti, *Interrogativi sul problema dei cavalli di S. Marco*, in Rendiconti Pontificia Accademia 43 (1979-71) 205-206.

(3) H. Rackham, *Pliny: Natural History* (Vol. 9), Loeb Classical Library, London, 1952 (reprinted 1968) p. 175.

(4) H. Blumner, *Technologie und Terminologie der Gewerbe und Kunste bei Griechen und Romern*, Leipzig, 1884, p. 311.

(5) D. Diderot and J. Le Rond D'Alembert, *Encyclopédie, ou Dictionnaire raisonné des sciences, des arts et des metiers*, Paris, 1751-65. See entry under ''dorure''.

(6) T.L. Shear, *Sculpture in the Athenian Agora: Excavations of 1971*, Hesperia 42 (1973) 121-179, esp. pp. 165-168.

(7) P.T. Craddock, unpublished analyses.

(8) P.T. Craddock, *The Composition of copper alloys used by the Greek, Etruscan and Roman Civilisations, 2: The archaic, Classical and Hellenistic Greeks*, Journal of Archaeological Science 3 (1976) 93-113.

(9) T.L. Shear, *The Sculpture*, in The American Excavations in the Athenian Agora: Second Report by T.L. Shear et al. Hesperia 2 (1933) 514-541, esp. pp. 519-527.

(10) H.A. Thompson, *A Golden Nike from the Athenian Agora*, in Athenian Studies presented to William Scott Ferguson, Harvard Studies in Classical Philology, Supplementary Vol. I, Cambridge, Mass., 1940, p. 198.

(11) P.T. Craddock, unpublished analyses.

(12) K.A. Thompson, *op.cit.* pp. 187-194.

(13) A. Apolloni, *Vicende e restauri della statua equestre di Marco Aurelio*, in Atti e Memorie dell'Accademia di S. Luca 2 (1912) 1-24.

(14) C. Stella, *I Grandi Bronzi del Museo Romano di Brescia*, Bergamo, 1976.

(15) W.A. Oddy, T.G. Padley and N.D. Meeks, *Some unusual techniques of gilding in antiquity*, in the proceedings of the 18th International Symposium on Archaeometry and Archaeological Prospection held at the Rheinisches Landesmuseum, Bonn, in March 1978. Forthcoming.

(16) K.Rackham, *op.cit.* p. 49. (Plinii, *Naturalis Historiae*, XXXIII, xix. 62-63).

(17) Theophilus, *De Diversis Artibus*, I. 23.

(18) Lucretius, *De rerum natura*, IV. 727.

(19) Martial, *Epigrammaton*, VIII, 33.3 and 15.

(20) K.N. Lechtwan, *Ancient methods of gilding silver: Examples from the Old and New Worlds*, in Science and Archaeology (ed. R.H. Brill) Cambridge, Mass., 1971, pp. 2-30.

(21) P.A. Lins and W.A. Oddy, *The origins of mercury gilding*, Journal of Archaeological Science, 2 (1975) 365-373.

(22) W.A. Oddy, T.G. Padley and N.D. Meeks, *op.cit.*

(23) Janet Lang, M.J. Hughes and W.A. Oddy, *Report on the scientific examination of the silver dish.... from Kaiser Augst*, forthcoming in the definitive report on the Kaiser Augst Treasure.

(24) P.A. Lins and W.A. Oddy, *op.ci.t*

(25) P.T. Craddock, *op.cit.*

(26) P.A. Lins and W.A. Oddy, *op.cit.*

(27) H. Rackham, *op.cit.* p. 51.

(28) F. Granger, *Vitruvius on Architecture* (Vol. 2), Loeb Classical Library, London, 1931 (reprinted 1962) p.117.

(29) S.F. Moran, *The gilding of ancient bronze statues in Japan*, Artibus Asiae 31 (1969) 55-65. See foot-note 5 on p. 55.

(30) O. Vittori, *Pliny the Elder on Gilding: A new interpretation of his comments*. Gold Bulletin 12 (1979) 35-39.

(31) K. Rackham, *op.cit.* p. 77 (Plinii, *Naturalis Historiae*, XXXIII, xxxii. 99-100.)

(32) See ref. 31.

(33) See ref. 31.

(34) O. Vittori, *op.cit.*

(35) O. Vittori, *op.cit.*

(36) P.A. Lins and W.A. Oddy, *op.cit.*

(37) See ref. 31.

(38) W.A. Oddy, T.G. Padley and N.D. Meeks, *op.cit.*

(39) E.R. Caley, *The Leyden Papyrus X: An English translation with brief notes*, Journal of Chemical Education 3 (1926) 1149-1166. See recipe no. 57 on p. 1158.

(40) J.M. Burnam, *A Classical Technology*, Boston, 1920, p. 127.

(41) C.S. Smith and J.G. Hawthorne, *Mappae Clavicula: A little key to the world of medieval techniques*, Transactions of the American Philosophical Society 64 (Part 4) (1974). See recipe 219 on p. 60.

(42) C.R. Dodwell, *Theophilus: the Various Arts*. London, 1961, p. 126.

(43) J.G. Hawthorne and C.S. Smith, *On Divers Arts: the Treatise of Theophilus*, Univ. Chicago Press, 1963, p. 145, give *brass* for *bronze*.

(44) J.G. Hawthorne and C.S. Smith, *op.cit.*, p. 145, give *unalloyed* for *ordinary*.

(45) O. Vittori, *Interpreting Pliny's Gilding: Archaeological Implications*, La Rivista di Archeologia, forthcoming.

(46) M. Picon, J. Condomin and S. Boucher, *Recherches Techniques sur des Bronzes de Gaule Romaine. II*, Gallia 25 (1967) 153-168.

(47) M. Picon, S. Boucher and J. Condomin, *Recherches Techniques sur des Bronzes de Gaule Romaine*, Gallia 24(1966) 189-215

(48) By kind permission of Dott. L. Mercando, Soprintendente Archeologico delle Marche, Ancona, and with the kind cooperation of Dott. P.L. Dal Francia of the Archaeological Laboratory for Tuscany in Florence.

(49) Department of Greek and Roman Antiquities, British Museum. Registration No. 1904.2-4.1249.

(50) P.T. Craddock, *The Composition of Copper Alloys used in the Classical World*, Ph. D. Thesis, Institute of Archaeology, London University, 1975, Analysis No. 0032.

(51) See note 50 Analysis no. 0662.

(52) Department of Prehistoric and Romano-British Antiquities, British Museum, Registration No. 1895.4-8.1.

(53) P.A. Lins and W.A. Oddy, *op.cit.*

(54) P.T. Craddock, *The Composition of Copper Alloys used in the Classical World, op.cit.* Analysis no. 1048.

(55) By kind permission of Dott. B.M. Scarfi, Sopraintendente Archeologica per il Veneto e il Friuli-Venezia Giulia, and the Primo Procuratore di San Marco, and with the kind co-operation of Geom. G. Fioretti.

(56) M. Leoni, *Enciclopedia Mondadori della Scienza e della Tecnica*, Milano, 1967, Vol. 68, pp. 392-3.

(57) P.T. Craddock, *op.cit.*

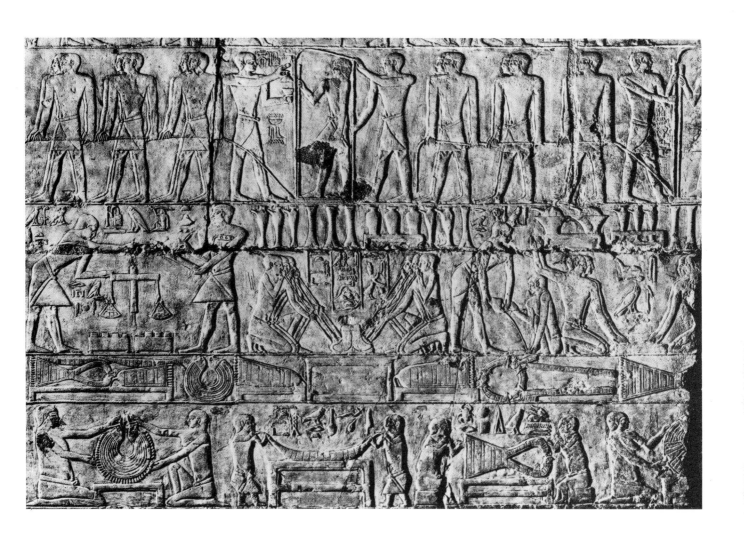

225. Detail of the 6th dynasty tomb relief of Mereru-ka (c. 2400 B.C.). Sakkara. The working of precious metals is depicted in the central and lower bands.

Part Three Scientific Studies and Techniques

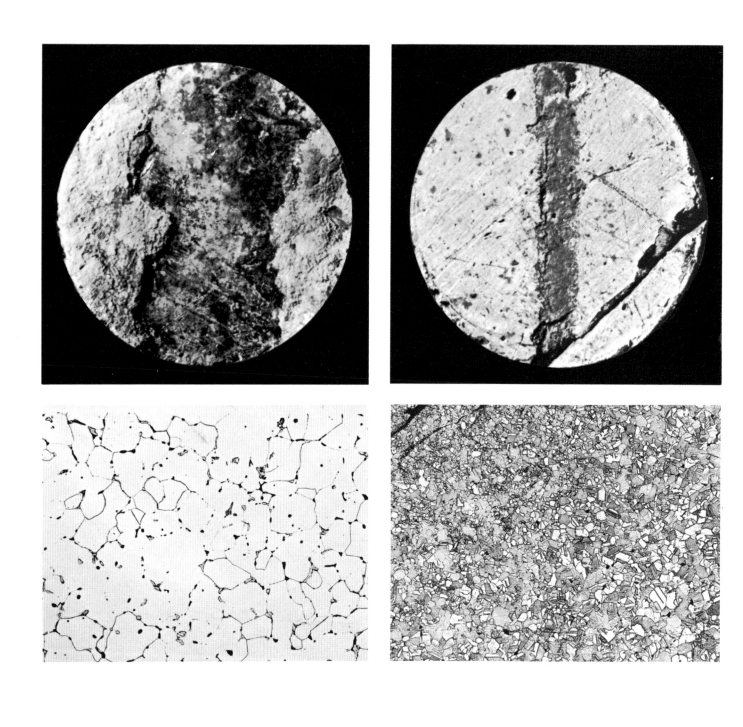

228. Microstructure of the cast walls in areas some distance from the sectional repairs (Mag. x 100. Etched in FeC1$_3$).

229. Microstructure of the cast walls in a cavity produced by the insertion of sectional repairs (Mag. x 100. Etched in FeC1$_3$).

226 - 227. Outer surface of the Horse at the area where the metallographic examinations were carried out (Mag. x 12.5).

190

Metallographic investigation of the Horses of San Marco

Massimo Leoni

This chapter provides a brief description of the results of the metallographic investigation of horses A and B, including the chemical analyses of the alloys used when casting various parts of them. It also includes the metallographic and thickness measurements of horse B and the radiographic examination of parts of horse A.

Analyses

Analyses carried out on the two horses to the left when looking at the Basilica from the Square - horses A and B - have revealed that they were cast in a ternary bronze alloy composed of copper, tin and lead which were so low in percentages that the metal could almost be considered impure copper. These findings would agree with Niceta Acomitano's reference to the horses as made of "gilded copper", if the transcriptions of this chronicler's words can be relied upon.

The results of these analyses, confined to the alloying elements and the principal impurities involved, are set out in table 1 below. These findings as far as the presence of tin is concerned, entirely agree with analyses carried out in 1815 by Klaproth in Berlin and Darcet in Paris, as well as by Bussolin, the chief assayer of the Venetian Mint, in 1842. The only exception to this is Barigozzi's analysis, undertaken in 1908, but this could be because he analysed an easily detachable fragment of metal forming part of a later repair. The percentage of copper in these past analyses was evidently obtained by adding up the percentages of the minor elements and assuming that the remainder was composed of copper, while Klaproth and Darcet were not concerned with the separation and nature of the lead involved. All these analytical results, supported as will be seen by the similar characteristics found in the casts, show that the four horses have a consistent metallurgical composition, and also perhaps reveal that the use of this particular alloy was deliberate. Even today, it would raise problems for the most expert bronze founders because of the extremely high heat needed to cast it.

The possibility that the four horses were cast at the same time from an identical source of metal must be excluded. Moreover, given the large number of pieces cast, it is evident that such an alloy was not used by chance, as for instance when accidental factors determined the alloy Cellini used when casting his Perseus.

TABLE 1

RESULTS OF THE CHEMICAL ANALYSES CARRIED OUT ON THE HORSES OF THE BASILICA OF SAN MARCO

	Cu %	Sn %	Pb %	Sb %	Ag %	Fe %
Horse A						
Head Sample 1	98.12	0.77	0.55	0.15	0.006	0.022
Sample 2	96.67	1.31	1.16	0.25	0.005	0.13
Body Sample 3	97.65	0.95	0.98	0.17	0.009	0.023
Sample 4	96.95	1.22	1.14	0.21	0.015	0.19
Collar Sample 5	98.35	0.39	0.11	0.90	tr.	abs.
Horse B						
Body	97.22	1.22	1.04	n.d.	n.d.	0.10
Klaproth (1815?)	99.30	0.70	—	—	—	—
Darcet (1815?)	99.18	0.82	—	—	—	—
Bussolin (1842)	98.75	1.00	0.20	—	0.05	—
Barigozzi (1908)	92.00	7.10	0.45	—	—	—

Recently in the restoration laboratories of Athens Museum, Marchesini has examined a fragment of a horse's hoof in gilded bronze from the Museum of Sparta. As this fragment resembled the Venetian horses, a small sample was obtained for chemical analysis. Detailed spectographic examinations of the fragment concerned have shown the presence of lead and tin in the alloy with the copper, together with low percentages of antimony, arsenic and iron. There are also traces of nickel and silver. Clearly gold was present on the surface although it was impossible to find any significant traces of mercury. Because of the smallness of the sample the quantitative chemical analysis was restricted to distinguishing the major elements present which would therefore be more technologically significant. The analytical results were as follows:

Cu. 94.74% - Sn. 1.96% - Pb. 1.92% - Sb. 0.08%

The Spartan horse provides us with the first reliably documented work of antique sculpture with technological characteristics comparable to those of the horses of San Marco.

The front part of the collar of each horse was not cast as the back portion was but applied mechanically instead using a large plate with a flange riveted on to it in imitation of the back part of the collar. The chemical composition of the collar is notably different from the other pieces of the horses due to the presence, as shown in table 1, of a high percentage of antimony and the absence of iron. It will be necessary to make a further examination to decide whether these parts of the collars are original or were added later, as well as where and when they were made and added to replace lost pieces. Antimony has not only been used in copper alloys since the early days of metallurgy but also during the Middle Ages and Renaissance. Vanuccio Biringuccio, speaking about antimony in the above-mentioned *Pirotechnia* states that ''they brought to Venice from Germany metal ingots for the bell-founders because they discovered that by mixing a certain amount of it with their metal the resonance was greatly increased; it was also employed in manufacturing tin vessels as well as by mirror-makers for both the glass and metals used, as they still do now''. A spectographic analysis which shows the presence of mercury, as well, of course, as the gold, has been carried out on the gilded surface of the Venetian horses. This would appear to indicate that gilding was done by using mercury with gold leaf.

Metallographic examination

The metallographic examinations were carried out on specimens obtained from the second horse on the left when looking towards the Basilica - horse B. One of the two specimens (sample a) was taken from the area on the right side of the rump which is badly corroded, while the other came from the left flank (sample b) - an area which is not particularly corroded but corresponds to one of the many dark lines present on the surface, which will be discussed later. This sample also contains one of the numerous sections added during antiquity to repair the surface of the cast. The areas selected for metallographic examination are illustrated in figs. 226-227 with little magnification (x 12.5). The micro-structure of the walls of the cast, varying in thickness from 7.5 to 10.5 mm. in the areas examined, was found to be made up of grains of alpha solid solution α (Cu), fairly homogenous and of small size. Some minute crystals of copper sulphide and globules of lead, extremely minute as well, are also present on the grain boundaries. However, this is typical of a cast which, after solidification, has undergone sufficient heating to homogenise the solid solution at least partially (fig. 228)

In sample b., taken close to where the slot was made for the section to be inserted, the microstructure of the wall of the cast showed a notable variation. This is the typical structure of a copper alloy, which has been cold worked and then heated, thus causing its recrystallisation (fig. 229). The structure, therefore, consists of grains showing the process of twinning and becoming finer as they approach the area where the slot has been made and the section inserted; that is, where there had been hammering on the solid cast wall, both through using a chisel to open the slot and riveting the section onto the cast. Some spherical cavities can be

seen on the inside walls of the cast which are typical of those formed by gas developing during the solidification of the metal. The Vickers hardness (10/15'') was practically the same in the two samples (HV = 69); it illustrates the striking homogeneity of the chemical composition and of the microstructure of the various areas of the cast.

A thin layer of gold for the 0.008 mm. thick gilding was present on the outer surface of the samples (fig. 230). The outermost layer of the gilding seemed to be more compact and slightly redder than the lower layer. This could support the conclusion that the gilding was achieved by applying thin gold leaves to the surface of the casts after they had been covered with an amalgam of gold and mercury. This method of gilding, which is also described by Biringuccio in his sixteenth-century treatise *Pirotechnia*, enables thicker and more continuous layers to be obtained. It also makes it easier to rectify gaps and areas of discontinuity such as those created by the sections, than it is with the method using an amalgam on its own, as described by Cellini in his *Treatise on Goldsmithery,* as it could not disguise the edges of the sections. A bi-metallic coupling is formed at the interface between the gold and the bronze which would be liable to electro-chemical corrosion, consequently forming spongy products of corrosion between the gold and the bronze. This corrosion, encouraged by the breaks inevitably present in the gilding, has caused the gilding to become almost completely detached from the bronze. For this reason the gold leaf no longer adheres to the metal base except in a very few places and, instead, lies on top of the products of corrosion present between the gold layer and the bronze, as illustrated in the micrographs of figs. 230-232. In the cases which we have examined, the thickness of the products of corrosion existing below the gilding does not exceed 0.05 mm. In the section of sample b corresponding to the dark line (fig. 232), the clear absence of gold leaf and the presence of pitted corrosion in the form of a shallow crater, slightly larger in size than the break in the gilding can be observed. The inside of this crater was almost completely filled with products of corrosive action.

The results of the alteration of the bronze - its composition is described in another paragraph - present two different structures: the area in direct contact with the bronze is clear and spongy in appearance, similar to the form of corrosion which is present underneath the gilding. The part which is furthest inside has reacted instead with the environment or with substances applied to the surface of the horses over the centuries such as beeswax, to form a more compact dark green patina. One can still trace inside the latter some crystals of the intermetallic phases present in the alloy. The crater is never deeper than 0.2 mm.

It is necessary to examine carefully all the details revealed by the metallographic investigations to understand the nature and purpose of the closely-knit system of innumerable dark lines covering the golden surface of the horses. The surface of one of these lines unaltered by the successive corrosion phenomena was examined under low magnification. It was found that these lines were made by using a tool with cutting edges about 0.8 mm

GILDING ————————

———————— CORROSION PRODUCTS ————————

———————— BRONZE ————————

230. Micrographic cross-section of the gilded surface. It can be seen that the gilding in this area is composed of two thin layers (Mag. x 500).

231. Micrographic cross-section of the gilded surface of the "Gates of Paradise" from the Florentine Baptistry by L. Ghiberti showing the same corrosion phenomena at the gold-bronze interface (Mag. x 500).

wide. The imprint of this tool is clearly seen where it was unable to cut away the gold leaf neatly, leaving behind filaments of gold towards the middle. These can easily be distinguished in fig. 227, showing that the tool producing the line had been moved with the cutting edges parallel to the direction of incision and not sideways, as would be the case if a knife or similar tool had tried to cut away the gold from the gilded surface. Such an operation would have produced scratches of irregular width and without the clear lines at the edges of the grooves. The clearness of the cuts, moreover, shows that when they were made the gold leaf lay firmly on a compact, hard surface as indicated by the metallographic surveys carried out on the wall area of the normal cast with lines. From the micrographic examination made at a hundred times magnification and illustrated in fig. 233, one can in fact see that the edges of the gold leaf here project some millimetres into the groove and lie on products of corrosion which would not have been the case if the incision had been made when the deterioration under the gold leaf had already started. The micrographic section also confirms that the process of corrosion, corresponding to the line, occurred after the cut in the gold leaf and that the dark material filling the crater formed by corrosion is made up of products of corrosion formed in the area itself and not by extraneous substances introduced at a later stage. The edges of the gold leaf which, as already noted, jut out on to the products of corrosion, would inevitably have been bent and removed owing to their almost total lack of physical adhesion if, as has been suggested, an extraneous substance had been introduced into the groove. The geometry of the section made of the

corroded area also confirms that galvanic corrosion is taking place. This corrosion is in fact more advanced and the resulting crater deeper when close to the cut edge of the gold leaf, that is, in the proximity of the gold cathodic area where there is a greater current density during the various stages of corrosion, as illustrated in fig. 234.

One can conclude, however, that a specially devised tool had been used to cut away the gold, and that the removal was carried out before corrosion had taken place on the gold-bronze interface.

Finally, in order to form a comparison, it should be remembered that corrosion - that is, galvanic corrosion - is also present on Ghiberti's "Gates of Paradise" of the Florentine Baptistery. They are gilded with a similar thickness of gold, and their galvanic corrosion is virtually identical with that found on the Venetian horses (fig. 231). This proves that these phenomena occurring on objects exposed to the atmosphere, begin swiftly but then slow down as time progresses owing to the formation of largely insoluble products, as happens in atmospheres unpolluted by SO_2 or other agents which are particularly aggressive towards the patina on the metal and the metal itself.

Radiographic study of the horses

The study of horse A was undertaken with the aid of X-ray exposures made by the Procol S.p.A. of Milan using apparatus appropriate for the task. From a complete examination of the numerous X-rays taken, it is evident that the typical characteristic

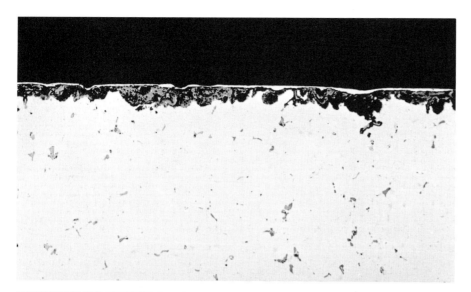

232. Microstructure of the gilded surface section corresponding to the area illustrated in fig. 227 (Mag. x 100).

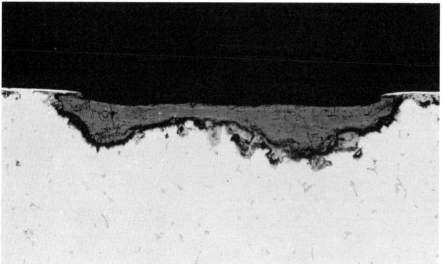

233. Microstructure taken in the area corresponding to the dark line with sharp edges present in the area illustrated in fig. 227 (mag. x 100).

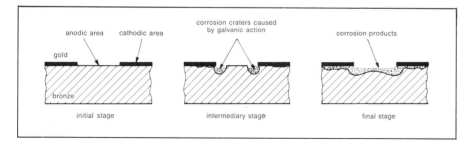

234. Diagram illustrating how corrosion occurs in connection with the lines on the surface of the horses.

235. X-ray photograph showing a casting attachment. Extended macroporosity is visible, parrticularly dense in the areas where the molten metal entered.

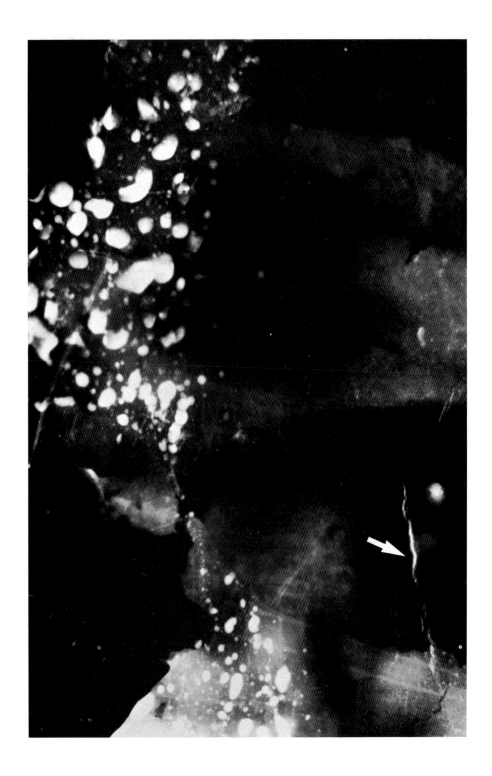

236. A detail from the x-ray photograph of the right flank where a crack and a significant amount of macroporosity is evident.

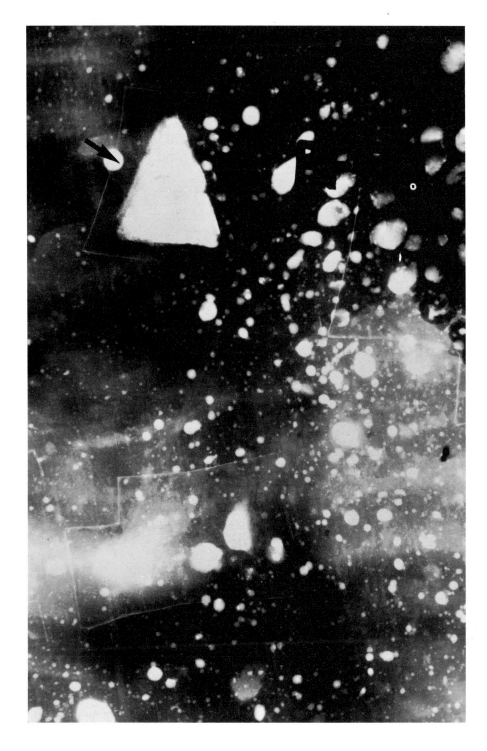

237. The x-ray photograph showing part of the horse's left flank. A triangular hole, probably caused by a distancing piece of the core, can be seen. A similar hole is present in the corresponding position in the right flank. The sections used in repairs can also be clearly seen.

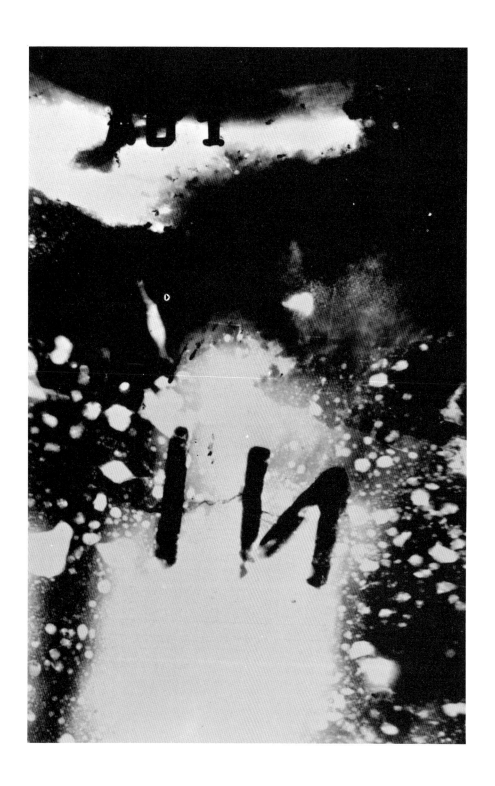

238. An x-ray photograph showing the marking which is presumed to be a numeral.

of almost all the walls of the horse studied is the presence of extensive porosity, associated with the introduction of oxide and with cracks of varying severity. This porosity spreads out mainly from the areas corresponding to the canal inlets (fig. 235-238). This is because during the casting the molten metal heats the areas adjacent to the inlets to a higher temperature when flowing into the mould. These zones would therefore be the last to solidify after the mould has been filled. In the hottest areas of the mould where the metal solidifies in the last stage, an enrichment of gas in the molten metal leads to the formation of a high degree of porosity during solidification. It is in fact well known that the solubility of the gas (hydrogen) is much higher in the molten metal the greater its temperature, while it becomes almost negligible when the metal is in solid state. Thus the porosity produced by gas occurs during the solidification of the cast, when the molten metal has already been enriched by gas mainly derived from the moist atmosphere. The particular chemical composition of the alloy, which could not be cast without heating the molten metal to a very high temperature of at least 1200-1300° C, has favoured the notable enrichment of gas and the creation of the extensive porosity already described. Also the overheating of the walls of the mould induced certain shrinkage cracks which are clearly visible in the X-rays (fig. 236). The radiographic control also clearly shows the presence of sections in the areas of greater porosity, required to repair the surface of the castings and to enable them to be gilded. X-rays have revealed the presence of two triangular holes on the right and left flanks of the horse. These are most probably the traces of some of the struts used to attach the core firmly to the outer part of the mould. These holes had also been repaired with sections that are clearly visible in fig. 237.

The actual way the molten metal flowed into mould, revealed mainly through the formation of gas as well as other peculiarities, shows that the horse was cast in a normal upright position as is still the common practice today. Another detail which is clearly shown by the X-rays is the incision of marks taking the form "IN" close to the area where the front right-hand leg is attached to the body of the horse (fig. 238).

As shown by the micrographic and radiographic examinations, the extreme thinness of the walls of the horse and the presence of numerous areas of damage and porosity, justify grave concern for the conservation of these sculptures. This not only involves the structural condition of the works but to a greater extent their progressive deterioration through corrosion. As the considerable porosity of the cast walls encourages the absorption and retention of moisture, rainwater, combined with other agents of pollution in the atmosphere, can cause deterioration when in contact with the surfaces of the horses.

The external features of the horse recently examined closely resemble those of the other three horses, so they are bound to be subject to the same deterioration and to possess the same characteristics as revealed by the numerous experiments undertaken on horses A and B as summarised above.

The translators wish to acknowledge the invaluable advice given by Dr. P. Boden of the Department of Metallurgy, Nottingham University, in preparing this and remaining technical contributions to this book.

Corrosion phenomena on the Horses of San Marco

Lino Marchesini and Brando Badan

The corrosive phenomena affecting the horses of San Marco, and which are still occurring seem to be somewhat complex for many reasons both connected with their nature and their long exposure to different atmospheric conditions. An effort will be made here to discuss at least the most important corrosive processes which have taken place in the past and those which are still active.

Corrosive processes

Corrosion generally consists of a complex of physio-chemical phenomena causing the surface of a solid metal to be damaged by external agents. In practice the term is used to indicate the reactions which take place between a metallic material and the environment; the contact causes the former to corrode through the transformation of its constituent elements into various chemical combinations, that is, to a more stable thermodynamic state. Many corrosive phenomena are of an electrochemical nature involving the presence of an electrolyte which is in contact with the metal. The electrolyte is usually an aqueous solution of an acid, a base, or a salt; consequently this type of corrosion is known as wet corrosion.

Corrosive phenomena of a chemical nature can also occur alongside the electrochemical type, as a result of the direct action between the electrolyte and the products of corrosion formed previously.

Other types of corrosion, such as dry corrosion, which are not relevant to this present study will not be discussed.

Corrosive phenomena can be found to be widely-spread or localised or in a selective form on the surface of metallic materials.

Uniform corrosion occurs when the whole metallic surface of the material is equally attacked. Localised corrosion instead takes place when the corrosive processes prefer to attack specific areas of the surface having particular morphological aspects. It can take place along breaks or cracks usually on the surface of the material, or the corrosive attack can produce cavities which, according to their shape, are indicated as tubercles, craters, or pits, etc.; in particular the attack can be a perforating one if it occurs through the whole depth of the material.

Finally selective corrosion occurs when some specific constituents of the material are attacked, with the consequent selective disintegration of either the boundaries of the crystals (intercrystalline corrosion) or of the whole grains themselves.

Corrosion is connected with a flow of electricity between different areas of a metallic surface known as anodes and cathodes and through a solution capable of conducting the current which induces corrosion at the anodic zones.

The mechanism of wet corrosion corresponds to the working of a battery, that is to galvanic systems in which the phenomenon is the result of an anodic process of attack on a metal together with a cathodic process. The wet processes follow the laws of thermodynamics and electrochemical kinetics.

The anodic process involves the oxidation of the constituents in the metallic material and makes electrons available in the metal itself while the cathodic process, due to the passage of the electrons from the metal state, leads to the reduction of substances present in the aggressive environment.

The ions in the electrolyte carrying a positive or negative charge allow the current to be conducted through the solution.

As will be shown later, the electrochemical type of corrosion takes place even on metals exposed to humid air as a result of a thin liquid film formed in localised areas on the metal surface through the condensation of atmospheric humidity. Considering the most simple system, an electrochemical system is made up of two regions distinguishable from each other on a corroding metal surface. These numerous regions constitute a large number of electrodes, that is to say, a combination of many cathodic and anodic regions.

These local electrochemical cells which cause corrosion can be sub-divided according to the dimensions of their electrodes as follows:

> Macroscopic cells
> Microscopic cells
> Submicroscopic cells

According to another point of view their classification is based on the nature of the factors which determine their function according to this criterion. They can be distinguished as follows;

1) Cells whose electrodes are chemically different. Amongst these are included those whose existence is due to different properties of the layer which covers the various parts of the metallic surface formed both by primary and by secondary reactions.

2) Cells whose electrodes have the same chemical composition but are physically different.

3) Cells which are formed as a result of local differences in composition of the electrolyte which is in contact with the metal.

Corrosion induced by the contact of different metallic materials (macroscopic cells) are known as contact corrosions, whereas the cases of corrosion due to the structural heterogeneities are known as structural corrosions.

Corrosion under a liquid film

The absolute humidity of the air is indicated by the amount of water vapour contained in it and is expressed in grams per m^3. At a given temperature the air cannot contain more than a given quantity of water vapour, corresponding to a saturation level, a temperature which is known as the dew point.

The relationship between the quantity of water vapour contained in the air and the quantity needed to promote saturation at the same temperature, expressed in a percentage, is in fact known as the "Relative humidity". When the amount of water vapour goes beyond saturation point, small condensation drops form (fog) and slowly settle on the objects they come into contact.

In these conditions a metallic surface will become wet through a continuous film of liquid forming on it. In the case of a rough surface or one covered with either solid particles (dust, coal, etc.), or by a layer of porous corrosion products, vapour condensation can occur inside the cavities and pores before the dew point is reached, with the consequent local formation of films of water often to a considerable depth.

Both the normal gaseous constituents of the air (N_2, O_2, CO_2) and the possible gaseous impurities (SO_2, nitrogen oxides, HCl, NH_3, etc.) dissolve in the drops of liquid which, having been transferred onto a metallic surface, cover it with a solution composed of the various gases present in the air.

Even in the presence of very low concentrations of certain gases in the air, their condensation in the water droplets can reach significant concentrations due to their high solubility.

Close to the sea the air always contains salt particles so that the metal is easily covered by a liquid film containing chlorides and sulphates.

In areas of concentrated industrial development or high population density the air can contain, apart from significant quantities of SO_2, also variable amounts of HCl, NH_3, fluoride compounds, etc.

The dissolution of these compounds increases the solution's conductivity and thus contributes to the increase in the corrosion current.

Apart from the impurities described above, deposits of solid particles in suspension (dust) can also have a significant bearing on corrosive processes - their harmfulness varies according to their nature. The normal constituents of the dust can be classified according to this criterion as:

1) Particles which are corrosive due to their own nature, $(NH_4)_2 SO_4$, NaCl and other salts.

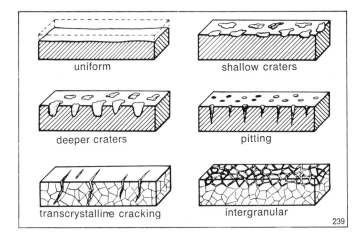

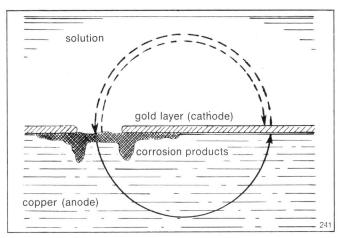

239. Diagrammatic illustrations of typical forms of corrosion attack.

240. Possible sources of capillaries where condensation can occur: cracks or defects (1), dust particles (2), pores in the corrosion deposits (3).

241. Diagrammatic illustration of the corrosion due to the copper-gold galvanic couple.

201

2) Particles not corrosive in themselves, but which are able to absorb strongly corrosive gases from the atmosphere such as SO_2, HF, etc. A notorious group of these emanate from combustion processes, particularly those which depend on petroleum products.

3) Non-corrosive land non-adsorbent particles (sands, silicates, etc.).

One must take into account the hygroscopic nature of the corrosion products present on the metallic surface since they can lose or absorb water with respect to the atmosphere depending on the relative humidity.

One can, therefore, verify rapid accelerations of corrosion under the influence of the impurities found in the air which are evident even when the relative humidity is well below saturation point, as long as certain conditions are present on the metallic surface.

It is worth stressing that a thin film of liquid or a small drop of water presents only a weak resistance to the diffusion of oxygen and other substances found in the air promoting corrosion.

Galvanic couples

It has been stated previously that if two different metallic surfaces are connected electrically, a current will flow between them as long as there is a liquid conductor (electrolyte) capable of carrying the electric charges. In this electrolytic cell, the metal which functions as the anode goes into solution and corrodes. The atoms of every metal which is immersed in aqueous solution show a certain tendency to dissolve as ions, a process known as an electromotive force, as a result of which a difference in potential is established between the metal and the solution.

Each metal will find its own equilibrium potential, depending on the characteristics of the metal itself, the nature and composition of the solution in contact, and on the temperature, and this will result as the electrode potential. Since one cannot directly calculate or measure the value of a single electrode potential, it is determined experimentally by comparison with a reference electrode whose potential is arbitrarily set at zero. The normal hydrogen electrode is assumed as a point of reference.

For the purpose of having values which can be compared, the concept of a normal standard electrode has been introduced; it is defined as the potential of a single cell formed by a metal immersed in a solution of one of its own salts of unit activity.

The standard potentials of an electrode for all metals can be obtained by constructing cells in which one electrode is the standard hydrogen electrode, whereas the other consists of the specific metal immersed in a solution of its own salts of unit activity. (Table 1).

Since the hydrogen electrode potential has been given the value of zero, it is clear that the difference in potential evident in the cell gives the values of the potential of the electrode of the metal in question.

When the metals are arranged in the order of their standard electrode potentials, an electrochemical series is obtained where these potentials vary according to the convention adopted.

When two different metallic surfaces of a different nature are immersed in a solution at the same time, they assume different potentials with respect to the liquid, with the formation, if joined together, of an electric circuit represented by the system:
Metal A - electrolyte - Metal B - with A and B coupled together. This system constitutes a galvanic couple with a current flowing through it and where the difference in potential between the two electrodes (when standard conditions apply) is given by the algebraic difference between the single electrode potentials of the two metals.

In the galvanic couple, the metal which assumes the more electronegative potential (a greater tendency to send ions into solution) becomes the anode and therefore corrodes, whilst the one with a more electropositive potential acts as the cathode and therefore remains protected.

It is evident that the corrosion of the anode varies according to the metallic coupling; as long as the other conditions remain the same, the more the anode is corroded, the larger the difference in potential between the two electrodes.

Polarisation phenomena

Certain irreversible phenomena can occur close to the electrodes which tend to hinder the flow of the current, and modify the electrical conditions in the cell. This is known as electrode polarisation and results in a reduction of the differences in potential between the electrodes and thus also reduces the corrosion current. The polarisation can be due mainly to a change in concentration, to overvoltage phenomena, or to the presence of a superficial film or deposit on the electrodes.

As the reaction proceeds, corrosion products accumulate in the solution close to the electrodes and, thus, the local ionic concentration differs from that in the bulk of the electrolyte. These variations in concentration are caused by a slow diffusion of ions in the regions adjacent to the electrodes.

The diminished velocity of ionic diffusion consequently leads to a slowing down of the corrosive processes. Overvoltage phenomena play an important part in corrosion processes. Over-

TABLE 1

THE STANDARD ELECTRODE POTENTIAL (E_o)
OF SOME ELEMENTS COMPARED
TO THE HYDROGEN ELECTRODE

System	E_o [V]	System	E_o [V]
Mo/Mo^{3+}	-0.2	$H_2/H+$	-0.000
Ge/Ge^{4+}	-0.15	Cu/Cu^{2+}	$+0.337$
Sn/Sn^{2+}	-0.136	$Cu/Cu+$	$+0.521$
Pb/Pb^{2+}	-0.126	—	—
Fe/Fe^{3+}	-0.036	$Ag/Ag+$	$+0.799$
—	—	—	—
		Au/Au^{3+}	$+1.50$

voltage defines the difference in potential of an electrode when, on the one hand, one actually observes the development of a gas on it and, on the other, the theoretical value of the potential when it is in equilibrium with its own ions in the electrolyte.

The electrode overvoltage is a measure of a particular type of polarisation due to the difficulty in evolution of a gas from the metal, or to the molecular combination of the gas formed at the electrode in the atomic state. The most important example is given by the cathodic reduction of hydrogen

$$H^+ + e^- \rightarrow \tfrac{1}{2} H_2$$

whose corresponding polarisation is known as the hydrogen overvoltage.

The oxygen in the solution can act as a depolariser, removing the hydrogen atoms from the surface of the electrode.

Notable polarisation phenomena can also take place on the cathode through the release of OH^- ions from the reduction of oxygen

$$\tfrac{1}{2}O_2 + H_2O + 2e^- \rightarrow 2\,OH^-$$

known as the oxygen overvoltage.

Finally, on the surfaces of both cathode and anode electrodes some protective films may be formed as the reactions take place; the films are due to a combination of secondary electrode reactions and the action of the atmosphere. These films act as a kind of barrier separating the metals from the electrolyte. This leads to an increase in the resistance between the anode and the cathode and to a decrease in the diffusion velocity of the reagents and the products of the electrode reactions towards and from the electrode surface. The combined effect leads to an increase in both the anodic and cathodic polarisation.

One should note that the anodic polarisation carries the danger that each accidental breakage of the film may lead to intense localised corrosion with the probable formation of very deep corrosions, pitting for example.

The formation of cathodic and anodic areas

Alongside corrosion processes of a galvanic type, analogous corrosion mechanism can affect only a single metal or alloy. Even in a pure metal there can be very many continuous cathodic and anodic regions; their diversity of potential can depend on other factors which we will attempt to clarify.

In some cases the localisation of cathodic and anodic areas can be verified by differential aeration whenever various points on the same material are in contact with a solution which has been differently aerated, that is, with different proportions of dissolved oxygen. In such a case cathodic areas form where there is an availability of oxygen, whereas anodic areas form wherever dissolved oxygen is in low concentration but in contact with the electrolyte.

The distinction between cathodic and anodic areas can be linked to the heterogeneity of the metallic material. If, for example,

there are work-hardened areas next to unstressed areas, the former will show anodic behaviour with a high level of corrodability.

Further, in binary alloys the particles of the second phase obviously represent regions with a different electrode potential from that of the matrix and can thus promote a localised corrosion process. Boundaries of the crystals, segregations of impurities, and zones subjected to a non-uniform thermal treatment also epresent sources of electrochemical differences.

Quite large numbers of contiguous cathodic and anodic areas can also arise from the different crystallographic orientation of the individual small crystals. The position of such areas fluctuates constantly, resulting usually in a uniform type of corrosion even if, at every instant, the cathodic areas remain protected from the corrosion process.

Corrosion of gilded copper

According to the previous considerations, one can theorise about at least some of the corrosive phenomena which should have taken place on the horses of San Marco from antiquity to the present times.

The material consists of a copper alloy with low percentages of additives (tin, lead) and is of a typical monophase bronze α structure, with the possible presence of minute spheres of lead dispersed in the matrix or along the boundaries of the crystals, as described in M. Leoni's section.

The horses were made by a casting process which must have been extremely difficult since there are many defects scattered all over the cast (cavities, blow-holes, sponginess, etc.) both at the macro and microscopic levels. Only the most noticeable of these have been repaired by means of tassellated sections with copper plate. At a later stage the horses were gilded and scored, consequently partially removing gold from their surfaces.

As they were exposed to the atmosphere from this moment, one can assume that the various corrosive processes started. These processes can be considered on a hypothetical level at least, and for this purpose the material will be discussed as an impure copper rather than a true bronze alloy from the point of view of its propensity to corrosion.

Little or nothing is known of their history before 1200, when they stood in the open in Constantinople. That city's atmospheric conditions are maritime in nature - fairly windy, with alternative periods of high relative humidity and of hot, dry spells, with a preponderance of the latter, when there is little rain and wide temperature differences between day and night. These conditions favoured the formation of periodical condensation of moisture on the horses, which, along with the normal constituents of the atmosphere such as oxygen and carbon dioxide, dissolved pure chlorides and, in lesser quantities, sulphates which came from marine atmosphere.

It is most unlikely that there was then any atmospheric pollution such as oxygen compounds of sulphur, ammonia and its derivatives or other pollutants.

Condensation could certainly appear on the horses' surfaces even when the relative humidity was below saturation point, especially inside the enormous number of defects varying in size, some of them even reappearing on the surface after the gold scoring had been added.

Thus the material was periodically in contact with an electrolyte of high conductivity due to the presence of dissolved salts; this formed a short circuit between the gold-copper couple which, in standard conditions gives a large difference in potential of the order of 0.97 volts and in which the copper acts as the anode. The electromotive force of the couple leads to a series of reactions including the following stages:

Reaction at the anode during the corrosion on the copper. Flow of electrons in the metal from the copper to the gold. Cathodic reaction on the gold which uses the flow of electrons from the anode.

Ionic current in the solution with the migration of cations Cu^{++} towards the cathode and various anions (OH^- Cl^-, etc.) towards the anode.

According to this scheme, the cathodic reaction should be characterised by the decrease in oxygen dissolved in the electrolyte as follows

$$O_2 + H_2 + 4e^- \rightarrow 4OH^-$$

which becomes alkaline near the cathode.

The anodic reaction, instead, is characterised by the oxidation of the copper according to the reactions

$$2Cu^{++} + 2OH^- - 2e^- \rightarrow Cu_2O + H_2O$$

and

$$Cu^{++} + 2OH^- - 2e^- \rightarrow CuO + H_2O$$

The copper remains partly in the form of practically insoluble cuprous and cupric oxides which are found near the anode, and partly in soluble forms, which can migrate into the electrolyte.

As the corrosive phenomenon continues, the large difference in potential between the electrodes diminishes. The electromotive force which is available for the circulation of current in the short-circuited system is diminished by concentration polarisation. The separation and accumulation of the products of corrosion slow down the diffusion processes which would tend to readjust the chemical composition of the electrolyte.

For these reasons, the galvanic type of corrosion phenomena has continued relatively slowly after an initially rapid stage of development, with localised manifestations mainly at the margins of contact at the incisions with the gold leaf as well as under the leaf itself. The composition of the corrosion products in the two zones covered or uncovered by gold leaf must have been different because of different atmospheric conditions. For example, the products under the layer not subjected to direct contact with the atmosphere or the actions of rain, wind, etc.

A localised concentration of corrosion products has therefore been found under the gold which is sufficiently compact and relatively impermeable to the electrolyte; these conditions consequently increase the polarisation phenomena and the ohmic re-

sistence of the cell as the distance between anode and cathode increases.

Under the gold leaf, stratifications have been formed characterised by the prevalence of the oxides close to the anode, whereas the other corrosion products are to be found mainly in the central band of the deposit.

The variations in volume which have resulted from the formation of the corrosion products have not been significant enough to cause large cracks lifting or separating the gold leaf. Though not now joined onto the metal base, but only resting on the products of corrosion, it has adhered for a long time and still does so, at least in some places.

The situation in relation to the scratches is however different. These have gradually been covered over by corrosion products in, probably, fairly short periods of time because of the direct contact with the atmosphere. The corrosion products are characterised by oxides, basic carbonates (malachite and azurite), basic chlorides (mainly atacamite) and basic sulphates (mainly brocantite).

One also finds local corrosion phenomena, especially near the edges of the gold, which goes quite deeply into the copper mostly in the form of pitting; sometimes they are found along the boundaries of the crystals in small quantities but enough to constitute the predominant corrosion phenomenon. In these conditions however the ''patina'', understood as the total corrosion products, could still protect the metallic material sufficiently through the remaining adhesion because of its non-porous and impermeable nature, its stability and non-hygroscopic quality, when placed in contact with a neutral or near-neutral electrolyte. After the initial phase, the corrosion process has slowed rapidly down through time.

Periodic localised accelerations of the corrosion processes could take place following dissolution causing a lack of continuity of the patina, provoked, for example, by the washing away and mechanical action of the rain and the winds. This is a result of the modification of one of the elements which had provided an autoprotective system or one having little corrosive action.

Mechanisms of alteration in the Venetian atmosphere

It is probable that the horses reached Venice in these conditions where they were placed in another maritime environment not essentially dissimilar to that found in Constantinople, but certainly more harmful through the much higher levels of humidity and rain. It is, therefore, probable that the corrosion processes already present were accelerated in the new environment without actually changing in type, though probably atmospheric pollution in small quantities could be present even in the earliest decades as a result of the increase in the industrial activities, especially of the artisans.

It is only in more recent times that the mass use of coal and later petroleum products has been the source of energy for industrial and artisan enterprises, for domestic heating and for motorised transport. In fact, the development of heavy industry on the coast

TABLE 2

PRINCIPAL MINERALS PRESENT IN THE VARIOUS SAMPLES TAKEN FROM HORSE A

Characteristics and area where the samples of the patina were taken	Malachite $CuCO_3 \cdot Cu(OH)_2$	Azzurrite $2CuCO_3 \cdot Cu(OH)_2$	Cuprite Cu_2O	Antlerite $CuSO_4 \cdot 2Cu(OH)_2$	Atacamite $Cu(OH)Cl \cdot Cu(OH)_2$	Broccantite $CuSO_4 \cdot 3Cu(OH)_2$	Basic lead sulphate $PGSO_4 \cdot PbO$
1) Light green; incision on the chest	—	—	●●●	—	●	●●	●●
2) White green; under the belly	—	—	●●	—	●●	●●●	●
3) White; lead patch on the right flank	—	—	—	—	—	—	●●●
4) Black with some white flecks	—	—	●●	—	—	—	●●
5) Light green; tail	—	—	●●●	—	—	●●	●●
6) Light geen; interior of head	—	—	●●●	—	—	●●	—
7) Light green; interior of head	—	—	●●●	—	—	●●	—
8) Light green; interior of body	—	—	●●●	—	●●●	●●	—
9) Green; left hindleg	—	—	●●	—	—	●●●	●
10) Black; breast-band	—	—	—	—	—	—	●●
11) Light green; holes in the breast-band	—	—	—	—	—	●●●	●●●
12) Green; under the belly	—	—	●●	●●●	●●●	—	●●●
13) Light green; left flank	—	—	●●	●●	●●	—	●●

TABLE 3

RESULTS OF THE CHEMICAL ANALYSIS CARRIED OUT ON THE WASHINGS OF HORSES B, C and D

Horse tested and stage of washing	Suspended solids after drying at 100°C (mg/l)	Analysis of filtrate (mg/l)										
		Cu	Pb	Fe	Sn	Na	Ca	Mg	NH$_4$	SO$_4$	Cl	pH
B 1	210.0	112.50	0.41	0.01	0.2	17.44	63.50	14.00	26.0	444.5	12.0	6.25
B 2	33.0	22.44	0.15	abs.	0.2	2.79	11.50	1.63	5.0	84.8	13.0	6.30
C 1	209.0	166.50	0.69	0.02	0.2	19.01	43.00	6.15	28.0	539.5	18.0	5.90
C 2	82.4	23.97	0.20	0.01	0.2	3.92	9.00	1.52	6.9	90.5	9.0	6.30
D 1	248.6	126.50	0.40	0.02	0.2	11.61	34.00	4.13	21.1	381.9	9.0	5.95
D 2	56.0	44.88	0.33	abs.	0.2	3.63	8.50	2.72	8.3	125.1	8.5	6.25

TABLE 4

RESULTS OF THE CHEMICAL ANALYSIS CARRIED OUT ON SUSPENDED SOLIDS IN THE WASHINGS OF HORSES B, C AND D

| Horse tested and stage of washing | suspended solids | | Analysis of portion soluble in HNO_3 | | | | | | | | | | | |
	Insoluble in $HNO_3N/10$ (mg/l)	Soluble in $HNO_3N/10$ (mg/l)	Cu mg/l	%	Pb mg/l	%	Fe mg/l	%	Na mg/l	%	Ca mg/l	%	Mg mg/l	%
B1	116.5	93.5	37.16	39.75	2.37	2.53	37.16	2.52	0.42	0.45	7.37	7.88	2.53	2.71
B2	18.2	14.8	4.15	28.03	0.60	4.06	4.15	4.36	0.12	0.82	2.29	22.21	0.65	4.39
C1	123.2	86.3	25.20	29.20	4.87	5.64	25.20	3.92	0.28	0.32	3.58	4.14	2.19	2.54
C2	45.7	36.7	5.46	14.90	1.24	3.37	5.46	3.14	0.12	0.33	6.79	18.50	1.30	3.54
D1	134.1	114.5	17.57	15.30	4.08	3.56	17.57	2.18	0.36	0.31	5.31	4.63	2.16	1.88
D2	30.7	25.3	9.23	36.50	2.00	7.90	9.23	3.95	0.09	0.37	2.14	8.47	0.63	2.48

near Venice means that the city has levels of pollution radically changing the atmosphere.

From this era, parallel with the electrochemical corrosive phenomena already mentioned, a new group of corrosion processes have become evident; they are more strictly chemical in nature and attack the corrosion products formed over the centuries.

These are due to the presence in ever-increasing amounts of oxides of sulphur in the atmosphere, for which the final stage is the creation of sulphuric acid. However, the recent condensation on the horses (considering a span of some centuries) must have been characterised by increasing acidity, and present-day measurements have shown that in the Venetian environment, the highest SO_2 concentration in the atmosphere often coincides with the maximum levels of relative humidity.

As far as the erosive action of the condensation is concerned, it is calculable in terms of the sulphuric acid content, since it is the final product of the oxidation process of the SO_2 due to the atmospheric oxygen which is spontaneous, rapid and susceptible to the action of numerous catalysts constantly present in the environment.

A sulphuric acid solution reacts with the oxides and the salts produced by the corrosion of the copper (peroxide and oxide, carbonates, basic chlorides and sulphates, etc.) transforming them gradually, through repeated condensations and evaporations of the water, into compounds becoming progressively more soluble. The final stage consists of the alternate crystallisation and redissolution of cupric sulphates and chlorides in various stages of hydration in relation to the environmental conditions; they migrate with the condensation along the surface and are certainly transportable if subjected to the washing action of the rain.

With the gradual modification and transportation of the original patinas, the corrosive processes are re-activated due to the increased porosity of the residual products, the depolarisation phenomena, and greater contact with a highly aggressive electrolyte.

Accurate measurements show that the critical level of relative humidity, indicated as the point at which a rapid increase in the velocity of corrosion takes place, is, for a copper surface, in the order of 90% in a mormal atmosphere, whereas it drops to under 80% in the presence of sulphur dioxide (SO_2).

Certain solid particles coming from the combustion of petroleum products (smog) and deposited on the metallic surface can contribute significantly to the absorption of sulphur dioxide (SO_2) from the atmosphere and to its oxidation. Many of the products of degradation, in relation to the amount of water needed for them to crystallise, can absorb water from the atmosphere at levels well below saturation point. For example, condensation takes place

TABLE 5

THE QUANTITY OF GOLD CARRIED AWAY IN THE 1st AND 2nd WASHES OF HORSES B, C AND D DETERMINED BY CUPELLATION

Horse tested and stage of washing	Insoluble in $HNO_3N/10$ (mg/l)	Total amount of gold removed (mg)
B1	116.5	85
B2	18.2	65
C1	123.2	81
C2	45.7	66
D1	134.1	15
D2	30.7	66

RESULTS OF THE CHEMICAL ANALYSIS OF RAINWATER FOUND UNDER THE HEAD OF HORSES D
(Quantity of water collected: 4,000 cm^3)

Suspended solids after drying at 100°C (mg/l)	Cu	Pb	Fe	Na	Analysis of filtrate (mg/l) Ca	Mg	NH$_4$	SO$_4$	Cl	pH
32.5	42.5	0.1	0.1	7.1	7.0	1.8	10.0	36.1	28.8	4.9

SUSPENDED SOLIDS

Insoluble in HNO$_3$N/10 (mg/l)	Analysis of portions soluable in HNO$_3$ (mg/l and as a % of total suspended solids) Cu mg/l	%	Pb mg/l	%	Fe mg/l	%	Na mg/l	%	Ca mg/l	%	Mg mg/l	%
18.9	3.44	27.1	0.6	4.7	0.78	6.1	0.15	1.1	0.44	3.4	0.25	2.0

Fragments of gold were found in the portion insoluble in HNO$_3$

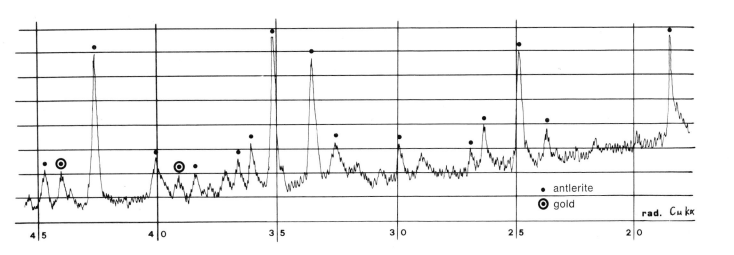

• antlerite
◉ gold

rad. C_u k_α

242. X-ray diffraction data of corrosion products indicating the presence of antlerite in deposits found in the rear part of the Horse's belly.

207

243. Scanning electron micrographs: (a) basic lead sulphate crystal prevalent in the belly of Horse "A" on a patch of lead (Mag. x 500); (b) gold layer found in the rinsing water from Horse "B" (Mag. x 500).

with only 33% relative humidity on a mixture of copper sulphate $3H_2O$ and copper sulphate $5H_2O$.

From the various processes one can make at least an initial assessment of the order of priority of the conflicting evidence to explain the present stage of development of the corrosion.

Periodic renewal of contact with a sulphuric acid solution tends to direct all the reactions towards the final stages (cupric sulphates and chlorides), but by different ways and time-scales. Only for certain reactions can the timing of different processes coincide.

The product of corrosion has been degraded and removed by a specific chemical action and, at the same time, is formed again *in situ* through a further anodic attack on the copper.

In view of this the total disappearance of the basic carbonates from the patina ("normal" mineralogical species in the corrosion products of copper in "normal" atmospheres) certainly present on the horses in the past can be explained.

One is confronted here by a practically irreversible process in which the breakdown of the carbonate cannot obviously be compensated by the formation of carbon dioxide in an acid electrolyte containing sulphuric acid when in equilibrium with the atmosphere.

Kinetic considerations exclude the possibility that in the present situation, with exposure to the open air, conditions can take place which will restore stable and protective patinas on the horses, in the sense that corrosion processes can be contained within acceptable limits.

The breakdown of the corrosion products now takes place more slowly; however, equally serious effects are occurring even beneath the gold leaf. In these areas, through the large variation in volume which accompanies the phenomenon of the transformation of the corrosion products, the gold leaf is shifted and finishes by becoming detached from the rest of the horse in various small fragments by mechanical action such as from the beating of heavy rain.

Effects of condensation of moisture and rain

As far as possible, a distinction has been made between the action of water from the condensation of humidity and that from rain. The former, in fact, must be held responsible for the attack and transformation of the pre-existing corrosion products and the progression of galvanic corrosion phenomena, whereas the latter has mainly a washing and a mechanical effect.

This is confirmed by the tests and checks which have been carried out on the basis of considerations which take account of the two effects separately. The results should be mentioned, if only briefly.

Examinations of exposed portions which are subjected to continual changes of condensation and rain can be made and evaluated on the momentary state of the system, in which long-term or microscale modifications are very difficult to quantify.

Interesting results are certainly obtainable on a statistical basis by comparing the characteristics in a transitory situation of a large number of positions through chemical and metallographic analyses, selective solubilisation, X-ray diffraction (an example of this is given in table 2), scanning electron microscopy and electron probe analysis. These statistics clarify the progression of corrosion and the recognition of its various intermediate stages, but they are incapable of quantifying the effects of the two processes because of the many variables which can influence trends locally. Even though only qualitative results, they show the comparison between the horses' situation and that of samples of copper or its alloys exposed for a long period of time in atmospheres having more or less similar characteristcs to those found in Venice.

A differentiation is, in fact, possible because during the past few years two of the horses in the open (B and C), and, partly, the third (D), have been protected from the action of the rain by the scaffolding used to carry out the work on the Basilica's principal façade.

244. Scanning electron micrographs of material prevalent in the deposits from Horse "B": (a) antlerite crystals under the gold layer (Mag. x 1000); (b) crystals emanating from a crack in the gold layer (Mag. x 3000).

Thus two only have been subjected only to the formation of condensation and the subsequent evaporation of water for a sufficiently long period of time. To evaluate the consequences of this action, the three horses have recently been subjected to a wash in two stages, each stage using exactly the same quantity (60 litres) of pure water, approximately equal to a summer downpour. The analyses of the average water samples have shown that they are acid and contain considerable quantities of salts, both in solution and in an insoluble form, in the first wash far more than in the second.

Copper is the most prevalent cation, and sulphate is the most prevalent anion compared to chloride. On the insoluble part, gold has already been found to be present, in some cases in greater quantity in the water of the second wash compared to the first.

The horses which underwent the washes each with 60 litres of water, each lost more than 20 g. of copper oxide and about 150 mg. of gold on average, roughly equal to the removal of a 10 cm^2 area of gold leaf.

Rainwater collected during the winter from under the part of the third horse not covered by the scaffolding had quantities of salts which were a lot less than found in the previous samples; about 25% of the copper content compared to the previous sample and only a few pieces of gold.

A further confirmation has been obtained from the investigation into the corrosion products found in the large number of pits, probably of recent formation, located in the rear part of the horses' bellies and in other positions where condensation forms but cannot be subjected to the washing effects of heavy downpours of rain.

The results have shown unequivocally the transformation of the corrosion products taking place at the gold-copper interface as observed on a macroscopic scale through the lifting and the fracturing of the gold leaf until it falls off together with the

corrosion products increasing in volume with time. An X-ray diffractometer survey has shown that the highest concentration is mainly basic copper sulphate $CuSO_4 \cdot 2Cu(OH)_2$ (antlerite) compared to other compounds. The micrographic enquiry has clarified some of the mechanisms of corrosive attack shown by the sulphuric acid on the various crystals of the pre-existing patina. The results of these corrosive attacks increase markedly the volume of the patina and eventually lead to the fracture of the crystals and the gold leaf. Cracks are thus formed allowing new products to appear on the outer surface where they crystallise when the water has evaporated.

This demonstrates the serious nature of the corrosive phenomena as the result of the formation of condensation, whilst the major effect of rainwater should instead be to wash away the corrosive environment.

Other causes of corrosion

The various phases and consequences of the corrosive process have been shown with particular emphasis on examining the effects of the gold α-copper galvanic couple and the chemical modification of the pre-existing corrosion products in Venice's present atmosphere.

As well as these most serious corrosive effects, there are others which though less significant, are still worth mentioning.

Galvanic corrosive phenomena tend to be located at the junction of the repair sections inserted after the original casting because of the diversity in structure and, most probably, as a result of the difference in composition between sections themselves and the casting material, as has already been shown by M. Leoni.

Galvanic couples also take place between the casting metal and the lead repairing sections which were inserted at various stages in the course of many centuries; lead would act as an anode in a Cu-Pb cell and therefore is corroded. The process is normally

245. Detail of the front right-hand flank showing brown-black deposits of ferrous oxides.

246. Detail of the chest showing a black patina in the scratches.

slowed down to a significant degree through the effect of anodic polarisation by producing a passive layer on the lead surface of its insoluble sulphate. However, the noticeable accumulation of basic lead sulphate crystals (Pb SO_4 . PbO) located in an area of a very large patch (below the stomach of one of the horses), shows that the corrosion phenomenon is by no means negligible.

Finally, steel insertions such as bolts, pegs and reinforcements are found to be suffering from corrosion since they will act as the anode with respect to all the other metallic elements present in the horses.

The oxidation of iron, with the formation of rust, is a phenomenon which takes place with a large increase in volume thus creating considerable pressures on the surrounding material, whilst the obvious yellow-brown oxide and basic carbonate stains starting from the steel insertions and running downwards confirm the existence and importance of the corrosive phenomenon.

The above-mentioned phenomena taking place after the formation of condensation and the subsequent evaporation of the water from the surface of the horses, as well as the action of heavy rain are mainly responsible, though to differing extents, for the recent increase in the degradation of the horses in the present Venetian environment. In view of this, every possible means will be taken to avoid condensation and the effects of heavy rainfall by putting the horses in the most appropriate place. Research into preventative and protective measures will be carried out so that a future for the whole monument can be garanteed. It must however, be always borne in mind that the less protected areas of the works are still liable to be covered with a film of liquid even when the relative humidity is well below saturation point.

Techniques to protect the Horses of San Marco

A survey carried out by the Istituto Centrale del Restauro

Examinations of the patina and the incrustations
V. Alunno Rossetti [*] *and M. Marabelli*

1. *Premise.* As far as the preservation problem is concerned, the first investigation to be carried out consisted of a series of examinations of the patina and incrustations found on the surface in order to find:
1) data on the composition of the patina in various areas, and on its stability and resistance to washing processes;
2) useful information to clarify the process of ongoing deterioration;
3) indications concerning the composition of the superficial stains and incrustations to enable them to be removed.

The specimens were taken on 5th March 1974 from the horse brought inside the Basilica (the first horse on the left looking at the façade), as indicated by Tables I and II, with the intention of taking test specimens from areas as diversified as possible in terms of appearance and exposure.

On the specimens indicated in the Tables, three types of analysis have been carried out:

I) X-ray diffraction analyses of the corrosion products; these analyses indicate the individual crystalline compounds present and consequently the composition of the corrosion products of the metallic alloy (patina). This examination is of fundamental importance in establishing subsequent criteria for cleaning;

II) measures of conductivity of aqueous extracts from patina samples to obtain the percentage of soluble compounds. These measurements enable one to establish the percentage of soluble salts and, therefore, also of soluble corrosion products which are removed by the washings with water;

III) chemical analyses directed above all towards measuring soluble and insoluble chlorides present in patina samples and, in addition, the sulphates of copper and lead in order to determine the principal components of the patina. The soluble chlorides, in particular, hinder the conservation of objects made of copper alloy because they accelerate the

* from the Institute of Applied Chemistry, Faculty of Engineering, Rome University.

electrochemical corrosion process; to a lesser extent the soluble sulphates also contribute to this process.

2. *Results.*
From the data in the accompanying two Tables the following can be summarized:

2.1. The brown, grey and blackish stains and patinas present on the right flank under the extensive sectional repairs on the stomach, on the left foreleg, and generally on and around the surfaces of the lead sectional repairs are made mainly of anglesite (lead sulphate) (samples 4, f,e). The anglesite is derived from the corrosion of the lead sectional repairs and, to a minimum extent, from the electrochemical attack of the lead in the alloy.

2.2. The black stains on the right shoulder and (sample 1) on the left side of the neck come from the corrosion of iron elements inserted into the statue (fig. 245).
The iron oxides partially hide and stain the gilt.

2.3. The black patina, present in some incisions on the chest, on the left side of the neck, and on certain parts of the right flank, contains copper, iron and the sulphide ion (sample 1, a: a sample from the left flank). The X-rays were not able to pick out crystalline sulphides; in sample a, some magnetite was noted (fig. 246).
This patina, which in the specimen is detached together with the gold residue and the green patina underneath, is probably a mixture of copper, iron oxides and sulphides.
Traces of sulphides are also present in samples 5, 9, e.

2.4. The shining, smooth and brown-black patina, directly in contact with the metallic surface, as can be seen, for example, on the legs and left rump (sample 9), is made mainly of cuprous oxide (cuprite).

2.5. The green patina, taken from the surfaces of the stomach, one leg, the tail, the small holes and some incisions on the chest (samples 2, 3, 6, 7, b) consists of copper and lead sulphates (brocantite, anglesite) and of cuprite, which probably comprises a thin layer directly in contact with the metal.
The samples which are not in direct contact with the outside and those which are distant from the lead patches, do not contain anglesite (samples 11, 12, 13, g).

TABLE I

Sam-ple	Type of patina and area examined	Cuprite	Brocantite	Antlerite	Atacamite	Paratacamite	Ossalato	Anglesite	Copper	Gold	Gypsum	Magnetite
1	Black/left part of neck		+					+				+
2	Light green/incisions on chest and left flank	+ +	+ +					+ +				
3	Grey green/under the belly	+ +	+ +					+	+ +			
4	White/area with lead patch on right flank; Brown/under lead patch							+ +				
5	Black with light flecks/tail (*)	+					+ +				+ +	
6	Green/tail	+ +	+ +					+ +				
7	Green/left hindleg	+ +	+ +					+				
9	Black/left hind part (*)	+ +										
11	Green/interior of head	+ +	+ +			+	+ +				+ +	
12	Green/interior of head (another part)	+ +	+ +								+ +	
13	Green/interior of body	+ +	+		+						+	
a	Black/incisions on chest (*)							+ +		+		
b	Light green/small holes on breast-band	+ +	+ +					+ +				
c	Light green/interior of neck	+ +	+ +									
d	Light green/rump	+ +	+ +									
e	Green/Lion of the Evangelist St. Mark			+ +			+					
e'	Green/edge of the Lion's wing	+ +	+ +		+							
f	Grey/area of lead patch under belly							+ +			+ +	
g	Green/interior of right ear	+ +					+ +				+ +	
h	Earthy deposits inside right ear	+			+		+				+ +	
l	Grey black/left foreleg (*)							+ +				

(*) Cu, Fe, S = present by chemical analysis
Cuprite = Cu_2O − Brocantite = $Cu_4(OH)_6SO_4$ − Antlerite = $Cu_3(OH)_4SO_4$ − Atacamite and Paratacamite = $Cu_2(OH)_3Cl$ − Copper oxalate = $Cu(COO)_2 \cdot nH_2O$ − Anglesite = $PbSO_4$ − Gypsum = $CaSO_4 \cdot 2H_2O$ − Magnetite = Fe_3O_4
+ phase present in sample; + + phase in major quantity

TABLE II

Sample	Type of patina and area examined	Conductivity in microS. cm⁻¹/100 mg.		% soluble salts		% Soluble chlorides as Cl⁻	% Insoluble chlorides as Cl⁻	% Total chlorides as Cl⁻	% Copper	% Lead	% Total sulphates as SO₄	% Soluble sulphates as SO₄
		a 72 h	a 24 h	a 72 h	a 24 h							
1	Black/left part of neck (*)	134.4	90.8	5.5	3.7	0.5	2.2	2.7	2.7			
2	Light green/incisions on chest and left flank	155.8	131.5	6.4	5.4	3.4	3.1	6.5	32.7	5.5	9.0	2.3
3	Grey green/under the belly	156.0	131.5	6.4	5.4	3.7	3.5	7.2	43.6	5.9	9.7	2.9
4	White/area with lead patch on right flanck; Brown/under lead patch	217.7	170.1	8.9	7.0	5.2	3.4	8.6			4.8	1.1
5	Black with light flecks/tail (*)	139.9	116.5	5.7	4.8	4.2	2.6	6.8				
6	Green/tail	205.2	116.3	8.4	4.8	3.5	2.7	6.2				
7	Green/left hindleg	161.2	149.4	6.6	6.1	5.2	3.2	8.4				
9	Black/left hind part (*)	272.6	198.0	11.2	8.1	1.0	2.4	3.4				
11	Green/interior of head		207.9		8.5	5.9	3.7	9.6	38.6	traces	3.9	2.7
12	Green/interior of head (another part)		234.7		9.6	6.2	4.0	10.2				
13	Green/interior of body	365.5	328.3	15.0	13.4	10.7	4.1	14.8				
a	Black/incisions on chest (*)	278.5	200.6	11.4	8.2	6.1	3.1	9.2				
b	Light green/small holes on breast-band	166.9	127.1	6.8	5.2	4.3	0.2	4.5				
c	Light green/interior of neck	205.2	188.9	8.4	7.7	4.2	1.3	5.5				
d	Light green/rump	300.5	144.4	12.3	5.9	2.4	2.3	4.7	37.6	1.1	16.0	3.1
e	Green/Lion of the Evangelist St. Mark	395.8	352.8	16.2	14.4	2.2	0.5	2.7				
e'	Green/edge of the Lion's wing	135.5	122.2	5.5	5.0	1.8	0.8	2.6				
f	Grey/area of lead patch under belly											
g	Green/interior of right ear	653.0	638.0	26.7	26.1	2.6	2.5	5.1	34.0	traces	21.8	3.6
h	Earthy deposits inside right ear											
l	Grey black/left foreleg (*)	211.3	150.8	8.7	6.2	2.1	2.4	4.5	14.4	58.5	14.7	2.6

For comparison, two samples of green patina were taken from the Lion of San Marco which is situated on the external façade of the Basilica (samples e, e'). In both the specimens cuprite and brocantite are present; of interest is the presence of a copper sulphate, antlerite, which is rather rare in outdoor bronzes [3].

2.6. Copper oxalate is present in five samples. This compound was identified by Staffeldt[4] on a Venetian bronze. Some hypotheses can only be formulated concerning the constitution of the oxalate:

a) reaction of pigeon excrements or the products of the metabolism of microrganisms with the components of the patina;

b) reaction of oxidation of hydrocarbons which are present in the atmospheric smog and deposited on the metal as a result of the catalytic action of the copper [5].

In any case a microbiological attack on the metallic alloy would be highly improbable.

2.7. Crystalline copper chlorides (atacamite, paratacamite) have been noted in four samples, whereas the gypsum, a usual component of patinas found on outdoor bronzes, is present in seven samples. There is no nantokite.

2.8. The conductivity measurements have revealed that a significant percentage of patina is soluble in distilled water. Most of the soluble salts are seen in areas not affected by rain, such as the inside and the ear of the horse as well as the rear part of the Gospel of the Lion of San Marco (samples 10, 11, 12, e, g). Samples taken from inside the statue have the highest levels of soluble chlorides.

2.9. The data referring to copper, lead and total sulphates, confirm the X-ray results. There is no lead in the patina taken from internal areas.

To these observations it must be added that in January 1962, as a result of studies undertaken on the Horses by the Central Institute for Restoration, crystals formed under the stomach were removed for X-ray analysis. These crystals turned out to be formed of copper sulphate pentahydrate ($CuSO_4.5H_2O$). This suggests that in an atmosphere with a high level of industrial pollution, whilst copper carbonates are totally absent, the formation of sulphates with decreasing basicity until neutral copper sulphate penta hydrate soluble in water, is facilitated.

Note

I) The X-ray diffraction analyses were carried out with the following criteria:
a) one phase is considered present when at least three peaks characteristic of the compound are distinguishable without overlapping;
b) the number of crosses for each phase is related to the intensity of the characteristic reflections.

II) The conductimetric analyses were carried out on the solutions obtained by extracting 10 mg of patina with 30 ml of distilled water at room temperature for 24 and 72 hours respectively; the values given were all referred to a 100 mg sample. There was practically total extraction after 72 hours. The percentage of soluble salts was found by applying the formula: % soluble salts = KvX/p, where K is a constant (for a certain range of conductivity) [2], v = volume in millilitres of the aqueous extract, p= weight in mg of the sample, X = conductivity in micro Siemens cm^{-1}.

III) The percentage of soluble chlorides was obtained by colorimetric titration of the chloride ion in the aqueous extract. The insoluble residue containing insoluble chlorides was dissolved by the action of an acetic and nitric acid solution; the insoluble chlorides were then measured by colorimetric titration.

The copper and the lead were determined by an electrochemical method after dissolving the samples with nitric acid; the total sulphates by turbidimetric analysis on the filtered solution coming from the electrochemical test.

Cleaning tests
S. Diana, P. Fiorentino, M. Marabelli and M. Santini

1. Premise. The next phase of study consisted in a series of cleaning tests, carried out in controlled conditions and with the analyses of the removed ions. The experiments were repeated many times from 27th May 1974 to 18th April 1975, always on the horse inside the Basilica.

These tests aimed at establishing the ways and controlling processes of removal of the lead sulphate and iron oxide incrustations, as well as the washing treatments with distilled water and distilled water with Tween 20 (surface active reagent - see Note) for the removal of the soluble salts present in the patina. Besides, two different concentrations of sodium sesquicarbonate solution were used experimentally; this alkaline treatment facilitates the extraction and dissolution of the chlorides that are most difficult to dissolve in water, and the neutralisation of the eventual components of the patina with an acid pH.

2. Cleaning operations

2.1. Treatments to remove deposits: To remove the lead sulphate and iron oxide deposits which conceal the gilt underneath, it was necessary to carry out preliminary research in laboratory in order to choose the deposit removers and work out the best way to clean the Horses.

The most suitable deposit removers applied subsequently on the areas marked with the numbers 1 and 2 found to be ammonium tartrate for the lead sulphate and potassium oxalate for the iron oxides. The deposit removers were applied in compress at room temperature, discovering the gilt without dislodging particles of gold (figs. 247 - 248). The pH and the conductivity of the rinsing water were controlled for both applications. The details of the cleaning treatments are given in table III.

2.2 Preliminary alkaline treatment tests:

As a preliminary test for the efficacy of washings with sodium sesquicarbonate, areas marked with the numbers 3 and 4 were chosen; they correspond to zones of green patina and gold lining.

The alkaline treatments were controlled by the measurements of the chlorides, sulphates and copper ions in the washing waters; the final washings with distilled water were concluded when a neutral pH and a conductivity value equal to or less than 10 micro Siemens cm was reached, because it was

considered unwise to prolong the treatments due to the fragility of the patina.

The preliminary tests related to areas numbered 3 and 4 are described in Table IV.

2.3 *Comparison between the various types of treatment:* On the areas of green patina, numbered from 6 to 9, a further series of treatments took place based on:
— 1% sodium sesquicarbonate
— 3% sodium sesquicarbonate
— Distilled water
— Distilled water + 2% Tween 20 (surface active agent, see Note)

The following analyses were made of the waters of the washings aud alkaline treatments and the following measures were carried out:

Analysis of the removed copper ion

Analysis of the removed amnonium ion

Analysis of the removed sulphate ion

Analysis of the removed chloride ion

Measurement of the conductivity for areas 8 and 9 (control of the removed soluble salts).

Measurements of the pH and conductivity in the final phase of the washings and after the alkaline treatments.

The details of the tests and the treatments carried out are to be found in Tables V and VI and in the relevant diagrams.

In Table VI and in the diagrams the amounts of the chlorides (and of ammonium ion) removed, indicate the effectiveness of the various treatments in terms of the removal of the harmful ions contained in the patina.

The amount of copper ion and, partially, of total sulphates removed is proportional to the quantity of patina removed by the treatments, and must therefore be kept within reasonable limits in order to conserve the patina itself. The measurement of the conductivity is in relation to the quantity of soluble salts present in the patina and removed by the washings with distilled water and distilled water + surface active agent. These salts must be eliminated in order to lessen the possibility of renewed corrosive attack.

The measurements of conductivity and of pH also have the role of controlling the final phase of the washings in order to indicate the end of the cleaning operations.

3. *Observations on the results of the analyses*

From the results found in Table VI and the diagrams the following conclusions can be made:

1. The deposit remover tests carried out on the areas numbered 1 and 2 eliminated both the lead sulphate and iron oxides respectively, making the gilt underneath visible again. During the cleaning, no separation of the gold leaf was noted; however, the significant removal of the copper ion (8.4 and 4.2 mg respectively for a surface of 7 x 7 cm) indicated that the treatments must be carried out with great caution, for the time strictly necessary and only in the areas containing significant amounts of deposit.

2. The stabilizing alkaline treatment with 3% sodium sesquicarbonate in water was sufficiently effective in terms of chlorides but it is notably reactive as it removed the largest quantity of copper ion compared to the other methods.

3. The alkaline treatment with 1% sodium sesquicarbonate is as effective as that with 3% sesquicarbonate, but with the added advantage that it removes a smaller quantity of copper ion.

4. The Tween 20 treatment was particularly effective with regard to the chlorides and removed a relatively low amount of copper ion.

5. The distilled water treatment was not effective on the basis of the amounts used.

4. *Cleaning treatment programme*

As a result of the preliminary observations made, a treatment programme for removing deposits and for washing and stabilizing the corroded surfaces could be drawn up with the aim of eliminating incrustations, soluble salts present in the patina and removing, wherever possible, the chlorides. This treatment should consist of the following steps:

A. Deposit removal of anglesite and iron oxides with ammonium tartrate and potassium oxalate, following the application of the deposit-remover with a distilled water washing. It will be necessary to control the deposit remover action with the amount of copper ion removed, and the washings with pH and conductivity measurements.

B. Washing of the whole surface of the horse with 2% Tween 20 in water or with another equivalent surface active agent. This washing must take account of the quantity of chloride, sulphate, ammonium and copper ions removed in the subsequent steps of the washing process. The conductivity of the water (total soluble salts) must also be measured.

C. Alkaline treatment of the whole surface with 1% sodium sesquicarbonate in water, carrying out the same controls as in B, except for the measurement of conductivity.

The treatments B and C can be considered concluded when the quantity of chloride ion removed will become practically negligible. The time taken by treatments must, however, always be compatible with a limited removal of copper ion.

D. Final washing of the whole surface with distilled water. This washing must be checked with conductivity and pH measurements.

Note. The alkaline treatment completes the removal of the chlorides and neutralizes any possible acid products present in the microporosities spread over the horse's surface.

Most of the checks carried out during the experiments described in this report used portable equipment or kits. In particular the following were used:
— for the analysis of the chloride ion: Amel chloride counter;
— for the measurement of conductivity: W.T.W conductivity meter model LF 39;
— for the analysis of copper and ammonium ion: Hach kit.

In addition the following products were used:
— Aerosol 200V (colloidal silica) Eigenmann and Veronelli;
— Sodium sesquicarbonate ($Na_2CO_3 . NaHCO_3 .2H_2O$) BDH.
— Tween 20 (polyoxyethylene-sorbitane-monolaurate Merck; solution 2% surface tension = 35.0 dyne cm^{-1}).

247. (a) Area no. 1: before removal of lead sulphate deposit (Mag. x 3); (b) Area no. 1: after treatment (Mag. x 3).

248. (a) Area no. 2: before removal of ferrous oxides (Mag. x 3); (b) Area no. 2. after treatment (Mag. x 3).

TABLE III

PROCEDURE FOR REMOWING DEPOSITS

Number of area	1	2
Description of area	Left flank, under a large lead repair 35 x 20 mm.	Right shoulder, on a long brown-black stain 35 x 20 mm.
Deposit to be removed	Lead sulphate (anglesite)	Iron oxide
Removing agent	Ammonium tartrate spray [1]	Potassium oxalate spray [2]
Number of applications	3	3
Time of a single treatment	20'	20''
Temperature	40°C	40°C
Solution for alkaline treatment [3]	Sodium sesquicarbonate 1% in water	Sodium sesquicarbonate 1% in water
Number of treatments and volume of the solution	10 x 20 cc	10 x 20 cc
Time of a single treatment	5'	5'
Temperature	Ambient temperature	Ambient temperature
Cu^{+2} removed (in mg.)	1.2	0.6
Washing solution [3]	Distilled water	Distilled water
Washes until pH7	100 ml.	100 ml.
Number of final washes and solution volume	2 x 100 ml.	5 x 100 ml.
Time of a single wash	5'	5'
Temperature	Ambient temperature	Ambient temperature
Final conductivity [4] (microS. cm^{-1})	10	5

[1] Saturated solution carried to pH8 by the addition of ammonia; application of a cold compress with a colloidal silica spray.

[2] Solution at 5%, pH5 obtained by adding oxalic acid; applied as above.

[3] Applied with a brush.

[4] The value of the distilled water was of 4 microS.cm^{-1}. It was considered sufficient to interupt the washes when a conductivity of \leq 10 microS.cm^{-1} had been measured.

Table IV

DETAILS OF THE ALKALINE TREATMENTS

Number of area	3	4
Description of area	Right cheek, on the gold and green patina 7 x 7 cm.	Right part of neck, green patina with traces of gold 7 x 7 cm.
Preliminary wash with cold compress	Distilled water and spray	Distilled water and spray
Time	20'	20'
Alkaline treatment [1]	Sodium sesquicarbonate 3% in water	Sodium sesquicarbonate 1% in water
Order of treatments and volume of solution used	10 x 150 ml. = 1500 ml.	10 x 150 ml. = 1500 ml.
Time of a single treatment	5'	5'
Cu^{+2}, $Cl-$, SO_4 = removed (in mg.)	5.3/7.9 [2] /7.0	2.2/ 10.7 [3] /3.2
Washing solution [1] until pH7 is reached	Distilled water ~ 300 ml.	Distilled water ~ 300 ml.
Number of final washing and volume of solution used	2 x 300 ml.	2 x 300 ml.
Time of a single treatment	5'	5'
Final conductivity (microS.cm^{-1})	5	4

[1] Applied with a brush
All the operations were carried out at room temperature, including the wash with a cold compress.
[2] Chlorides still present at the 10th treatment.
[3] Chlorides absent from the 4th treatment onwards.

Evaluation of the Examinations and Tests
P. Fiorentino and M. Marabelli

From the above results it is possible to clarify certain aspects of the corrosion mechanism and to indicate the best possible methods of conservation.

No traces of basic copper carbonates (malachite and azzurrite) have been found on the Horses. They are compounds which decompose when in contact with an atmosphere which is greatly polluted by sulphur dioxide; on the other hand copper and lead chlorides and sulphates are present in large percentages, that is, as the typical components of a patina formed in a maritime-industrial environment. In the course of time both atmospheric pollution and water have played their part in the formation of this patina and in its subsequent development. There are two main ways in which water comes into contact with the surface of the statues and can determine their deterioration: as condensation humidity or as rainwater.

The metallic mass of the statues heats up during the day and cools down during the night. Condensation phenomena, caused by the high level of Venetian atmospheric humidity, have been verified in the early hours of the day, when the temperature of the statue is, in fact, lower than that of the air. Besides, the settling of hygroscopic salts on the surface (e.g. chlorides) causes the humidity on the surfaces of the bronzes to remain stationary for a longer time [6].

From data concerning the dosage of sulphur dioxide in the period February 1973 to January 1974 (S. Alvise and S. Giorgio survey stations), it has been found that for a half-hour period the greatest number of values exceeding 0.30 p.p.m. of sulphurous dioxide in the air took place from November to January and between 3.00.a.m. and 12.00 a.m. each day [7]. Presumably, therefore, when the humidity condenses on the Horses, the maximum content of acid and sulphur dioxide in the atmosphere tend to be at their greatest concentration.

Water from heavy rain certainly drives away the patina, removing the soluble salts, and making it porous and friable. The destructive part played by even the small, mechanical impact of the rain drops on the surface cannot at present be evaluated but it could be of considerable importance. It should be borne in mind, however, that in the water collected after an experimental washing (done with distilled water applied with quite a soft spray), some minute pieces of gold were observed. Finally, the rainwater running down the sides of the Horses has created some characteristic stains on the surfaces of the statues. These stains, flow over the gold, cover and corrode the edges of the incisions.

TABLE V

PROCEDURE OF THE TREATMENTS [1]

Number of area	6	7	8	9
Description of area	Left hind flank	Left buttock	Left side of muzzle	Near area 9
Preliminary wash with cold compress (i)	Sprayed distilled water	Sprayed distilled water		
Time	20'	20'		
Solution treatments used	Sodium sesquicarbonate 3% in water	Sodium sesquicarbonate 1% in water	Distilled water	Tween 20, 2% in water
Number of treatments and volume of solutions (nn. f 1-10)	10 x 150 ml.	10 x 150 ml.	10 x 150 ml.	10 x 150 ml.
Time of a single treatment	5'	5'	5'	5'
Washing solution	Distilled water	Distilled water		Distilled water
Number of washes and volume to give solution a final pH7 (nn. f 1-10)	3 x 100 = 300 ml.	3 x 100 = 300 ml.		3 x 100 = 300 ml.
Number of final washes and solution volume (nn. f 12-14)	3 x 300 ml.	3 x 300 ml.		3 x 300 ml.
Time of a single wash	5'	5'		5'
Final conductivity (microS.cm^{-1})	5	5	10	5

[1] All the operations were carried out a room temperature.
f = fraction.

TABLE VI

QUANTITY OF IONS REMOVED (in mg.) BY THE TREATMENTS ON VARIOUS AREAS

Number of area	Chlorides up to 10th treatment	Total chlorides	Sulphates up to 10th treatment	Total sulphates	Copper up to 10th treatment	Total copper	Ammonia up to 10th treatment	Total ammonia
6 sesq. 3%	5.6	9.4	21.2	33.2	3.8	4.6	2.0	2.7
7 sesq. 1%	6.2	9.6	21.4	39.0	2.1	2.4	2.3	2.9
8 H$_2$O	4.3	4.3	24.8	24.8	2.9	2.9	1.2	1.2
9 Tween 2%	12.6	26.3	29.7	48.1	2.3	3.3	—	—

copper = $Cu+2$ soluble + insoluble
ammonium = NH_4^{-+}
sulphates = SO_4 soluble + insoluble
chlorides = $Cl-$ soluble + insoluble

It was not possible to analyse the quantity of ammonium ion from area 9 because the Nessler reagent became turbid when added to the test solution.

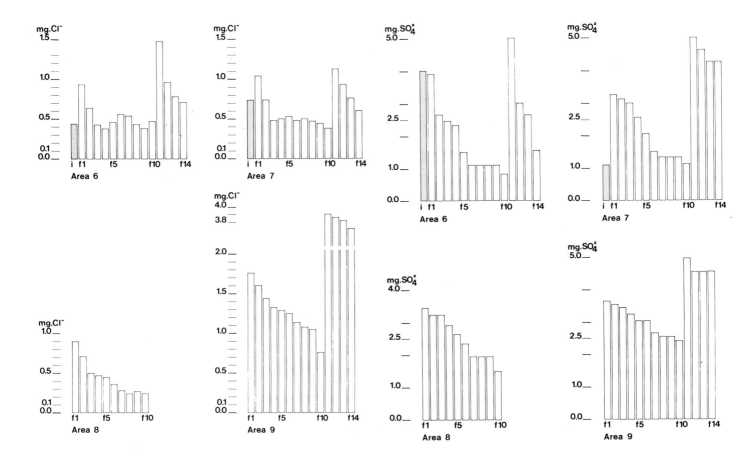

Legend: i cold compress by spray
 f1 ÷ 14 sequential fractions of treatments and washes

SEQUENTIAL ANALYSES OF CHLORIDES REMOVED

Legend: i cold compress by spray
 f1 ÷ 14 sequential fractions of treatments and washes

SEQUENTIAL ANALYSES OF SULPHATES REMOVED

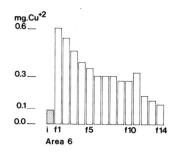

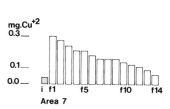

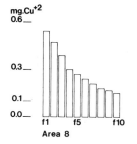

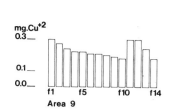

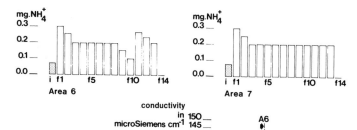

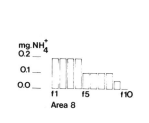

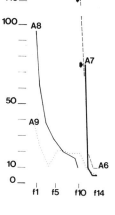

Legend: i Cold compress by spray
 f1 ÷ 14 Sequential fractions of washes for each treatment

SEQUENTIAL ANALYSES OF THE COPPER ION REMOVED

Legend: A6 9 Area 6 7 8 9
 Successive alkaline washes
 i Cold compress by spray
 f1 ÷ 14 Sequential fractions of treatments and washes

SEQUENTIAL ANALYSES OF THE AMMONIUM ION RE-
MOVED AND THE MEASUREMENTS OF THE CONDUCTI-
VITY OF EACH OF THE WASHES

251

252

To conclude, the original patina, formed in an unpolluted atmosphere by a process of electrochemical corrosion, favoured by the presence of the gold-copper couple, has interacted with the new environment [8]. As a result of this contact with atmospheric pollution, a new patina has been formed, completely converted to sulphates and which is unstable and partially soluble in rainwater. The surviving gilt rests on this degraded patina and is in-part covered by it (see M. Leoni).

The presence of water on the surface of the bronzes, in whatever form and quantity, gives a high conductivity solution of salts which favours the corrosion of the metal underneath. It is, therefore, certain that the patina of the Horses, far from being a protective layer, becomes the more unstable and damaging the more it comes into contact with water and polluting compounds of the atmosphere.

As a temporary solution to reduce the corrodibility of the metallic alloy, attempts could be made to extract the soluble salts, that is, those salts which can be removed from the surface without damaging the gilt (which, as we remember, actually rests on a patina which is partly soluble). It must be said immediately that acting in such a way may eliminate, it is true, a certain quantity of the more easily soluble salts, but it may at the same time increase the porosity of the patina and thus its fragility and permeability to air and water. As a consequence, the first conservation action or ''cleaning treatment'' which consists of the extraction, within certain limits, of the damaging soluble salts and thus also the soluble products of corrosion, though necessary, is in no way sufficient to stop the Horses' deterioration in the open air, but only to slow it down slightly for a very short time.

The cleaning treatment is thus only the first of the preventive methods needed to conserve the Horses. It is carried out in various stages: deposit removal; washing with surface active agent; alkaline washing with 1% sesquicarbonate; final washing.

The methods used to check the treatment are as follows:
1. colour macrophotographs of sample areas;
2. chemical analyses;
3. conductimetric controls and pH measurements.

Through the macrophotographs, taken before and after each test, it has been proved that the chosen cleaning treatment, if carried out correctly (in particular, avoiding any mechanical action), does not leave behind any visible sign of damage on the corroded surface or on the gilt. Through the chemical analyses of the solutions used in the tests, one has been able to ascertain that the quantity of ions extracted from the patina during the cleaning is quite significant (see in particular the chlorides removed by the treatment using the surface active agent). From these results, which are in complete agreement with the conductivity measurements of the soluble salts present in the patina itself, the two following conclusions can be drawn:

A. The cleaning process can be controlled through the use of the methods indicated (analyses of the chloride and of the copper ions; conductivity; pH), in such a way as to determine with sufficient accuracy the moment when the treatment must be interrupted to avoid an excessive removal of the patina. The analyses can be undertaken directly *in situ* during the treatment with the use of portable equipment and kits.

If it were feasible to have an ''ideal'' cleaning treatment, it would correspond to a maximum extraction of chlorides from the corroded surface, together with a removal of as little as possible of copper and consequently of patina.

B. After the cleaning operations it will be necessary to protect the patina from contact with the acid products of the atmosphere which make it soluble, and from the action of water, whether through condensation or heavy rain. The precautions taken to protect the Horses should also ensure that the metallic alloy is adequately isolated from the environment in order to slow down, as much as possible, the electrochemical corrosion. Since at present not enough reliable research has been undertaken to find a way of isolating the metallic alloy, the problem of the outer protective layer for the Horses after they have been cleaned must be tackled by a particular study; its contents have already been defined and preparatory work completed. This initial work has, above all, shown that the protective materials used must be compatible with the following characteristics of the statues:

a) the presence of a surface which is unhomogeneous and badly corroded and porous;
b) the presence of a patina which is very friable, partially soluble and with particular chromatic characteristics which must not be altered;
c) the metal has a high thermic expansion coefficient.

Taking account of such conditions, and also that the protective materials used must be absolutely ''neutral'' with regard to the components of the patina and capable of being easily removed at any time and without causing damage, an initial choice of synthetic resins and waxes has already been made to be subjected to artificial and accelerated aging tests (exposure of the samples to ultraviolet rays, thermic cycles, saline fog and sulphur dioxide) as well as the ''natural'' test of being placed in the open close to the Horses. Periodic checks on metallic test-pieces will ascertain the effectiveness of the protective action of the selected materials at various stages during the aging processes.

The conclusions of a study which has yet to take place should not be anticipated, but it is certain that, whatever the results of current research on protective coatings, the conservation of the Horses will only be able to take advantage of them for a satisfactory long period of time if it is incontrovertibly shown that the protective treatment, once its effect is lost (as is sooner or later inevitable) can be removed without damaging the horses and then reapplied without losing any of the protective and long-lasting effects obtained through its first application.

Even though current studies may reach a similar conclusion, the present state of affairs indicates that for a secure and lasting result one cannot rely on cleaning and on protective coatings; one must instead shelter the Horses from direct exposure to the corrosive elements of the Venetian environment, as has already been indicated.

Note: Superior figs. 3-8 refer to bibliography.

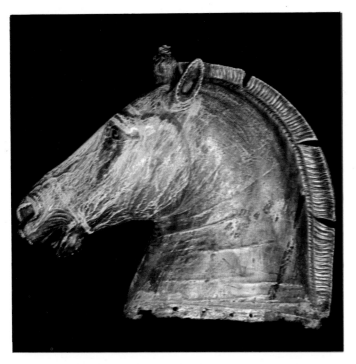

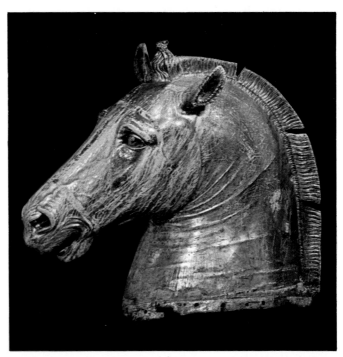

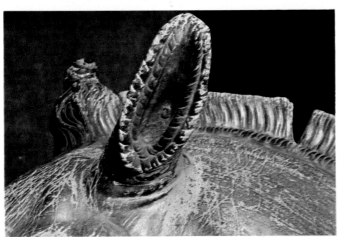

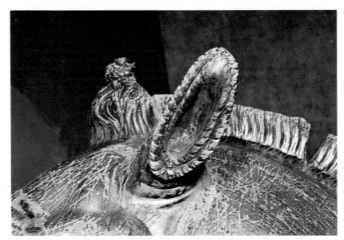

253. The head before treatment.

254. The same after treatment.

255. Detail of the left ear before treatment.

256. The same after treatment.

Cleaning a horse
P. Fiorentino and M. Marabelli

The cleaning treatment of the horse placed inside the Basilica of San Marco consisted in the removal of deposits from the gilt surface and the extraction, through various suitable washings, of the soluble salts contained in the patina, both on the inside and outside of the statue. The following is a brief description of the methodology used and the results obtained.

Along the right shoulder and all around the collar, brown-black iron oxide stains were evidently due to corrosion of some iron screws placed to attach the head. These stains were removed through the application of cold compresses of potassium oxalate [1]; the gold underneath was restored to the daylight everywhere except for the back part of the collar, which had been re-made at a later date and only shows traces of gilt.

Other whitish-grey lead sulphate stains, due to the corrosion of the many lead repairs spread over the surface of the statue, alternated to give a "zebra" effect with black stains containing sulphides. They have been removed by compresses at room temperature containing ammonium tartrate.

Over the whole surface a fair amount of the gold has been discovered, and even the "zebra pattern" is much less evident. In addition, through this treatment all the incisions formerly covered by corrosion products are now clearly visible. The internal washing of the statue was carried out with a pump sucking the solutions from a bowl under the horse up into the inside of the bronze.

Initially it was necessary to clean the inside of dirt, mould and most of the soluble salts which had accumulated there in the course of time, with three successive one-hour washings utilizing a total of 300 litres of distilled water. These were followed by three more washings, each of an hour utilizing a further 300 litres of distilled water. By the end of the sixth washing the water was almost clear, containing 4.982 gr of soluble salts [2] in the last 100 litres (in particular 40 mg of copper ion and 500 mg of chloride ion). After this a washing, with 50 litres of Tween 20 1% solution took place for an hour, followed by rinsing with 50 litres of distilled water, which removed 3.378 gr of soluble salts (in particular 20 mg of copper ion sand 250 mg of chloride ion).

Finally, the horse inside was washed with 50 litres of sodium sesquicarbonate solution for an hour, followed by three rinses lasting 20 minutes each with a total of 150 litres of distilled water. The measurements relating to the last rinse gave the following values: conductivity 25 μS cm^{-1}; pH 5.5; 10 mg of copper ion removed; no chloride ion.

With the same procedure, but using smaller quantities of solutions, the inside of the horse's head was treated until practically the same result was obtained.

The external surface was washed using a brush because of the fragility of the patina and the gilt, in the following order - head, front, middle, rear.

After washing with distilled water in order to eliminate every trace of deposit removers, the following rinsings were used for each part: 20 litres of Tween 20 solution for 15 minutes, 20 litres of distilled water for 15 minutes, 20 litres of sesquicarbonate for 15 minutes, and five times 20 litres of distilled water for 15 minutes.

At the end of the first rinsing after the treatment with the Tween 20, in each of the areas the analysis of the water was as follows:

	Total salts in solution	Copper ion	Chloride ion
Head	1.324 gr	8 mg	200 mg
Front part	1.051 gr	8 mg	140 mg
Middle part	1.187 gr	8 mg	100 mg
Rear part	1.324 gr	8 mg	100 mg

At the end of the final distilled water rinsing, the following values were found for the 20 litres:

	Conductivity	Copper ion	Chloride ion	pH
Head	8 μS cm^{-1}	2 mg	20 mg approx.	5.6
Front part	10 μS cm^{-1}	4 mg	40 mg approx.	5.8
Middle part	9 μS cm^{-1}	4 mg	20 mg approx	5.6
Rear part	5 μS cm^{-1}	1.5 mg	traces	5.6

The sulphate check (with barium chloride and hydrochloric acid) always came out negative for all the stages of the treatment, beginning with the' Tween 20' solution washing.

Between one stage of the treatment and another, and at the end, humidity was eliminated by a flow of hot air.

The cleaning operation was carried out by Miss M. De Luca and Mr. I. Di Bella, restoration specialists of the I.C.R. Mr. G. Fioretti of the Procuratoria of San Marco was responsible for the photographic documentation and arranged the organization of the laboratory.

Notes

1 For the details of the treatments, when not given in the text, refer back to "Cleaning tests".
2 Total soluble salts means the sum of the soluble salts originating from the outside environment and the soluble compounds of the metals of the alloy.

Bibliography
1. V.F. Lucey, British Corrosion Journal, 7, 36-41 (1972)
2. J. Rodier, *L'analyse Chimique et Physico-chimique de l'Eau*, Dunod, Paris 1966.
3. Rutheford J. Gettens, *The Corrosion Products of Metal Antiquities*, Smithsonian Institution, Washington 1964.
4. E.E. Staffeldt, O.H. Calderon, D.F. Kohler: *Assessment of corrosion products removed from La Fortuna, punta della Dogana da Mar, Venezia*, paper presented at the Third Interpetrol Congress, Rome, 1972.
5. G.W. Poling, Journ. Electrochem. Soc., 117-4, 520-24 (1970).
6. M.A. Bertolaccini, S. Cerquiglini, V. Fassina, G. Torraca, *Study of some gaseous and particular pollutants in the atmosphere of Venice*, International Centre, Rome 1975.
7. *Rilevamento dell'inquinamento atmosferico nella zona di Venezia: febbraio 1973 - gennaio 1974*, Tecneco, Venice.
8. M. Leoni, Metallurgia Ital., 27, 1579 (1972).

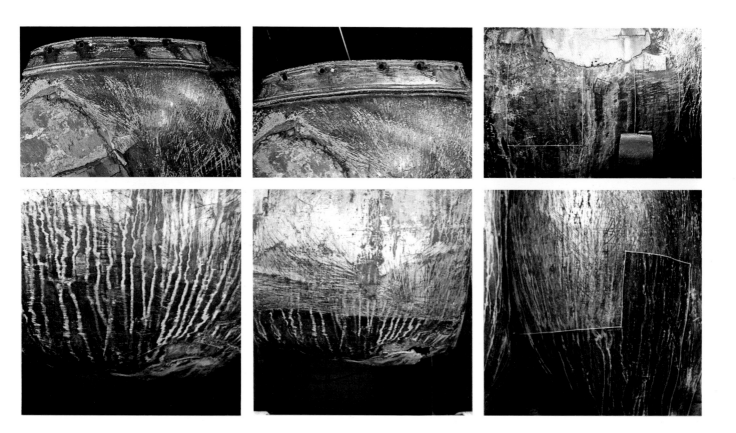

257. Detail of collar with stains of ferrous oxide.

258. The same after the removal of the deposit.

258a. Detail taken during the removal of the lead sulphate deposit.

259. Detail of belly before cleaning operation.

260. The same during the removal of the deposit.

261. Detail of rear right-hand flank during the removal of the deposit.

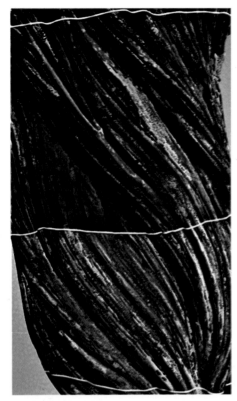
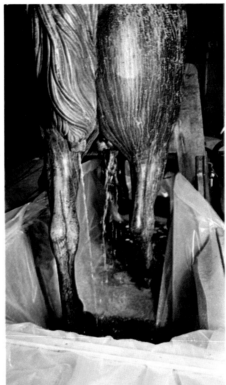
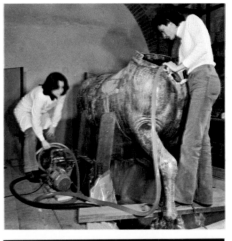
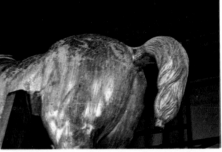
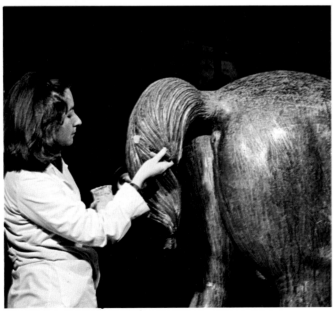
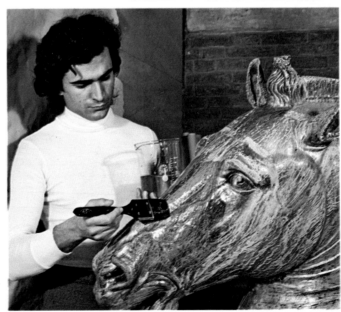

262. Detail of the tail during the cleaning operation.

263. Draining of the solution during the internal washing.

264. Washing operation of the Horse's interior.

265. Detail of the Horse after the cleaning operation.

266. Application of cold compress to remove the deposit.

267. Washing operation on the exterior of the head.

226

Appendix

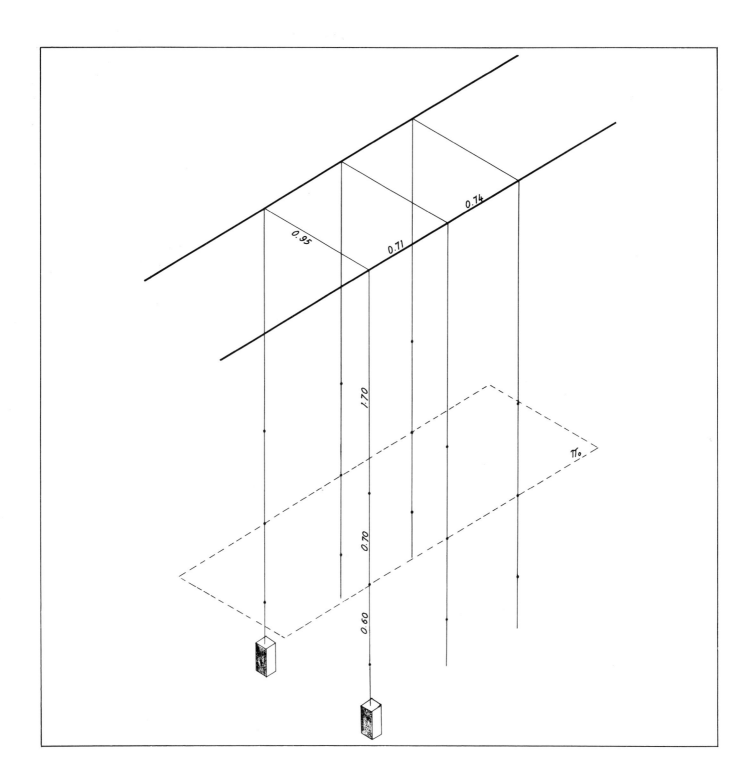

A detailed photogrammetric survey of one of the Horses of San Marco

Carmelo Sena

The general measurements of the horse which we have been asked to use for the requested geometric survey are 2.60 metres in length, 0.90 metres in width and 2.40 metres in height.

The horse was placed in a small room inside the Museum of the Basilica of San Marco, which made it much easier to carry out both the photography and to provide necessary topographical supports for the statue in order to make the most effective use of the space around it, compared to the restricted conditions which would have been imposed by its normal site. Workers were able to move freely to the best possible advantage, and the work too was easily moved so that the under-side of the statue could be photographed to give a lower plan elevation.

After careful consideration of the aims set by this survey, the dimensions of the work mentioned above and the work location of the object to be examined, it was decided to use a scale of 1:5. It was agreed that a complete geometrical description of the work could be obtained from six appropriate views.

The selection of six planes of projection was made with the aim of providing easier planes of reference both for the photogrammetric measurements and for their subsequent utilisation so that the survey could be exploited to the full. The photographs were taken and the topographical supports set up between 15th and 20th December 1975. Beforehand, the wire structure (fig. 268) to provide the grid for the points of topographical support around the horse was set up at the Institute of Topography and Photogrammetry in the Engineering Faculty at the Turin Polytechnic.

Apart from its having to be easily moved and assembled wherever the work has to be examined, the guiding principle in planning and building this structure was the setting up of a series of co-ordination points (eighteen in all) laid out on two vertical planes at a suitable distance from one another, with their relative positions noted to an accuracy of about a tenth of a millimetre. With this aim in mind six wires each containing three reference points placed at a fixed distance were set up with the above-mentioned precision. After several tests had been carried out, it was decided to use piano wire 0.6 mm in diameter. Many experiments were also carried out for the small reference points and finally bronze reference points cylindrical in form were used; they were 15 mm long and 10 mm in diameter, with a hole along the axis so they could be inserted into the supporting wire. Every small cylinder has a mark or line cut around the diameter to enable accurate measurements to be made by both the topographic instruments and by the subsequent photogrammetric processing. The cylindrical form enables the reference point to be clearly visible from any position (when adequately lit) and renders any possible twisting movements of the wire during the various operations negligible.

The wires and small cylinders have been found to be effective and accurate for creating the measuring grid and for fixing the reference points to the various wires in order to obtain satisfactory vertical positions in the grid. Each wire was stretched with a weight of 5 kilos which was found adequate for this purpose (the tensile stress δ came out as 18 kg/mm^2).

The small blocks on the wires were positioned so as to obtain the most suitable distribution for dividing the space occupied by the work into squares. The small blocks were then fixed to the wires using suitable rapidly-hardening adhesive.

A system of metal clamps allowed small vertical movements to be made to all the reference points on each wire.

The positioning of the reference points relative to one another on the grid was the first of the operations carried out in the course of the survey.

A tubular metallic structure already in the workshop came in very useful after appropriate modifications had been made. In fact, the grid with its reference points as previously described (fig. 269) was attached to this useful structure. The position of the six central reference points of the six wires (plane π in fig. 268) was determined with a precision level utilising the Wild N3 level type fitted with a plate gauge. The relative distances between the various wires were imposed and controlled by means of direct measuring operations with a steel precision metre triangular in section. In point of fact, the system described above enabled the co-ordinates of the reference points to be assembled to form a unique reference system, with quadratic errors certainly averaging less than $^+ - 0.3$ mm.

This precision is adequate for the type of relief map required.

It must be pointed out that the wire calibrations were repeated many times, also when the work had been completed, in order to control possible variations that might have occurred in the relative distances between the reference points during the time taken for the measurements and under the same environmental conditions. These controls show that the precision was good since the

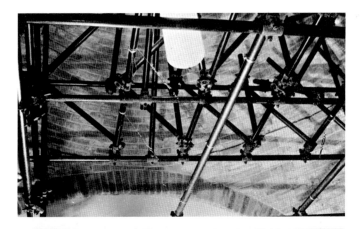

above test showed the variation was negligible.

The photographic operations were then started. The horse was placed in position on a wooden support which guaranteed its stability (fig. 270). Since the head had been removed for previous tests to be carried out, it had first to be replaced in the correct position on the body.

The relief plan was determined by the use of the T.M.K. Zeiss Oberchochen photogrammetric camera which has a focal length of 60.31 mm; the principal distance compensated is of 59.80 mm (to take close-ups a suitable additional lens had to be used). The size of the photographic plate was 9 cm x 12 cm though the effective size actually used was 8 x 10 cm.

The distance of the camera from the average place of each elevation was about 1.80 m with a minimum distance of 0.80 m (fig. 271 illustrates the scheme followed for the photogrammetry). The relationship b/d therefore takes the value of 0.44. The average scale of the photogrammes was 1:30.

For the double series of photogrammes of the side elevations, some photogrammes taken at stations $S_1 - S_2 - S_3$ and $S_6 - S_7 - S_8$ (figs. 272-273) are referred to.

For the front elevations, the photogrammes taken at the stations $S_4 - S_5 -$ and $S_9 - S_{10}$ (fig. 274) is referred to. The camera used for these exposures was used in the horizontal position. For the lower plan elevation (fig. 276) the camera was used in a vertical up position; for the exposures of the upper plan elevation (fig. 277) it was used with a vertical down position. The last two series required the use of a suitable adaptor made by the Zeiss Oberchochen company for placing in the vertical position, whereas for the exposures taken with the vertical up position, the use of a two-way support (fig. 278) was built for this very purpose.

There were particular problems with the exposures from below; it was in fact necessary to raise the horse with the help of a pulley, to maintain the exposure distance indicated above.

In this position, the grid with the reference points as constructed could not be used, and it was therefore necessary to build a new net-work suitably linked to the previous one.

Special lighting equipment was required during these operations because of the location of the work and the characteristics of its reflecting surface. Indirect diffused light was eventually used, since anti-reflecting varnish might have damaged or altered some substances on the surface.

For the exposures with the T.M.K. camera, the photographic glass plates used were Kodak panchromatic (metallographic) 9 cm x 12 cm, 50 DIN film sensitivity.

It was also possible to use for some side exposures a different photogrammetric camera, the Wild P31, kindly made available to us by Wild-Italia. Fig. 279 illustrates a photogramme taken with this camera. Aviphot Pan 30 plates 20 DIN sensitivity were used. The processing of the photogrammes was carried out in the laboratory at the Centre for Photogrammetry of the Turin Polytechnic between January and March 1976. The instrument used for the plates obtained with the T.M.K. photogrammetric processor was the Stereosimplex 2/A from the Officine Galileo.

269-270

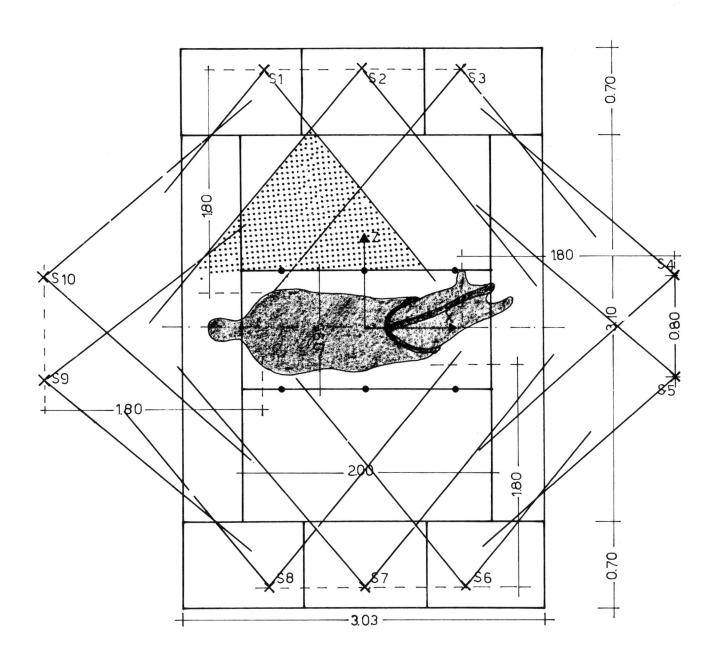

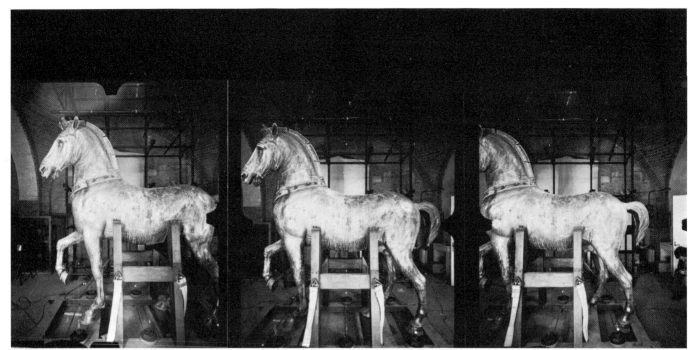

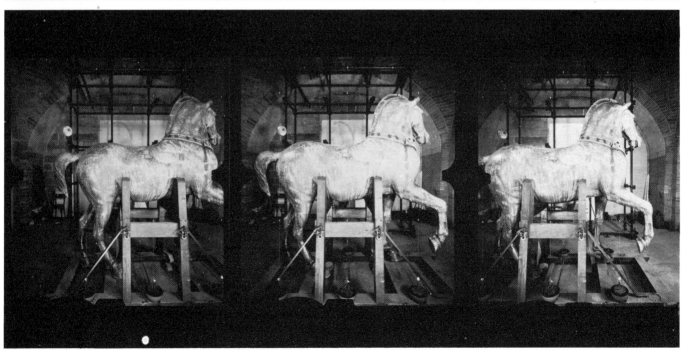

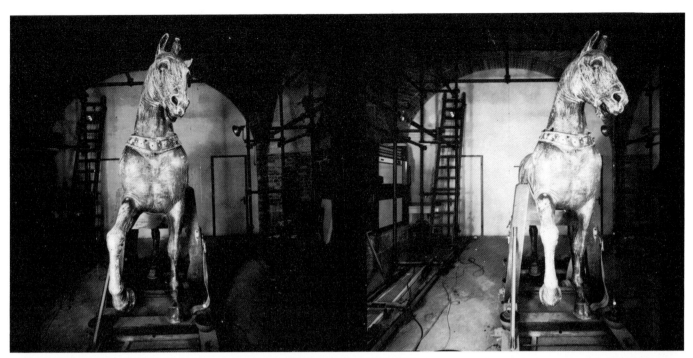

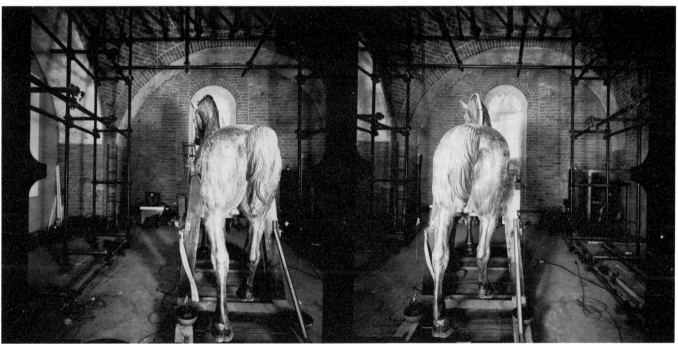

274-275

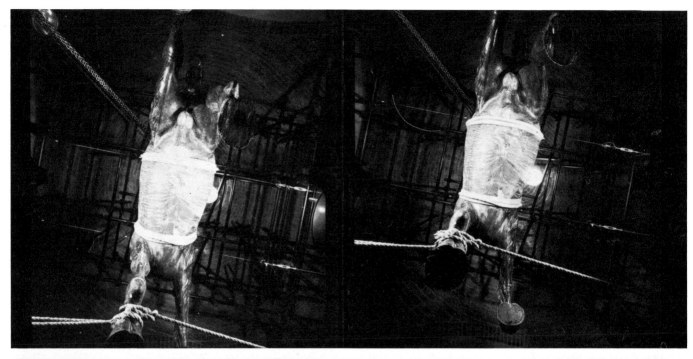

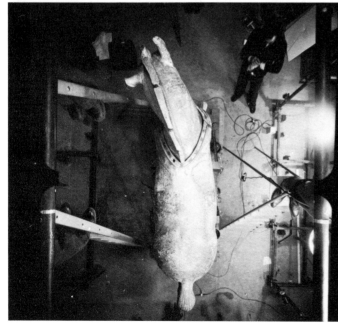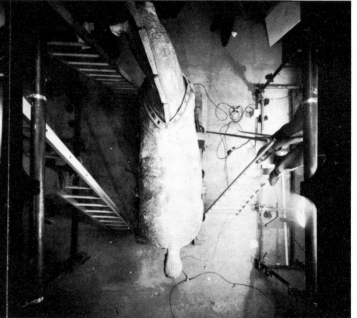

Given the scale of the photogrammes, the models were produced to the scale of 1:10 for the lower and upper plane elevations.

On the relief map, the six elevations with the scale 1:5 are drawn out (figs. 280a-280f), the enlargement ratio being 1.25 : 1 and 2:1.

The "Stereocartografo IV" Galileo was used for the processing of the photographs obtained with the Wild camera photogramme scale 1:18, model scale 1:6, drawing scale 1:2, with therefore an enlarging ratio of 3:1 on the plotting. It is important to recall the definition of the projection planes chosen when processing the elevations: the grid fixes the planes through its wires and cylindrical markers.

As already mentioned, there are three co-ordination points on the same wire which define the vertical within the precision limits of the operations which here are being examined. The following situations can be distinguished: a) planes defined by three wires (side elevations); b) planes defined by 2 wires (front and upper plan elevations); a plane which is defined through reference points on the artefact itself (lower plan elevation).

The wires therefore define planes considered to be vertical and the cylindrical markers, the horizontal planes. In particular, for the two planes defined by three wires, the utmost attention has been paid so that the definition should be the reference that is always used (using the precision line marked on the cylinder). The ideal projection plane to which the two side elevations refer, is the mean plane between the two as defined before.

The "levels" which represent the horizontal distances from the surface of the reference plane are given with reference to this vertical plane. The front projection planes are instead referred to the vertical plane defined by the two external wires towards the tail.

The upper and lower plan elevations are projected on the plane π (see fig. 268). In these last two elevations, the levels represent the distances from the surface of the artefact to the reference plane, this time along the verticals. In this way it was possible to obtain a unique system of reference, providing drawings with contours that can be clearly interpreted and showing extensive areas with the same survey. It is important to indicate that, still with reference to the "legibility" of the contours, the graphic problem is resolved by having contour lines with an equal distance between them of 2.5 mm for the tables with a scale of 1.5 and of 2 mm for the tables with a scale of 1.2. Following a common practice in Cartographic Topography, thicker contour lines have been drawn after every 5 normal contour lines, to enable the relief to be read more easily. Consequently at some significant points on the artefact the relief surface appears to be level.

I would like finally to thank Prof. Bruno Astori and the surveyors Guido Malan, Pietro Satta and Giuseppe Debernardi for their help with the survey, and the architect Gabriella Tescaro for the drawings.

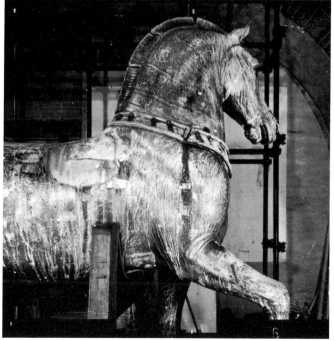

278-279

235

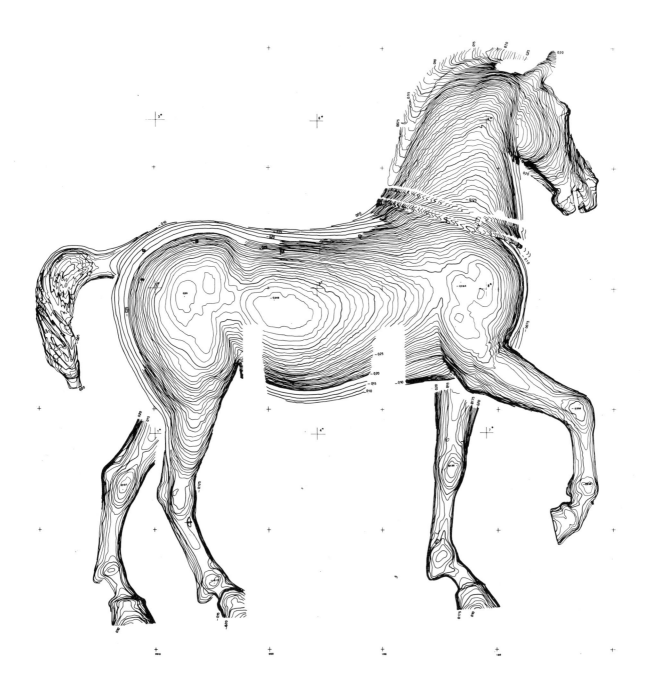

280a

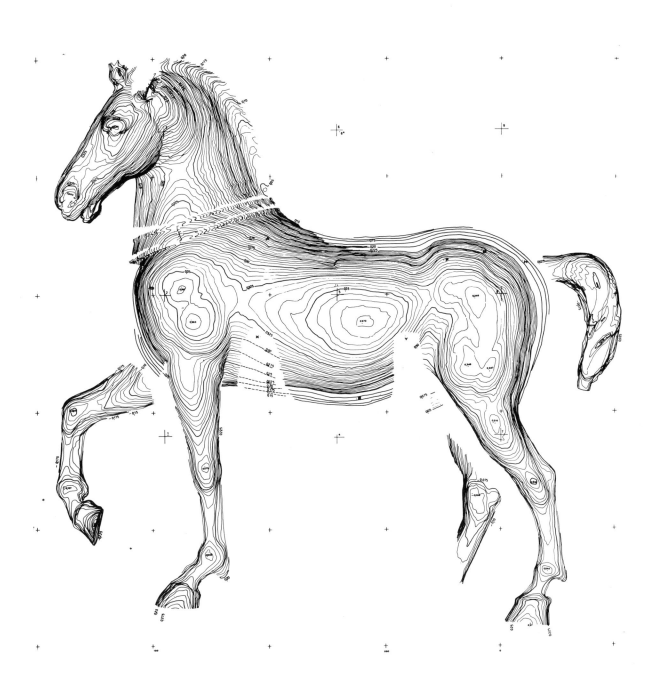

280b

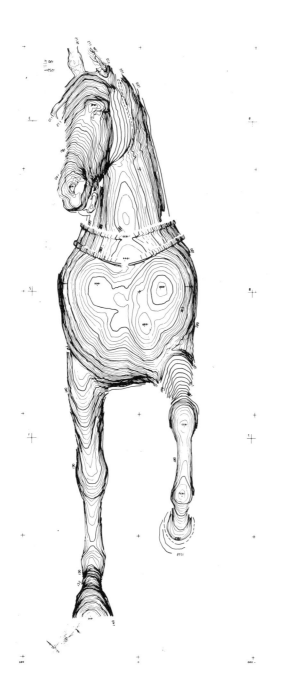

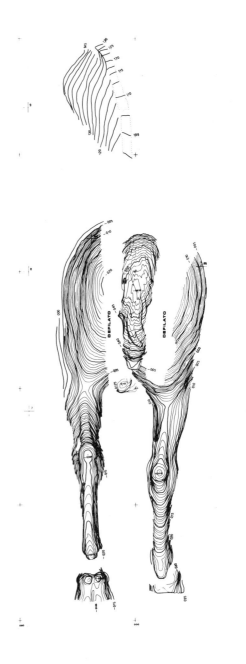

280c

280d

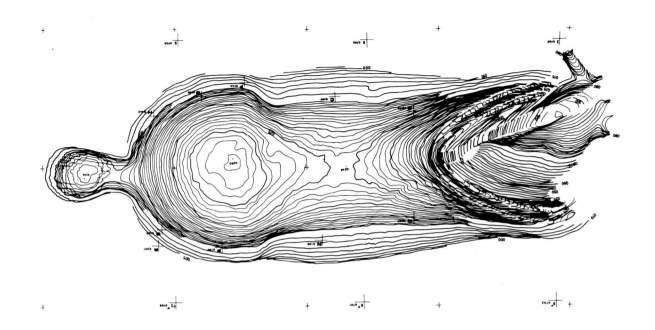

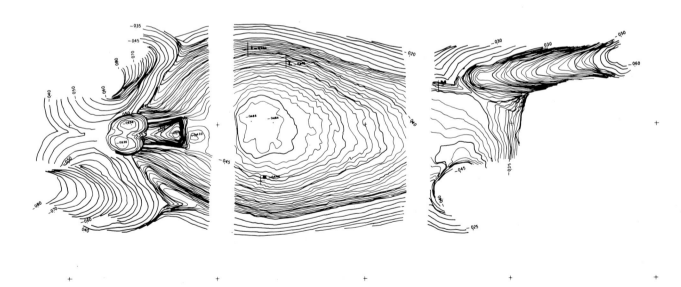

280e

280f

Copper alloys: their structure and corrosive phenomena

Massimo Leoni

It would indeed be useful for all scholars concerned with the conservation of works of art to know something about the most common bronze alloys, the structure they might assume as the result of the technical cycle of production, as well as the changes the products can undergo through the progressive corrosion caused by their environment. Here then is a brief survey of the copper alloys, of their structure and the corrosion they are prone to.

Copper alloys

As is known, bronze is an alloy of tin and copper, generally with tin not exceeding 15%. Some bronzes for particular uses can, however, reach a tin content of 25% as for example in bronzes for bells or in the Roman *speculum,* still used until a few centuries ago for the casting of small mirrors.

The alloy composed only of copper and tin is called a binary alloy of bronze. Besides the tin, it can contain small amounts (which may vary considerably), of other metals such as lead or zinc; in this case they would be ternary bronzes of copper - tin - lead, or copper - tin - zinc, or quaternary bronzes of copper - tin - zinc - lead if zinc and lead are present together. If, on the other hand, zinc is present as the only alloying element in the copper or in a noticeably higher proportion compared with the other elements, the alloy then becomes brass.

The alloying element indicates the element intentionally added to the alloy and it is generally present in significant percentages, especially in the bronzes.

Other elements can be present in the alloys, such as impurities which have not been deliberately introduced but either come from the minerals the metal has been extracted from, or through the contamination of the alloy during the various casting operations. Silver, nickel, arsenic, antimony and sulphur are impurities present in copper ores which can, however, be found in limited percentages in metallic copper. Nowadays modern extraction and purification processes enable metals of higher value, such as silver, to be recovered as well as the almost total elimination of other impurities.

Another element generally present as an impurity is iron coming from the contact of the molten metal with the iron implements. Impurities are almost always found in limited percentages, but there are indeed some cases where an undesirable element may even be present in a high percentage, either through accidental causes or deliberate adulteration.

An alloy normally has notably higher mechanical properties than those found in each of the single alloying elements. Copper wire one square millimetre in cross-section breaks under a load of 20 kgf, while an identical bronze wire containing only 1.8% of tin can support up to 40 kgf.

In most of the cases the presence of an alloying element lowers the casting temperature of the alloy in comparison with the base metal.

Pure copper melts at $1083°C$, while the presence of 13.5% of tin lowers its melting point to about $1000°C$. The same decrease in the melting temperature is obtained with about 20% of zinc or with 25% of lead. Besides, while a pure metal begins and ends solidification at a constant temperature, the alloys instead solidify slowly over a wide range of temperatures which can vary considerably. For example, while pure copper begins and ends solidification, as already mentioned, at $1083°C$, a binary bronze containing 13.5% of tin, begins to solidify at about $1000°C$, and ends at about $798°C$, a difference of more than $200°C$. The more alloying elements present, the lower the melting temperature and the wider the range of the alloy's solidification.

It is, however, self-evident that an alloy might be more easily melted when compared with pure metal and would have an easier flow, that is, a greater tendency to fill a mould reproducing its finest details better.

In founder's jargon, a metal low in alloying elements is called "lazy" in filling the mould.

To illustrate this point, table 1 (page 196) shows the chemical compositions relating to the principal alloying elements in the alloys used for some of the most famous bronze monuments.

Typical Microstructures of Copper and Bronze Artifacts

Before describing the structural alterations which can be found in bronze works likely to be attacked by external factors, some typical structures of copper and of the most common bronzes containing tin will be outlined.

Copper

Like all pure metals, copper in the as-cast state shows a microstructure made up of polygonal crystals homogeneous in structure. In modern production of cast copper, and even more so when produced in antiquity, impurities are always present, being mainly silver, nickel, arsenic, antimony, oxygen and sulphur.

Oxygen with copper forms the compound cuprous oxide, while sulphur forms sulphides both with copper and with the other impurities that may be present. However, a copper cast always shows a dendritic structure, made up of dendrites of copper containing in solid solution the soluble impurities, surrounded by eutectic crystals of compounds formed from the various impurities.

The micrograph of fig. A1 refers to 99.95% cast copper with crystals of cuprous oxide present in it.

When a copper cast undergoes cold work such as hammering, cold rolling and so on, with intermediate heat treatments of annealing which cause recrystallisation and, consequently, the softening of the metal, the microstructure undergoes significant transformation. The crystals of insoluble intermetallic compounds which may be present, such as cuprous oxide, arrange themselves along the direction of the prevailing deformation, while the solid solution crystals take on the particular structure of twinning, as illustrated in the micrograph of fig. A 2. This shows the microstructure of the sheets of copper used for the wings of the Gryphon of Perugia, which is typical of an annealed sheet.

If the material was not annealed after cold working, the crystals are seen first to be deformed or elongated (fig. A 3), and if further cold work is done they take on a fibrous structure where the original crystals can no longer be identified if the deformation is considerable.

Copper-tin Binary Bronzes

The structure of copper-tin binary bronzes varies according to the percentage of tin present, the conditions for solidification and the state of the alloys. Under equilibrium conditions, the various phases present are indicated by the relevant equilibrium diagram. The alloys in the as-cast state containing a low percentage of tin have a microstructure wich shows a single phase structure made up of dendrites of solid solution α (Cu) and heterogeneous in composition because of the microsegregation phenomena (coring).

When the cast is heated for a long time at a high temperature (600-800 °C), the homogenisation of the alloy occurs. The solid solution α (Cu) varies in colour from copper to yellow-gold depending on the increase in the tin content of the alloy.

In alloys containing more than about 6% of tin in their as-cast state which have been solidified quite quickly, the presence of dendrites of solid solution of a new phase can be found at the edges. This new δ-phase originates from a series of eutectoid reactions of the β phase which is rich in tin and only stable at elevated temperatures.

For percentages of tin under 15.8%, an alloy can be made of a single and homogeneous phase through appropriate heat treatments causing the dissolution in the solid solution α (Cu) of the δ phase.

For tin percentages greater than 15.8%, two phase alloys instead are always obtained consisting, at room temperature, of solid primary solution α (Cu) and of the eutectoid α (Cu) + δ^+.

The δ-phase, silvery-white in colour, is characterised by extreme hardness and brittleness so that its presence renders cold work of this alloy impossible. Alloys with a high percentage of tin, above 15%, can therefore only be formed through casting.

If the percentage of δ-phase becomes excessive, as in the case of tin percentages above 25%, the cast obtained with such alloys becomes brittle and therefore breaks easily under impact. They therefore do not have many practical uses. Regarding the microstructure, the single phase cold-worked alloys both annealed and hardened, have practically the same structure as the pure copper in exactly the same states.

As for the two phase alloys, the as-cast ones show that the δ-phase grows with the increase in the tin content and that the dimensions of the crystals of the eutectoid δ-phase become larger the slower the cooling rate of the process.

In the micrographs of figs B1, B2, B3, B4 the microstructures of the as-cast state of some alloys containing 15% and 25% of tin, the microstructure of identical alloys which had been heated for a long period at 700 °C and left to cool slowly in the furnace, are illustrated.

Influence of Zinc and Nickel on the Structure of the Bronzes

Zinc shows a very similar influence to that of tin on the microstructure of copper base alloys though to a much more limited extent, with zinc, however, being roughly twice the percentage of the tin required for this microstructure to be found.

A ternary alloy containing for example 10% of tin and 10% of zinc will, however, show an equivalent structure to that of a binary bronze containing 15% of tin.

Nickel is soluble in all the percentages in copper and therefore does not exercise any appreciable influence on the microstructure, especially if present in very limited percentages as is normally found in ancient bronzes.

Lead Bronzes

Lead dissolves both in copper and in copper-tin alloys when in the liquid state while it is completely insoluble in the solid state. During solidification, however, lead is separated in the form of globules at the boundaries of the solid solution dendrites.

The number and size of these globules depend not only on the percentage of the added lead but also on the rate at which the alloy solidifies.

A micrograph would show the lead in the form of small dark globules when it is present in limited percentages in the alloy, or by grey, considerably larger globules granular in structure, when

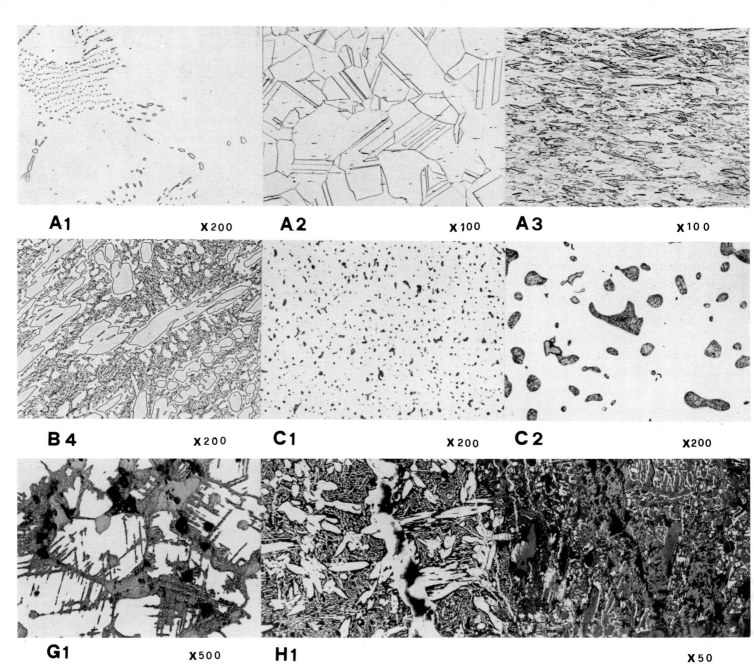

A1 X200 **A2** X100 **A3** X100

B4 X200 **C1** X200 **C2** X200

G1 X500 **H1** X50

A1 Microstructure of as-cast copper. On the boundaries of the dendrites the eutectic crystals of cuprous oxide can be seen. Mag. x 200. Etchant NH_3 + H_2O_2

A2 Microstructure of an annealed copper sheet. The cuprous crystals lined up in the direction of deformation can be seen (Wings of the Gryphon in the Palazzo dei Priori, Perugia). Mag. x 100. Etchant NH_3 + H_2O_2

A3 Microstructure of a copper sheet in the cold-worked state. The deformed and elongated crystals caused by the cold-working can be observed. Mag. x 100. Etchant NH_3 + H_2O_2

B1-B2 Microstructure of a binary bronze as-cast alloy with 15% tin (B1), and after prolonged annealing at 700° C (B2).

The almost complete solubilisation of the eutectoid phase can be observed. Mag. x 200. Etchant NH_3 + H_2O_2

B3-B4 Microstructure of a binary bronze as-cast alloy with a high tin percentage (25%) (B3), and after prolonged annealing at 700° C (B4). Mag. x 200. Etchant NH_3 + H_2O_2

C1-C2 Microstructure of a multi-phase bronze with 9.8% lead, 6.8% zinc, 4.1% tin in the as-cast state, when solidified rapidly (C1) and slowly (C2). The different dimensions of the lead globules can be observed. Mag. x 200. Etchant NH_3 + H_2O_2

D1 Pitting corrosion on a bronze statue with a low alloy content. (Horses of San Marco). Mag. x 100.

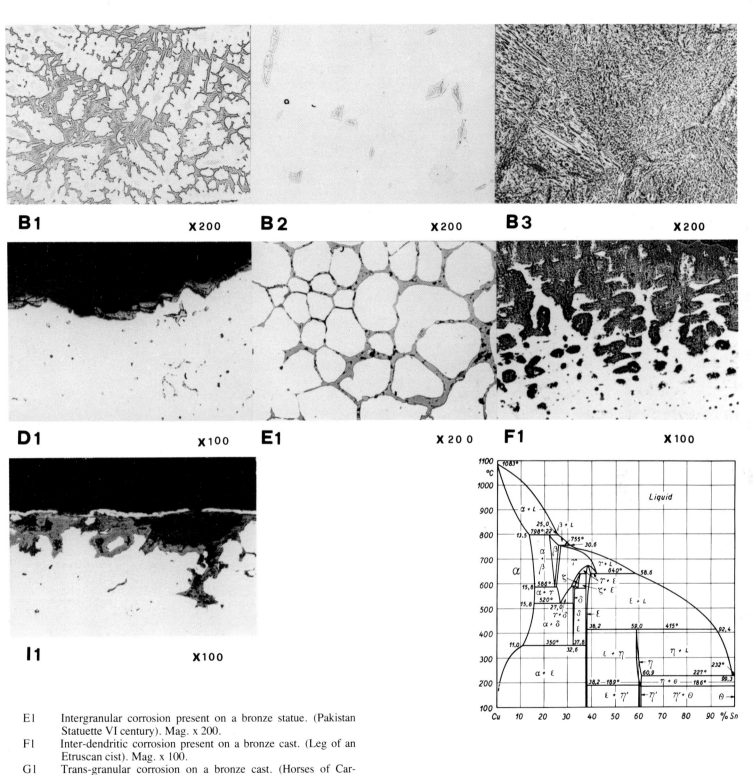

B 1 X 200

B 2 X 200

B 3 X 200

D 1 X 100

E 1 X 200

F 1 X 100

I 1 X 100

E1 Intergranular corrosion present on a bronze statue. (Pakistan Statuette VI century). Mag. x 200.

F1 Inter-dendritic corrosion present on a bronze cast. (Leg of an Etruscan cist). Mag. x 100.

G1 Trans-granular corrosion on a bronze cast. (Horses of Cartoceto). Mag. x 500.

H1 Selective corrosion on a bronze fragment from a bell. On the right-hand side there is α (Cu) phase corrosion, on the left eutectoid δ-phase corrosion. Mag. x 50.

I1 Galvanic corrosion appearing on the surface of a gilded bronze monument, showing the detachment of the gilding ("Gates of Paradise" by L. Ghiberti). Mag. x 100.

it is contained in a high percentage.

The micrographs of figs. C1 and C2 illustrate the different dimensions assumed by the lead globules in two castings having practically exactly the same chemical composition, but solidified at markedly different rates.

The other phases maintain, to all intents and purposes, the structure peculiar to the tin percentage present and to the state of the material.

Lead as an alloying element does not have any influence on the corrosion resistance of the alloys.

Microstructural Aspects of the Various Corrosive Phenomena

The corrosive phenomena found on the most different types of copper or bronze artefacts depend on several factors, the principal ones being the chemical composition of the alloy used, the technology followed for its production and the environment in which the work is placed, as well as the duration of its exposure there.

It should be noted that the conditions under which a particular object is exposed can vary significantly in the course of time, according to the different vicissitudes the work itself has gone through. In the case of those coming from archaeological sites, they could have been exposed for a certain period of time to the atmosphere; then they could have remained buried in a great variety of soils or submerged in sea or fresh water, later to be brought to light and exposed to the atmosphere again.

While buried, their condition could also be influenced considerably by environment, climate and weather conditions.

These works therefore might show at the present time various forms of corrosion attack. Some of the most typical aspects will be described below.

The various forms of corrosion can co-exist on the same object and, according to the conditions affecting it *in situ*, the products of alteration could remain attached to the object forming a wide variety of patinas or could be washed away, especially in objects exposed to the atmosphere in areas prone to heavy falls of rain, snow or hail.

Pitting Corrosion

One of the most common and frequent types of attack is that of crater corrosion. It occurs when the alloy is attacked without any particular preference and the corrosion works from the ouside inwards forming a fairly uniform and shallow area of corrosion.

During its progressive action the corrosive phenomenon produces pitting of various sizes and depths which can be found in localised areas or uniformly spread over the entire surface of the object.

Corrosive phenomena of this kind can be found on many different types of copper and bronze artefacts as well as on works made either by cold working or by casting.

The micrographs of fig. D1 illustrate the appearance of pitting corrosion found on a bronze.

Inter-granular Corrosion

Inter-granular corrosion is the corrosion phenomenon which is largely confined to the boundary of the crystals. In a later stage the corrosion can attack the inside of the crystals, thus completely destroying their internal structure.

This corrosion attack, which is typical of polyphase structures, can be found both in as-cast bronzes or in ones which have undergone heat treatment as well as in cold-worked bronzes.

Corrosion can proceed according to a particular stratified course, tending to follow the fibres of the material in the case of those which have been considerably cold-worked.

The micrograph of fig. E1 illustrates a typical case present on a bronze statuette. Intergranular attack is a particularly serious form of corrosion because the products are difficult to remove. Also, the various crystals in the alloy are only joined together by the corrosion products in the areas attacked; this can be to a considerable depth, and even in some cases through the whole sections. So any chemical or electrochemical process to eliminate the products of corrosion could lead to considerable portions of the material itself being removed, if not to the total disintegration of the piece.

Inter-dendritic Corrosion

Inter-dendritic corrosion in similar to intergranular corrosion; the former, however, is found only is works made through casting. In this case corrosion progresses along the boundary of the solid solution dendrites both through the presence of chemical or structural heterogenity and through microporosity.

The micrograph of fig. F1 illustrates a typical case of this particular form of corrosion.

Transgranular Corrosion

In some cases the corrosion, besides proceeding along the grain boundaries, also penetrates inside the crystals themselves following articular crystallographic planes and, in the first stage of the attack, showing characteristic geometrical figures inside them, as illustrated by the micrography of fig. G1.

This particular corrosive phenomenon, called transgranular corrosion, is typical of bronzes containing an average percentage of tin, largely made up of the solid solution α (Cu) wich have been deformed through cold-working and then heat treated. The transgranular type of corrosion phenomena is frequently found in Etruscan mirrors; these particular objects were in fact made of binary bronzes containing 10-15% of tin through successive annealings and hammerings, so they consequently have structures which favour this type of corrosion.

This type of corrosion has also been found on other monuments, such as the horses of Cartoceto.

Selective Corrosion

This particular type of corrosion is found in alloys with a polyphase structure, that is, in alloys containing a high percentage of tin, having besides the primary solid solution α (Cu) also the eutectoid α (Cu) + δ .

Depending on the environmental conditions to which a particular work is exposed, a selective attack of one of the two phases present may occur.

Both the attack of the solid solution α (Cu) and the α (Cu) eutectoid phase can be observed, while the eutectoid δ phase remains practically unaltered.

In other environmental conditions the preferential attack of the δ-phase can be noted, while α (Cu) could remain almost completely unchanged.

The two forms of selective corrosion can also be found on the same object, indicating a significant variation in the conditions of attack on the alloy. In the micrograph of fig. H1 it is in fact possible to observe the reversal of the course of corrosion found on a fragment of a medieval bell which had remained buried for some centuries. On the outermost part the α (Cu) had begun to corrode; further inside, although quite clearly separated, the δ-phase had undergone attack, while the α (Cu) remained practically unaltered.

On the boundary separating the two types of corrosion, the presence of a thin layer of copper deposited through cementation was observed.

Selective corrosion has also frequently been observed in a very particular form in Roman mirrors made of *speculum*. The attack of the solid solution α (Cu) with the formation of dark-coloured products of corrosion was in fact noted on these samples, while the δ -phase, silvery-white in colour, remained unaltered. The products of corrosion, having preserved the very same volume as the phase that was attacked and showing quite a compact structure, have maintained a notable brightness on the surface observed, giving it a silvery-grey colour, while the original colour of the alloy was light yellow.

This effect is caused by the disappearance of the yellow solid solution α (Cu) which was replaced by dark-coloured corrosion products, while the δ -phase, silvery-white in colour, remained unchanged.

Electro-chemical or Galvanic Corrosion

Electro-chemical or galvanic corrosion originates when two metals with a different electro chemical potential are in contact in the presence of humidity.

In this case, the less noble metal (the anodic area) dissolves, while the nobler one (the cathodic area) remains unchanged.

Typical examples of electro chemical corrosion are those found on gilded bronze works. In these cases it is the bronze which, acting as an anode, is corroded. Because the attack tends to take place at the gold-bronze interface, the gilding becomes detached and is only held to the metal base by the corrosion products.

The micrograph of fig. I1 illustrates a corrosive phenomenon of the type described above produced on Ghiberti's "Gates of Paradise" of the Baptistery in Florence.

Photographic acknowledgements

Alinari, 24, 27, 32, 33, 34, 35, 37, 38, 39, 40, 41, 42, 43, 45, 48, 49, 51, 53, 57, 91, 93, 96, 101, 151, 159, 160, 199.
Archivio di Stato, 69.
Archivio Fotografico del Vaticano, 47.
Biblioteca Marciana, 67, 68.
Osvaldo Böhm, 84, 94, 95, 97, 98, 99, 100, 108, 158, 182, 189.
British Travel and Holidays Association, Londra, 145.
Edizioni Storti, 22, 105.
Eliofoto s.r.l., 121, 146, 149.
Fondazione Cini, 109, 110, 127, 128.
Gallerie Ca' d'Oro, 92, 111.
Giacomelli, 104.
Hirmen Fotoarchiv, München, 29.
Istituto Archeologico Tedesco, Roma, 23, 28, 36, 42, 44, 46, 50, 55, 59, 190, 191.
Istituto Tedesco di Studi Veneziani, 89.
Istituto Italiano di Cultura, Istanbul, 82.
Monuments Historiques, Parigi, 90.
Museo d'Arte Moderna, Ca' Pesaro, Venezia, 134.
Museo Correr, Venezia, 88, 103, 123, 126, 129, 130, 131, 132, 133, 138, 139, 147, 148, 166.
Museo Civico di Bassano, 142, 143, 144.
Palazzo Ducale, Venezia, 59, 65, 125.
Procuratoria di San Marco: Archivio Fotografico, 6, 9, 15, 16, 18, 72, 73, 76, 150, 152, 153, 179, 204-214, 215-219.
Eliofoto s.r.l., 2, 3, 4, 8, 10, 14, 65, 77, 80; Leopoldo Franco, 102, 103; Giuseppe Fioretti, 5, 7, 11, 12, 13, 17, 19, 20, 21, 25, 30, 31, 54, 56, 58, 74, 75, 78, 83, 85, 86, 87, 106, 141, 161, 162, 163, 164, 167, 168, 169, 170, 171, 172, 173, 174, 175, 176, 177, 180, 181, 184, 185, 189, 192, 193, 194, 195, 196, 197, 198; Paolo Spezzani, 221, 222, 223.
Roiter, cover.
Soprintendenza alle Antichità delle prov. di Napoli e Caserta, 61, 62, 63, 64.
Soprintendenza Gallerie, Venezia, 112, 118, 119.
Stournaras, Atene, 201.
The Warburg Institute, 140.

Printed in July 1979 for Thames & Hudson ltd.
by Elli & Pagani, Milan, Italy